Our Boston

Also edited by Andrew Blauner

Central Park: An Anthology
Coach: 25 Writers Reflect on People Who Made a Difference
Brothers: 26 Stories of Love and Rivalry
Anatomy of Baseball (with Lee Gutkind)

Our Boston

*Writers Celebrate the City
They Love*

EDITED BY

Andrew Blauner

*A Mariner Original
Mariner Books
Houghton Mifflin Harcourt*
BOSTON NEW YORK
2013

For information about permission to reproduce selections from this book,
write to Permissions, Houghton Mifflin Harcourt Publishing Company,
215 Park Avenue South, New York, New York 10003.

www.hmhbooks.com

Library of Congress Cataloging-in-Publication Data
Our Boston : writers celebrate the city they love /
edited by Andrew Blauner.
pages cm
ISBN 978-0-544-26380-2
1. Boston (Mass.) — Literary collections. 2. American
literature — 21st century. I. Blauner, Andrew.
PS509.B665O96 2013
810.8'035874461 — dc23
2013027063

Printed in the United States of America
DOC 10 9 8 7 6 5 4 3 2 1

Credit lines and permissions appear on pages 354–55.

For Mary Ann Leslie-Kelly

For Boston

Patriots' Day

Restless that noble day, appeased by soft
Drinks and tobacco, littering the grass
While the flag snapped and brightened far aloft,
We waited for the marathon to pass,
We fathers and our little sons, let out
Of school and office to be put to shame.
Now from the street-side someone raised a shout,
And into view the first small runners came.
Dark in the glare, they seemed to thresh in place
Like preening flies upon a windowsill,
Yet gained and grew, and at a cruel pace
Swept by us on their way to Heartbreak Hill —
Legs driving, fists at port, clenched faces, men,
And in amongst them, stamping on the sun,
Our champion Kelley, who would win again,
Rocked in his will, at rest within his run.

RICHARD WILBUR

Contents

Running Toward the Bombs

Kevin Cullen

Dawn broke clear and clean over Boston on Patriots' Day 2013, and Dan Linskey was up before the dawn.

He walked down Boylston Street, near the finish line of the Boston Marathon, as he does every Patriots' Day, because this is his town and this is his baby. Dan Linskey is the chief of the Boston Police Department. And he owns every big outdoor event in the city, from the raucous celebrations that follow the championships of Boston's sports teams, which seem to happen every other year, to the star-spangled festival when the Boston Pops serenades the city every Fourth of July.

His was not an idle walk. As chief of the department, Linskey had drawn up several disaster scenarios, and the reality is that in the post-9/11 world, the marathon, like every other outdoor event in Boston, was a target for terrorists.

Still, there was nothing on this sunny morning that led Lin-

skey to believe it would be anything other than the day it usually is, the people lined along Boylston, five deep, cheering the runners on those last few hundred yards, toward the finish line at the Boston Public Library.

Patriots' Day is a holiday in Boston recalling the shots fired at Concord and Lexington, just outside the city, when a bunch of farmers took on an empire and won. The traffic is light. Out of the corner of his eye, Dan Linskey spied a woman who had set up camp on the corner of the Ring Road, blocking it. The Ring Road was an access point for emergency vehicles to Boylston Street.

"Ma'am, you can't stay here," Dan Linskey told the woman.

This being Boston, she gave it right back to him, informing him that she had got up early to stake out a prime spot on Boylston and she wasn't giving it up, no matter what he said.

Dan Linskey, a cop for twenty-seven years, a Marine before that, can be nice when he has to be. But he can also be firm. With this woman he was firm, and soon she had begrudgingly decamped to a place farther down Boylston. She was angry, furious actually. But in moving, at Dan Linskey's insistence, that woman unwittingly saved many lives.

Bill and Denise Richard told the kids the night before that they were heading into town from their Dorchester home to see the marathon. Their children — Henry, nine, Martin, eight, and Jane, seven — were excited. It was a family tradition, and like all family traditions, it was something cherished.

Bill and Denise were what some suburbanites would call homesteaders. From the 1970s right through the end of the twentieth century, many people had left Boston in what the demographers dubbed "white flight." The Richards were the other side of the coin. They chose to live in the Ashmont section of

Dorchester, which like a lot of neighborhoods in Boston's inner city had seen something of a decline in the second half of the twentieth century.

But the Richards were part and parcel of Ashmont's revitalization. They sent their kids to the local charter school. They, like others, saw things changing for the better when Chris Douglass, one of the city's premier restaurateurs, opened a high-end place, the Ashmont Grill, right in the middle of the neighborhood in 2005. And the Richards were prime movers in getting the state to invest heavily in rebuilding the Ashmont train and bus station. The Richards were among those who breathed new life into an old neighborhood, giving it endless possibilities.

The Richard kids were giddy with excitement, leaning against the metal barriers, watching the runners, who were different colors, like the flags of all the world's nations lining the last portion of the marathon route.

Standing there, enraptured by the sights and sounds of people finishing the last steps of twenty-six miles, the cheering sustained, neither the Richards nor anyone else noticed as a nineteen-year-old Chechen kid named Dzhokhar Tsarnaev, wearing his baseball cap backward like many other kids in the crowd, approached from behind. Tsarnaev placed a backpack right behind eight-year-old Martin Richard, then continued to walk up Boylston Street.

They call the fire station Broadway, even though it's in the South End, a mile away from the real Broadway in South Boston. It houses Engine 7 and Tower Ladder 17, and it is one of the busiest firehouses in the city.

On Patriots' Day, as the runners passed the finish line on Boylston, the men from Engine 7 were around the corner, at an

apartment building on Commonwealth Avenue, Boston's grandest boulevard. A group of college students had managed to put a gas grill on a narrow balcony to cook hamburgers and hot dogs while they partied Patriots' Day away.

Two firefighters, Benny Upton and Sean O'Brien, looked at each other, thinking that however smart these kids were to get into college, they couldn't be that smart.

"Do you guys know how dangerous this is?" Upton asked them.

The college kids were offering sheepish apologies when there was a boom from around the corner.

Upton, a former Marine who had done three combat tours, knew exactly what had happened.

"Bomb!" he yelled, and he and the men from Engine 7 and Tower Ladder 17 were soon running at full clip up Exeter Street, right into the belly of the beast. They had only just begun running when they heard a second explosion.

"Jesus Christ," Tommy Hughes said to himself as he ran. Like Upton, he was a former Marine and could only imagine what lay around the corner on Boylston.

Actually, he later told me, he couldn't imagine it. It was worse than anything he saw in the military. Acrid smoke hung in the air and people lay scattered across the sidewalk. There were pools of blood, body parts. It was, at first, eerily quiet and the firefighters instinctively ran to the sides of the wounded.

Upton, like the other firefighters, knew it was terrorism, and they assumed they were running into secondary explosions, and perhaps a biochemical attack. But they, like their brother and sister police officers and paramedics and EMTs, ran toward the bombs anyway, because that's what they do.

Tommy Hughes was almost immediately faced with a Hob-

son's choice. Two children, one a boy, the other a girl, both missing a leg, lay on the sidewalk, like fish out of water, wriggling helplessly. Hughes reached down and picked up the boy, who was closer to him, but his guilt was assuaged immediately because another firefighter picked up the girl.

The little boy was as much in fear as he was in pain. Tommy Hughes hugged him as much as he carried him.

"It's OK, buddy," Tommy Hughes whispered into his ear. "I've got you. It's OK, pal."

Sean O'Brien, a firefighter from Engine 7, was almost as stunned as the victims, because when he rounded the corner he came face to face with Bill Richard, a friend from the neighborhood in Dorchester.

"I can't find Denise!" Bill Richard yelled to Sean O'Brien. Bill Richard was clearly in shock, his ears numbed by the explosion.

It was a short-lived blessing, because he did not fully comprehend, in that moment, that his family lay scattered around him: his son was dead, his daughter was missing a leg, his wife had shrapnel in her eye.

O'Brien pushed his emotion aside and his training kicked in. But his task was Herculean. He looked down and saw young Martin.

"I knew Marty was gone," O'Brien told me a day later.

Sean O'Brien was not just looking at a little boy. He was looking at a little boy who was kind to everyone, including O'Brien's daughter, who was in the same third-grade class. O'Brien's heart ached so badly that he almost keeled over. But whatever feelings he had for little Martin Richard, Sean O'Brien forced himself to try to save others. The best way to honor Martin, he later told me, was to save others.

In fact, almost every firefighter from Engine 7 and Tower Lad-

der 17 knew the Richard family. Many of them were Dorchester guys. The daughter of Kevin Meehan, the chauffeur — firefighter lingo for the engine driver — babysat the Richard kids. The daughter of Eddie Kelly, who was off duty but raced to the scene after watching his wife cross the finish line, was in the same Irish step dance school as Janey Richard.

All that coincidence underscored that Boston was the smallest of big cities in America. But if the firefighters and police officers and paramedics and EMTs who fanned out across the battlefield that was Boylston Street recognized some of the injured, they tended to strangers with the same fervor.

Benny Upton found a homeless man, his ragged clothes made more ragged by the bomb, propped against a wall. The man's foot dangled, held on by a thin shred of flesh.

"I looked him in the eye and asked if he was OK," Upton said. "But he was in shock. He couldn't talk."

Shrapnel had pierced Denise Richard's eye. Her son lay near her, dead. Her daughter, Jane, had lost a leg. Bill Richard's legs were shredded by shrapnel. Only Henry escaped physical injury, but his soul had been shredded by shrapnel too.

Benny Upton came across a woman, a bone protruding from her leg, her femoral artery pumping out a deep red ooze. He put a tourniquet around her leg and saved her life. And then he moved on to the next person.

Tommy Hughes continued to whisper soothing words into the ear of the terrified little boy as he and a paramedic from the city's Emergency Medical Services tried to tie off the boy's leg. There was so much blood that the tourniquet kept slipping. They finally got it tight, and Tommy Hughes and the paramedic hoped for the best as the ambulance carrying the boy sped away.

Moments after the second bomb exploded, Lieutenant Joe Roach and the firefighters from the Boylston Street firehouse

were wading into the sea of injured. Mike Materia, a firefighter from Ladder 15 who looks like an NFL linebacker, reached down and swept up a woman named Roseann Sdoia, whose leg was severely injured.

"You're gonna make it," he told her as he ran toward the medical tent that had instantly become a triage center. "You're gonna make it."

She believed him.

When the first bomb went off, many of the people gathered at the finish line instinctively ran away. Like the firefighters and the police officers, including all of the female police officers from Station 4 in the South End, Carlos Arredondo ran toward the bombs.

Carlos was born in Costa Rica, and was a so-called illegal immigrant when his son joined the Marine Corps. When his son was killed in action in Iraq in 2004, Carlos was so overcome with grief he tried to kill himself. He eventually took that grief and turned it around, committing himself to work not just as a peace activist but as an advocate for military families.

Even before the second bomb exploded, Carlos flew over the barriers. Like other first responders, he pulled down some of the flags of the various countries that lined the route to get to the wounded. Those flags lay in the middle of Boylston Street, scattered like so many victims. Somehow, Carlos's cowboy hat stayed on his head.

Carlos went to the side of a guy named Jeff Bauman, whose legs were a bloody pulp. Bauman's life was seeping through a ruptured femoral artery. Carlos reached down and pinched the artery and held it tight. They loaded Jeff into a wheelchair and raced down Boylston Street. Carlos held on for dear life, and in doing so saved Jeff's.

Carlos wasn't alone. If the bravery of the cops, firefighters, and EMS workers who ran toward the bombs was breathtaking, the similar reaction of ordinary people like Carlos Arredondo was even more extraordinary. They were following a higher calling, risking their own lives for total strangers.

Some of them were ex-military. Others had some rudimentary first-aid training. And still others were like Rob Wheeler, a college kid who could not stand idly by. Wheeler had just finished the marathon when the bombs went off. He ran back toward the explosions and heard Krystara Brassard screaming for someone to help her fifty-one-year-old father. Ron Brassard was lying on the sidewalk, blood pouring out of the severed artery in his leg. Wheeler, twenty-three, pulled the sweaty shirt from his back and tied off Brassard's leg, saving his life.

The smoke was still rising over Boylston Street when Detective Sergeant Danny Keeler realized what had happened.

Keeler, a former Marine known for his take-charge, nononsense approach at crime scenes, uncharacteristically began screaming.

"Keep those roads open!" he shouted into his radio. "We need to get ambulances in here!"

Most cops' first instinct would be to hop out of their cruisers and wade in to help. But the ones on the ground were already doing that, and Keeler would be damned if he was going to let wellmeaning cops clutter the access roads with abandoned cruisers.

Danny Keeler saved untold lives by being Danny Keeler.

Dan Linskey heard Keeler's screams over his radio and knew immediately that it was bad. Keeler screamed only when absolutely necessary.

"I'm not sure what we got, boss," Linskey said into his cell

phone to Police Commissioner Ed Davis. "But I think it's bad. I'm hearing multiple amputations."

Davis's heart sank when he heard those words: multiple amputations.

Boston Police Superintendent Billy Evans, like Linskey a member of the brass whose office was the street, was relaxing in his native Southie, having run his eighteenth marathon. He was at the Boston Athletic Club, in the whirlpool, resting his fifty-four-year-old bones, when one of his cops burst in.

"Super," the cop said, "there were just two explosions at the finish line."

Having already run twenty-six miles, Evans ran some more, back to his house, where he put on his uniform and raced to the scene.

When he got there, he couldn't believe what he saw. He and Chief Linskey and Commissioner Davis set up a command center at the Westin Hotel, around the corner from the finish line.

In the Back Bay, people opened their doors to runners who couldn't get back to their hotels because the entire neighborhood had been sealed off as a crime scene.

The city's EMTs and paramedics were extraordinary in their professionalism, as were the doctors and nurses, some of them still wearing their running togs from the race, at the city's numerous hospitals. They took on battlefield injuries with skill and aplomb.

Dr. Barbara Ferrer, head of the Boston Public Health Commission, told me they moved ninety seriously injured people to the hospital in thirty minutes, an unprecedented effort that saved an incalculable number of lives.

"We had a plan," she told me. "It was chaotic after the bombings. But it wasn't chaos. We had a plan. And, to a large part, it

was Dan Linskey's plan, with all of the other city agencies chipping in, so that when this happened, we were ready. But beyond planning, it comes down to the extraordinary work of individuals."

Individuals like a young doctor at Children's Hospital named Natalie Stavas. She was running the marathon with her father when they and thousands of other runners were stopped by police officers a half mile from the finish line.

Stavas normally respects authority, but she knew there were wounded up ahead, so she leapt over a barrier and raced down toward Boylston Street even as the cops told her to stop.

"I'm pretty fast," Stavas allowed.

She came across a woman whose thigh was torn wide open. She screamed for an ambulance and fashioned a tourniquet out of a belt a man handed her. Then Stavas ran thirty more feet down Boylston and found a woman in a similar state.

Stavas was positively heroic, but when I talked to her a week after the bombing, she shook her head.

"I wish I could have done more," she said, racked with something the psychologists call survivor's guilt. "I should have done more."

"Natalie," I told her, "everyone you went to help lived. You saved lives."

She nodded, accepting the truth of that, still struggling with what she saw.

In the hours after the explosions, I sat at my cluttered desk in the *Boston Globe* newsroom and tried to write a column. I called my wife and said I'd be late. I didn't have to explain.

It had started out, as Lou Reed might put it, a perfect day. Dry and seasonable, not hot like the previous year, which had given

the African runners an advantage, as if they needed it, because the Africans always win the Boston Marathon.

Those Africans, especially the Kenyans, have become adopted Bostonians. We love them. And they love us back. They are humble and gracious winners.

Four days before the bombs went off, the elite African runners visited Tom Keane's third-grade class at the Elmwood Elementary School in Hopkinton, the town west of Boston where the marathon begins. For the past twenty years, the elite runners, most of them Kenyans, all of them black, have visited the Hopkinton kids, almost all of them white.

The kids serenade the Kenyans in Swahili, and the Kenyans smile and hug the kids.

"You know something," said Wesley Korir, who won the 2012 marathon, "it makes me feel very loved."

And it was thoughts like those that washed over me as I sat at my desk and tried to take in the enormity of what had just happened.

Patriots' Day is, ostensibly, a celebration of nationalism, recalling the first shots of the Revolutionary War. But in Boston, it is not a day we turn inward. Just the opposite. It is the day when Boston, an international city, is at its most international, as we welcome people from all over the world to run or watch our marathon, to drink in our peculiarly provincial internationalism, to listen to our ridiculous accents, and to carbo-load in the North End, our Little Italy.

The Boston Red Sox, the baseball team that alternately woos us and drives us crazy, always play a morning game on Patriots' Day. It's timed so that when the game lets out, the crowd can leave Fenway Park and meander through Kenmore Square toward the marathon route in Back Bay.

On this Patriots' Day the crowd was jubilant, because Mike Napoli had just kissed a ball off the Green Monster in the bottom of the ninth, sending Dustin Pedroia scampering home all the way from first base, giving the Red Sox a walk-off win.

But just as the Red Sox fans began mingling with those who had been lining the marathon route for hours, a perfect day morphed into something viscerally evil.

The location and timing of the bombings appeared sinister beyond belief, done purposely to maximize death and destruction. But the bombers failed in one crucial respect: they put the bombs near the finish line, where a group of doctors and nurses were assembled in a medical tent that was quickly converted to a MASH-style triage unit.

If we had lost our innocence twelve years earlier, on a similarly beautiful September morning, the Patriots' Day bombings had robbed of us any notion that we'd always be safe in our city. It was a psychic wound. Deep and profound.

And so I sat at my desk, stunned like the rest of our town, wondering who might have done this and then concluding that it didn't matter who did it, because the murderous ideology, whether foreign or domestic, was irrelevant. There was no understanding anyone who would do such a thing.

In my column, I wrote about watching in awe as Lisa Hughes, an anchor at WBZ-TV, the CBS affiliate in Boston, did her job at the finish line with such unflinching professionalism. Since 2005, Lisa has been married to Mike Casey, who lost his wife Neilie on one of the planes out of Boston that crashed into the twin towers.

I found out that Boston's mayor, Tom Menino, who had been being treated for a series of ailments, ignored his doctor's advice and signed himself out of the hospital after he heard about the bombings.

"I don't care what you say, doc," the mayor said, lowering himself into a wheelchair. "I'm going."

And I took some comfort from knowing Tom Menino did that.

Boston was knocked down, but, like Tom Menino, it got right back up. Slowly, painfully, and with some effort. But it got back up.

I finished my column and was heading home when I spontaneously got off the Southeast Expressway and headed to the Eire Pub in the Adams Village section of Dorchester. My purpose was twofold: I knew there would be some cops and firefighters there, because there always was, and a lot of the regulars, and even some of the bartenders, like Kevin Kelly and Pat Brophy, run the marathon every year.

Besides, I was starving and craved a corned beef sandwich and a pint of Guinness.

As I walked toward the pub entrance, I noticed Joe Finn, a deputy chief and one of the best firefighters in the city, standing on the sidewalk. He was talking on his cell phone and motioned me over with one hand.

He ended the call and said, "I was trying to get Sean O'Brien to come out, just to talk. I'm worried about him. I hope he's going to be OK."

I knew Sean, so I said, "What happened to him?"

"He was there," Joe Finn said. "He was there with the little boy who died."

That's when I first learned of what happened to Martin Richard and his family.

I felt sick to my stomach. I went into the pub and said hello to Joe's wife, who knows the Richards. I asked for Kevin's and Pat's race times. I said hello to a couple of firefighters and a cop I knew who worked at headquarters and who looked like he had just gone through hell, and then I realized I had to go home.

That corned beef sandwich I had craved just minutes earlier, I never ordered.

In the days that followed, we took a measure of the dead and injured.

Besides Martin Richard, the bombs had killed Lu Lingzi, a twenty-three-year-old Chinese graduate student at Boston University, and Krystle Campbell, a twenty-nine-year-old restaurant manager who had grown up in the town next to where I grew up.

At hospitals across the city, more than two hundred people were being treated. Many had lost legs to the bombs, which were primed to do just that, kill and maim.

Inside the FBI offices across from city hall, investigators began poring over images taken from the various surveillance cameras at the restaurants and stores that line Boylston. Homeland Security agents stood in Logan Airport and politely asked travelers if they had any video on their cameras or smartphones that might be useful.

Investigators eventually narrowed their suspects down to a pair of young men in baseball caps, one of them turned backward. By Wednesday, FBI analysts had produced clear photographs of the two men.

One of them, Dzhokhar Tsarnaev, seemed unfazed by having killed and maimed so many. "I'm a stress-free kind of guy," he tweeted shortly after Tuesday turned into Wednesday.

He might have felt more stress had he known that investigators were approaching the bedside of Jeff Bauman, a man whose legs had been lost to the bombs but whose life was saved by Carlos Arredondo.

"That's them," Bauman said, pointing at the photos of Tamerlan and Dzhokhar Tsarnaev. "Those are the guys with the backpacks."

Those backpacks contained pressure cookers packed with ball bearings and nails and a hatred that seemed incongruous given that the United States had given the Tsarnaev family sanctuary, had given them free health care and benefits, had given Dzhokhar a scholarship to attend college.

But Tamerlan had embraced a radical form of Islam, so extreme that he criticized people who let their children read Harry Potter books. When the imam at his mosque compared Martin Luther King Jr. to the prophet Mohammed, Tamerlan exploded in a fit of rage, accusing the imam and others at the mosque of being kaffirs, unbelievers.

Tamerlan infected his little brother — up to this point a fully assimilated American kid who liked to smoke marijuana and goof on his friends, black and white, at Rindge and Latin High School in Cambridge — with a hateful ideology that called for killing innocents because American forces had gone into Iraq and Afghanistan.

Tamerlan styled himself a devout Muslim, but he had smoked marijuana and drunk alcohol for years. He also beat his girlfriend. A trained and skilled boxer, he saw no contradiction in his self-professed fundamentalism and his hypocritical lifestyle. He was in the vanguard, and people would die, and so, too, would he.

On Thursday morning, three days after the bombings, Boston Police Superintendent Billy Evans set the alarm clock in his South Boston home for 3:30 a.m.

President Obama was due in town later that day, and Evans wanted to get in a quick run. He was on the job by 4:30 a.m.

Obama stood on the altar at the Cathedral of the Holy Cross and, in tones that suggested African-American preacher as much as commander in chief, said that Boston's response to the atrocity visited upon it had been a lesson for everyone.

"That's what you've taught us, Boston," the president said. "To persevere. To not grow weary. To not get faint. Even when it hurts. Even when our heart aches. We summon the strength . . . and we carry on. We finish the race."

Tom Menino, the mayor, summoned the strength to drag himself out of the wheelchair and stand up on the altar. In doing so, a mayor whose oratory skills are sometimes used to deride him made his critics look small and petty: Menino had come to embody the new battle cry, Boston Strong.

That evening, the images of the Tsarnaev brothers flashed across TV screens around the world.

They knew their time was running out. Tamerlan decided they would go out with a bang.

Unfortunately, they would take a wonderful young police officer with them.

Sean Collier was born to be a cop.

When he was six years old, his mother, Kelley, took him and his little brother Andy to a Papa Gino's for some pizza.

Sean noticed a woman sitting in a nearby booth, crying.

"Mum," he whispered, "you've got to talk to that lady."

Kelley looked over at the woman and tried to reassure Sean.

"Sean," she said, "I'm sure she just wants to be alone."

"Maybe she has no one," Sean replied. "You're a nurse, Mum. Please go talk to her."

Her conscience tugged by a six-year-old, Kelley walked over to the woman and asked if she was OK.

Andy looked up to his big brother. Once, when Andy went to step on an ant, seven-year-old Sean Collier stopped him.

"You can't kill it," Sean told his little brother. "It's a living thing. Pick it up with a napkin and put it outside."

Jen Lemmerman was always close to her brother Sean, but

they became especially tight during a summer when Sean was in high school and Jen was in college. They shared a job typing medical records into a computer system. The work was tedious, and to pass the time they listened to the radio, and at one point the station they listened to had a fundraiser for the Jimmy Fund, the Red Sox charity that helps kids with cancer. Sean was transfixed by the stories of young survivors.

"Sean was so profoundly affected by those stories," Jen told me. "He went home that night and made a donation. He was in high school. He didn't have any money, but he set up an automatic withdrawal from his account. He had that automatic withdrawal until the day he died."

He died that Thursday night, when the cowardly Tsarnaev brothers crept up on him as his Massachusetts Institute of Technology police cruiser idled outside a building on the MIT campus in Cambridge. They shot him five times, twice in the head.

They wanted his gun, but they were too stupid to figure out how to unfasten his holster.

"I just killed a cop," Tamerlan boasted as he climbed into the back seat of a black Mercedes-Benz SUV driven by a twenty-six-year-old Chinese guy named Danny.

Danny had pulled over to check a text message. That's when the Tsarnaev brothers carjacked him.

"You know about the Boston Marathon bombing? I did that," Tamerlan snarled. "Don't be stupid."

For the next seventy-five minutes, a terrified Danny drove around the Brighton section of Boston, as well as the neighboring communities of Cambridge and Watertown. The bombers wanted more than the $45 Danny had in his wallet. They talked about driving to New York. They had more bombs they wanted to use in New York City.

But they needed money to make the next stop on their bomb-

ing tour work. Tamerlan pointed the silver handgun at Danny and demanded his ATM card. The younger Tsarnaev got out of the car and withdrew $800.

When Danny's cell phone rang, Tamerlan pointed the gun and said, "Answer it. If you say a single word in Chinese, I will kill you."

"Where are you?" Danny's roommate asked in Mandarin.

"I'm gonna sleep in my friend's place tonight," Danny replied in English, staring at the gun. "I'm sorry, I have to go."

They were short on gas, so they pulled into a station off Memorial Drive in Cambridge. As Tamerlan fumbled with a GPS, his little brother got out to buy gas with Danny's credit card.

Danny decided to make a run for it. He felt Tamerlan grab at his jacket as he jumped out of the SUV. He ran at an angle, hoping it would make it harder for Tamerlan to shoot him. He ran across to a Mobil station and burst into the store.

"They want to kill me!" Danny shouted.

The clerk, a forty-five-year-old Egyptian immigrant named Tarek Ahmed, called the police and waited for the gunman to come. But he never came.

The bombers fled, and when the police came to the Mobil station they smiled when Danny told them he had left his cell phone in his car, which also could be traced through its GPS system.

The net was closing, fast.

Police traced the car and were able to figure out the brothers were somewhere in Watertown.

Joe Reynolds, a Watertown police officer, was into the first hour of his midnight shift when he heard the dispatcher say, "OK, the vehicle is now in Watertown, in the area of 89 Dexter," a neighborhood of duplexes and single-family homes.

"I'm right behind that vehicle," Joe Reynolds radioed back.

Sergeant John MacLellan, the patrol supervisor, didn't like Reynolds being alone.

"Don't stop the car until I get there," MacLellan told Reynolds over the radio.

But it was too late. Tamerlan pulled the Mercedes over. His brother pulled over a green Honda Civic he had picked up earlier. The bombers got out and suddenly Joe Reynolds had bullets bouncing off his cruiser. He threw his cruiser into reverse and came to a stop just as MacLellan rolled up in a police Ford Expedition.

MacLellan then did something right out of the movies: he got out of the vehicle but kept it in drive and let it roll toward the bombers.

Tamerlan Tsarnaev emptied his weapon into the empty police car as it inched toward him. His little brother reloaded the gun for him and handed it back.

At the same time, the brothers began throwing bombs at MacLellan and Reynolds, who returned fire. One of the bombs landed right next to MacLellan as he used a tree for cover. MacLellan rolled himself up, certain he was going to be killed by the bomb. But it never exploded.

At that moment, Sergeant Jeff Pugliese, a thirty-three-year veteran of the Watertown force, pulled another scene right out of the movies. Instead of driving into the firefight, he went up a side street, parked, and raced through a series of yards so that he would get the drop on the bombers, approaching from the side.

Pugliese began firing at Tamerlan, who turned and fired back. Not surprisingly, Pugliese, his department's chief firearms instructor, was a better shot. He hit Tamerlan several times, and the bomber's knees buckled.

When Tamerlan realized he was out of bullets, he threw his gun at Pugliese. The gun bounced off his arm, and Pugliese

rushed Tamerlan and tackled the terrorist. Other Watertown officers and cops from other departments rushed to help Pugliese subdue Tamerlan. As they converged on him, they heard the revving of an engine. In the confusion, Dzhokhar had climbed into the Mercedes and was barreling toward them.

The cops rolled off Tamerlan, who was run over by his little brother, his body dragged down the street before it popped out from under the chassis, a bloody mess.

Dan Linskey, the Boston police chief, was a few blocks away as the firefight unfolded. Then, over his radio, he heard what no cop wants to hear.

Officer down! Officer hit! We need an ambulance!

In the crossfire, a Transit Police officer, Dic Donohue, was shot in the upper thigh and was bleeding out. It was most likely friendly fire, but that was irrelevant at this point.

Linskey knew that plaintive voice calling for help for an officer down. It was Ricky Moriarty, one of his best street cops. Both Linskey and Moriarty are former Marines, if there is such a thing. They are close friends, and Linskey started running, yelling into his radio.

"Ricky! Please, please, let me know where you are!"

Moriarty strained a ligament in his hand while doing CPR on Donohue and pulled off in agony. Another Boston cop, Walter Suprey, jumped in seamlessly. Moriarty gathered his breath and spoke clearly into the radio.

"One Forty-four Dexter!" he yelled to his chief. "One Forty-four Dexter!"

Linskey ran up to the knot of officers giving Donohue first aid. Then he turned and saw one of his cops, Jarrod Gero, holding the handcuffed Tamerlan across the street.

"Be careful, Jarrod," Linskey yelled, "he might be loaded."

Linskey ran over and he and Gero began ripping Tamerlan's clothes off, frisking him for an explosive device. They found none.

Linskey radioed for an ambulance for Tamerlan, someone he knew had killed and maimed men, women, and children.

"That's the difference between us and them," Linskey told me later.

At that moment, two Watertown firefighters, Pat Menton and Jimmy Caruso, arrived at Donohue's side in a paramedic unit. When Pat Menton heard "Officer down!" all he could think of was "Don't let it be Tim." His brother Tim Menton is a Watertown police officer.

When the two firefighters jumped out of their ambulance truck, they realized the poor cop was not Tim Menton but a transit officer. Chris Dumont, a state trooper trained as a paramedic, had helped keep Donohue alive, along with a pair of Harvard University cops, Mike Rea and Ryan Stanton, who had fashioned tourniquets.

But Donohue had lost so much blood, Menton and Caruso thought he was a goner. They yelled for the cops to put Donohue in the back of the truck, and they jumped in the back along with Dumont. Caruso used all his strength to clamp the pulsing femoral artery, from which Donohue's life was ebbing away.

"We need a driver!" Pat Menton hollered. "We need a driver!"

Menton couldn't see, but his brother Tim jumped in the driver's seat. Tim Menton didn't have the first clue of how to operate it, but he got it going.

Protocol called for them to go to the trauma unit at Beth Israel, at least five miles away.

"We'll never make it," Pat Menton said.

"We'll never make it," Jimmy Caruso agreed.

Go to Mount Auburn, they yelled to the unseen driver, who

had been joined up front by Donohue's partner. Mount Auburn Hospital was less than two miles away.

They came to a screeching halt at the hospital, and Pat Menton and Jimmy Caruso went right into the ER with Donohue before turning him over to a team of waiting doctors and nurses.

Pat Menton and Jimmy Caruso were covered in blood but were relieved as they walked back to the parking lot and their waiting truck. They had given Donohue a fighting chance. As they approached the truck, they saw Tim Menton standing there.

"What are you doing here?" they asked.

"I drove the rig," Tim Menton said, indicating the boxy ambulance truck with his thumb.

Then they all stopped and sniffed. There was an awful, metallic odor in the air.

Tim Menton didn't know how to disengage the emergency brake. They had driven the two miles with the metal grinding all the way.

Dzhokhar Tsarnaev got away, but not for long.

The police cordoned off an area in Watertown and began a house-to-house search. The authorities asked people in Boston, Cambridge, Watertown, and a few other surrounding towns to stay indoors, and many complied.

The search went on all day Friday. By early evening, Dan Linskey was standing in the command center at a mall in Watertown. He'd been working more than forty hours straight when he felt a hand on his shoulder.

It was Ed Davis, the police commissioner.

Linskey didn't want to go home, but he could barely stand, and besides, orders were orders.

He shook a few hands, wished his comrades good luck in their search for the remaining bomber, and began walking to his car.

Linskey's good friend Eddie Kelly, the firefighter from Tower Ladder 17 whose daughter was in the same Irish step dance school as little Janey Richard, headed toward him.

"You're not driving your car, are you?" Kelly asked.

"No," Linskey replied, tossing him the keys. "You are."

Kelly drove him home, where he and Linskey's wife, Michelle, led him to the couch. Michelle handed her husband a beer and asked him to get some rest. Before he even took a sip, the phone rang: they had cornered Dzhokhar Tsarnaev in a boat stored in a backyard in Watertown.

There, the chaos and drama continued. While the police surrounded him, the nineteen-year-old bomber wrote a hurried, rambling manifesto, explaining that he didn't like to kill innocents but it was reprisal for American forces killing Muslims in far-off lands.

At some point, a police officer saw something he perceived as a threat: the tarp on the boat was raised. Officers had been warned that the suspect might still have explosive devices or a gun. In fact, he had neither, but an officer opened fire, leading several others to do so.

Billy Evans, the marathon-running Boston police superintendent who had taken over at the scene after Linskey was relieved, jumped forward.

"Hold your fire!" Evans shouted. "Hold your fire!"

Moments later, a wounded Dzhokhar Tsarnaev was taken into custody. The Transit Police comrades of Dic Donohue were given the honor of slapping the cuffs on him, and it was over.

But for the victims, and the rest of Boston, it was just beginning.

The Richard family sent the police their congratulations, with a somber reminder to all. "None of this will bring our beloved Martin back or reverse the injuries these men inflicted," the fam-

ily said. "We continue to pray for healing and for comfort on the long road that lies ahead."

Jerry Foley, who runs the fabled South End tavern J.J. Foley's, cleared a table just a few hours after they pulled Dzhokhar Tsarnaev from that boat in the backyard in Watertown.

Detective Sergeant Danny Keeler, still wearing a black SWAT uniform, led a group of young cops in the back door and they sat down heavily. They were exhausted. They weren't even there for the beer, though most of them raised their hands when Foley asked if anyone wanted one. Mostly, they wanted to unwind in a place where they didn't have to train their guns on anybody.

Keeler was there when it all began, screaming into his police radio to keep the access roads open so the ambulances could ferry the wounded from the bombing sites to the hospitals. Now he was there when it all ended.

Keeler was a Marine, but he can be a sophisticate. While the young cops ordered beer, Keeler asked Jerry Foley to bring him a glass of red wine.

The cops held their glasses aloft, to a job well done.

Then they raised their glasses again.

"To Sean," Danny Keeler said.

"To Sean," the young cops replied.

Sean Collier, the murdered MIT cop, had learned just before he died that he was going to be hired by the Somerville Police Department, fulfilling a lifelong dream. Collier was a beautiful person and the prototype young police officer. When a young woman was assaulted on campus, she was reluctant to press charges. Collier literally held her hand, and she identified her assailant, and he was later convicted.

Many of the students at MIT are from Third World countries where the police are not trusted. On the tribute page the univer-

sity set up so students and others could offer remembrances of Collier, one student wrote: "I am brown and a foreigner so usually American police make me a little nervous, but I recall passing by you one time and deciding that I liked you, because you looked unusually nice and trustworthy."

Back inside J.J. Foley's, another toast.

"To Dic," Danny Keeler said.

"To Dic," the young cops replied.

Dic Donohue had almost died, but he was a Navy vet and he was made of tough stuff. He would recover, and no doubt that toast at J.J's helped.

"They were in the police academy together, Sean and Dic," a young cop told me, shaking his head. "What are the odds of that?"

Eddie Kelly, who a few hours before had given Dan Linskey a ride home, came in the back door of the bar and started shaking hands with the cops. He put his hands on Danny Keeler's shoulders and said to the table, "This is one of the finest days in the history of the BPD."

The cops nodded in appreciation.

Kelly came over to me.

"You see those guys?" he said. "Some of those guys were with us at the finish line after the bombs went off. And they were there tonight, taking the bomber in. They didn't kill him. They brought him to justice. I couldn't be more proud of our guys."

It was an early night. A couple of beers, a red wine for Keeler, and they were out the door.

Brendan Walsh, a great young cop, was walking toward the back door of the bar when he stopped and shook hands with a young EMS paramedic. They shared a word, Walsh patted the paramedic on the back, and then Walsh was out the door, back to a home he hadn't seen in almost a week.

"You see that kid Brendan said hi to on the way out?" Kelly asked me. "That kid and his partner were with us on a call this morning. We had a jumper."

While the world's media were focused on Watertown, and as Dan Linskey, Danny Keeler, Brendan Walsh, and all their comrades were looking for a bomber, a distraught man was threatening to jump off the Washington Street Bridge in Boston, onto the Massachusetts Turnpike.

The cops, firefighters, EMTs, and paramedics who assembled to save some poor soul's life formed a reunion of the people who had run toward the bombs on Boylston Street just a few days before: the cops from District 4, the EMS trucks out of the South End, the firefighters from Engine 7, Tower Ladder 17, and Fire Rescue 1.

They talked the poor guy down, another life saved, far from the cameras in Watertown, far from the madding crowd.

When Roseann Sdoia walked out of the Spaulding Rehabilitation Hospital a month after the bombing, she was missing her leg. But she couldn't miss the fire engines out front.

Mike Materia, the firefighter who saved her, was standing there, and she went toward him, her crutches moving madly. He lifted her off the ground and she hugged him tightly.

"What's this?" she said when he put her down, indicating the fire engines.

"We brought you in," Materia told her. "We're taking you home."

Sdoia put her crutches to the side and was helped up onto one of the engines. The firefighters drove her back to her home in the North End.

Like so many others wounded and maimed by the bombs,

Sdoia faces a long struggle, physically and financially. The latter issue will be made easier by the One Fund, which is helping victims of the Patriots' Day bombings and to which the proceeds of this book are going.

The families of the dead struggle too. In China, Lu Lingzi's friends and family still can't comprehend that a beautiful girl who loved the opportunities in America could be killed by two nihilistic young men who spurned all the opportunities that had been handed them.

The University of Massachusetts at Boston established a scholarship in the memory of Krystle Campbell, who was so well loved by her friends that she had been a bridesmaid seventeen times before she turned twenty-nine.

The Richard family, meanwhile, mourned Martin even as they worried about Jane's recovery and the impact the trauma was having on the oldest sibling, Henry. Bill Richard remained a rock for his family, and Father Sean Connor, their parish priest, did his best to comfort not just them but their Dorchester neighborhood.

The bombings created lifelong friendships among people who otherwise would never have met. Ron Brassard and his wife and daughter drove down from New Hampshire to attend the graduation from Framingham State University of Rob Wheeler, the kid who ripped his shirt from his back to tie off Ron Brassard's gushing leg.

If the bombers' intent was to bring out the worst in people, it had just the opposite effect, including the strangers from all over the world who donated money and offered prayers and thoughts to the dead and the injured.

A couple of weeks after it was all over, even as we all knew that for the survivors it was just beginning, I was sitting in the

Eire Pub, eating that corned beef sandwich I had abandoned the night of the bombings. Kevin McCarron, one of the bartenders, put a pint of Guinness in front of me.

"Hey, Kev," I protested, "I didn't order this."

Kevin pointed over to a table, and it was Sean O'Brien, the firefighter who stood over Martin Richard's body that terrible day, the firefighter who couldn't come out of his house for a pint that first night, so distraught was he at what he had witnessed and waded through.

I went over and sat with Sean and his wife Patty for a while. Sean said he was doing a lot better. His wife gave me a little head nod, to let me know he wasn't just telling me what I wanted to hear. He really was doing better. The old Sean was back. He's a great firefighter, and a better man.

"Katie Couric wants me to go on her show," Sean told me. "Do you think I should do it? I don't want to look like a glory hog, but I want to talk about all my brothers and sisters on the job, the cops, the EMTs, the paramedics. I don't want to talk about me. I want to talk about them. I want to talk about the courage of the victims, the survivors, all the people still living with what happened that day."

Like all of the first responders, Sean O'Brien, like Dr. Natalie Stavas, the young pediatrician who saved lives at the finish line, will probably wonder if they could have done something more. They will unfairly second-guess themselves, like that scene in *Schindler's List* when Liam Neeson, playing Oskar Schindler, wonders if he could have done more, to save more lives.

If you remember that scene, the Schindler Jews surrounded him and hugged him and comforted him.

And we in Boston will do that to our first responders. We will surround and comfort the people they saved, the maimed and grievously wounded. And in the process we will defy the people

who tried to hurt us, who tried to kill us. By our actions, they will know that they will never win.

They tried to make us look weak, but they only revealed their own weakness, and in doing so showed our strength.

In their pathetic cowardice, they showed our strength.

They unwittingly introduced a new phrase into our lexicon: Boston Strong.

And Boston is strong. Stronger than a bomb. Stronger than hate. Stronger than a devastating injury. Strong enough to put on the biggest marathon ever, in 2014.

Count on it.

Walking on American Avenue

Mike Barnicle

D ORCHESTER AVENUE RUNS like a ribbon through one
neighborhood's history, a place of parishes and people,
some of whom have never placed a toe in the water of the bay
that laps a shore less than a mile away yet feel as if they haven't
missed much at all. It is a street where dreams that often be-
gan across the distance of history and oceans have been fulfilled
or sometimes crushed in a city, Boston, and a country, America,
continually fueled and energized by the constant flow of immi-
grants who work, worship, and live in a zip code built with cal-
luses and the hard work of hope.

St. Ambrose, a red-brick Catholic church, rebuilt after fire de-
stroyed much of the original structure in January 1984, is on Ad-
ams Street, fifty yards from the intersection of Dot Avenue. Each
weekday at noon there is a Mass where the congregants gather
and the service lasts about half an hour.

On the late-spring day I attended, about twenty people (me-

dian age about seventy) sat in pews the way longtime season-ticket holders sit at Fenway Park: with a constant faith and a familiar devotion rooted in belief and habit. And while they are at a Mass that has changed as much as American League baseball did with the decades-old designated hitter — it is no longer celebrated in Latin — still, rapt attention was paid to a reading of the day's gospel:

> *One of the scribes came to Jesus and asked him,*
> *"Which is the first of all the commandments?"*
> *Jesus replied, "The first is this:*
> *Hear, O Israel!*
> *The Lord our God is Lord alone!*
> *You shall love the Lord your God with all your heart,*
> *with all your soul, with all your mind,*
> *and with all your strength.*
> *The second is this:*
> *You shall love your neighbor as yourself.*
> *There is no other commandment greater than these."*
> *The scribe said to him, "Well said, teacher.*
> *You are right in saying,*
> *He is One and there is no other than he.*
> *And to love him with all your heart,*
> *with all your understanding,*
> *with all your strength,*
> *and to love your neighbor as yourself*
> *is worth more than all burnt offerings and sacrifices."*
> *And when Jesus saw that he answered with*
> * understanding,*
> *he said to him, "You are not far from the Kingdom*
> * of God."*
> *And no one dared to ask him any more questions.*

After Mass, I sat for a while in the empty church thinking about the idea of neighbors and neighborhood and a street, Dorchester Avenue, and all the places that used to be and were no more: the churches that have closed or been renamed or combined into one larger parish, economics forcing the faithful to confront the reality of a consolidated Catholicism. The neighborhood taverns shuttered and then reopened as nail salons, laundromats, or variety stores where Spanish and Vietnamese are now the common languages. Town Field, the ballpark where the sight of the young playing soccer is more familiar than a couple kids playing catch or a pickup game of hardball beneath a blistering city sun.

Dorchester is the largest of Boston's neighborhoods, six square miles, with about 115,000 people. And the avenue, Dorchester Avenue, has always been a highway of assimilation. For decades in the early twentieth century it was where the Irish arrived, started families, began work, sent their children to public and parochial schools, and pursued the same dreams and hopes now held by newer, later arrivals from countries like the Dominican Republic, Haiti, Puerto Rico, and Vietnam.

This is not the Boston of postcards, duck-boat tours, Freedom Trail walks, a burgeoning seaport district, Quincy Market, or the old ball yard in Back Bay where the Red Sox play eighty-one times a year, itself an enormous tourist attraction.

And while change has occurred in the snap of a finger — a couple decades, not long at all when measured by the slow second hand of history's clock — the differences between then and now are amazingly similar to everything that went into building each block, each street, each home, each life that walked the avenue three quarters of a century ago.

"The parish, St. Ambrose, now numbers about three hundred Hispanics, fifteen hundred Vietnamese, and one hundred Eng-

lish-speaking Catholics," Father Dan Finn, the pastor of both St. Ambrose and St. Mark's, was saying. "At St. Mark's we have about a thousand people in the parish. Seventy percent are Vietnamese, and they talk fondly about 'the old country' much the way we Irish, old and new arrivals, reminisce about the old country too. It's interesting, the similarity, the memories we all have of the places we came from, fond or otherwise."

Dan Finn has been a priest for forty-one years, most of them spent in Dorchester — thirteen years at St. Peter's, until 1983, and then on to St. Mark's, where he has been pastor since 1993.

He is a tall, thin, soft-spoken sixty-nine-year-old man with an athletic bearing, short-cropped graying hair that still has a tinge of red to it, and a pleasant, welcoming smile on an angular face that provides every indication of where he was born: County Cork, Ireland.

"I used to dream about coming to the United States," he was saying as he sat at a table in an office at St. Mark's rectory, a church built by immigrants in 1905. "I thought America must be great, that everyone in America wore sunglasses and drove big cars, because in Penterk, the small town I grew up in, we saw very little of either, the sun or cars."

His family brought him to Lowell, Massachusetts. He went to public school, worked at various construction jobs in Boston, took Latin classes at Somerville High, and then decided to enter the seminary, embarking on his life as a priest who is now as familiar a figure on the sidewalks and in the three-deckers of Dorchester as is the mayor, Tom Menino.

"The changes that have occurred across the last four decades here in Dorchester, along the avenue, in the neighborhoods have been both challenging and enriching. It is a very warming and rewarding experience to sit and hear the stories of people who

have come here just as I did, just as my family did, to hear what they went through to get here, to witness their resilience and their commitment to this country, to their church, to their families."

Down the avenue from St. Marks's, past Field's Corner, now filled daily with a crush of people shopping, working, the street filled with traffic and commerce on any weekday, there are indications everywhere of the fact that immigration, the tide of history, can continually breathe new life and fresh optimism into a city's heart. It has happened in several areas of the town — South Boston, Hyde Park, Jamaica Plain, Brighton — yet it is arguably most visible, most apparent, along Dorchester Avenue.

There is the Blarney Stone — newly refurbished by the owner, Ben Johnson, himself from Ireland — where young mix with old and the menu as well as the tap can compete with anything in the larger city around it. Then, three more blocks along the boulevard, directly across the street from the Pho Hoa Restaurant, filled with customers at lunchtime, there is a two-story, tan, cinder-block building with a flat roof, next to the Dorchester House Multi-Service Center. On the second floor of the cinder-block building, which also houses a chiropractor and a travel agency, a young man sits alone behind a desk, working intently, papers stacked to one side, two chairs alongside the desk, both empty, his office door open to capture a breeze on a humid afternoon.

His name is Dan Tran. He is thirty-six years old, married, with two children. He is wearing a white shirt open at the collar, no tie, and has a pen in one hand while he types with the other on a keyboard set in front of a desktop computer. He is a lawyer, and his story represents much of the best that this country, this city of Boston, still offers to those who know that America, despite all the cynicism and polarization that plague our culture and our politics, remains the ultimate reward for anyone willing to work

hard to chase the same vision that lured so many here so long ago.

Tran's family fled South Vietnam after the war ended in 1975. His father served with the South Vietnamese Army, making him a marked man when Saigon fell during that long-gone spring when the communists took control.

Tran graduated from Brockton High School and then went to the University of Pennsylvania and the Wharton School of Business. He got a job at Johnson & Johnson in New Jersey and then worked for a few years at Wells Fargo Bank in southern California before coming back to Boston, where he enrolled nights at Suffolk Law School.

"I realized that this is where I wanted to be," Dan Tran said. "And this is what I wanted to do, help people with their lives through the law. And I'm glad I made that decision."

Outside, a school bus coughed through the early-afternoon traffic. It was stop-and-go for several blocks, as cars, trucks, and buses pushed through the day's heat. At the intersection of Dorchester Avenue and Mayfield Street, the bus stopped and a whole gaggle of young people spilled onto the sidewalk a few yards from the James A. Murphy & Son Funeral Home, a landmark business for decades.

And here it was: a demographic portrait of one neighborhood in a city where, when you were young and Irish, you could get off the trolley at Park Street Under, look around at the faces of older people milling through the turnstiles, and see exactly what you'd look like thirty years from that moment in time. But the face of Boston has changed and is constantly changing still. The faces here now were of Haiti, the Dominican Republic, Vietnam, Morocco, Bangladesh, Cape Verde, and China. The average age on the corner, perhaps fifteen.

However, power changes hands slowly and often reluctantly

in our politics and our culture. And the change comes at a cost, as resentment and parochialism push back against the inevitable. Over the last sixty-six years, Boston has been governed by only five men, and only one, Tom Menino, was not Irish Catholic.

The instruments of true power in the town used to be in the hands of a few downtown men of wealth and pedigree, always referred to as "the Vault." These were somewhat well-intentioned suburban Wasps whose hard, silent voices controlled the banks, the real estate, and the growing skyline of a city seemingly forever locked into a 1950s mindset. That roadblock to progress began to break apart when Kevin White, unafraid of talent and arrogant enough to talk back as well as to lead, took the city through the trauma of busing and pushed as well as coerced urban development that forever altered the psyche as well as the look and feel of huge parts of Boston. And over the past two decades, Tom Menino has continued that journey, pulling the city into the twenty-first century.

Today, if you want to imagine what the city will look like in another two decades, all you have to do is eyeball the classroom of any public school.

In the spring of 2013, out of forty-four high school valedictorians, twenty-five of those young, accomplished graduates, all heading to college, either were born beyond our shores or were born here, the children of parents chasing the same dream that filled the imagination of Father Dan Finn growing up in Ireland: the freedom to breathe and grow.

"I remember right after I got here and went into the high school, I had a meeting with the guidance counselor," Father Finn recalled. "I had no idea what a guidance counselor was. I'd only been here a few months and he asked me what I wanted to do, what I wanted to be, and I was astonished at the question.

Nobody had ever asked me that before in Ireland and I had never given it a thought. What did I want to be? That was an amazing question to me. That question represented in my mind what this country is all about and still is. What do you want to be?"

Nobody ever asked Ha Le to pay a single cent for the right to dream. He arrived in Dorchester from Vietnam, after stops in a refugee camp in Indonesia and then work as a dishwasher in Utah and Georgia. He is today behind the counter of his daughter's store on Dorchester Avenue, Trang's Flower Shop, located alongside Ha Le's own variety store.

"This is place where it is easy to smile," Ha Le says in halting English. "Place where you can have many, many jobs. Work hard."

His daughter, Trang Nguyen, graduated from the John D. O'Bryant School of Math and Science. She opened her small shop a year ago, and on this one day she was busy delivering orders in the middle of the morning as her father worked the counter. The shop is across the street from the Truong Thinh Market, which was packed with customers, one of them a slight, middle-aged Vietnamese mother, who with great embarrassment took out an EBT card (Electronic Benefits Card — food stamps) to pay for grocery items — three boxes of rice, noodles, canned goods, milk, and apples.

"I am ashamed," she said, "but I lose my jobs and need to use the program to get food for my family. I have four children."

"Your jobs?" she was asked. "How many jobs did you lose?"

"Two," she reported. "I was working at two jobs, same time. Both jobs go when business get bad and go away."

One of the jobs was in the kitchen of a downtown restaurant that saw its business slide when the whole economy ruptured in 2008 and has yet to fully recover for people like Ly Tran and

many, many others. The second was folding wash in a laundromat five nights a week, a chore that paid cash but disappeared when the owner closed the shop.

Still, she looks for work every day in stores along the avenue. Still, she makes sure her children — the oldest twenty and about to enlist in the United States Army, the youngest nine and in school — are fed and clothed, a timeless tradition that families everywhere, from every place, have followed forever.

So, here on Dorchester Avenue, Boston, Massachusetts, we have the eternal circle of life: immigrants arriving in a country and a city where the degree of freedom — the stocked shelves of grocery stores, the availability of so much both good and bad, the access to education and, difficult as it is at the moment, employment, and the ladder to a better life — is both shocking and exhilarating.

I realize this is a small portrait of a single slice of a larger city and a bigger universe, one avenue and the neighborhood that surrounds it. I know most of us are consumed by quick, fleeting items and headlines that emerge from the paralyzed politics of Washington or the all too ugly and familiar tales of crime and greed and false celebrity that claim enormous portions of the media as well as the national conversation.

But the street here, Dorchester Avenue, is real and it is us and it is the way it has always been, a place where Twitter and blogs and Facebook and a rapidly expanding culture of no eye contact and cemented opinions shaped more by cable TV shows than actual experience surely does exist, but does not dominate.

Here we have a mini time capsule, a daily urban drama where many of the characters, the residents, the shopkeepers, the tavern owners, the store clerks, the priests, and the pupils, may not wear the familiar faces from decades past, yet they behave similarly to those who once were here and have either died or moved

on. They have their friends, their favorite places to eat, to play, to take their children, to feel safe. They have their parish, their store, their coffee shop, and they think and hope and dream and sometimes actually believe it will last forever.

And of course it doesn't.

But the vibrancy of life does. It defeats the small felonies and the larger outrages that afflict all of us at different moments in time. It means that each day begins with some promise and perhaps more potential, because a child will do well in class, a baby will be born, a marvelous voice will sing a song on a street corner, a young person will discover her own talent, a parent will beam with pride, the Red Sox will win a big game, an e-mail from a relative in a distant land — the old country — will show up in the in box of a smartphone, and with it will come the realization that here along Dorchester Avenue, in the city of Boston, shattered by a bombing on marathon day, it is still more than possible, more than anywhere on earth, to succeed or even thrive. It is that singular American dream that remains constant across the ages, especially to those who work so hard to get here.

Pride or Prejudice

André Aciman

For Robert and Blanca Colannino

I SELDOM WENT TO Boston during my first two years in Cambridge. After spending a weekend with my parents in New York, I'd be back by train late Sunday afternoon, get off at Boston's South Station, and immediately hop on the Red Line to Harvard Square. Once underground, I had already turned my back on Boston, eager to be in time for dinner with friends around the square. I did get off the train once at Boston's Back Bay station, but that was by mistake, and right away, after speedily scrambling through streets, found my way back to the Red Line and was soon enough back in Cambridge without even realizing that I'd finally actually been on Commonwealth Avenue that day. I did venture forth to Newton once on the Green Line for a part-time-job interview, and friends did persuade me to join them on a group visit to the Museum of Fine Arts one desultory Saturday afternoon during my first fall in Cambridge. There'd also been a couple of errands for food around Haymarket Square. But all of

these were sporadic trips that rarely lasted more than a couple of hours. Before I knew it, Boston was already behind me. Boston was far. Boston was across the bridge. Boston was another world. I didn't have a feel for Boston. Boston never got under my skin.

Each one of us has his or her way of reaching out to a new city, of narrowing the distance between us and the world. Some unpack everything they've got and are ready to settle in. Others live out of their suitcases for weeks into months, as though ready to run away at a moment's notice. Some have a sprint in their gait when they arrive in new cities — confident, curious, eager — while others work their way out ever so gingerly, like wary snails spiraling out to take furtive peeks before slithering back in. They distrust too many streets for fear of getting lost, they never speak to strangers, and they never ask directions when they do get lost.

Then there is my way — the most feral of all. I turn my back, I shut down, I refuse to explore, won't listen, won't budge, won't care, won't negotiate, and will always play hard to get. A place must come to me, court me, want me, not the other way around. Recalcitrance, after all, is seldom more than diffidence wearing a mask.

For months I'd behaved no differently with Cambridge. My Harvard universe was confined to a strip of four to five blocks on Massachusetts Avenue, with a mere two blocks extending over to Brattle Street, along with the area immediately surrounding my dorm. This was Cambridge, my Cambridge, my comfort zone. Might as well have been living in a gated community. I never ventured beyond.

It took me forever to realize that from Brattle I could cross over to the Cambridge Common, head north to Waterhouse Street, reach Everett Street, and be back to my dorm on Oxford Street. Still longer to realize that Mount Auburn eventually intersected Mass. Ave., or that Boylston Street could take me from

Harvard Square to, of all things, a huge body of water that people called the Charles. What was the Charles, a river or an estuary? I wasn't sure, couldn't be bothered, sooner or later I'd find out anyway, so why rush? Here I had spent months at Harvard without even realizing there was a river nearby, and along this river a row of majestic river houses. What were river houses? Couldn't begin to tell.

All these would have to come to me, one by one. And always, it seems, by happenstance. Which is how life takes things into its own hands. Some people, armed with foresight and will, cross oceans to discover new worlds, new lives, new ways of doing everything. I've come to know my planet and ultimately my life inadvertently, without meaning to, almost against my will. Some people study maps to know what to look for, where to go, how to set their bearings so as never to get lost. I have no inner sense of what a city looks like on paper, what are its focal points, or how a park or a river might separate one precinct from another. Boston's Marlborough, Newbury, and Beacon Streets may parallel one another, but to me they might as well belong to altogether different neighborhoods, because I've come to each from a different direction, on different errands, with different friends. In fact, I've seldom had to cross from Marlborough over to Beacon Street. These streets could just as well belong to different cities, different time zones, different itineraries, and ultimately to different selves. Who I was in Copley Square with a girlfriend one day is in no way the same person I was two years later near Faneuil Hall when I stopped by a store to buy a down jacket. One self couldn't possibly have known the other. As it turns out, these two areas are not far apart. But I would never have known it at the time, much less known how to get from one to the other. I never connect the dots.

I am so little interested in the layout of a city that I can live

years in a place without looking at a map. What I go by instead is a sort of inner compass. Its needle is magnetized to nothing whatsoever in the real world, but it is aligned to a capricious pole that is in me and only me. Until that needle begins to stir and to respond to a city, the city does not exist. It is only by stumbling that I discover my real districts, my real quarters, my intimate *sestieri* and personal *arrondissements,* spaces that are no less twisted and unreal on the ground than I am warped and insecure within.

One day, after lunching with a friend, we decided to stroll around the Quincy Market area, which is when it dawned on me that Boston's Italian neighborhood was practically across the street. We crossed over to Hanover Street and found an outdoor café with plastic chairs and an umbrella, ordered espressos, and split a cannoli. As we sat on the sidewalk under the blinding summer sun, suddenly, like a timid cat, Boston started sidling up to me. The needle in my compass quivered. Inadvertently, I had let my guard down, and, without knowing, the moment had finally come. I didn't want to lose this moment. That same spot outside that café on Hanover Street became my lodestone, my magnetic pole.

At first Boston courted me, the way the Sirens did: with voices from the past. After lunch I would sometimes head to the Italian neighborhood because, with or without friends, just sitting in the sun with coffee summoned Italy for me, and with this illusion of Italy fluttering and billowing like thin muslin sheer over Boston's North End came the comforting presence of something I'd known many years earlier: the Mediterranean. I was almost home.

Soon enough, Boston began to stir my compass with more familiar images. Crossing the Longfellow Bridge on the Red Line from Kendall Square over to Boston and being suddenly struck

by the massive span of water splitting the city in two was just like riding the Étoile–Nation Line in Paris on the Pont de Bir-Hakeim and facing the Seine on the way to Passy. How I loved that moment when both underground trains, in Boston as in Paris, come up for air as they cross a bridge and, after showcasing the most expansive river views of their city, chuff back down underground, serenely, having accomplished their mission.

Then one night, riding in a friend's car along Storrow Drive by the Esplanade and glimpsing all those faraway lights shimmering across the river on Memorial Drive, I was for a few moments back to my childhood. This was uncannily familiar; I could not ignore it. Boston had used whatever means it had, broken through all my defenses, and found its way in. I had resisted as best I could; now it was time to yield.

Sometimes we reject a place for fear it might reject us and not welcome us at all. Or we reject it fearing disappointment, especially if we invest so much time getting to know it. Small towns, like beautiful Volpaia in Tuscany and Saint-Rémy in Provence, are easy to know. They do not intimidate; in the space of an hour, we may already be on familiar terms. But a large city threatens us, resists all of our measly attempts to master it, and instead asks us to surrender. Some of us don't wish to give in. We may not even want to admit how little we know and how much there is to learn; this may take years, we say. So we shut down. Or we learn to take things in by the bite-size, in installments, on spec, on consignment. Perhaps we fear our period of adjustment may never end and that we're destined to remain strangers. So why even bother? We keep our luggage handy and refuse to throw overboard things we may no longer need. We call it prudence.

Then one day, by virtue of cobbling together pockets of memory along scattered areas and streets of Boston, I had not only managed to set up familiar corners in an unfamiliar city, but

by seeking out these areas for what they were and not for what they reminded me of elsewhere, I had, without knowing it, made them my own and layered over them the story of my own passage here, so that walking on the shady, brick-laid sidewalks of Buckingham Street one midmorning day in May, I knew I was finally discovering and loving Cambridge, and that if I could grow to love Cambridge then I might just as easily grow to love the brick-laid sidewalks of Marlborough Street on a sunny day in May — which is indeed what happened — and from Marlborough, I could radiate farther out and discover Commonwealth Avenue and Newbury Street and Beacon Street and Boylston Street and the Boston Common, areas I had seen before but hadn't noticed, or ever deigned to consider, like someone who needed to meet the same woman again and again to realize that all along there was more love in his heart than either pride or prejudice.

The Former Legends

E. M. Swift

MY WIFE WOULD love for us to become snowbirds in the winter, to fly south and escape Boston's snow and bitter winds, freeing ourselves from shivering and shoveling. It has its appeal, I admit. The bones creak more in the winter. The golf game rusts. But not quite yet, I tell her. I'm not ready to give up my spot on the Former Legends.

I prefer the team's abbreviated nickname, the Legends. Once a legend, always a legend — especially if it's in your own mind. The funny thing is, the longer I play under such a sobriquet, the more the irony of the name is lost on me. When I see *The Legends, Locker Rooms 3 & 4* on the blackboard of our rink, I feel like one of Robin Hood's band of merry men entering Sherwood Forest.

It was 1998 when Dick Byrd founded the Former Legends. He remembers the year because it was a few months after the U.S. women's Olympic hockey team, playing in Nagano, Japan,

won the first-ever gold medal in that newly recognized Olympic sport. The coach of that Olympic team was Ben Smith, and Smith was an original Former Legend. So was Steve Cedorchuk, who once coached Boston College. So was Harvard great Gene Kinasewich, who led the Crimson to the 1962 Beanpot title and the 1963 ECAC hockey title. Those guys really were former Hub hockey legends, kids who grew up locally, made good, and never left; or moved to Boston when they were young and stayed. Boston is the kind of town where people grow roots, even in winter.

We call Byrd "the Admiral" because he is, in fact, the grandson and namesake of another real-life legend, Admiral Richard E. Byrd, the polar explorer who earned the Medal of Honor for being the first man to fly over the North Pole. The original Admiral Byrd, despite his fondness for ice and cold, was not a hockey player. He grew up in Virginia and, in an odd bloodline twist, was a direct descendant of Pocahontas. In Boston we are used to descendants of the Pilgrims, so Dick's Native American lineage sets him apart from the traditional Brahmin crowd, though with his reddish hair, pale complexion, and freckles, it's difficult to see Pocahontas's blood running through his veins. On his mother's side the Admiral does, in fact, trace his lineage back to the Pilgrims. He is also the grandson of Leverett Saltonstall, longtime U.S. senator (1945–67) and three-term governor of Massachusetts, best known in hockey circles for outskating the legendary Hobey Baker to a loose puck to score the winning goal in overtime in a 1914 game in what was, to that point, the longest college hockey game ever played: Harvard 2, Princeton 1.

Small wonder the Admiral has legends on the brain.

Byrd was in his mid-forties when he launched the Former Legends. A onetime Harvard defenseman who'd played prep school hockey at Nobles, Byrd had been coaching his daughter's hockey team for a decade or so rather than playing. Instead of trying

to hook up with a squad of young guns like the Boston Hockey Club, or some other hotshot amateur team in the Boston area, he and a couple of friends decided to form their own group of like-minded old farts who played hockey for fun and not glory. Score would not be kept. No checking. No refs. No visiting teams. It would be like indoor pond hockey with goalies. Byrd would divvy up his hand-selected group into a white team and a dark team, and we'd play amongst ourselves. Fifteen years later, thirty-five of us are still at it, clinging to the game and the friendships of our youth.

Today the squad ranges in age from mid-fifties to mid-seventies. It's a total mixed bag. There are doctors, lawyers, teachers. Financial analysts, real estate developers, small-business owners. Unemployed and retired. Three beekeepers. Guys from the Ivies. From BC and BU, Bowdoin and Trinity. Most hail from Boston, but there are guys who grew up in Buffalo, in Chicago, in Montreal, in Princeton, New Jersey. There are preppies, townies, Catholic school toughs. Not everyone is an F.O.D. (friend of Dick). Some are friends of friends who came and never left. A couple of years ago we were talking after a skate and discovered that three of us had played in the 1965 U.S. National Bantam tournament in Lake Placid — one for Weymouth, one for Buffalo, and one for Lake Forest, Illinois. (Only eight teams were there.) Back in the day, the hockey world was a small one. Legends locker room banter leans toward Hub stuff: school sports, college hockey, the Bruins, Sox, and Pats. The Celtics, not so much. Seldom does anyone talk about business. No one ever talks about money, except at Christmas, when the Admiral passes the hat for a holiday bonus for the Zamboni drivers.

"At first we took anyone in because we were so short of bodies," Dick told me. "We were desperate. We had to play three-on-three sometimes. But it caught on, and now there's a ton of guys who

want to join and can't. We just don't have room for any new players."

The skills run the gamut. A number of Former Legends played Division I college hockey, and one, Tim Cutter, spent some time with the 1972 Olympic team. But others never played anywhere but the pond, and at the far end of the spectrum are Legends who are genetically incapable of simultaneously skating and making a pass.

Somehow, it all works. The occasional celebrity used to make an appearance with the Legends. Bobby Orr skated with us once, back before his knees completely gave out. So did Senator John Kerry. No one made a big deal of them, and in fact both were a little shy, the way men are when they are suddenly thrown in with a bunch of guys who make up a team. The Admiral told Senator Kerry — jokingly, he says — he wouldn't pass to him if a certain bill passed in the Senate. Kerry took him seriously and switched teams. The senator played old school, without a face shield, and scored a goal. No one fist-pumped him or made a fuss. It's not the Legends way.

There were, and are, some real characters among us. One of the early Legends was a professorial type called John Finley, who played while smoking a pipe until the rink manager told him the pipe had to go. An ex-goalie who moved to forward used to play in a bicycle helmet. Another original Legend, still with us, is Bill Boyce. A former altar boy, on Sunday Bill can be heard singing in Latin as he showers, a Gregorian ditty the nuns taught him when he was in the church choir. It's haunting. When he was a senior at Somerville High, in the ultimate show of moxie, Boycie got a friend who'd just entered Boston College to sign up to try out for the freshman hockey team. Boycie took the spot, and he wound up making the squad. Was given a uniform. A number. He used to hitch a ride to BC practices on the back of a friend's motor-

cycle. A few weeks into the season, one of the varsity players was watching the BC freshmen practice and said to the coach, "That guy Billy Boyce is a helluva basketball player for Somerville."

"What are you talking about? He's a freshman. His name's Bob."

"His name's Bill. He's a basketball star at Somerville High."

The coach was incensed. Boycie bolted, but he kept his BC hockey pants as proof.

These days Boycie needs hearing aids, which he removes when he skates. That may sound sensible, but it's problematic for those playing against him, because it doesn't slow his trash talking one bit. He will mock and rail and heap scorn — that's fine, we all do — but he cannot hear a thing you say back to him. The wittiest rejoinder is utterly wasted on him. It is beyond frustrating. And his yapping never stops. When I approach him with the puck — Boycie usually plays defense — he starts to rattle off advice: "Go wide, Swifty . . . Look for a trailer . . ." Sometimes it's good advice, but who gives advice to an opponent? It makes my head explode. I was a goalie through college, so playing forward, as I do now, is still a learning experience. Very little of what I do up front comes as second nature. I listen. I often follow his advice. It's insane.

"Don't pass yet . . . Hold on to it, Swifty . . . Now pass."

Is he suckering me? No. I pass.

Boycie intercepts. Then he gives the puck right back to me.

"Try again," he says.

I am his bitch.

Boycie plays for the white team. I play for the dark team. Some guys switch back and forth, and some guys are permanent fixtures. No one knows why the Admiral divvies up the teams the way he does. It's one of the Legends' mysterious charms. We could toss sticks into the middle and let chance separate us. We could have permanent sides: north of Route 9 vs. south of Route 9,

inside 128 vs. outside 128. But the Admiral likes doing it, and he never explains the method to his madness. He keeps it even, too. And if it's not even, he will make a midgame trade so that it is.

In general, the dark team passes more. The white team has more speed. The Admiral, too, is a dark-teamer, and he's always paired with his skilled younger brother Levy. Another dark-team fixture is Steve Dagdigian, who played with Levy on one of Harvard's best hockey teams, under Billy Cleary in the early seventies. Two other former members of that team play for the white team, Paul "Cat" Haley and Mark Noonan. Arlington guys, with an edge to them. They are good.

Noonan's equipment is vintage 1973 — torn, ragged, leather. He plays without a face shield — one of the few guys to do so. He radiates meanness on the ice. I feel that, even though he has never done anything hurtful to me personally — if you don't count all the goals his Harvard team scored on me in college. You hear stories, though. Boycie told me that when he and Noonan were in their forties, they played in a no-check adult league in Acton. Some guy beat Noonan at the blue line, and as he skated past, Noonan gave him a two-hander that felled him like an oak. It might have broken the guy's leg. A bench-clearing brawl ensued. Afterward Boycie asked Noonan why he'd done it. "That's my territory," Noonan replied. "He broke into my territory. I will do whatever I have to do to defend my territory."

So when I come up against him, I just throw away the puck. It's best for all. I am deeply afraid.

Billy Roman, another big, strong defenseman, is also a white-team lifer. He played at Brown and has two real-life hockey legends in his background. He is Milt Schmidt's great-nephew, and his mother used to date Gordie Howe. That is almost as good as Admiral Byrd and Pocahontas! Roman is a sweet guy off the ice, mild-mannered and polite. On the ice he plays defense like he's

protecting the Virgin Mary from the Mongol horde. He will hook and hack you with a smile on his face, then look down on you as you writhe on the ice. Sometimes we have guest appearances by women hockey players who are home from college on Christmas vacation. (Levy coaches a girls' high school team.) They are fast and skilled and share the puck, but not *so* fast and skilled that they make us feel pathetic and ancient, as the high school boys do. We like them. One of those women put a nice move on Roman at the blue line and broke past him, a clean breakaway. Anyone else would have let her go. Roman hooked her off her feet. He was roundly booed for this lack of chivalry but remained unrepentant. Boycie isn't the only one who can turn a deaf ear.

Such malfeasance stands out because it is anti–Legends ethos and increasingly rare. The main reason the Admiral doesn't let us keep score (at least not officially) is that as soon as there is a scoreboard, hypercompetitiveness kicks in. Players start to hook and hold and generally misbehave, because from the earliest age, hockey players — especially those from Boston — are taught that it's a bad thing to lose, and that instinct never dies. One player was asked not to return because, as the Admiral said, "it was too important to him. He didn't get it. He was too intense. He hadn't learned it was OK if someone took the puck from him."

It's not great, mind you. Your teammates will give you unrelenting grief for turning the puck over. But it's no excuse to go after the guy (or girl) with a stick.

November through March, we have three hours of ice a week, and the times are to die for. Most senior leagues in the United States are shunted to playing in the middle of the night, after the kids have gone to bed. But in the Greater Boston area, between the private and public schools, the colleges, the for-profit rinks, and the town-owned suburban arenas, there are something like one hundred sheets of ice. Thank you, Bobby Orr! His Bruins

of the late sixties and early seventies launched the hockey boom from which the city has never recovered. The Legends skate on Saturday and Sunday mornings from 9 to 10 a.m., and on Thursday evenings from 6:45 to 7:45 p.m. I would tell you where, but there is limited parking and I have an aversion to being mocked. One year the team sweetly invited our wives to watch a late-season skate, then join us afterward at O'Hara's in Newton, our regular watering hole, for pizza and beer. Those who came laughed and laughed. Many had been in the stands during our youthful prime, and they couldn't believe how slow we had become. At the bar, words like "molasses," "crystallized honey," and "galoshes" were bandied about while beverages were consumed. It was a very amusing evening. The wives were never asked to return.

The fact is, for us, playing in a vacuum, it seems as if nothing has changed. The fast guys thirty years ago are still the fast guys; the smooth stick-handlers can still weave and dangle better than anyone; the shooters can still score. Only it all happens at a slightly different pace. It's a wonderful thing, like never-never land, where we never grow up and we never grow old . . . as long as we do it together.

Then there are the goalies. It isn't easy to find goalies of Legends vintage, let me tell you. The knees become arthritic, the groins tear, the hamstrings shorten, and the bruises never heal. Plus, the old equipment is outdated and the new stuff unaffordable. But somehow the Admiral finds them. Some, God bless them, show up with their leather pads and tiny little mitt-sized gloves, playing the standup style they were taught in their youth. No neck guards. Cotton batting for shoulder protection. Fiberglass, form-fitted masks made when they were teenagers, with the top of their heads and ears sticking out. They are the black-and-white TVs of the hockey world. Others have invested in the new, oversized, lightweight stuff that makes them fill the net like

Michelin Men. Our celebrity goalie is Joe Bertagna, who plays
with us a few times a year. He goaltended for Harvard from 1971
to 1973, the same years I played at Princeton, and is now the
much-respected commissioner of Hockey East. At sixty-one, "the
Commish" can still tend his goal. He is an inspiration, and very
difficult to beat. I got one past him last season on a breakaway,
and after he got over the shock, he skated out and gave me the
puck. I smiled about it for a month.

But our favorite goalie target, at least until he flies off to
sunnier climes in January, is Michael Moody. In the late 1970s
Moody was one of the founders of the Boston Hockey Club and
used to organize hockey excursions to Europe, California, even
China, where the BHC would play local teams and generally
wreak havoc on the host cities. As a goalie Moody is all arms and
legs, splits and sprawls, flips and flops, the human equivalent of
a 16-millimeter film spilling from its reel. Picture the Scarecrow
from *The Wizard of Oz* in goalie gear. Fortunately he practices
yoga. A normal man his age would dislocate his spine.

Moody joined the Legends after a seven-year retirement
from hockey, brought about after he took a puck to the throat
that could have killed him. It broke his larynx. He wears a throat
guard now, like all the young goalies, and despite his long layoff,
he has returned to the sport none the worse for wear and playing
just the same. We certainly love having him back, because there
is nothing as pleasurable as scoring a goal on Michael Moody.

It's heaven. And of course for him it's hell. He cares so much.
I take no special glee in putting the puck past someone I don't
know. It's nice, but it doesn't make me want to laugh. But a friend
like Moody? Tickle his twine and every fiber in my being wants to
giggle and slap him on the back.

And it isn't just me. Everyone on the Legends feels that way
when they score on Moody. Levy Byrd once had Moody's son de-

liver a puck to him on a silver tray while he was still in bed. I don't know what the accompanying note said, but it was something in the nature of "Still looking for this?" Then there was the time Fred King, who'd lit him up for five goals in a game, gave him a birthday present of a puck on which he'd written, "Who's your Daddy?" When Moody turned the puck over, there was a picture of Fred waving at him.

It's good times, so good that the only time anyone retires from the Former Legends is after a career-ending injury. It happens every year. Ben Taylor broke his hip. Fred Lane popped a tendon. Jeff Randall got hit in the eye. Steph Cowan tore up his knee. We don't heal very fast at our age, if we heal at all. You never know who will be next.

But there's not much turnover. Dick tried to institute an upper-end age limit a few years ago to make room for some new blood. One of the Legends was in his early seventies, and the thought was that it was time to retire. Enjoy the spoils of an ill-spent youth. Move on. The Admiral had a talk with him and told him he could play a final year for free. Sort of a Lifetime Achievement Award. At the end of the season we all bid him a fond farewell. Everyone promised we would stay in touch.

Next November, first skate . . . there he was. A year older. A year slower. No retirement.

I pulled the Admiral aside. "What happened?" I asked.

"I couldn't do it," he said. "I just couldn't."

Over the summer the dismissed player had started calling Dick. "Please," he begged. "Where can I send the check? For this year *and* last year." The man's wife called Dick. "Please," she begged. "It means so much to him. He loves it so."

"I couldn't say no," Dick said and shrugged. "He was so happy when I said he could come back, it was like I'd given a nine-year-old a new baseball glove."

That was three years ago.

That's when I decided I'd better start keeping my stats. I wanted to be the first to know when it was time to bid adieu. I didn't want to outstay my welcome, to be the guy slowing everyone down, the guy no one wanted to be on a line with. I'd keep my goals and assists totals, and when I saw a dropoff, I'd step aside, head south in the winter, hang up my skates.

So I kept my stats. Faithfully. Every skate. Now I have three years of hard data, and it's incredible. The numbers haven't changed. Not materially. One year a few more goals, one year a few more assists. But they add up to almost exactly the same number: three points per game.

Hey, who retires when he's still scoring three points per game? Never mind that King and Cutter and Haley and Didge probably average six. Gretzky didn't average three points per game!

So I showed the numbers to my wife. We were getting ready to drive south in March, watching the weatherman keep track of the third major winter storm of the month. Maybe next year we can leave a little earlier, she said.

"But look at these numbers," I said, almost apologetically. "They haven't changed. I promise I'll retire, but I've still got it. I can't leave yet."

She looked at the stats and laughed in disbelief. "You idiot. Those numbers will *never* change. You're all slowing down at exactly the same rate."

It was a reasonable point.

So I recently asked the Admiral: "How long are you going to keep doing it?"

"What do you mean?"

"Keep running the Legends?"

He looked at me, thoroughly puzzled, as if I had asked him,

say, how hair grew. "Why would I stop? What else would you rather be doing in Boston in the winter?"

I shrugged. "But are you going to keep at it till they drag you out of there with your toes up?"

The Admiral gave me a funny little chuckle. "That's my plan."

Former Legends never die. They just skate that way.

A Boy's Boston

Charles McGrath

WERE MY MOTHER still alive, she would probably insist that she was not a Bostonian but a Brooklinian, or whatever you call someone born in Brookline, which she considered the grander address. But when she married my father, she moved into the house where he was born, in Brighton, and except for occasional nervous visits to Connecticut, where my brother and I both went to college, they seldom ventured beyond the Boston city limits. For them, and for many people of their generation, Beantown really was the Hub of the Universe. New York, where I moved in the early seventies, was just a distant rumor — a place Bostonians went only if they were lucky enough to have tickets to *The Ed Sullivan Show* or had some strange need to visit the top of the Empire State Building. (The Hancock Tower hadn't gone up yet, and when it did, a few years later, and the windows started popping out, it confirmed — for my father, anyway — the folly of erecting tall buildings in the first place.)

Before I moved away, my mother took me aside and said, "I want you to promise me one thing. I want you to promise you will never root for the Yankees." I never have. Nor have I ever said a single kind thing about the Knicks, the Rangers, or the Giants. (I do have a soft spot for the Mets, and I think my mother might have forgiven that.) But I have been pretty faithless to another promise I made: that I would come back and visit often. I seldom did even when my parents were alive, and now I rarely do, even though I still have family there and even though I spend much of the summer these days in a seaside town that is only an hour or so away.

Partly this is just laziness, and partly it's that my Boston, the Boston of my childhood, isn't really there anymore. The city is now cleaner, safer, more prosperous and cosmopolitan. It's an altogether superior place. But it's not the Boston I remember. You can walk for blocks now, even in neighborhoods like Charlestown and the North End, without hearing an authentic native speaker. (To hear the pure, R-less dialect now, and to keep my own accent in tune, so to speak, so I can turn it on at will, I listen a lot to the sports-radio channel WEEI, whose callers tend to be masters of traditional Boston speech.) Southie has been gentrified, and so has the South End, once a grim and foreboding no man's land. The only reason you'd be afraid to walk around there now is that your clothes aren't fashionable enough and you don't own a pair of designer dogs. And where is the Combat Zone? I tried to find it a couple of years ago, remembering teenage evenings there of thrillingly illicit beer-drinking and gaping at strippers, and found that it had shrunk almost to nothing — to a single bar, as far as I could make out, with a doorman extracting an exorbitant cover charge.

Riding the T these days, and the Red Line especially, you sometimes get the feeling that the city has been taken over by in-

terlopers, people in sandals or Birkenstocks who read the *Economist* instead of the *Herald*. I was briefly reassured two summers ago when I happened to be visiting a sick friend at Mass. General on the day of the Bruins' Stanley Cup parade. Because I knew that driving around the city would be impossible, I left my car in Quincy that morning and took the T into town. The train was already packed with fans when I got on, and more got on at every stop, most of them wearing Bruins gear and many with the broad, toothy Irish smiles that used to be such a Boston trademark. In Dorchester, well before noon, a woman my age got on. She was wearing an ancient Bruins jersey — I'd like to imagine it was Bronco Horvath's — and she was blissfully, unashamedly shitfaced. Now *here* are the real T passengers, I thought, but in fact that day was clearly an exception, and most of my fellow riders were probably like me: people from out of town — or from the suburbs, anyway — just trying to beat the traffic.

The Boston of my youth was a city of neighborhoods, clannish, suspicious, and a little territorial. People were neighborly — up to a point — but also fiercely protective of their turf. My father, normally the shyest and mildest of men, was driven to stuttering rages by people who allowed their dogs to pee on a little patch of ground in front of our house on which for decades he tried, and failed, to grow something resembling a lawn. And one winter he got into a shoving match, a near fistfight, with a man we called One Lung. One Lung — I guess nowadays you'd call him a cancer survivor, but we were crueler then — lived next door but for some reason, instead of completely moving in, used the trunk of his Cadillac as a clothes closet, and in order to have ready access to his wardrobe he usurped the parking place my father had shoveled out in front of our house. Snow and parking brought out the worst in Bostonians back then, and I think they probably still do. I happened to be in Southie on a rare visit a couple of winters

ago after a big snow and I noticed that all the parking spots had been staked out or cordoned off with lawn chairs, traffic cones, sawhorses, or even shopping carts.

In Brighton, which we thought superior to any other neighborhood, we lived on Nottinghill Road, which my mother, who was fond of superlatives, claimed was the highest point in Boston, with the best air, at least ten degrees cooler than it was downtown. The street was largely working class, a mix of single- and two-family houses, and about equally divided between Catholics and Jews. When my younger sister was about six or seven she pointed out that you could tell the families apart because Catholics had blue eyes and Jews brown ones. Possibly, she ventured, Protestants were people with one blue eye and one brown one. None of us had ever seen a Protestant up close, and even decades later I couldn't help being a little taken aback when on an airplane I fell into conversation with a woman who said her father had been the pastor of the Episcopal church in Brighton. I hadn't known such a place existed, and I still can't picture where it might have been.

Nottinghill Road was a one-way loop — imagine a lasso canted on its side — and it really was a hill, a steep one. At its highest end was Skeleton Mountain, or that's what we called it, a large vacant lot with some scrubby woods and a stony outcropping on which some long-ago kids had painted a crude skull and crossbones. To us it seemed a nearly perfect place for climbing, hiding, tossing eggs into the backyards below, and for playing with matches. My brother and a friend once set it sufficiently on fire that the police and the fire department had to be summoned.

In the winter, after the plows had come around but before too many cars had passed by, our street was a great and dangerous sledding spot. You could take a running start, throw yourself on your sled in front of our house, and if you weren't clipped by a car

coming up the other way, zip all the way down Nottinghill, shoot across the Colborne Road intersection, and then go all the way down Blenford Road. This was our version of the Cresta Run, the great bobsled course in St. Moritz.

In warmer weather, we accomplished the same descent, with nearly equal risk, in what we called go-karts — homemade buggies with wheels from baby carriages or from wagons we had outgrown. You steered with a rope and braked, if you had to, with your feet, usually ending in an elbow-scraping rollover. Sometimes we wore football helmets, but more for aesthetics than for true protection. Years later, when my brother had acquired a small motorcycle, we had the bright idea of having me tow him around the hill from the motorcycle while he sat in one of our old buggies. Neither of us gave much thought to the power of centrifugal force, or was prepared for the way the buggy whipped around as I accelerated, and smashed into a parked car, requiring a hasty visit to the emergency room at nearby St. Elizabeth's. Because my brother was not yet eighteen, I tried to pretend I was his guardian, but no one was fooled. During our earlier teens we had made so many visits to the ER that we were practically on a first-name basis with the nurses.

More than we rode — until we got our licenses — we walked. In those days parents didn't chauffeur kids around, and so we walked everywhere. We walked to the City Yard, an unused depot for public works vehicles, set fires in the abandoned garages there, and one year, after some spectacular flooding, went rafting through deep puddles in a sawed-off oil tank someone had dropped off. We walked to Cleveland Circle, no more circular than Harvard Square is square, where there were ball fields, an ice rink, and, as we in time discovered, a drugstore that wasn't too fussy about selling beer to the underaged. Nearby, there were woods to drink it in. During winter, in search of ponds to skate

on, we walked all the way from Chandler's Pond, practically in Newton, to Hammond Pond, miles away behind the Chestnut Hill Mall. We walked all the way to Brookline, where on weekend winter afternoons you could swim in the indoor pool at the high school. I remember jumping off the high-dive and then opening my eyes on the way back up, looking through the water at the windows high above framing bare trees against the blue sky. It felt like levitation.

Looking back now, it seems to me that this was more nearly a small-town childhood, and a fairly idyllic one, than an urban one. Downtown Boston was far away, accessible only by the orange trolley car that ran down the middle of Commonwealth Avenue, and we seldom went there except to visit the city's two great shrines: Boston Garden and Fenway Park. At what now seems an absurdly young age — I was eleven or twelve and my brother two years younger — my parents allowed us to go unaccompanied to day games, where we could sit in the bleachers for 75 cents, or to attend the open practices the Bruins sometimes held at the Garden. The slap shot was just coming into vogue then, and I remember once watching Johnny Bucyk and my idol, Don Mc-Kenney (known as Mary, alas, because he had the un-Bruin-like distinction of having won the Lady Byng Trophy for good sportsmanship), firing pucks high up into the stands just for the hell of it. That old Garden, leaky, smoky, rat-infested, was replaced by the FleetCenter, now renamed the TD Garden, but whatever you call it, it has none of the charm of the old barn. Similarly, Fenway Park, under new ownership, has been so tweaked and renovated and added on to that it now resembles an old two-decker that some fanatical homeowner has turned into a McMansion. It still has the same impossible, fanny-squeezing seats, though, the ones in right field facing in the wrong direction, and there is still that magical moment when you come in off the street, pass

through the turnstile, and, right in the middle of the city, come upon that startlingly green expanse.

I've always loved that from the outside the brick façade of the ballpark looks like a factory, an old New England mill. What they manufactured in there — or did when I was a kid — was heartbreak. Boston is now a place accustomed to winning, and after so many years winning feels pretty good. I still remember how elated I was when the Sox finally won the World Series. I had opera tickets in New York that night, but was unable to sit still and left at intermission to watch the final game at a bar near Lincoln Center. And yet loss and disappointment had a sweetness, or bittersweetness, of their own. There wasn't a Red Sox nation then, just a village, and we recognized each other by our long faces. A lot of nonsense has been written about how sports build character, but in Boston, sports, or sports-fandom, really has shaped the civic temperament. In a place so often riven by neighborhood clannishness, class, and racial resentment, passion for the local teams has become both an identity and a way of belonging. It's how I belong still.

The other Boston — the Boston of the Brahmins, of Emerson and Oliver Wendell Holmes, William James, Isabella Stewart Gardner — I learned about only later, when I began hanging out at McKim's great public library in Copley Square and poking about in Richardson's Trinity Church, across the way. I used to go there — to the library, not the church — to study and, I hoped, to pick up girls. I never once succeeded. I lacked the guile and the smoothness of a guy I once saw who, over the shoulder of a pretty girl, stole a glance at the book she was reading. He then sat down beside her and pretended to be surprised. "Malaria!" he said. "Fascinating."

I used to daydream a lot in the library and plot my escape from Boston. I had concluded by then that unless I went some-

where else I would always be stuck with my Boston labels. I would always be Irish. I would always be Catholic. I would always be working class. I have a vivid recollection of sitting there one day in my junior year of high school, reading *The Great Gatsby* and feeling a powerful sense of identification with Nick Carraway. Like him, I decided, I would go to New York and make something of myself. Then I got to the great passage near the end where Nick remembers going home from prep school to Minnesota on the train at Christmastime, and in that melancholy, self-important way teenagers have, I started feeling nostalgic for my own past and for a city I hadn't even left yet.

Things in Threes

Madeleine Blais

A BALLPARK, A BOAT, and a freezing, windswept ramp outside the old Boston Garden: things in threes, as the nuns used to say. I started my career as a reporter in Boston, and in the end, my holy trinity of favorite assignments involved going to Fenway to cover the first woman to cover the Boston Red Sox, joining the guests on a yacht in Boston Harbor celebrating the graduation of Edsel Ford from Babson College, and interviewing a small band of young girls who routinely skipped school in order to operate rogue fan clubs in honor of the Bruins (and the Braves). To this day, these stories play like a slide show in my mind, the images clicking past, a reminder of how little I knew and how much Boston taught me, a reminder too of something essential about the spirit of the city.

The Boston I encountered in the early 1970s was scrappier than today's version. Dublin West, people called it: "Every other face, a map of Ireland." Boston was not exactly a toy city with toy

problems (there was the Strangler, after all), but it had a pleasing human scale, especially in contrast to its rivals, New York City and Chicago. The broad strokes of the city were, and are, easy to discern: the love of learning, the mix of young and old, politics as sport, and sport as religion. Sister Corita's art (pronounced *aht*) on the liquefied natural gas tanks in Dorchester, huge dripping bands of color, introduced whimsy where you least expected it. The waitresses at Durgin-Park shoved bloody slabs of rare roast beef at customers amid shouts of "More chowdah!" Their rudeness had the durability of a landmark. The Charles River, which everyone said would someday be clean enough to swim in, radiated, at best, a murky pride. On the other side of the river was Cambridge, home of MIT and Harvard, a town Bostonians sometimes dismissed as "conseeded"— practically the worst thing you can be in Boston, worse even than a Yankees fan.

In those days, half my disposable income went to Filene's Basement, where every purchase was a word problem in math. How many days does a Priscilla of Boston wedding dress have to languish on the rack before it is marked down by one-third divided by a half minus 10 percent? Women stripped in the aisles to see if the clothing fit. Forget the Combat Zone: Filene's Basement was known as the best peep show in town.

Boston had not only its own accent but also its own vocabulary, such as the word "pol," short for politician. The more prominent the pol, the more likely he was to be known by his first name or nickname: Barney. Teddy. Tip. Dapper. I knew a good deal about politics in Boston before moving there. My uncle Dermot Purcell Shea worked for the state government, running the Consumers' Council, and our house in the western part of the state was filled with talk of Volpe and Furcolo and Peabody, not to mention James Michael Curley and Honey Fitz. The mayor of *my* Boston: a Democrat, Kevin, youthful, promising, savvy enough to realize

that the night after Martin Luther King died it would be wise not to cancel a sold-out James Brown concert at the old Garden. The governor: a Republican, Sarge, toothy, nice-looking, with a solid Yankee pedigree, savvy enough to realize that in a city filled with colleges, it was a good idea to fly the flag at half-mast after the Kent State shootings.

Boston had secret status markers: slowly but surely, like a Polaroid photo (invented by a Harvard alum), blankness yielded to smudgy impressions and then to clarity. Eventually one learned where to dine (Locke-Ober), what to order (finnan haddie), and how to describe a person who graduated from Boston College High School, Boston College, and Boston College Law School (a triple Eagle).

Back Bay and Beacon Hill overflowed with college students. Cheap digs, still possible, became even cheaper when boomers, in faded jeans and flannel shirts, piled into them and shared the rent. The less attention the tenants paid to housekeeping, the more quickly they could claim to be living in a commune. Groovy!

The South End (not the same as Southie; very confusing to an outsider) was all but abandoned, boarded up and decaying in the shadow of the new Prudential Building. Nearby, the Hancock Tower became famous because its windows keep misbehaving — kept, in fact, popping out. In Boston, the underutilized SAT word "defenestration" filtered into common conversation. As a result, everyone in Boston sounded *wicked smaht*.

My résumé for those days included a five-week tryout at the *Record American*, and then a year each at a radio outfit that harvested actualities for other media in and out of town, at the Boston bureau of *Women's Wear Daily*, and at the *Globe*, covering the suburbs.

At the *Record American*, a Hearst paper, I was told to go to

St. Elizabeth's Hospital one fall morning in 1970, where a police officer, shot during a bank holdup in Brighton, lay dying. The heist was engineered by a couple of ex-cons who persuaded two college girls from Brandeis to be their accomplices, telling them that the loot would help finance the coming revolution. I was against the war in Vietnam, but I was not in favor of creating fatherless families. Several of the officer's children (there were eight in all) had been pulled out of school, and, still in their uniforms, they gripped each other in the hospital lobby, silent, with stricken eyes, in a state of shock and grief. By all accounts their father, Walter Shroeder, was a good man from a prominent policing family who did not deserve to be caught in the crossfire. I stood to the side, immobilized. I called my editor from a pay phone and explained that I had no story. I told him I did not know how to begin to talk to these kids.

"Go up to them," he said. "Just bullshit."

"I can't."

End of tryout.

For the radio job, I lunged all over town, tape recorder in hand. My sole function was to hit the On and Off buttons, which seemed about right considering how green I was. On a June day in 1971, Daniel Ellsberg stood outside the federal courthouse in Boston, justifying his role in the release of the Pentagon Papers. He appeared intense, wiry, and confident as he challenged the clandestine acts of a government as it waged an unjust war, sacrificing boys whose fathers banished them at mealtime from the dining room table on the basis of their objectionable opinions coupled with the length of their hair.

Did I understand the momentousness of the event, the extent of the corruption Ellsberg exposed?

Not at all.

But I did get to see firsthand how history is always a player in

Boston, whether you find it on the Freedom Trail or in the smell of molasses on a hot day in the North End or while observing a single individual in an act of courage.

For *Women's Wear Daily* I visited Filene's Basement as a reporter, not just a customer. I learned how 36,700 pairs of nylons were gone in three hours during World War II, and in 1955, 10,000 umbrellas (sold at $1 each) and $30,000 worth of Irish crystal both sold out in a single day. When it came time to cover high fashion in Boston, the default position was to simply interview and then reinterview the Fiandacas, father and son. Pasquale was the head tailor at the Harvard Coop, and young Alfred ruled Newbury Street. On a typical day, a customer might call Alfred Fiandaca's salon in a panic, wanting six versions of the exact same dress in the same color for her six different homes: "I despise carrying luggage." Alfred believed the most interesting people in the world were the very rich and the very poor. He had sympathy for his clients: "For a lot of these women, their husbands have reached a certain financial level and he's like a bull in a field of cows. But she went to the top of the hill with him and she wants some attention."

Of all my jobs, the best was at the *Globe.* The city editor, Matthew V. Storin, called to say a young reporter named George Regan was quitting as a correspondent covering night meetings in Quincy, Braintree, and Weymouth. I remember thinking, This guy is making the mistake of his life. Who cared if the job was part-time but with full-time hours and no benefits? I said yes without hesitation. The *Globe* was one of the most vital, raucous, crusading, and talent-heavy newspapers in America. The newsroom burst with legendary figures. Roaming the offices on Morrissey Boulevard, formal in a suit, George Frazier, the elegant elderly gossip columnist, skinny, smoking, would recall the time he interviewed some starlet or other and then he would ex-

tol duende, the Spanish concept of ineffable grace. He claimed
to have a secretary who answered his correspondence with sta-
tionery that said, "From the desk of C. U. Jones." David Nyhan
covered politics. At six feet four, he was one of those strapping
people amiably trailed all his life by tales of his athletic prowess:
wasn't he the guy who scored a touchdown at Harvard with a
fumble recovery in the Yale end zone in 1961? Marty Nolan, in
the Washington bureau, was on Nixon's enemies list, the highest
compliment you could pay a reporter at the time. Diane White
and Ellen Goodman offered two bold female voices. The Spot-
light Team exposed corruption. Presiding over it all was the edi-
tor in chief, Tom Winship. His spectacles and suspenders gave
him the mild-mannered, distracted air of a county editor, yet he
was fierce in his desire to put out a good paper, famous for his
tiger notes, distributed whenever someone did a good job, notes
that read simply, "Good job, tiger."

As a suburban correspondent, I kept busy, attending night
meetings and writing the occasional feature, such as a profile
of Dunkin' Donuts University, which happened to be in nearby
Braintree, and an account of a local beauty contest for children:
"Here she is, all 46 pounds and 43¾ prize-winning inches of
her, Little Miss Weymouth of 1972, Laura Ann Murphy." Still,
I longed to be cut loose from the tedium and anonymity of the
buttoned-down burbs — oh, to be given as assignment within city
limits.

And then . . . the ballpark:

September 15, 1972. A sunlit fall day and the Sox are play-
ing the Cleveland Indians that evening. The *Globe*'s cracker-
jack sports section, which knew everything and everybody, had
received a tip: a woman from a weekly newspaper called the
National Observer was threatening to sue the Sox if the team
didn't let her cover the game that night. No one was even think-

ing about allowing women into the locker room at that point. This was simply a matter of access to the field and the press box. Shouldn't the *Globe* be sending someone as well? Did the paper want to look like a loser in these feminist sweepstakes? I had been about to go home, but changed course when I got the order to head to Fenway Park.

Before the game, the park on a perfect day looks like a dress that has yet to be worn. The clubhouse was filled with drinks on ice and featured free hot and cold running seafood. The male reporters barely gave us a glance, mouthing their cigars, tapping the ashes, hacking away on portable Olivettis, worried only that their job might be jeopardized if the extent of its cushiness ever became public.

"You girls," said one, "are ruining our racket."

As for the players, their indifference was democratic and universal. All they wanted, pregame, was as few distractions as possible. Some were throwing or catching a ball, some running at a slow trot, some stretching. Carl Yastrzemski acknowledged that he liked to wear the same socks on the outside if they had been worn previously in a winning game. Reggie Smith told me he didn't like to talk to reporters in general, and it made no difference to him whether the people he didn't like to talk to were male or female. A couple of the players smiled tolerantly, leaning on their bats, as I approached them, but they did not say anything of note. I filed a story heavy on atmosphere and short of facts, neglecting to include the final score, which, fortunately, the real baseball reporter, a guy in the sports section, did.

The boat:

It was an evening of contrasts, of black tie and sneakers along with Dramamine and moonlight.

At the age of twenty-four, Edsel Ford was the first male in the Ford Motor Company dynasty to graduate from college. Invi-

tations were sent to Princess Grace of Monaco, Ari and Jackie Onassis, and Lady Bird Johnson, as well as two hundred Babson College classmates, on copies of the "Late Party Edition" of the *Invite Tribune,* which bore the motto "All the fun that's fit to be had." It was the classmates who showed up at Rowe's Wharf — a half hour early, as instructed, to be checked in by security. Henry Ford, Edsel's father, refused to say what his graduation gift had been: "Say I gave him a VW. Say whatever you like. This is a social occasion and I'm just another invited guest."

What he had provided was "name entertainment," as his son Edsel called it, apparently not intending the pun, referring instead to the musical services of singer-songwriter Jim Croce, belting out "Workin' at the Car Wash Blues" and "Bad, Bad Leroy Brown," the number one hit on the charts in the weeks before the party. Croce was Bruce before there was a Bruce.

I felt pretty marginal at the gathering — for good reason. I *was* marginal. With my notebook instead of a mop, I was a kind of scullery maid, necessary to some element of the enterprise — in this case, feeding vanity rather than scrubbing floors — but not worthy of notice. I remember one guest — perhaps all of twenty-two or so — exclaiming to another, "I have never been so excited about a piece of real estate in my life." During one of the band's breaks, I stood by a railing, staring out to sea, trying to be as invisible as I felt. A couple of the band members joined me, including Croce. He and I spoke briefly, sharing one of those stoned observations that people back then made even if they weren't stoned, about how the words of the songs he had just sung were now out there in the night sky, probably hobnobbing with the Gettysburg Address.

The ramp:

The old Boston Garden was considered obsolete almost from the day it opened in 1928. It never had air conditioning, it was

often oversubscribed, and the pillars that held it up guaranteed obstructed viewing for a fair number of fans. The back entrance, as I remember it, was a wind tunnel filled with scurrying sounds, the source of which I preferred not to contemplate. It would never be the kind of place you would want your daughter to hang out unsupervised, but a band of young girls did, a half dozen or so at a time, their candy-ravaged teeth chattering in the cold, as they elbowed each other to gain a glimpse of their favorite players, whose schedules, for both practices and game days, they had memorized. *Bobby Orr comes in three hours before a game, John McKenzie is two and a half hours early,* they whispered among themselves. As the self-appointed heads of fan clubs for the players, all they wanted was a smile, a wave, an autograph, any gesture whatsoever that confirmed, at least in their minds, an ongoing relationship. The turf wars over who got to be the president of which player's fan club were largely of their own making and largely in their imaginations, but anyone who tried to head more than one of these mythical fan clubs was definitely *conseeded.*

The girls rarely attended the games and spent the hours they waited for a game to be over outdoors, discussing the previous game and guessing who would score in the current one. While the athletes loaded up on calories before a contest, the girls found they were too upset to eat, preparing for the moment when the players exited the building, hoping to run to the players' cars beforehand to write congratulations on the dirty windows or to clear snow off the windshields.

One fan had a Bobby Orr jigsaw puzzle shellacked permanently in place; when she ran out of wall space, she put posters on the ceiling. Another treasured a scar on her forehead that resembled a backward number 7; in the mirror, with the left-to-right distortion, it called to mind Phil Esposito, her favorite

player, the real number 7. Sometimes they would thrust gifts of stuffed animals at the athletes, asking them to put them on their beds. One girl dreamt of being run over by Derek Sanderson, because then he would be obligated to visit her in the hospital and to bring her flowers. I asked a different girl if her obsession had ever helped her with her schoolwork, and she said yes, that when she had to write a composition about "What I Would Most Like to Be," she responded, "Hockey ice, because then the players would need me and they would think about me even when they weren't at the rink."

I loved her answer. I wanted to say: Keep talking, kid, you are a five-dollar raise.

A few days after my story appeared, the girls at the Garden were rousted by truant officers and forced back into the classroom. The power of the press.

I have not lived in Boston for many years now. The old *Record American*, combining forces with the old *Herald Traveler*, is long gone. The Boston bureau of *Women's Wear Daily* closed many years ago as well, due to a perceived lack of glamour in a city where the dowagers don't buy ball gowns. They inherit them. The kid who I thought was making the biggest mistake of his life by leaving the *Globe*, George Regan, went on to run the Regan Communications Group, which counts the Boston Celtics, Legal Sea Foods, and Suffolk University among its clients. It is the largest privately held public relations firm in New England, the ninth largest in the nation. Jim Croce died with the rest of his band in a plane crash about three weeks after singing for Edsel. Alfred Fiandaca died a few months before the marathon bombings, but not before he finished putting the finishing touches on a museum-worthy dress of dupioni silk for the daughter of his first cousin, who wore it with pride on her wedding day.

Yet the city beats on, and every time I visit, I marvel at its present incarnation, at its prosperity and its *life*. At the same time, I am borne back ceaselessly to the past, to a ballpark, a boat, and a ramp. All my life I have carried my memories of those places close to me, like charms, like lucky socks.

Each proved indelible for a different reason.

Covering the Sox that one time, even as a stunt, ushered me into their history. I am at best a footnote to a footnote, but I can feel forever that I have been folded into a story larger than my own.

History really is always a player in Boston, even on Yawkey Way. Especially on Yawkey Way.

Edsel Ford's party may have been more ostentatious than most, and his dad may have been more snappish than a lot of dads when he said, "Say I gave him a VW. Say whatever you like. This is a social occasion and I'm just another invited guest." And it may have taken Edsel five years to get through school (blame it on mono), and his dad may have donated money to the college's building fund (supposedly three quarters of a million dollars). But it was still a night to remember, gilded, Gatsby-like.

The essence of the scene — the proud family moment when a young person is celebrating his or her graduation — is repeated all the time in Boston, with its own variations on a theme. Boston reveres the past, but it is in love with the future.

Boston is a launch pad — for humans.

And when I think of the young girls at the Garden, I think they could comfortably exist in the pages of two great Boston writers, Dennis Lehane and George V. Higgins, who once said: "Dialogue is character, and character is action." Which surely applies to someone who wants to be "hockey ice, because then the players would need me and they would think about me even when they weren't at the rink."

These kids were original.

They could not have been more individualistic or more feisty.

They had mastered that incredible trait everyone associates with Boston, that don't-tread-on-me defiance.

They were survivors.

Just like their city.

Getting Over Boston

George Howe Colt

I WAS WALKING ACROSS Boston Common with my great-uncle on a late-spring afternoon. I had come up from New York for a few days on business, and after a leisurely lunch in the wood-paneled confines of the Tavern Club, we had stepped out into brilliant sunshine. Children on their way home from school skittered past us along the tree-lined walkways that crisscrossed the Common, their voices flaring with sudden excitement. In the distance, the sun glinted off the gold dome of the statehouse and made the red bricks of Beacon Hill glow like the embers of a dying fire. Boston, I thought, had never looked more lovely. "I can imagine moving back here someday," I said.

Eighty-five years old and crooked with arthritis, my great-uncle turned on me with astonishing vigor. "Don't *ever* do that," he snapped, waving his cane in the air as if he were spelling out

exactly what the consequences of such a move might be. "Your grandfather did, and it was the *ruin* of him."

It was an old family story, a Boston Brahmin tale as pointed as anything from Aesop. My grandfather had come east to Harvard from a small town in upstate New York. There, he had made his mark: president of the freshman class, captain of the freshman hockey team, president of the A.D. Club. At a coming-out party in the Back Bay, he had met the beautiful, doted-on only daughter from an old Boston family that had made its money in the China trade and then watched it dwindle. After they married — her father gave her a Stutz Bearcat on her wedding day — they moved to New York, where my grandfather went to work for J. P. Morgan. But my grandmother, "the belle of Boston of 1919," legend had it, found that her Boston bona fides didn't go far in the larger pond of Jazz Age New York, Stutz Bearcat notwithstanding. Within two years she had persuaded my grandfather to move back to Boston and work for her father. Under the well-intentioned benevolence of his in-laws and the stultifying embrace of Proper Boston, my grandfather atrophied, and by his late forties he was living off his wife's modest trust fund and spending the bulk of his time frowning over the *Christian Science Monitor*, placing orders for marmalade and melba sauce with S. S. Pierce, and pouring himself another two fingers of Gilbey's gin.

Even as a boy, tiptoeing around my grandfather, I knew the moral of the story: beware the siren call of Brahmin Boston. I saw men like my grandfather at every family reunion, Christmas get-together, and Labor Day cocktail party: former prep school stars from old Boston families who had ended up State Street bankers, estate lawyers, and trustees; tending their friends' money, drawing up wills, and serving on boards of directors.

(The more adventurous among them became headmasters of their old boarding schools.) The points of their compass rarely extended beyond the bar of the Somerset Club, the fifty-yard line at Harvard Stadium, a shingled summer place in Cotuit, and — on occasion — a locked ward at McLean. They were the men of whom I'd hear it murmured, "You should have known him when he was young." As I saw it, my grandfather had nearly dodged this fate — I imagined him as the hero in a Hollywood thriller, *Escape from Boston!* — only to find himself sucked inexorably back into Boston's maw. I was terrified that if I wasn't careful, I too might end up on State Street, fiddling with my watch fob. Cold Roast Boston, it was called — a phrase that made it seem as if the entire city had been trussed up, cooked till it was juiceless as a bone, and left on a mahogany sideboard.

You might have thought I was safely beyond the reach of Boston's gravitational pull. I grew up just outside the city limits in one of the leafy suburbs to which Bostonians retreated in ever-greater numbers during the first half of the twentieth century. And the Boston to which our grandparents introduced my brothers and me on expeditions "into town" seemed innocent enough. There were the swan boats in the Public Garden, where we'd scramble for the front bench, flinging peanuts at the ducks our grandmother assured us were descendants of Mack, Jack, Kack, and the rest of the Acks in *Make Way for Ducklings.* There was the Chilton Club (named, we were told, for the first woman to step off the *Mayflower*), where my grandmother's old Winsor School classmates sipped Dubonnet and cooed over us as we nibbled watercress sandwiches with the crusts cut off and waited in vain for the real food to arrive. The only hint of spice in my grandparents' Boston was the Athens Olympia, a dimly lit second-floor cocoon of cozy wooden booths and white linen tablecloths where swarthy waiters served us lamb souvlaki and rice pilaf — cuisine

only a Bostonian raised on creamed cod and brown bread would consider risqué. From my vantage point, Boston seemed a stodgy old place, an impression bolstered by the occasional forced march along the Freedom Trail. (Call me un-American, but there were few words I dreaded more as a child—with the possible exception of "nature walk"—than "Freedom Trail," invoking, as they did, the innards of churches, the Articles of Confederation, and endless sermonizing about Boston's glorious past.) Indeed, all of Boston seemed to steep in the thick soporific air of preservation, as if the city itself were a museum. Years later, walking in the Public Garden, a peanut's throw from where I'd ridden the swan boats, I was not surprised to find that one of the city's most prominent monuments commemorated the discovery of ether.

And yet Boston was capable of magic. One night I was invited to a Bruins game at Boston Garden, whose name had me half-expecting North Station to be swaddled in ivy, like Harvard Yard. The Garden, I learned, was more carnival funhouse than horticultural oasis. Even without the periodic rumble of passing trolleys, the building shook with our cheers. Our seats hung so vertiginously over the rink I felt that if I were to jump, I'd land at center ice. As the game progressed, the Garden, proudly unimproved by air conditioning, became a steamy cauldron in which fog rising from the ice met billows of cigarette and cigar smoke. When a crewcut eighteen-year-old Bruins defenseman named Bobby Orr wound up behind the net for a rink-length rush that brought all 14,659 of us, roaring, to our feet, he seemed to have materialized from the very mists of time.

As a teenager, taking the Orange Line in from Forest Hills with my friends, I would discover an entirely different Boston. Counting off the stations whose names we knew by heart—Green, Egleston, Dudley, Northampton, Dover—we watched the suburbs

give way to the city, stomachs tightening as we passed through "the ghetto," as Roxbury was referred to in the pages of the *Globe*. Approaching downtown, our elevated train plunged underground, as a swimmer dives under an oncoming wave too big to crest, and rattled through the darkness to Essex and, finally, to Washington. Surfacing among the Saturday shoppers, my friends and I made a beeline for the attractions that constituted our Wicked City: Jack's Joke Shop, where we tried out handshake buzzers, whoopee cushions, and fart machines; Bailey's, where we slurped up hot fudge as it slid down alps of ice cream and onto condensation-stippled silver plates. Coming from the manicured suburbs, I found *this* Boston alluringly louche: the bikinied mannequins in the windows of Jordan Marsh; the fading stills of the strippers in the dust-furred display cases of Combat Zone clubs. Even Fenway Park — decades before it was discovered to be a national treasure — had a touch of the forbidden, its cavernous bowels smelling sourly of beer, cigarettes, and urine. (Years later, when I saw the prison drawings of Piranesi, my first thought was of the Fenway Park concourse.) But by the end of the day, my friends and I were secretly relieved to be reversing our journey — Dover, Northampton, Dudley, Egleston, Green, Forest Hills, home.

As the sixties revved up, Boston, a city that had spent the twentieth century resisting change, seemed to epitomize the buttoned-up conformity that had given birth to the decade. Yet even as its inhabitants were abandoning downtown, I headed in the opposite direction, increasingly dependent on the city for whatever whiff of counterculture cool I could inhale. Across the street from the Public Garden, I joined in antiwar protests on the less-kempt Common. (I was the most clueless of activists; when a young woman next to me screamed, "We're defoliating

Asia," I thought she was referring to some kind of skin condition we were inadvertently inflicting on the Vietcong.) At Boston Garden, where I had seen Bobby Orr emerge from the mists, I watched Mick Jagger prance across the stage in a staccato volley of flashbulbs. Instead of searching for the perfect plastic dog turd at Jack's Joke Shop, I spent entire afternoons flipping through the bins at record stores along Boylston Street in hopes of finding that one perfect album that would validate my adolescence. Boston wasn't exactly hip, but it was infinitely hipper than suburbia. What other city boasted, however unwittingly, a rainbow-colored profile of Ho Chi Minh painted by a left-wing nun on a fifty-six-foot-tall storage tank? (New Hampshire had its Old Man of the Mountain; we had Ho Chi fucking Minh!) Back home, marooned in my room, I relied on dispatches from Paul Benzaquin, Charles Laquidara, and the *Boston Phoenix* to remind me that there was a real world out there beyond our picket fence. But even then, as I lay in bed listening to WBCN ("a boss sound in a boss town"), I dreamed of greener, groovier pastures: New York, San Francisco, Paris.

I got as far as Cambridge. (I had intended to get all the way to New Haven — how intrepid of me! — but Yale refused to play its part.) At Harvard, where generations of family members had preceded me, I was a shoo-in. Harvard, however, seemed almost more class-conscious than Brahmin Boston. Worried that I'd taken a giant step toward becoming my grandfather, I found myself heading back across the Charles in search of blue-collar authenticity. Friday after classes, my roommates and I joined the hoi polloi at Haymarket, returning to Cambridge on the Red Line lugging enough potatoes to provide us with a week's worth of French fries. Saturday nights, I'd head to Paul's Mall to hear the Persuasions sing a cappella or to Wally's, where I'd tap my toe

to the bebop and convince myself I was something approaching hip. Or I'd just take a long walk through nighttime Boston, ending up, on occasion, in a Combat Zone strip joint, ogling in person the strippers whose eight-by-tens I had ogled years before.

Even then, there were unsettling glimpses of the Boston I was attempting to flee. I had decided to become a poet — an occupation as far removed from State Street banker as I could imagine. Robert Lowell, who had sent blue-blood Boston into a tizzy by writing about his Beacon Hill upbringing in *Life Studies,* was teaching at Harvard at the time. I audited his poetry workshop. In class, Lowell's quixotic brilliance alternated with a spaced-out blankness bordering on catatonia — a symptom, no doubt, of the bipolar disorder from which he suffered, but which I couldn't help thinking might be the price he paid for trying to shake the grip of Brahmin Boston. I couldn't decide whether Lowell was a role model or a cautionary example.

Senior year, a friend invited me to the Winter Ball, the high point of what remained of Boston's debutante season. I accepted, thinking it might be good for a laugh or a poem. But I also considered it a test, the way one inoculates oneself against a disease with a small dose of the virus in question. Gussied up in one of my father's old tuxedos, I walked into the gold-and-marble lobby of the Copley Plaza, where my grandmother had made her debut fifty-six years earlier. I lasted less than an hour before I fled to the nearest dive I could find.

Even as I searched for authenticity, any hint of the real thing unnerved me. One hot May night, I was awakened at 3 a.m. by the voice of a drunken young woman singing out, *"Here we go, Charlestown, here we go!"* to a deserted Harvard Square. I sleepily took note — another slice of the real Boston to record in my journal! — and then listened, horrified, as she punctuated her refrain with *"Niggers suck."* (These were the years of the busing

crisis.) She repeated her two-part chant over and over, the sound receding as she walked away down Mass. Ave.

And then I moved to New York and, for some years, didn't look back — as if, like Lot's wife, I might be turned into a pillar of salt. Coming to the city that never sleeps from a city that seemed inordinately fond of naps, I felt as if I'd time-traveled; as if, without knowing it, I'd been living in the previous decade. Even as a jobless, scrounging newcomer, I felt part of New York's astonishing energy. I had only to step out the door to find myself swept along on a river of humanity. Best of all, in a city where everyone seemed to be from somewhere else, no one cared about where I was from. I was as anonymous as a gangster in a witness protection program, but without having to look over my shoulder (except for muggers). Whenever I found myself walking past Gramercy Park, where my grandparents had lived during their New York interlude, I wondered how they could have left this exuberant city.

And yet, as the years passed my work frequently took me to Boston. My brother was living in the North End, and he'd take me to his favorite espresso place on Hanover Street, or we'd wander over to Chinatown, where, in a basement restaurant, we'd eat fat sea scallops dripping with ginger and black bean sauce — as good as any Chinese food, I grudgingly admitted, I'd had in New York. Or we'd browse the wharves before lapping up bowls of chowder at the No Name, not long after it went uppercase. Approaching Boston as a visitor made it easier to appreciate the city I'd resisted for so long. When I had a free afternoon, I'd stand at the corner of Beacon and Park near the Shaw Memorial and contemplate my options: the Common at my feet, Beacon Hill behind me, Faneuil Hall and the North End to the east, Copley Square and Comm. Ave. to the west. Choosing a direction, I'd

plunge in, reveling in the fact that, despite its cozy dimensions, Boston, with its alleys, culs-de-sac, and crooked streets, was still a city I could get happily lost in. More and more, I looked forward to assignments that brought me to Boston. It was on one of those trips that my great-uncle warned me against moving back.

I would stay in New York twenty years. I felt free there, but I also felt rootless, never fully at home. I could be anyone there, but I realized I wanted to be someone — perhaps even the someone I'd run away from. I felt increasingly pulled toward New England. So with my wife's approval, we moved back — not to Boston or its suburbs but to a small town in western Massachusetts. Ninety minutes from Park Street, I felt within reach of Boston, yet safely beyond its gravitational influence.

We moved here, in part, to be in striking distance of both New York and Boston. Yet it was to Boston we found ourselves drawn. My children have tossed peanuts from the swan boats and fallen for the dollar-bill-on-a-string trick at Jack's Joke Shop. When we could get tickets, my son and I have roasted in the bleachers at Fenway Park, which, despite its iconic status, doesn't look (or smell) all that much different, thank goodness. My son has even been administered small, discrete doses of the Freedom Trail — followed immediately by compensatory scoops of ice cream with jimmies. While I was away, Boston had become a younger, hipper, more diverse descendant of itself. I have enjoyed this new, improved Boston, although when I walked into the Dickensian hulk of the Charles Street Jail, a favorite destination on my old nighttime rambles, and found it had been converted into a luxury hotel where guests can dine on sashimi of yellowtail with black garlic ponzu, I wondered whether Boston might have become a little *too* hip. When friends, after years in the suburbs, talk of moving into the city now that their kids have grown up,

of getting an apartment on Comm. Ave. or in one of those glassy waterfront high-rises, I find myself a little envious.

And yet I would be lying if I said it was for this souped-up Boston that I find myself returning. I grieve each time I turn onto Stuart Street and am reminded that the Athens Olympia has given way to McDonald's. In middle age, increasingly susceptible to looking at life in the rearview mirror, I find myself seeking out vestiges of the Proper Boston I once so strenuously avoided: the public library, the Gardner Museum, the Brattle Book Shop, and Emmanuel Church, where my grandfather's funeral was held. Boston's reverence for the past now seems admirable, its dowdiness homey, its deliberate pace meditative.

A few years ago, I was invited to visit the Athenaeum, which was described many years ago as "a shrine whose primary purpose is to preside over the last rites of Brahminism." From my seat in the second-floor reading room, whose sepulchral hush was punctuated only by the occasional rustle of a turning page, it seemed that nothing had changed since Hawthorne, Alcott, and Emerson had worked here more than a century earlier. Looking up, I gazed out the window at the Granary Burying Ground, where — I knew from my Freedom Trail days — an even earlier layer of Boston luminaries reposed: Revere, Hancock, Samuel Adams. And then I lifted my eyes and noticed, beyond the graves, a third layer: shoppers and tourists and bankers on their lunch hour, heading back and forth along Tremont Street, on their way somewhere but not seeming in any particular hurry.

It is said that a guest at a White House reception, introducing himself to Franklin D. Roosevelt, said, "I'm from Boston." The president replied, "You'll never get over it."

I no longer want to.

Accents, or The Missing R

Susan Orlean

A s most linguists might tell you, regional accents are a lot like underpants. Everyone has them, and usually no one notices his or her own, but the world would be a very different place in their absence. This is particularly true in Boston, where we speak the kind of stunningly bizarre burr to which we, of course, pay no heed but that freezes non–New Englanders in their uninflected tracks. Quite simply, it is the Case of the Missing R. We have a number of vocalic peculiarities, but the heart of the Boston brogue is the peculiar disappearance of that very popular letter in the alphabet. With the exception of Cardiff, Wales, which for some reason has an accent nearly identical to ours, Boston is the only city in the world where the exclamation "Bob's shot!" can mean Bob either has been hit by a stray bullet or is suffering from a height deficiency.

Like the majority of our eccentric habits (such as eating boiled foods and driving badly), losing our R's is an English affectation.

Since 1798, when it was first reported that the rage in London was to go R-less, Englishmen have been dawdling in the *pahk* and walking their mad dogs in the *ahftahnoon* sun. Another linguistic fancy at the time was the Broad-A Class. Snobby British prep schools trained their charges to pronounce certain — but not all — words with A's in an exaggeratedly languorous fashion. Thus, a word like "laugh," ordinarily pronounced *laff,* became *lahhhf.* This pronunciation helped the members of the Broad-A Class sound bored and rich. The final quirk in the accent appealed to the circumspect, irritable side of the British personality: the Great Vowel Shift, which made words like "cot" and "caught" sound the same. Thus, everyone could pronounce them so that no one could understand what anyone was saying.

The five big Tory cities in the United States — Boston, New York, Savannah, Charleston, and Richmond — were settled by people who thought this intonation was just great, and their enthusiasm made for the accents that have persisted today. Each city was later influenced by different waves of immigrants, which is why Bostonians are rarely mistaken for citizens of Savannah. The fact is, Bostonians are rarely mistaken for anything other than Bostonians because no one loses R's, broadens A's, and shifts vowels as we do. Remember, Bostonians are a tidy people: we don't ditch our R's into the linguistic equivalent of a black hole — we just move them to inappropriate places in other words. For instance, everyone reads about the Caribbean; only Bostonians read about *Cuber.* And when we read, we get *idears.*

Within the Boston elocution are distinct variations, but each is clearly part of this amazing whole. There's the pure Anglophilic Brahmin trill; the proto-nasal Dorchester chop; the wheezy Revere; the absent-minded Harvard twang; and Kennedyspeak, which cobbles together all four and punctuates with carefully considered stammers. But the beauty of the thing is that all of

these subsets would agree that it's no *laahfing matta* for *Liser's ahnt* to be arrested for standing on the *connah*. Moreover, being not-so-secret xenophobes, we'd also agree that it's just fine that nonnatives can't entirely figure out what we're trying to say.

Which, of course, is the whole point of regional accents and where they part company with underpants. While the latter is a rather private issue, the former is the ultimate in public display and therefore serves as an obvious way to distinguish people who are of this place from people who aren't. Oh, you can *play* at being a native — you can boil a dinner and rip around a rotary and dash into the corner spa and make pithy comments about the late mayor Curley — but if you don't leave your R's at the door, you might as well be from Ohio. And in that case, as far as Bostonians are concerned, you might as well be from *Mahs*.

Bonfire of the Memories

David M. Shribman

L ET ME BEGIN by asking you an important question: how many cookies did Andrew eat?

More on that in a bit. Because I'm about to argue that my Boston is a city frozen in time. It is a place where Yastrzemski roams left field in Kenmore Square, where Leinsdorf conducts the Boston Symphony on Massachusetts Avenue, where you can buy a chicken-liver omelet or a mountain-high sandwich at Jack & Marion's in Coolidge Corner, where the Harvard-Dartmouth game is always played at the Stadium because Memorial Field in Hanover, with its mere fifteen thousand seats, isn't nearly big enough to accommodate the crowd. It's where the very best Italian meal in the city, and by that I mean a monster veal parmigiana, oval plate of spaghetti marinara on the side, can be had at Stella's in the North End, where it's possible the president might show up, the president of course being John F. Kennedy. It's

where Francis X. Bellotti is either lieutenant governor or attorney general, where Francis W. Sargent is either lieutenant governor or governor, and where Connie Francis is singing "Who's Sorry Now?" in a city she says is one of her favorites.

It haunts me, this town and that time, maybe because it doesn't matter how old you are but it matters very much when and where you were young. Because I was young in Boston — very young, I now know, in retrospect — and though I left the Greater Boston area more than four decades ago, Greater Boston never left me. Run into me on the street and you will hear it in my voice. Watch me look at the ball standings and you will see my eyes drawn — it is an involuntary response, like yanking your hand from a hot stove — to the American League East. Catch me on one of those days when the news reports talk of a nor'easter bearing down on New England and you'll see me pick up the phone and hear me ask how much snow has fallen, and how much more is expected. I haven't shoveled snow in New England since 1972 and still I want to know.

Because for me the phrase "Eastport to Block Island" needs no explanation. The phrase "Havlicek stole the ball" resonates with meaning that I could never explain to my wife or kids. And the five words "there's pandemonium on the field"? The only sentence that means more to me begins with the words "And so, my fellow Americans: ask not . . ."

But wait. Maybe I'm speaking too soon. That may not in fact be the most important phrase in my life, and the "ask not" riff of John F. Kennedy at his 1961 inaugural may not even be the most poignant Kennedy line to begin with an "And so" opening. Try this test: if you can read the following three sentences without misting into tears, you are either not from around here or you are younger than fifty:

And so it is that I carry with me from this state to that high
and lonely office to which I now succeed more than fond
memories of firm friendships. The enduring qualities of
Massachusetts — the common threads woven by the Pil-
grim and the Puritan, the fisherman and the farmer, the
Yankee and the immigrant — will not be and could not be
forgotten in this nation's executive mansion. They are an in-
delible part of my life, my convictions, my view of the past,
and my hopes for the future.

That (and I shouldn't really have to tell you this) is an excerpt
from Kennedy's speech to the Massachusetts legislature eleven
days before he became president — when he reintroduced into
the American lexicon the phrase "city upon a hill," which had so
moved John Winthrop when he employed it on the deck of the
Arbella as the colonists of 1630 made their way to the Massachu-
setts Bay Colony. I would personally hear Ronald Reagan use the
phrase twice, once at the 1984 Republican National Convention
(his renomination) and then in 1989 (his farewell as president).
But for me — for us — it is not Reagan's but Kennedy's, no matter
that the language is really from the Book of Matthew. We have
our own scripture here.

All this we believe. All this we believe firmly and fervently,
along with the faith that if a cold front is coming in from the
nohth Don Kent will be there to tell us about it; the certainty
that when Kevin White said "mother of God" it was one word,
not three; the consensus that Jess Cain's finest hour was when
he crooned that "the state of Maine is going quite insane"; the
conviction that Ron Robin didn't really believe that disco was
anything more than a passing trend; and of course the doc-
trine, never to be challenged or transgressed, that Wednesday is
Prince Spaghetti Day. We also believe Jack & Marion's admoni-

tion about its fabled chicken-in-the-basket ($1.25, in case you're wondering, which you are), printed right there at the bottom of the menu in all-capital letters so as to assure you don't miss the point: TO BE EATEN WITH YOUR FINGERS.

And so — maybe all our sentences start this way — Jack & Marion's is gone, John F. Kennedy has been gone for a half century, Stella's is gone from the North End. Yaz is a grandfather. And I'm probably the only one left who cares about the Harvard-Dartmouth game. The solemn vow my crowd made forty years ago, that we would meet every October at the Larz Anderson Memorial Bridge and march, together as brothers as the green flag flew from the near side of the concrete stands, to the game that meant more to us than anything? I'm probably the only one left who remembers that vow. That is the way of the world, how, as Robert Frost (one of ours) put it, "way leads on to way."

We Bostonians — legatees of Thoreau and Emerson, Hawthorne and Garrison, plus the 54th Massachusetts Volunteer Infantry and Jonathan Edwards — are that way. Harsh and forbidding, perhaps. But also sentimental. Wicked sentimental, in the dialect of our town. But when we cry we hope that no one notices and pretend that no one did. We're Mallo Cups: hard on the outside, marshmallow-soft on the inside. Which is why there is so much goo in essays like the ones in this volume.

We like to say the future was born here — our ancestors, at Lexington and Concord and then again at Breed's Hill (we all know that the Battle of Bunker Hill wasn't fought on Bunker Hill), died with the conviction that a brave new future was being born, and that it was being born here. But in fact our default mode is nostalgia. We're the people who bellowed "We love ya, Cooz" when Bob Cousy retired, a day remembered as the Boston Tear Party. Even now, we cry at Ernie Boch videos on YouTube that make others, from other places, snicker, as they should.

Tens of thousands among us listened to Dick Summer and his *Night Light* show, perhaps the greatest expression of goo ever produced on the airwaves — until, that is, the inexplicable advent of the execrable Delilah. Which raises the question: what kind of people are we, drawn on the same radio dial to Dick Summer's goo and to the train whistle of a disc jockey known as Woo-Woo?

This is the kind of people we are: Strong (before Boston Strong was a T-shirt and an emblem painted on the Green Monster). Gritty (in our hearts we know we could have gone to school during the blizzard of 1969, and then again in 1978, and are only admitting the truth now). Demanding (not that demanding a victory in the World Series did us much good from 1919 to 2003). Tolerant (we put up with Dick Stuart at first base for 313 games and Clive Rush for 21). Snooty (it is our devout belief that there are no colleges outside New England, maybe excepting Notre Dame). Severe (the phrase "cold New England fish" applies to a personality type, not an entrée at the Union Oyster House). Cheap (Mike Dukakis isn't the only one who asks for change from a quarter to assure the tip isn't too generous). Ritualistic (which is why we were so vulnerable on April 15, 2013, when everyone knew what we'd be doing and where we'd be standing). Warm and cuddly (just kidding).

You'll notice the absence of the trait of flexibility, though we did permit Julia Child and Dapper O'Neil to occupy the same decade. Oh, we have invented new things, discovered new ways of looking at the world, even pioneered new ways of looking at the thing that matters to us the most (that would be . . . the past). But we're not all that flexible. The other night I met a childhood chum and his wife at Legal Sea Foods, in part because Legal Sea Foods is the place I always go when I'm not going to Durgin-Park or, when in a particularly adventuresome, madcap mood, over to the NewBridge Café, on Washington Avenue in Chelsea, which

because it opened only in 1975 I think of as a new place. Here are exact excerpts from the conversation at LSF, as we insiders often call it:

Friend: I like it here because there are not lots of sauces.

Wife of friend: I know Rich would never leave me because that would mean he would have to get used to someone new.

Exactly. No new sauces, no new wives. An entire ethos in seven syllables. Can Dallas do that? Can Milwaukee? Can New York?

Many paragraphs back, I spoke of "our ancestors" at Lexington and Concord, knowing full well that almost none of our ancestors were there. Our ancestors were in Galway and Kilkenny, County Durham and Buckinghamshire, Brandenburg and Pomerania, Naples and Sicily, Yerevan and Macedonia and Silesia and some horrible shtetls in the Pale of Settlement of the old Russian empire, plus, of course (for the more recent among us), in Asia, Africa, and Central and South America.

And yet we — all of us, or almost all of us — think of those militiamen on the rude bridge that arched the flood (no attribution needed for that line) as our progenitors, just as we somehow think of England as our historic mother country. The result is that we, perhaps alone among Americans, have both a mother country and a homeland. John Adams is one of our ancestors even if none of our ancestors ever heard his name. I think of Daniel Webster as one of my forebears even though my own people were toiling in the soils of Lithuania when he was replying to Senator Hayne in the scene depicted in the remarkable and unforgettable painting by George Peter Alexander Healy that hangs in Faneuil Hall; we went to the same college and he represented my state in the Senate. Thus, we're brothers. Samuel Adams? A cousin, at least. As a boy I devoured stories about the Boston Massacre and Bunker Hill. I could pass a lie detector test saying

that Paul Revere and William Dawes are my historical ancestors. I'm not the only one on my block who could. Here's betting that Deval Patrick could, too.

Now comes the time of reckoning. I now live somewhere else, where nobody knows what the Beanpot is or what the *Andrea Doria* was, where no one ever watched *Community Auditions*, no one ever rolled a bowling ball against a candlepin, and no one ever waited outside WHDH-TV to get an autograph from Judy Valentine or Frank Avruch or spent Saturday morning with Rex Trailer in Boomtown. But in truth I really do like that somewhere else. It's nuts about sports (we share Babe Parilli and Don Schwall after all). It has a great symphony. A beautiful ballpark. Some good universities. A lot of lousy weather. Its own dialect. Terrible drivers. A tad xenophobic, now that you mention it. My kind of town, because it is so much like my original town.

I left, but so many came. And they came with the zeal of the convert. Many of them stayed; my own mother, born in Montreal, came here in 1951 as a young bride and before long had a Boston accent more pronounced than that of her husband (born in Salem, 1925) or of any of her children (b. 1954, 1956, 1958, 1961), natives every one of them. The Bruins are her team, not the Canadiens. She's from here, even though she's not. (Please, God, don't let her read this, especially that last "she's not" part.) Those few of you who have ventured west of Worcester and south of Dedham — and really there is no reason ever to do so — surely have encountered scores of people who have come to Boston for an advanced degree, or an eye operation at Mass General, and who have adopted the city, or the Red Sox, as their own. These visitors have taken a little bit of Boston home with them — a Harvard Athletics sweatshirt, maybe, or maybe more than that, like a pitiful one-pound chicken lobster in a cardboard box with an

awkward handle — and so many of them claimed Boston as their home, their true spiritual home, by the time the second bomb went off on Boylston Street.

They know, perhaps more than we do, that Boston is more than a cartoon — a Thomas Nast cartoon, I might say, except for the fact that he is so closely identified with a city whose name we dare not utter, or type. Yes, the city has an obsessive preoccupation with the antiquarian — mention the year 1919 and you'll prompt a passionate conversation about the molasses flood and the police strike, and about the day that June when David I. Walsh, the state's first Irish-Catholic senator, introduced the president of the fledgling Irish republic, Eamon de Valera, at Fenway Park. But it has always been modern.

That is more an accident of geography than of history. Boston is greatly influenced by the sea and the opening that the ocean provides. It has always been a welcoming place for immigrants, the Puritan experience notwithstanding, and a tolerant place, its horrible experience with busing also notwithstanding. These are the fabled exceptions that prove the rule. Dave Loggins had it pretty much right when he wrote, "Please come to Boston in the springtime," because here, like Paris, just about anyone can sell paintings on the sidewalk.

This openness is particularly strong in our own time, much of the credit for that going to the easy style of Mayor Tom Menino. Today there are black people living in South Boston, the redoubt of the anti-busing sentiment and the place where Louise Day Hicks famously, or notoriously, proclaimed, "You know where I stand." Gays are comfortable in Boston, and not only in the South End and Jamaica Plain. Jews are content in Boston, though they have fled Blue Hill Avenue. And the Irish are happy in Boston, especially members of this new generation who couldn't distin-

guish Martin Lomasney from Martin Linsky and who read about Honey Fitz in a book by a onetime Harvard faculty member.

This latter point is perhaps most significant of all. Yankee power has been supplanted by — perhaps it is more accurate to say that it has been complemented by — Irish power in a city that was once the setting of a range war between Yankee and Irish. Three of the last four editors of the *Boston Globe*, the city's leading newspaper, have been Irish Catholics. Boston College had something to do with this curious but irresistible Irish ascendancy; its transformation from a commuter school to a national research university was one of the most important events in the history of modern Boston, and it may have been prompted by one touchdown pass. When Gerard Phelan pulled down a forty-eight-yard Hail Mary pass — and, really, what else could such a pass off the arm of a BC quarterback be called? — from Doug Flutie to defeat Miami with six seconds remaining in a football game in November 1984, Boston College did more than triumph over a sporting rival. It changed its entire academic profile.

That would be important in any American city, but it was vital in Boston, the *über*-college town. (There are people in Boston who really appreciate a few foreign words thrown in here and there, *en passant,* and in some precincts of our town you can never go wrong with an umlaut.) Chicago has many fine universities, Northwestern and the University of Chicago chief among them. Los Angeles has UCLA and the University of Southern California and a bunch of others none of us have ever heard of. New York has Columbia and Barnard and New York University and many other institutions (think City College, for example) that have shaped American life, especially in the arts and letters. But Chicago, Los Angeles, and New York are not college towns. Boston is. You cannot spend forty-eight hours in Boston without

being aware of the influence of intellectual and academic life on the community. Winter and summer, the streets of the Back Bay are never empty of pedestrian traffic because of all those young people. On nice days in spring and fall they ride their umlauts to class.

You see the influence of all those colleges everywhere you look. You see it in the pages of the *Globe,* where Harvard and Boston University and Tufts and MIT profs write op-eds, many of which are comprehensible to the average reader, and in the sorts of offerings on the shelves of booksellers. (In other places there aren't any, or many, bookstores. We have loads, and cherish them, every one.) You sense it in bars and coffee houses (we had them before Starbucks, and we had them even before Seattle had a world's fair, which none of us visited, Seattle being situated well beyond Holyoke). Most of all, you hear it on the radio, where first Christopher Lydon and then Tom Ashbrook preside over talk shows that are civil and thoughtful, not the protectorates of the fellowship of the miserable (the line's from Rick Pitino, decidedly not one of us), spewing their imbecilities and prejudices.

And then there are the town's contradictions — and not only the collision between wine and cheese and "Hi neighbor! Have a 'Gansett." First Boston was the most puritanical part of the country, more recently the most Catholic corner of the country. Now it is probably the most secular part of the country. For a long while it was the most conservative part of the country, its leading national political figures (Henry Cabot Lodge and Calvin Coolidge come to mind) stalwarts of conservatism. Now it is one of the most liberal parts of the country. Anthony Lewis of the *New York Times,* who taught at Harvard Law School, went to his grave believing the reason George McGovern won Massachusetts in 1972 — his only state — was the liberal influence of the *Boston Globe,* where I worked as assistant managing editor and

Washington bureau chief for a decade and where I realized that the way to assure your story got on page one was to include one of the following words in the lead: woman, abortion, Kennedy, Fenway, Harvard, Parcells. In earlier times, the killer two-word combination "bottle bill" would have done.

And so — here we go again — I really didn't have to ask you how many cookies Andrew ate, because if you read this far, then surely you know he ate 8,000. That question and that answer were part of a popular Boston radio jingle for a carpet-cleaning operation. Pick up your iPhone and hit ANdrew 8-8000. (Aside to the digital generation: "AN" is the old-time way of indicating "26" on a phone pad. Nothing to be afraid of.) The lady at the other end of the line will say "Adams and Swett," just as a lady at the end of the line always has. It's still there, and Boston's still Boston. And how many cookies did Andrew eat? Andrew ate 8,000. Still.

A City Not on a Hill

Joan Wickersham

E VERY CITY HAS a nickname, used primarily by people who
don't live there. New Yorkers don't talk about "the Big Ap-
ple," tourists do. My sister, who lives in Chicago, has never men-
tioned the wind to me. Boston, where I've lived for over thirty
years (well, Cambridge, which for the purposes of this essay is
close enough), is sometimes referred to as "the City on a Hill." If
nicknames in general have little chance of catching on, this one
seems particularly clunky. It reeks of rhetoric — in fact, it was
first applied to Boston in a Bible-quoting speech by Puritan John
Winthrop in 1630 — and it has a kind of self-conscious eagerness
about it, a panting and futile wish to be adopted. It shows up in
guidebooks and political speeches, but that's about it.

Still, though I never heard the phrase while I was growing up
in New York and then Connecticut, that's what Boston seemed
like to me. I first encountered the city in a novel: *Johnny Tre-*

main, which I read in fifth grade. Boston! It was a place of sunlit wharves and screaming fishwives, silversmiths and revolution, coffee houses and roasted squabs and arrogance and heartbreak and a night spent crying alone among old gravestones. Its place names — Hancock's Wharf, Beacon Hill, Copp's Hill, the Neck — were deeply familiar to me (I read the book at least a dozen times) and imbued with a kind of bright glamour. Boston was sharp, smart, alive, beckoning. It shimmered in the distance on its hill. I lived there, though I'd never been there.

My next glimpse of Boston came a few years later, when my younger sister started watching a TV show called *Zoom.* I would sit with her pretending to read or do my homework (the show was too young for me), but covertly fascinated by the juvenile utopia of *Zoom,* where kids wrote and delivered the jokes and conducted science experiments and art projects and talked about their lives and there wasn't an adult in sight. I envied them their autonomy and their striped shirts and their camaraderie, their twitchy nerdy smart-ass curiosity, which in the world of my school was definitely a social liability, but in their world was cool. I never thought much about where other TV shows were made, but *Zoom* shoved Boston in your face, punctuating and ending each episode with invitations to mail in your jokes and ideas; the kids in the cast chanted the address — "Box 3-5-0, Boston, Mass." — and then they sang, "0-2-1-3-4." That zip code, which couldn't have been farther away from Colonial America, did the same thing to me that Johnny Tremain's Beacon Hill did. It glittered with smartness and made me wistful; I wanted to go there.

And then I did go there. I started spending time in Boston, but I could never seem to find it. I went and had a bunch of crummy, crabby little Boston afternoons, each disappointing in its own way. I was at boarding school in New Hampshire, and people

used to take the bus to Boston after Saturday classes. I remember getting off under the highway near North Station and walking around in a maze of dark streets, thinking, *Huh?* I took a different bus and got off in front of a Howard Johnson's behind the Park Plaza, and walked around boring concrete streets and thought *Huh?* again. Everyone was always saying how beautiful Boston was, but this was baffling, ugly. Where was Beacon Hill? Where was 02134? I kept walking around in circles, too shy to ask. Eventually I took the bus in with my friend Holly, who knew things: that you had to take the T from North Station to Harvard Square, and that once you were in Harvard Square you had to go to Design Research. Holly loved Design Research — the airy glass building with its floating blond staircase, the Aalto vases and Breuer chairs, and especially the Marimekko dresses, brightly colored and dramatically unshapely. I said I loved Design Research too, but really it made me feel young and stupid, as did the other things in Harvard Square that people seemed to love: the Coop, the Wursthaus. Much as I had yearned toward Boston from afar, once there I just didn't seem to get it. I went back during college to do research in the Museum of Fine Arts; my handbag was stolen (I had stupidly left it in the car). I went back again with my husband just after we were married; it was pouring and we couldn't find a place to park. This is all dopey little stuff, but isn't that often how we form our feelings about a place? The mechanic who ripped us off in Memphis, the time we got food poisoning in Houston?

In our early twenties, my husband and I moved from Connecticut to Cambridge. He was starting architecture school and I got a job as an advertising copywriter. We began to discover Boston in a different way — not as a mythical place on which to project our fantasies or our worries, but as a real place in which

to live. We fell in love with the bookstores in Harvard Square (in the early eighties there were more than a dozen), found records at the Coop and Briggs & Briggs, bought cards and Advent calendars from the gentle hovering ladies at Olsson's gift shop. We lamented Design Research, which was already gone by the time we moved but which we would have been old enough to appreciate. We did volunteer work for Physicians for Social Responsibility, went for walks in Mount Auburn Cemetery, saw the Christmas Revels in Harvard's Sanders Theatre.

That was all Cambridge, but I was getting to know Boston, too. The first ad agency where I worked was in Back Bay and the second was downtown. Walking around on my lunch hour, I found places that made me nostalgic for an older Boston I had never known, vestiges of what I thought of, affectionately, as Stodgy Boston: the little marble tables at Bailey's ice cream shops; Makanna's, a store on Boylston Street where you could still find lace handkerchiefs and seersucker blanket covers; and, a few doors down, with a gilded swan suspended over its doorway, the Women's Educational and Industrial Union, a venerable social welfare institution that ran a genteel shop where I bought needlepoint wool and a set of six old Portuguese side chairs. There was a fusty restaurant off the lobby of one of the buildings where I worked. The window was full of large and ancient cacti growing in a bed of sand — a landscape that felt eerily and perhaps deceptively sleepy, as if at any moment a snake might separate itself from the camouflaging vegetation to dart at some tiny, hapless, equally hidden creature — and the bar was inlaid with brass plaques commemorating the men who had done a lot of drinking there. Many of them still worked in my agency; they came upstairs after lunch and fell asleep.

Then we had children, and again the city opened itself to us

in new ways. We got to know the playgrounds and the schools, the aquarium and the Children's Museum, the plesiosaur skeleton and stuffed mammals at the Harvard Museum of Comparative Zoology, the ship-model rooms at the Museum of Fine Arts, and the Mathematica exhibit at the Museum of Science. We got lost going to birthday parties in parts of the city where we'd never been, which always seemed to involve driving on either the McGrath Highway or the Monsignor O'Brien Highway, two roads we confused so often that we began trying to psych ourselves out by choosing the one that felt intuitively wrong, only to find that that one, too, was wrong.

Another place where we always got lost was Jamaica Plain, which is adjacent to Boston — part of it, in fact — but which seemed to be in a different place every time we tried to find it. Then our kids grew up and our older son got an apartment there and we started going there a lot, and Jamaica Plain, too, became part of the Boston we knew.

A city on a hill is a city viewed from a distance: a symbol. But once you live there, it's the city where you get stuck in traffic on Storrow Drive; and where you go to the dry cleaner on Brattle Street because the one on Mass. Ave. kept smashing the buttons on your shirts; and where you've been a patient in a couple of the hospitals and a visitor to patients in pretty much all of them; and where you walk by the building with the Moorish windows on the corner of Newbury and Dartmouth Streets and wonder about Anne who used to live there, and Barbara and Ed who used to live there, and you realize you've been here long enough to remember the women's clothing store that used to be on the ground floor of that building and the video store that replaced it and the French interior-design store that went in after that, which is gone now too.

Once you are in it and of it, Boston stops being a city on a hill, a place you might aspire to and generalize about. It's not a tough town, or a resilient town, or a stodgy town, or a glittering town, or a small town, or a big town. You can't see it anymore. It's quotidian. It's maddening and beloved and you wouldn't want to live anywhere else. It's yours.

Our Chowder

David Michaelis

Boston celebrates certain odd but locally relevant holidays of which most Americans have never heard. Evacuation Day, March 17, marks the date of the British withdrawal from Boston in 1776 (but in due course a day of greater magic to the new masters of the city as St. Patrick's Day), and Bunker Hill Day follows on June 17, both of which are legally applicable only in Suffolk County. In April, of course, there falls Patriots' Day, the statewide observance of grit, sacrifice, and shed blood, which received a bitterly potent new resonance this past spring from Boston's determination to overcome the marathon bombings.

There is one other commemoration that the citizens of the Commonwealth of Massachusetts were once urged by their governor to "take cognizance of," but it is doubtful that you would recognize this day of rejoicing, and not just because the sponsoring governor happened to be Michael Dukakis, now unfairly lost to the shadows, but because I helped put it on the Bay State's

calendar, and I can hardly believe it myself. We are not talking here about the reconsideration and exoneration of Sacco and Vanzetti, the Italian anarchists whom Dukakis rightly freed from obloquy fifty years after they were convicted on their political beliefs and unjustly electrocuted for murder.

I am referring to an officially sealed proclamation given at the Executive Chamber in Boston, "this third day of January, one-thousand nine hundred and ninety one and of the Independence of the United States of America, the two hundred and sixteenth [*sic*]"—and of the third administration of Michael S. Dukakis, the very last. Which begins to suggest why His Excellency with a great flourish of ballpoint ink proclaimed Thursday, January 3, 1991 . . . Chowderhead Day.

It had all gotten under way one spring night ten years before, when the Red Sox came down to the Bronx for the first series of the season, and instead of ordering in pizza, the guys and I decided out to make chowder for the game.

It was all quite a business, into which we threw ourselves with immense gusto and a complete lack of irony, the then inescapable ethos of young New York. I went out to the housewares store on Broadway and bought a pot — we were five guys in our early twenties and barely owned cereal bowls. Besides which, I was the one whose sublet happened to have a kitchen big enough for us all to stand around in, swilling Haffenreffer Private Stock and stubbornly arguing over how much flour was too little and how much sufficient — only some, then a bit more, then a lot — and gleefully adding something further that someone else had just thought of: bay leaf, for instance, with its aroma of Nauset Beach sunshine burning the dune shrubs.

Still college kids in spirit, bearing long memories from New England's pervasive aquaculture and the Fenway bleachers, all

of us had been born in or around Boston and spent summers in fishy places like Gloucester and P-town, or at summer jobs in seafood institutions like Woodman's of Essex, or as regulars at the No Name Restaurant, at 15½ Fish Pier, Boston. That was as formal as requirements ever got for Chowderhead Society "membership." No one called the roll or collected dues—this was no Loyal Order of the Buffalo Heads. Whoever showed up chipped in. Malt liquor played its part, but if there was a collective wisdom governing the mysteries of chowder, it derived most of all from the counterculture epoch at Fenway Park, the early 1970s, when Bill Lee had been the voice of sanity.

Remember "the Spaceman," the American League's only leftist southpaw? Before pitching against the Cincinnati Reds' ace Don Gullett in Game Seven of the epic '75 World Series, Lee heard that Sparky Anderson had been questioned about his team's prospects that night. "No matter what happens," the Reds' manager told reporters, "my pitcher is going to the Hall of Fame." To which Lee flatly added, "No matter what happens, I'm going to the Eliot Lounge."

What made the Spaceman the patron saint of chowderheads was that he played extremely hard but never took himself seriously. To the stands it might appear as though he was pitching to Reggie Jackson with the bases loaded. "But in my head," as he later revealed, "I'm having an audience with a guru in the Himalayas. That keeps the pressure off me." As did yoga, organic farming, and happy hour at the fabled lounge of the old Eliot Hotel, the Back Bay sports bar where a horse walked in one night and no one minded.

We loved the Spaceman. Had we been making pancakes instead of chowder, we'd have sprinkled our buckwheats with a little homegrown to honor that free spirit—who, for doing just

that, had drawn a $250 fine from Commissioner Bowie Kuhn. The point about Lee was not that he was a rebel who wanted to subvert Major League Baseball by quoting Mao, championing social justice, and sounding off on environmental issues. He sought to challenge mainstream baseball and its apolitical owners because he was in love with the game and knew what belonged in a ballpark (grass, daylight, Sunday doubleheaders, fans) and what didn't (artificial turf, domes, designated hitters, furry mascots, Jumbotrons, T-shirt bazookas, luxury boxes).

We felt the same way about chowder, especially in the tarted-up New York of Trump, Steinbrenner, and Leona Helmsley. Each of us had very definite ideas about what went into the pot and what stayed out, though no one had ever actually made the stuff from scratch, and nobody had his mother's recipe, but I did still have an old Cape Cod picnic tablecloth that my grandparents had almost worn out, which seemed somehow ceremonially right for covering the Conran's coffee table. We were purists — or at least I was — but for sure the one thing we could all agree on were quahaugs, those chewy, husky-sized hard clams that smell of cellars and the sea.

First place we went, we could only get littlenecks — and these barely legal. Another market offered cherrystones, which are bigger but still a long way from the meaty chowder clam. I remember the guy at Rosedale Fish Market on Lexington hooting that he'd sell us some scrod because the Yankees were going to win the pennant and that's what we'd be — *scrod one more time, fellas!*

The pot was a sixteen-quart graniteware seafood steamer, and we all stirred it — too many cooks improve a chowder, everyone knew that. Gathered around the stove, it took us only once to learn that you never steam the clams open, which robs them of

their flavor. Shucking enough quahaugs to yield a quart and a half of coarsely chopped meats is a pain in the ass, but it still feels good getting it done — there's testosterone waiting for you in a clam knife — and quahaug after quahaug yielded its briny liquor to a pan we held in special reserve, after figuring out that potatoes cross the tongue more clammily when simmered in quahaug liquor than in tap water.

The salt pork we cut into ribbons and fried to crisps right in the pot, with a little clam liquor as well, so it wouldn't blacken like bacon. If quahaugs are the soul of a decent chowder, salt-cured pork is its heart, and no Gristedes carried it, no one at Zabar's had heard of it. It's packaged like slab bacon — the streaky pork-belly cut preferable to the lean pork-side or the fatback cut, which looks like a cake of your grandmother's washday soap. I think we finally got some directly from a butcher shop.

Next came two diced medium onions, slow-cooked until hissing in the rendered salt-pork fat, then the potatoes (three peeled Idahos minutely diced), covered by the thick, sharp liquor and simmered until done. Now, in with the chopped clam meats (we included guts and muscle sinew for extra punch), along with a couple of tablespoons of flour dissolved in a dessert spoon of whole milk, all the while stirring the pot until it was heated through but never boiled. We were always on the lookout not to overcook the clam meats.

And that was it: the essential chowder, the substance of the sea. The milk and cream and salt and pepper (and all those arguments) didn't scald up until the whole crew had shown up and the game had started and the Sox had gone on the scoreboard. Then we could breathe long enough to heat the mess until it steamed, ladle it into mugs, swirl in some butter, sit the hell on back, and relish the sheer crude wharfside wallop of aged clam

flavor. While feeling freer than ever to chuck dry round oyster crackers at the Trinitron whenever the $23 million bonus baby Dave Winfield sauntered to the plate.

We were steadily picking up tricks. You can use scissors to cut up the clam meat; you can't cover cooling chowder because condensation drips into the liquid and kills its essence; you have to let the chowder cool completely before it's put into the refrigerator to season overnight. These tips and others I picked up from the great Creole and Provincetown seafood chef Howard Mitcham, who had worked up his quahaug chowder from a hundred-year-old land's end recipe. The main pleasure of the making, the one thing you have to ripen completely for yourself, lay in the time consumed. Buying or, better yet, digging three or four dozen hard clams sets the stage for a whole afternoon or evening, or even weekend, away from work and women. Guys who play golf or sail or fish or hunt construct similar pleasures. Chowder took us off the clock, as do nine innings of baseball: it gets finished when it gets finished.

The most crucial time key was set by the incontrovertible fact that chowder tastes better on the second day, and best of all on the third. Thirty-six hours became the minimum before any of us thought about consuming the latest batch. So when it became a rite of us Boston guys in New York City to ripen these cauldrons fully — not just to start the Sox season or to stop another September slide, but, over time, also because we were feeling rambunctious or reverent or both (on account of, say, the Bruins returning to the Stanley Cup Final in 1988 and 1990) — we had to initiate the whole process earlier and earlier in the week. Which meant that a couple of times a year when I was supposed to be working, I would find myself shucking a lot of clams by myself in my latest Upper West Side sublet. I suppose that's the definition of a chow-

derhead: a guy who will put off anything, especially growing up, to get good clam flavor.

But I had not realized just how much I was putting off until late summer 1987, when something repitched the true chowder vibe. One hot early-September afternoon, about a month before the stock market crash, a neighbor jumped or fell off our building's roof into the inner courtyard, where he lay swollen but otherwise visibly undamaged in a dirty white T-shirt and black khakis for what seemed a long time. Everyone thought it was a window washer. When they finally came from the morgue to lift the body, I recognized the middle-aged guy in 3A, who, the previous winter, when he spotted my Red Sox warm-up jacket from the 1986 World Series against the Mets, needled me as if it were just another high school varsity jacket. Pointing at the chest patch, cut out in the shape of a red sock, he had asked with a completely straight face if I had been on the knitting team.

Death, I thought, I had somehow gotten adjusted to. My mother had died of cancer in 1981. She loved Cape Cod, was a lifelong gourmand of its seafood and shellfish, the more reekingly aromatic the better; so that making a good ripened chowder after she was gone had felt like a process of self-consolation. Coping mechanism would be another interpretation. Four years with an excellent psychotherapist had also done its work, though I was still a decade from understanding the chemical aspects of my depressive nature, and something about my neighbor's taking his own life had forced me to confront a new sense of our perishability.

By then, most of my knitting team had graduated from law school or med school, and/or had gotten married or moved to L.A. to prosper in the film business. The Boston guys remaining

in New York had begun working the 24/7 shift that every young, ambitious person with an iPhone and a hashtag puts in nowadays, but which back there in the sleepy old twentieth century was reserved for doctors rising through their residencies at the call of beepers on their belts, or law firm associates rarely finding the time to commute to the suburbs and back at the behest of the first clunky car phones, when they weren't catching at most an hour's sleep under the desk.

By 1987 everyone was married and having kids and had cast away the luxury of time to debate bay leaves or Bob Stanley's wild pitch and Richie Gedman's passed ball. The whole ritual had shortened and grown lazy in important ways. Suddenly littlenecks were OK; it was fine to steam them open. No one minded if the beer was Lite. Cleanup seemed to start even while the game was still on. The kitchen was left a little too spotless. It all began to feel staged, as if we were Druid reenactors seeing in the solstice — the kiss of death, since the whole point of piling up our Stonehenge of clamshells had been to recapture the slap of the sun on a morning by the sea.

"Billy Buckner," a Yankee guy taunted me that spring up at the Stadium, sticking his face right in mine as we crossed paths in the tunnel behind the third-base seats, and he reiterated this singsongy naming of our first baseman whose fatal tenth-inning error in Game Six at Shea had been unfairly judged the deciding factor in the Sox losing yet another Series in the seventh game, when any chowderhead paying real attention could tell you that Stanley's wild pitch and Gedman's passed ball, allowing in the tying run, were at least as much to blame, since the Sox in Game Six were twice only one strike away from winning it all. But Buckner, disgraced by a slow grounder dribbling between his taped-up ankles to give the Mets a 6–5 win, was noisily made

the goat over two media-crazed days of rain delay, and I felt for him.

Single again after my longest-yet girlfriend had moved out the following winter, and essentially unemployed between books and articles, shucking clams for another spring chowder opened me to my own small Hub of grief. Now the briny vapors worked like a whiff of naphthalene in a mothballed attic. Preserving the past can be easily toxic, and I sickened on unresolved rage, soddenly buried beneath strata of disappointment and sorrow, and I did the very Boston thing of ramming myself into a hair shirt to feel more painfully the flaws beating in on me from this new unholy world. I started judging certain chowder ingredients and their local purveyors as worthy or unworthy, denouncing the morons at a nearby restaurant's raw bar for having sold me puny, probably biochemically questionable, littlenecks; or the idiots at Smiler's who were perfectly glad to let this clearly deranged, rueful Quixote — raving about salt pork at one in the morning — purchase undercooked bacon from the salad bar. Could it really be that I had gone out and bought two pounds of *bacon* at a twenty-four-hour deli mart?

It is here that chowder becomes dangerous. These were not preparations for a state funeral, no matter how many times (four) across how many decades (four) the Red Sox had left themselves and their people in misery after the seventh game. Mixing up healing with quahaugs turns out to be a bad idea. A touch of longing for a loved one while stirring the pot is OK. Perhaps a few happy thoughts of the old family dog romping on the shore. Even inhaling the fumes as if this really were a day at the beach.

But failing to grow up? Blaming the dudes at Smiler's? Bringing untreated hurt to bear on inert ingredients — I had already steered (stirred?) perilously close to being the self-appointed

shellfish warden of the Upper West Side. All this risked the living death that rots up from fetishizing anything one loves. By becoming the Jack Nicholson of seafood nostalgia, I had sucked the life out of—out of *life*. The zing that had carried me and the knitting team back to our earliest Edens by releasing the marrow from that first batch of quahaugs had also steamed away. Chowder was dead, I had loved it and killed it, and so I, too, was worthy no more.

I will never forget how Peter Fisher—one of my oldest and dearest friends on the knitting team—looked when I asked his advice about how I should deal with the unrepentant dry cleaner on Broadway, confessing that I had entertained thoughts of pulling down the metal security gate on the front of the shop and sealing the guy inside with my own padlock.

Peter, at that time storming the heights of the New York Fed legal department, said that the scheme sounded like a felonious tort, and that I would almost certainly face a civil suit for damages, then asked briskly but compassionately whatever had brought this on.

"They lost the tablecloth. The guy won't even say he's sorry."

Peter's eyebrows popped up to his hairline. He knew exactly which Cape Cod picnic sacramental I was talking about, but at the same time looked as if, just over my shoulder, he had seen the men in the white coats sneaking in.

Making chowder is a good way to keep faith, no more. A journey back to the real Cape Cod in August 1991 undid the spell and started the process of repairing deeper hurt, but not before a last stand of real chowderheadedness. I don't even quite remember how this came about. It was the day after New Year's, when a phone call came from Boston to where I was staying in

Colorado. My old pal John Dukakis, an admired early member of the knitting team who had left for Hollywood to crown his movie and stage career with a new TV series before energetically turning to his father's presidential campaign in 1988, had very kindly tracked me down to pass the word that if I really wanted "that chowder proclamation" to be made official, the governor would be signing all such decrees tomorrow, his last full day in office, and I had about three hours to get the wording of it into the statehouse.

I didn't remember ever having floated such a "Gee, wouldn't it be great" with John, yet here he was calling out of the blue. I had had my share of grandiosity, true enough, but even in my twenties, when John and I had been hanging out on West 85th Street, it had never occurred to me to go through the state-house to get anything proclaimed. Besides, I had not the first idea of how to word so inappropriately ponderous a document, or what it would really say, or why, with all due respect, Gov-ernor Dukakis — to whose campaigns I had never been able to come up with more than a hundred bucks — should be offer-ing me his standing as chief magistrate to press my preoccupa-tion upon the citizens of the Commonwealth. But John, one of the nicest guys on the planet, was in the grip of his father's last crowded days; and so much remained unspoken in those years immediately after the Democrats had gone down hard to de-feat behind Dukakis as their grossly overblamed leader, John couldn't really give me anything but a fax number before he hurried on.

Curiously, I had never sent a fax. It was 1991. I was thirty-three and had last worked full-time in an office in 1986. I still wrote on a typewriter, which I happened not to have with me, and I was not having a good day, not quite knowing what to do with my-

self—same old problem: all for living life, just not knowing how to anymore, and here I was stranded for the holidays with my newly married brother and sister-in-law in their ski house. The ridiculousness of my development was so magnificently clear in that thin mountain air that, at first, it stopped me cold from doing anything that would in any way embarrass Governor Dukakis during his final hours in the Executive Chamber.

I hated to think of him in there, flourishing his pen over my foolishness. I respected his quiet courage in the face of so much loss and letdown—I didn't want to put any more dumb tank helmets on the guy's head. He was already the Bill Buckner of presidential politics, his whole campaign turning on that one "tank moment," when in fact Bush's swiftboating (like Stanley's wild pitch and Gedman's passed ball) had done as much or more damage. "There's no getting that skunk smell off of me," Buckner would still be saying more than twenty-five years later, even after the Red Sox had invited him back to Fenway to throw out a first pitch, and the fans had stood in forgiveness and dismay at the burden he had borne alone, weeping to bring him home from the wilderness.

No doubt the stubborn Greek would also still be blaming himself that next and last day, January 3, 1991, when for the second time in three terms he would perform his final gubernatorial obligation, known officially as the Lone Walk, or, popularly, depending on the fame or infamy of the outgoing chief, the Long Walk. Exiting through the rarely opened tall central doors of the statehouse, he would stride down the thirty-one steps of the capitol's front staircase and across Beacon Street to the Common, where as a private citizen he would rejoin the people of Massachusetts.

For Michael S. Dukakis that might be a very long Lone Walk

indeed. Too soon for tears of forgiveness, and among any chorus of cheers he might get on the statehouse steps, there would still arise jeers for Governor "Dutaxus" and "Zorba the Clerk" out there beyond the Shaw Memorial. He'd smile his lukewarm smile and go straight home to Brookline, I guessed. Even with twelve years of formidable administration to his credit, the longest in state history, the retiring Duke would no more swagger down Beacon Street, chatting, yukking it up, than he would drop into Spaceman Lee's old hangout for a few boilermakers. Michael (never the prole "Mike") Dukakis had always taken himself that shade too seriously. (But hey, who doesn't?) He was an immigrant's son, a high-minded reformer, a career government guy, famous for fastidiousness and suits from Filene's Basement. What did we expect?

Or was he — the image of that tank helmet with the governor's name stenciled on it suddenly rising to mind — *was he the biggest chowderhead ever?* Who else would try to show voters his strengths as a future commander in chief by letting himself be ridden around like a birthday boy in an M1 Abrams tank, wearing personalized headgear, giving directions, and waving? What a chowderbrain! *That* guy wasn't going to the White House (and no Hall of Fame either, Ace), but he'd certainly earned his afternoon at the Eliot Lounge. He could ride in there on a tank and no one would mind . . .

Maybe — now it all fell into place — maybe an *official* day of chowderheadedness was exactly what the Duke *needed* to get out of his administrator's head and cross his personal Beacon Street to get back with friends and neighbors on the Common.

So, right where I was sitting, on the edge of some fluffy bed covered by overstuffed pillows, thinking of Bill Lee and his Himalayan guru and the burden of being mortal, I wrote out what

the Duke and his people would need to know about chowder. Someone in the statehouse stirred my disembodied paragraphs into time-honored form:

BY HIS EXCELLENCY
MICHAEL S. DUKAKIS
GOVERNOR
A PROCLAMATION
1990 [SIC]

WHEREAS: In the Commonwealth of Massachusetts, a chowder-head is known to be a defender of the Quahaug; protector of the salt pork; advocate of the heavy cream; upholder of the common cracker; champion of the chowder; fan of the Red Sox; and keeper of the faith; and

WHEREAS: In the Commonwealth of Massachusetts, a bowl of quahaug chowder is known to be composed of a quart of clams (from Wellfleet, if possible); a quarter of a pound of salt pork; three potatoes; two onions; a quart of milk; a quarter of a pound of butter; plenty of common crackers; salt and pepper; a kernel of garlic; a jar of cream; and

WHEREAS: In the Commonwealth of Massachusetts, we like our chowder rich and creamy, and find laughable any and all of the inferior tomato-based concoctions such as can be found south of Worcester, including, but not limited to, the so-called Manhattan "clam chowder," which appears to be nothing more than a thin, watery minestrone consumed by misguided people;

NOW, THEREFORE, I, MICHAEL S. DUKAKIS, Governor of the Commonwealth of Massachusetts, do hereby proclaim January 3, 1991, as

CHOWDERHEAD DAY

and urge the citizens of the Commonwealth to take cogni-
zance of this event and to participate fittingly in its obser-
vance.

To this day, so far as I know, municipal offices and retail es-
tablishments remain open throughout the Commonwealth on
Chowderhead Day, and no restriction applies to any type of work
that may be performed. Until 1996, three-quarters of a mile from
the Boston Marathon's finish line, the doors of the Eliot Lounge
were open to runners, and though now even Filene's Basement
is shut, the Commonwealth proceeds, quietly brave, stirring the
nation by its determination to carry on.

Boston, 1972

Katherine A. Powers

I FIRST SET FOOT in Boston with my seven-member family
right off the boat from Ireland. It was July 27, 1965, and we,
and a large retinue of bags, cases, and trunks, were making our
way to the Pioneer Valley in western Massachusetts to start a
new life in the United States. The great difference between the
Irish multitudes who had been disembarking at the Port of Bos-
ton since the mid-seventeenth century and the seven Powerses
now trailing down the gangplank of RMS *Sylvania* was that we
were Americans. Except for the youngest, an Irish-born child,
we were all natives of the Midwest; but my parents had acquired
the habit of emigrating to Ireland, and then — upon their version
of thinking better of it — packing up and returning to the United
States. Normally, we hauled up in Minnesota, but now here we
were in the town that, unknown to me, would become the place
I love and know better than any on earth.

As it happened, this tenure in America was short-lived and we were all back in Ireland a year later. Time passed; time was squandered. I dropped out of college and worked as a barmaid in London and Dublin — illegally, as I was American. In 1972 I came back to Boston, this time alone, looking for another new start.

The Boston I came to in 1972 was still on the downward slide from its days of commercial and cultural eminence in the nineteenth century. Its population had been declining since 1950 and, since the later years of that decade, had, like so many American cities, felt the brute hand of urban renewal and highway construction. The people of the West End had been evicted, their homes leveled, most of the area now lying blasted and empty. Scollay Square, adjacent to Faneuil Hall, had been transformed from a neighborhood and scene of human-scale misbehavior to barren plazas and the oppressive bulk of government buildings. The North End had been partly demolished and isolated by the elevated highway of the Central Artery and the Callahan Tunnel. The fifty-two-floor Prudential Center, finished only eight years before I arrived, and the nearby extension of the Massachusetts Turnpike added to what seemed to be the triumph of ugliness.

Among those dismayed by the transformation was the indefatigable diarist and neurasthenic monster Arthur Inman, who — until he killed himself, unable to take the noise and devastation — had lived only blocks away from the Prudential and turnpike construction. Venturing out in his chauffeur-driven car ("the Baby-Carriage") as the massive projects got under way, he wrote, in a typical philippic, "An enormous warehouse, a large hotel, many minor properties were in the process of being razed. Parking properties with low taxes are visible, like gums naked from teeth drawn, everywhere. This graft-ridden city shrinks

yearly in population. The jackdaws pluck out its eyes, their greed unprincipled, unsheathed, insatiable."*

When I arrived in 1972, the people I met still buzzed about all this, and not in a spirit of civic pride. But that year also marked the beginning of the end of such large-scale depredations: it was the year that the projected I-695, an eight-lane inner beltway that would have bombed out parts of Boston, Somerville, Cambridge, and Brookline, was finally given the kibosh by Governor Francis Sargent. Despite Boston's ever-ascending skyline, the town began to pull itself together, finding a greater sense of its past, a temper much advanced, I think, by the nation's bicentennial in 1976, and culminating in the preservation of Fenway Park.

The Boston I came to in 1972 was a white and black town: the census of 1970 recorded it as 82 percent white and 16 percent African American, with the remaining 2 percent made up of a sprinkling of Native Americans and people from the rest of the world. Boston had yet to see the Caribbean, Central and South American, Asian, and African immigrants who make up such a great portion of this twenty-first-century, multiethnic city.† Boston in 1972 was also, not to put too fine a point on it, racist, a disposition that came as a shock to me; I had associated New England, and Boston especially, with high-minded causes, chief among them the abolition of slavery.

Of course there were — and are — many Bostons, but the ones I became acquainted with were the North End, Beacon Hill, Back Bay, downtown, Park Square, the Boston Common and Public

* Arthur Inman, *The Inman Diary: A Public and Private Confession*, edited by Daniel Aaron, vol. 2, p. 1586 (Harvard University Press, 1985).
† The 2010 census records Boston as being 47 percent white, 22 percent African American, and 31 percent a diversity of other races and ethnicities.

Garden, Chinatown, the Combat Zone, and the Fenway, specifically Fenway Park. I visited Southie only once in those early days: a month after I arrived, I went to its Saint Patrick's Day parade, a thrilling affair at the center of which was Mayor Kevin White: one moment pontifical, dispensing mayoral blessings with waves of his hand, and the next a creature possessed, scampering back and forth across the street to shake hands and pat babies. I also went forth a couple of times to reputedly Irish Dorchester looking for draft Guinness, though what I found would have meant a barman's excommunication in Dublin: a small tankard of dead dark fluid topped with a sad streak of spume. Of most of the South End and Dorchester, and Boston's annexations, East Boston, Charlestown, Roxbury, West Roxbury, Mattapan, Roslindale, Jamaica Plain, Hyde Park, Allston, and Brighton, I knew nothing.

In her notorious hatchet job of 1959, Elizabeth Hardwick wrote that Boston was "wrinkled, spindly-legged, depleted of nearly all her spiritual and cutaneous oils, provincial, self-esteeming." Its great vice, she said, was smugness.* I daresay that was true enough in the circle in which she moved, being married to Robert Lowell and all, but her crowd was quite a different one from mine. When I arrived, lonely and very poor, my plan was to get a job, probably as a bartender, and once I had made a lot of money, I would become something more distinguished, perhaps a novelist, maybe a doctor. Step one was a little more difficult than I had expected, as there were few openings for women behind the bar in Boston of that distant day. Indeed, a number of them banned women from entering their sacred portals at all — much like Dublin, in fact.

When I did finally come across an employment ad that wel-

* "Boston," *Harper's Magazine*, December 1959.

comed female bartenders, I dressed neatly and presented my-
self at the office of what turned out to be an agent who supplied
personnel to various unspecified businesses. A couple of other
aspirants showed up — two very young women from Worcester
seeking, I was relieved to learn, other positions. The four of us
trooped down Washington Street, our agent in his slick suit, the
Worcesters in white boots and miniskirts, and myself, feeling I
was making a good impression in a pleated skirt, white button-
down shirt, knee socks, and brown lace-up shoes.

Our destination, it turned out, was Boston's infamous Combat
Zone and the Two O'Clock Club, a strip joint. The playbills — as
they might be called — advertising the attractions inside were a
little alarming, but did promise a slice of life and grist for the mill
to be drawn on if I were ever to take up my pen. The Worcesters,
who, it emerged, dreamt of becoming "dancers," went off with
the dominatrix in charge of that art, and I was ushered into the
cockpitlike office of the manager. This was Mr. Venus, a practical
man who looked me up and down and asked me, disbelievingly
it almost seemed, if I knew what I was doing. Did I realize that
this wasn't Dublin or even London? I said yes, and dealt him a
knowing look. After being trained up for an hour or so by the bar
manager on how the place was run (give the splits of champagne
a good shake under the counter before uncorking them), I was
told to start the next day. Mr. Venus, if you are still around and
reading this: I'm sorry. I lost my nerve and I still feel bad about
standing you up.

I eventually got a job behind the take-out counter at the
Schrafft's restaurant in the Prudential Center's arid shopping
concourse. As it happened, the main building had just been sur-
passed in height by the Hancock Tower a few blocks away, which
had risen sixty floors and 790 feet to reflect the skies. Still, true to
the spirit of letdown that was Boston's at the time, the unfinished

edifice was shedding its windows, its celestial heights scored by patches of plywood. The ground below was cordoned off lest a great sheet of glass come sailing down (again) to attack the citizenry. Most Bostonians, but especially those of us who worked at the Prudential in however lowly a capacity, considered the trials of the Hancock an especially good joke.

I showed up at Schrafft's at 6:30 a.m., Monday through Friday, in a black nylon skirt and white Dacron blouse to start the coffee and set out Boston's breakfast: piles of doughnuts and a few crullers for more sophisticated palates. I had to learn what a "regular coffee" was and, when it came to lunchtime, the meaning of BLT, tonic, frappe, and even mayo. Behind my counter I worked the morning rush with a man called Joe, who I am sure is dead now. He looked like an ancient jockey and liked to call me — who could give him at least six inches — "the wee Irish colleen."

Joe was visited practically every day by a runner for "the numbers," but his greatest pleasures were romantic. He liked to arrange the doughnuts and crullers in obscene formations not recognized by the women customers for whom they had been erected. "Grab a crulla," Joe would invite selected typists and secretaries who came down to us from the Prudential Insurance Company above. He told me he'd grown up on "the wrong side of Beacon Hill," without a father, but that he had a lot of girlfriends. In our cramped space behind the counter, he was given to acts of tenderness that were not considered a breach of workplace manners in those days. (Joe's a good guy, the manager reprimanded me, after I had rebuffed the wizened little squirt by slamming him hard up against the cash register.)

I recently went to the Prudential Center to try to figure out where Schrafft's used to be, and it was impossible. The building's once barren, wind-torn plaza and forlorn concourse have been

given a transfusion of life. Those gray and lonely spaces are now filled with plants and with people, shopping and eating, something Bostonians used to do, but not in so many places and certainly not with such festive abandon.

The radical change in Boston's population has, I guess, had something to do with the change in its menu. When I first came here, the food, except in the North End, was as dispiriting as any you could find in Ireland or, indeed, in the resolutely unfrivolous Cambridge, across the river. Boston was, lest it be forgotten, the birthplace of Fanny Farmer's cookbook, a work in which the first sentence of the original edition's opening chapter sounds the tocsin: "Food is anything which nourishes the body."

Put another way, this was a town whose inhabitants thought Indian pudding was edible, and for whom the only known culinary sin was putting tomatoes in clam chowder, as the godless people of New York did. Except on the subjects of chowder, steamers, and pie, I sensed a resigned feeling about eating in Boston, but then the New England of that time was permeated with such an air of frugality that the lines between traditional Yankee stinginess, actual lack of money, and simple indifference were not easy to draw. But something else was at work. I began to see the town's attitude toward food as being part of a general air of endurance, one that sprang from one source: the Red Sox. Even though in 1972 Boston had two winning teams in the Celtics and Bruins, the tribulations of its baseball team colored its character, injecting the populace with a rueful, stoical streak, which dissolved finally, and I think forever, in October 2004.

Still, in my first year in Boston, the greatest of all things (as I saw it) was how few people actually went to Fenway Park, the exhilaration of having made it into the World Series in 1967 having worn off before I came to town. Indeed, the team's defeat in that contest's seventh game by the Cardinals — who had also van-

quished them in 1946, also in the seventh game — was added to half a century's litany of Red Sox fans' woes. It gave me the headiest joy to be able to walk to a major league ballpark, and this one such an unassuming green beauty jammed into its irregular little pocket. At Fenway Park, bleacher seats were $1, soaring to $2 in later years and to God knows how much today. One could sit anywhere, meaning, in my case, right over the bullpen, only a short, and to my mind companionable, distance from my favorites, Luis Tiant, Bill Lee, and, eventually, Bob Veale (who, when called on for relief, always chose to walk off some of his formidable mass instead of taking the ditsy Red Sox–capped bullpen cart).

Now I had a job, but my living situation was not dandy, as I was staying with a person with whom I was in perpetual warfare. Though I was still a lonely soul, I wanted to live in my own place, but making only $72 a week and not having a car (or knowing how to drive) were drawbacks. I did find an ad for a furnished apartment for $80 a month right in the nearer reaches of the South End. (Walk to work!) When I finally managed to find it, Boston being no more lavish with street signs then than it is now, the building struck me as having the sort of decrepit charm I had been used to in Dublin and London.

At least from the outside. When I had flushed the superintendent out of his cellar redoubt and he heard what I'd come for, he told me straight out that I didn't want to live there. I said I did, so we went up some dramatically horrible stairs, along a dark, ratty hall, and into a room with one filth-spackled window, a naked ceiling bulb, and walls painted psychotic green. There was an indescribable mattress exposing itself on a bed hunkered down beside a refrigerator; a hot plate was on the floor and there was one chair. I can't remember if there was a bathroom (aside from the stairs). All in all it was most decidedly a slice of life, just the sort

of place, I tried to think, in which writers of the past had plied their desperate trade. And yet, the superintendent persisted in his naysaying, elaborating on the peccadilloes of the other residents, and finally — against the objections I felt it was cowardly not to make — he simply refused to rent it to me.

So I got a job across the river in Cambridge as a housekeeper and cook, for room and board, at one of the masters' residences at Harvard, a cultural milieu, I learned when I wanted to listen to Red Sox broadcasts, devoted to KLH radios, machines too fastidious to receive AM stations. By the end of 1972 I had returned to school, attending the University of Massachusetts at Boston. It was exactly the right place for me, being, at the time, located in Park Square near the Hillbilly Ranch and the Greyhound bus station. The bar and the bus station are gone, and the university itself moved away two years later to Columbia Point, into spanking-new buildings built with old-fashioned graft.

Much of what I say above doesn't sound much like a celebration of Boston, but that is my own way of loving this town. My Boston is a palimpsest of four decades of change upon change, four decades of carping filling the margins. Boston, 1972, is when my life really got started. It marked the first time I voted ("Don't Blame Me, I'm from Massachusetts") and paid taxes; it's when I got my Social Security number. That year led to the best things that have happened in my life: a Boston education, work as an archivist at the Episcopal Diocese of Massachusetts on Joy Street and at the Harvard Business School's Baker Library (on the Boston side of the river), writing about books in the *Boston Globe*, a multitude of real friends, and, above all, my two Boston-born sons.

Transplants

Jabari Asim

Following the Signs

I was sleeping deeply. The prairie wind had yet to stir the cornfields at the end of our block. The nearby highway, an incongruous ribbon wrapped around acres of rising stalks, was mercifully devoid of the tractor-trailer rigs whose engines sometimes roared, surflike, from dusk to dawn. I'd learned to slumber in placid stillness even on nights when convoys raced through our quiet corner of Champaign, Illinois, on their way east to Chicago or west to St. Louis. For me, standing in our driveway and staring at the nighttime sky, reliably cluttered with more stars than I'd ever encountered, always eased the tensions I'd accumulated during the day. Later I'd settle my head on my pillow, at peace with the notion that small-town life suited me well.

My wife's gentle shaking roused me and I blinked a few times before peering at her curiously. "We need to go to Boston," she said.

I'd been there maybe a half-dozen times. My two sisters, both older than me, had trekked cross-country, thousands of miles from our midwestern home, to earn diplomas at Brandeis and Harvard. More recently, I'd visited for campus speaking engagements. On each occasion, I'd been in and out of town quickly. Aside from a quick stroll around the Boston Common on a brisk, blustery day and an equally chilly tour of Harvard Square on a subsequent trip, I'd spent more time in my hotel room than on Boston streets.

I rose up on one elbow. My wife, sitting on the edge of the bed, turned to face me. "Boston," she repeated. "We should move there."

Liana offered no further clarification, and I didn't press her for any. By then we'd been at this thing for a while, nearly twenty-five years, and we'd pretty much figured each other out. Our life together is neither dull nor predictable, but our interactions have acquired a comfortable — and comforting — rhythm. She trusts me enough to honor my impulses, and I trust her enough to respect her intuition. At this point, we don't always feel the need to explain ourselves to each other. We just go with it, and no matter how strange or unusual our path may appear to others, it usually turns out to be the best option in the end.

"OK," I said. "Let's do it."

I like to say I'm the kind of fellow who can live anywhere, but it may be more accurate to say that my peace of mind seldom depends on my surroundings. Since the Asim Team's earliest days, I've often proclaimed that all I need is a cot, a computer, and my favorite people — my wife and kids — under my roof. In the beginning, Liana and I shared a twin mattress on a splintery floor (we were skinnier then, much skinnier), and the closest thing we had to a computer was a small electric typewriter that actually belonged to my brother. But we had a roof, and we had

each other. Over the years our toys have gotten more plentiful and shinier but my basic requirements haven't changed. Liana is similarly disposed, and our kids have learned to regard our moves as another chapter in an ongoing family adventure. Although Liana and I didn't share our plans with any other adults, we had several conversations preparing our three youngest children, the ones still at home, for a likely return to the East. They were hardly perturbed when, five months after Liana suggested it, I announced that I had accepted a teaching job in Boston. Our youngest, who keeps his own counsel, merely shrugged. His big brother, then a seventh-grader, planned to keep up with his pals via the Internet. My daughter, then a freshman in high school, was particularly pleased. She'd made friends easily enough, but Champaign wasn't exactly a shopaholic's paradise. She quickly went online and acquainted herself with the boutiques and style emporiums of Newbury Street.

We'd all managed to make connections during our two years in the heartland. Some of my colleagues had emerged as genuine friends. We bonded over late-night office sessions and weekly dinners that Liana hosted. She, too, had begun auspicious relationships, at a church just a few blocks from home. The pastor was kindhearted and genial, and even a non-Christian like myself could sit through a sermon without being constantly reminded of my imminent damnation. Although Liana is an Illinois native, she'd long ago gotten over calling it home. Culture was her community of choice, and not the kind typically found within the serpentine embrace of agribusiness — theater, museums, concerts, more theater. After a lengthy stint minding our home and kids, she missed her days of treading the boards, inhaling the smell of the greasepaint, reveling in the roar of the crowd. Someday, someday soon, she meant to get back in the game. In the middle

of the night, the answer, as it often does, was emblazoned on her brain with all the snap and sizzle of a neon billboard: Boston.

Under an insistent midwestern sun, we stuffed the minivan and rolled toward our future. Behind us the corn, by then over six feet high, swayed in the haze.

Striving

"You're the first black man I've ever known who actually *wanted* to move to Boston," said a male colleague, also African American.

"You know, it's cold up there," warned a friend who'd spent most of her winters in windy Chicago.

My nonblack friends were unanimous in their support for the move. More than a few of my black friends, like those quoted above, were surprised and even discouraging. Via Facebook, one acquaintance felt compelled to provide a brief lecture on the dangers of racism.

I've been writing about our country's tortured racial history for nearly three decades, so Boston's shameful past and intermittently difficult present weren't unfamiliar to me. Episodes from that past had even made their way into my books and essays from time to time. My research had taught me that part of Boston's famed Beacon Hill neighborhood was commonly referred to as "Nigger Hill." I had quoted Southern opponents of Northern hypocrisy such as U.S. Senator Robert Hayne of South Carolina, who in 1830 included Boston in his condemnation of big cities where "there does not exist on the face of the earth, a population so poor, so wretched, so vile, so loathsome, so utterly destitute of all the comforts, conveniences and decencies of life, as the unfortunate blacks." I'd read Alexis de Tocqueville, who had Boston and other Northern cities in mind when he noted, "The prejudice of race appears to me stronger in the States that abolished slav-

ery than in those where slavery still exists." I knew that one of the largest elementary schools in Boston bears the name of Louis Agassiz, a nineteenth-century Harvard professor and ardent white supremacist responsible for some of the most maliciously racist pseudo-scholarship ever published.

In the modern era, while the Willie Horton spectacle and the Charles Stuart fiasco also have extensive shelf lives, Boston's turbulent busing years continue to resonate beyond the city's borders, perhaps even more durably than Bostonians realize. Many African Americans of my generation have never forgotten the photo showing a rabid young white man attacking a black Boston attorney, Ted Landsmark, with an American flag in 1976. That image, although thirty-some years old, was cited more often than any other when black friends responded to my moving plans.

I was only dimly aware of Boston's busing turmoil when I came to town a year after the flag attack for my sister's graduation from Brandeis. While I was taking an evening stroll with my father not far from campus, a car pulled up beside us. The young white men inside shouted at us, calling us "niggers" and urging us to "go home." We declined to acknowledge them and they soon tore away, spewing a cloud of exhaust. Earlier that year, whites in my hometown of St. Louis had called me that same epithet twice, once at my high school and another time as I walked to tennis practice at a nearby park. It had been just as ugly and stupid then, and the experience in Boston simply confirmed what I already knew: racism was everywhere and you didn't have to go looking for it. As sure as the sun rises, it will find you.

On that same trip, my father tried and failed to use the facilities at four different gas stations. At each stop the proprietor coldly looked my father up and down before derisively informing him that the restroom was broken, closed, or otherwise unavail-

able. Did they turn him away because he is black? He couldn't prove it, he admitted, but he had a feeling.

He had felt the same sensation many times in St. Louis, where a lifetime of slights had sharpened his awareness. My hometown, as much as many other American places, has a twisted history of racial outrage, laden with atrocities, humiliations, public confrontations, and systematic deceptions. As with Boston, the significance of its track record can hardly be overestimated but is by no means unique. Whenever a friend singled out Boston for its racism, I always wondered where the accuser had been born and raised. Did his hometown have a miraculously blemish-free history? Each time, I recalled that scene in *A Soldier's Story* when the sergeant, played by Adolph Caesar, tries to distinguish himself from the dysfunctional South. "Well," says Private Peterson, played by Denzel Washington, "where are you from? England?" If blacks want to live in a place free of a racist past and free of present-day racists, we'd have to go to the moon.

I don't expect racism to end any time soon, and a flurry of events unfolding as I write this essay — Paula Deen's wistful evocation of the antebellum South, the Supreme Court's evisceration of the Voting Rights Act, the George Zimmerman murder trial — demonstrate that postracial America remains a fantastic ideal, "to be pursued but never attained," as Haile Selassie would have put it. W.E.B. Du Bois, himself a son of Massachusetts, once argued that the typical black American simply wished to pursue his destiny without "having the doors of Opportunity closed roughly in his face." Liana and I have always felt that the best way to honor those striving African Americans of yesteryear is to become Strivers, relentlessly chasing after our own fate. Opportunity awaited us in Boston, and we saw no reason to resist its overtures.

In 1946, Richard Wright wrote about blacks in cities like Pitts-

burgh and Chicago desiring "a life compatible with the dignity of their aspirations." For us, Boston held as much promise as any other place we'd lived. We arrived to find a black governor presiding at the statehouse and black athletes welcoming the adulation of sports fans once widely considered the most racist in the United States. That such heartening occurrences can take place amid economic inequality, disparate incarceration rates, and other dispiriting realities is almost to be expected in a country whose citizens can elect a black president while keeping his most reactionary opponents in office.

Boston at its best and worst embodies the profound contradictions of our age. The warring impulses and unreconciled strivings that Du Bois attributed to African Americans are symptoms not just of the Bay State but also of the country at large.

Wild Turkeys

It's sometimes hard to say exactly why a place charms you. Perhaps you have a good feeling on the way to your destination. You're favorably inclined because bright prospects align before you like the landmarks you pass on the highway — a new job, a new relationship, a fresh start. But once you arrive, you can't always put your finger on the one thing that confirms your expectations.

When we moved from Missouri to Maryland in 1996, the deer sealed the deal.

I quickly became enamored of our new environment, even before we unpacked all the boxes. We all felt the same enchantment. After nine years in a violent inner-city community, we found ourselves in dramatically different surroundings. In our crack-ridden pocket of North St. Louis, a night seldom passed without the periodic punctuation of automatic gunfire. In our leafy Maryland suburb, I grew fond of taking Liana's hand and

asking, "Listen. Hear that?" "I don't hear anything," she'd reply. "Exactly," I'd say with a smile.

The most common wildlife in our old haunts had been pit bulls straining against the chains held by their gangbanging masters; deer were the new neighborhood's most visible fauna. Despite the lamentations of local gardeners, they roamed unmolested. At first their alleged ubiquity was lost on me. Weeks went by and I failed to spot a single one. After several comical near-misses, the running joke in our house involved whether I would ever actually see a deer. I was transfixed when I finally broke through. As I headed to the bus stop one workday morning, six of them stood on a corner less than thirty yards from my house, sturdy, majestic, and completely unconcerned. They stared into the distance for what felt like several minutes before heading off toward the park in a gentle trot. I waited on an adjacent corner, my eyes on them until they disappeared. Their radiant serenity became something I returned to for reassurance in moments of doubt, a catalyst to remind me not only that I'd arrived but also that I belonged. If the deer didn't worry, why should I?

Geese. Foxes. Turkeys. Raccoons. Skunks. Coyotes. Chipmunks. We've had close encounters with all of them in our little town eight miles outside Boston. I've had wild turkeys surround my car before I could leave the driveway. I've had to lean on the brakes on Beacon Street near the Chestnut Hill Reservoir to allow a line of geese to cross the road. When three coyotes strutted in front of us not far from a T stop, we followed them in our car and watched them come to a mysterious halt on a residential lawn, the house's inhabitants away or asleep, the coyotes still and sharp-eyed. Another time, we sat in the car until the skunk patrolling in front of our house skulked away into the trees.

I realize there's nothing exotic about that menagerie, but I'd

seen exactly none of them while growing up. As Boston newcomers, we were so unfamiliar with the local creatures that we just smiled politely and strolled at our leisure when a friendly real-estate agent cautioned us about a fisher cat lurking in the backyard of a house we were looking at. Why warn us about a humble feline? When we got home, we were astonished when a Google search showed us that instead of an overgrown kitten, a fisher cat was another beast entirely.

For me, the turkeys have had the most impact. Like my initial failure to find deer in Maryland, it seemed as if I'd never see a turkey here. My kids reported that a flock had arrived to greet us nearly as soon as we moved in, but I somehow managed to miss them. According to the Massachusetts Division of Fisheries and Wildlife, wild turkeys had been extinct in Massachusetts since the 1850s but were reintroduced to the Berkshires from New York between 1972 and 1973. Since then, the population has spread, and there could be as many as thirty thousand today. The males can grow as tall as four feet, weigh up to twenty pounds, and behave aggressively toward people. They have angered residents, terrorized pedestrians, "attacked" parked cars, raided bird feeders, and left piles of poop in inappropriate places. We knew none of that when a flock first surrounded our car in the driveway. We also didn't know that they can be chased away by clanging pots, swinging a broom, or skillfully wielding a garden hose. So we just sat. And watched.

My mother spent much of her childhood in Sacramento. She often told me about seeing flocks of peacocks in her neighborhood park when she was a girl. I thought of her recalling the glorious birds, her face aglow with fond memories, as I peered through the window at the gobblers. Although the only turkeys I'd seen up close had been stripped and bound in cellophane, I expected them to be as ugly as the vultures I'd once seen resting

on my neighbor's roof in Maryland. They were more attractive than I expected, with bronze, blue, green, and red glinting amid the black and brown plumage, luminous as tinfoil.

Liana is not so captivated by feathered Bostonians. She prefers the flesh-and-blood playwrights, Presbyterians, and producers she's been spending time with. Some are Boston bred, graced with accents lovingly invoked on billboards urging burger biters on a budget to "give yah wallet a breathah." Others, like us, are transplants, brought to town by jobs, study, spiritual quests, or significant others. From this fertile mixture of seekers and thinkers, Liana and I have begun to build the life, the community, that we envisioned. Liana appreciates a global awareness infusing the rich intellectual ferment so pervasive here, and a mindset among the artists we've befriended that is informed and supportive. "People who instinctively understand what you want to do and even suggest how you can do it" is how she describes them, "and there are more theaters — including little companies doing quality work — than any other place we've lived." She's found playwriting forums where professional actors have read from her scripts and other writers have provided valuable feedback. The world of novelists, poets, and nonfiction writers has proved just as fruitful: good writers give good readings here almost every night of the week. We've had trouble resisting the charming movie theaters that show more than multiplex mediocrities. The variety of cultural fare is so tempting that my primary challenge as a writer is to sit still long enough to work on my own stuff.

Our children are avid consumers of the same kind of culture we favor, preferring theater to sports, for example. Instead of lugging orange slices and soccer balls to parks and fields, we sit in black-box theaters and auditoriums while our teenagers take the stage for shows such as *Tartuffe, Twelfth Night,* and *How to Succeed in Business Without Really Trying.* At their high school,

theater kids are nearly as cool as jocks — something we never imagined was possible.

Which is not to say that sports culture is minimized. Quite the contrary. We've lived in sports-crazy cities before, but Boston seems distinguished by its embrace of four major sports franchises, all of which seem to be regarded with the utmost zeal. Which perhaps makes it so remarkable that there's still abundant room for other forms of large-scale devotion, athletic and otherwise, and plenty of places and events where passionate audiences gather in force. The Paramount. Berklee Performance Center. The Boston Marathon.

For three straight years I've vowed to walk one and a half miles to Commonwealth Avenue and watch the marathon contestants stride by. The layout promised better than a bird's-eye view, and I figured I'd be so inspired by the parade of slender, sinewy bodies that I'd embark on a fitness plan of my own. Maybe I'd be so fired up that I'd run back home instead of walk. Each year I've failed to keep my promise.

The Bullet in the Wall

My wife believes it happened like this:

"The first thing I remember is the boys playing peekaboo," she says to me. "Joseph was on the back porch and G'Ra was on the inside of the door. I remember G'Ra's laughter. Joe would pop up and say 'Peekaboo!' and G'Ra would giggle. I remember it being the sweetest sound. I'm thinking G'Ra was less than two, about eighteen months. Joe was about five. It was the summer. Then I remember you calling them to get ready for bed. It was after dinner, that's why I was washing the dishes. I finished cleaning off the table, ran the water in the dishpan, and was moving back and forth from the side drain to the pan. I had just moved from the

side drain on the right and back to the left when the bullet came through. The spray of the glass from the screen door splashed on the back of my neck. My immediate thought was that my boys were in the door, so I didn't do what you had told us to do. I didn't hit the floor. I turned toward the table, but you were in the other room with the kids."

I remember it differently.

G'Ra was in his highchair and I was sitting across the table from him. Joe was out of the room. Liana was at the sink, her back to the open door. It was a typically hot St. Louis summer, and we had no air conditioning. We usually kept the kitchen door open as long as we dared, with just the screen door between us and the heat and the alley's various dangers.

The quiet gave way to a loud crack as the window in the screen door shattered. Fragments of glass flew as I yanked G'Ra from his chair and moved away from the door.

At this point our memories converge. We remember knowing immediately that a shot had been fired. We didn't know where it had landed until the police arrived and quickly found the bullet hole in the wall above the sink, just inches from where Liana's head had been minutes before.

We had had close calls before, and there were more to come. But the bullet in the wall (the police were unable to retrieve it) was a durable, terrifying reminder that every day spent in our North St. Louis neighborhood was becoming a deadly wager with discouraging odds. Permanently lodged in the kitchen plaster, the bullet lurked just as tenaciously in our minds, forcing us to acknowledge our vulnerability every time we passed by. Just as much, the bullet urged us on, reinforcing in our minds the utter urgency of escaping to someplace safe.

In a short span, four young men on our block were shot, one

fatally. When we nailed a gate in place to prevent access to our backyard, a shotgun-toting teenager and his friends kicked it down and marched across our property in broad daylight, taunting us as they passed. Thieves tried to break into and steal our car. In the middle of the day. In front of many witnesses on a busy block.

As soon as we were able, we got out.

We had been in our wonderful new home in our wonderful new neighborhood for six years when terrorists attacked the United States on September 11, 2001. Liana found out first, when a friend called. She put down the phone, ran outside, and yelled for me. But I was down the road and too far out of range. I made it all the way to work without knowing what had happened. For weeks afterward, I insisted on walking my daughter to her first-grade class. I couldn't resist scanning the sky each time, and the walk across the schoolyard to the main entrance seemed to take forever.

Someplace safe.

In the fall of 2002, the Beltway snipers shot thirteen people over three weeks, killing ten. Six of the murder victims were gunned down in Montgomery County, our very own leafy suburb where deer frolicked unafraid.

In contrast, we lived in fear of white vans. As I traveled to work each day via public transportation, every van looked white and every street seemed clogged with them. As the siege continued, we could tell if the sniper had struck simply by gauging traffic patterns. Roadblocks, pulsing blue lights, and long lines of unmoving cars meant someone was dead.

On one such morning, my neighbor Kathleen pulled her car to the curb as I was walking by. "I know you don't plan on standing on that corner," she said angrily. I shrugged. "That's where the

bus stop is," I told her. "I have to go to work." She glared at me and said, "You're a brave man." She said "brave" but it was clear she meant "stupid." She knew as much as I did that our concept of our neighborhood as someplace safe had been exposed as a wistful illusion.

I recalled that feeling of vulnerability last April, when Governor Deval Patrick and law enforcement officials announced that during the search for the second suspect in the marathon bombings, the citizens of Boston and its surrounding suburbs should "shelter in place." Is that what they call lockdown now? I wondered, recalling the many evenings in St. Louis when we hunkered in the dark while shots rang out. What a weird yet oddly appropriate phrase, I thought, remembering the day the Beltway sniper shot a middle school student in the back, prompting parents all over the region to pull their children from classes and seal them up behind closed doors. I pictured resolute Bostonians suffering the same agonies endured by people in any place where violence has transformed an event from something joyous or ordinary into something horrific and deadly — places like Oklahoma City and New York City and the Washington metro area and Newtown, Connecticut, and Chicago, where 260 schoolchildren have been killed in the past three years.

I imagined the tough, proud, and generous friends we've been privileged to meet rolling up their sleeves even in the midst of their astonishment and grief. I envisioned them coming to grips with a grim realization: there's no such thing as someplace safe. If there ever was. My mind strayed back to our long-ago kitchen in North St. Louis. I wondered if the bullet was still in the wall. Then my thoughts returned to Boston, where cheers were erupting at the news of the marathon suspect's capture, ten miles from my home. There would be more cheers, I knew. And tears. Then

the city's residents would reemerge to wring something marvelous from terrible tragedy. Before the dust cleared and the rubble settled, they'd get back to work, rebuilding blasted storefronts and broken lives. Rebuilding themselves. Rebuilding us.

You get that about Boston. Even if you're from somewhere else.

Diamonds (and Dugouts)
Are a Girl's Best Friend

Lesley Visser

HERE'S WHAT I love about Boston: when I used to say "the center cannot hold," people didn't know if I was talking about the Patriots or Yeats. It's that kind of town; people are smart and funny and almost everything is connected. Funeral homes are Irish parties — they might be filming *Mystic River* in the middle of the service — and local writers coin merry terms like "Curse of the Bambino." The original Mad Men moneyman John Spooner took me to the Harvard Club when I was nineteen years old and told me, "Everything is a bit, write it down." Was there ever better advice?

I was born in Boston; how lucky am I? My dad grew up in Nazi-occupied Amsterdam during World War II and had come to Boston to go to school. He was not of a Jewish family, but for six years everyone in Holland was starving and wholly protective of their neighbors, Jewish descent or not. My mother, working-class Irish from western Mass., could not have been more differ-

ent from my dad: he was Swiss-boarding-school-educated, she was the first in her family to graduate from college. They tried to make a go of it, had two kids, and went their separate ways. We moved often — to Maryland, to Ohio, almost to Sweden — but I'd always been proud to be a native Bostonian. In the aftermath of the marathon bombings, seeing the soul-wrenching response to the devastation, Boston proved to be fourth-quarter tough. I lived in Manhattan on 9/11, so I'd seen that kind of passion and strength up close, but Boston cut me almost as deeply, maybe because I'd stood at the finish line of the marathon at least ten times, covering it for the *Boston Globe*. Until the Boston bombings, I used to say my favorite words in the English language, quoting Henry James, were "summer afternoon." Now when I'm asked, I say my two favorite words, without question, are "first responder."

During my childhood, three things were important: the Red Sox, the Celtics, and Arnie "Woo-Woo" Ginsburg. In the late fifties, kids listened to either Bruce Bradley on WBZ in the afternoon or crazy Woo-Woo on WMEX at night. Woo-Woo's voice always sounded irritated, and he used a variety of sounds, train whistles and baroque slide effects, like some kind of audio circus. He introduced America to the big hit "Does Your Chewing Gum Lose Its Flavour on the Bedpost Overnight?" and he first played "Louie Louie" as a joke. We loved Woo-Woo. He promoted a restaurant on Route 1 north of Boston that served "Ginsburgers," and even though my family lived on the South Shore, in Hingham, not far from the Cape, my brother and I begged our parents to drive us up U.S. 1 to wherever Saugus was.

Woo-Woo was important, but nothing compared to the carmine hose.

I'm a child of the Red Sox, which means I spent my youth listening to Curt Gowdy on cheap transistor radios. My older

brother and I, raised absurdly independently, sometimes took the bus to Fenway from Quincy, where we were born. On more than one occasion, Chris and I walked halfway home after our bus money turned into Fenway Franks. We savored going to see the Red Sox in person, where the thirty-seven-foot-high Green Monster looked, to us, like the Great Wall of China. We'd fallen in love with the stumbling Sox of the late fifties and early sixties. They were an unusual collection. The first black player on the team, Pumpsie Green, would come in as a pinch runner for either left-handed-hitting Pete Runnels, who threw right-handed, or shortstop Don Buddin, who was once called "the most booed man in Boston." Willie Tasby spent exactly one season in center field, and Teddy Ballgame was forever in left. We thought nothing of a manager named Pinky. Most kids, of course, loved Ted Williams, but my favorite was journeyman Ike Delock. The devoted right-hander pitched twenty games a year for the Red Sox. He once vaguely looked my way (in the bleachers?) and I was forever hooked. With a cap pushed back on his head, Delock was twenty-two years old when he broke into the big leagues. Number 14, Ivan "Ike" Delock, from Highland Park, Michigan. I've carried his card ever since. What, you don't remember him?

I never got to see Ted Williams in person, but in Boston the arguments were always clear: Williams over DiMaggio; Russell over Chamberlain; and number 4, Bobby Orr, finished at twenty-eight. My first visit to Fenway was not until 1961, so I missed Williams at the plate, but I've made the pilgrimage in Fenway to section 42, row 37, seat 21, to see where Williams's 502-foot rocket to right bounced off Joseph Boucher's hat and landed there, immortalized in a proud red seat. Here's a fun story, moving the videotape forty-five years down the road. The New Orleans Saints' Super Bowl–winning quarterback Drew Brees wears number 9. Do you know why? For Teddy Ballgame! He told me that his dad

used to show him tapes of Williams hitting when he, Brees, was a child, and the memory — that perfect swing through the hips — stuck with him, even though Brees is right-handed. About five or six years ago, I gave Brees an old battered 9 Red Sox cap, and he keeps it in his locker to this day.

It's strange that Red Sox fans know the colors of Fenway so well, Box-Seat Red and Fenway Green (which is also the color of my two other favorite sports venues, Lambeau Field and Wimbledon). Someone told me that it was the color, in the 1920s, that liquid turned after painting over rust.

One of my strongest memories of Fenway, ironically, is of a professional football game there. In 1964, my father, Max, somehow got a couple of tickets to see the Patriots play against the Oakland Raiders. The football configuration was strange, laid out left to right, covering the infield. It turned out to be one of the most memorable events in Fenway history, a long-ball tie, 41–41. The AFL striped ball went sailing through the crisp October air as Babe Parilli and Gino Cappelletti marched up and down the field. Al Davis had changed the Raiders' colors to black and silver, in honor of the cadets at West Point (OK, he was off by half; he later said he was color-blind), and the Patriots wore red jerseys with blue and white stripes around the shoulder. I made my way down to the field, just a few feet beyond the makeshift bleachers, and saw the biggest man I'd ever seen (bigger, even, than Patriots defensive tackle Houston Antwine, whose thighs were the size of submarines). I was standing next to double zero, Jim Otto, the legendary Oakland center who became my favorite Raider. In 2006, when I had the privilege of becoming the first woman to be enshrined in the Pro Football Hall of Fame, Jim Otto was there and said, "You've done pretty well for a little girl shivering on the sideline in '64."

The Patriots have become the NFL equivalent of a Fortune

500 company behind the brilliant care of Robert Kraft — more on him later. Kraft was the first owner to give me equal access, and it wasn't the NFL, it was team tennis! But the scene wasn't always so glorious for the world champions. When I was growing up, the Patriots were gypsies, moving from Boston University to Boston College to Fenway to Harvard and finally, when I had a chance to cover them, to Foxborough. The stories were something out of a Tim Burton dream. One player arrived driving a bus, followed by a state police cruiser because he failed to pay the Connecticut tolls. Running back Bob Gladieux, who'd been cut by the team, was drinking beer in the stands at Harvard when the public-address announcer said he was needed to suit up. In the spring of 1968, coach Mike Holovak accidentally drafted a dead man. Bill Sullivan, the glib and gutsy original owner of the Patriots, was never flush with cash. He once famously told the players not to turn down the bed sheets while taking a nap in the hotel so they wouldn't be charged for another night.

But we loved the logo, Pat the Patriot. Other teams had mythical helmets — the G of the Packers, the blue of the Bears, the burnt orange of the Browns. Boston had a strange-looking man with dark eyebrows and a goofy smile wearing a tricorn hat while squatting over the line of scrimmage with the ball. Pat the Patriot was designed on short notice by *Boston Globe* cartoonist Phil Bissell, who was asked by Billy Sullivan to come up with something in 1960, and Pat lasted until 1992. There is a museum in downtown Boston called The Sports Museum, and everything is there, from photos of Johnny Bucyk (the "Chief") wearing a huge Indian headdress, to Doug Flutie dropping back, to former rivals Magic Johnson and Larry Bird hugging each other. Beyond the photos, there are exhibits, among them Gino Cappelletti's 1964 MVP contract ($18,000), the actual 24-second clock that the Celtics took with them on the road in the 1950s, and a picture

of Richard Cardinal Cushing in 1967 wearing a Patriots helmet, literally immortalizing Pat the Patriot!

I wanted to be a sportswriter from the time I was ten years old. We had moved to Cincinnati, Ohio, and I began to read *Sports Illustrated*. There were articles on Y. A. Tittle and Cassius Clay, and of course Tom Heinsohn and the Celtics. Princeton's Bill Bradley was on the cover, and there were stories on John Wooden and Jack Ramsey and Bones McKinney, all of whom I got to know as I covered college basketball along the way. When I told my mother that I wanted to cover sports, it was like saying I wanted to go to the moon, since the job did not exist for women. But my mother, Mary, a high school English teacher, didn't look at me like I was from Mars; she didn't tell me covering sports would be next to impossible. She looked at me and said, "Great, sometimes you have to cross when it says Don't Walk." And so I sallied forth. On Halloween, in Cincinnati, other girls would dress up as Mary Poppins or Cinderella, but I would go trick-or-treating as Sam Jones, the Celtics guard. I had a homemade number 24 green shirt and wore high-top green sneakers. My mother would send me out the door with an expression between horror and pride. (I'm friends with Sam Jones to this day.) When I started at Boston College, in the fall of 1971, I immediately went to the school paper to see if I could write sports. I was accepted, though a guy named Mike Lupica, who was a singular talent even then, got all the great assignments. Years later, I attempted to lie about my age and tried to get Doug Flutie to go along. Finally, at a Super Bowl in the early nineties, Doug said, "Lesley, I can't take it anymore. You were ten years behind me at BC, I didn't know any of your roommates, and I don't know any of their kids." Oh, all right, it lives on Google anyway.

Going to college in Boston, being in Boston, you cared about everything. In my freshman year, I worked for George McGov-

ern's presidential campaign. While knocking on doors in the freezing cold of New Hampshire before the primary, we were told to compare McGovern with Adlai Stevenson, though most of us were nine years old when Stevenson died. In 1974, I won a Carnegie Foundation grant, given to twenty women in the country who wanted jobs in fields that were 95 percent male, which were basically all white-collar jobs. I went to the *Boston Globe*, to the fabled sports section of Peter Gammons, Bob Ryan, and Bud Collins, of Will McDonough, Leigh Montville, and Ray Fitzgerald, with editors Tom Mulvoy, Dave Smith, and Vince Doria. It was the summer of Barry White and forced busing. It was the summer of Watergate, and no one, absolutely no one, was luckier to be at a big liberal paper that cared about politics and sports.

Peter Gammons would take me to Paul's Mall to hear a young Patti Smith, and John Spooner would take me to parties at George Higgins's brownstone. Higgins had written *The Friends of Eddie Coyle*, my first introduction — albeit fictional — to crime boss James "Whitey" Bulger, who fled Boston in 1994 when he was tipped off about the impending indictment of his former FBI handler. In the *Globe* sports department, the inimitable Will McDonough would be on one phone with Whitey, his childhood friend from Southie (whom Will once visited in prison at Leavenworth), and on the other phone with either NFL Commissioner Pete Rozelle or Rozelle's sworn enemy Al Davis. On Saturday nights, Dan Shaughnessy, Kevin Dupont, and I, after covering high school football (where I'd take the ferry to Martha's Vineyard and record the stats myself), would get cheap margaritas on the wharf, or we'd go to the Eliot Lounge, the smart sloppy bar, where bartender Tommy Leonard tried to remember to make us pay and where Bill Lee so famously said, "Don Gullett's going to the Hall of Fame and I'm going to the Eliot Lounge."

The *Globe* sent me to cover everything, including sailing races

in Marblehead, where the yacht clubs all looked like Monet's painting *The Terrace at Sainte-Addresse*, with wind-whipped flags flying. I'd get to cover the events with the renowned sailing writer John Ahern, who'd greet King Constantine of Greece by saying, "Connie, how are you?" I remember one Red Sox story I did on an opposing player. While interviewing the player, he showed me a tattoo of a bird and a worm on his biceps. When he flexed his arm, the bird appeared to eat the worm. I couldn't believe the assignments I got! The editors would send me out like some sort of George Plimpton, to hang-glide, or skateboard, or get lost in the woods orienteering. In the mid-seventies, Vince Doria and company assigned me to cover the Boston Lobsters, the World Team Tennis effort owned by Robert Kraft. The Lobsters were a hoot, coached by the chain-smoking Transylvanian Ion Tiriac, who picked Boston because he said it was "the only civilized city in the United States," and led by twenty-year-old Czech defector Martina Navratilova. Bob Kraft and his wife, Myra, took a huge leap of society and let me into the locker room after the games — not that any of the 2,500 people at BU's Walter Brown Arena noticed or cared. But I have loved the Krafts ever since.

In Boston, you hang on to people that way. I was Rick Pitino's beat writer when he first started coaching at Boston University in 1978, when seventy-five people would go to the games and we would count them in the stands. I hung with him through Providence and the Knicks, through the Celtics and Kentucky. He introduced me to my husband, Bob Kanuth, a former Harvard basketball captain, and I celebrated when he won his NCAA titles in 1996 and 2013. I met my first husband, Dick Stockton, the night he called Carlton Fisk's home run at the sixth game of the 1975 World Series, and a year later, a young lawyer named Bob Rodophele and I stuffed envelopes for Ed Markey's first

congressional campaign, at his mother's backyard barbecue in Malden. Markey had decided to run when Congressman Torbert MacDonald, who'd been the Harvard football captain and JFK's roommate, suddenly died and left the seventh district seat open. This spring, Bob Rodophele and I supported Markey when he ran for John Kerry's U.S. Senate seat. I still count Shaughnessy and Bud Collins as two of my closest friends, and I still want Vince Doria to edit everything I write.

In 1975, the *Boston Globe* made me the first woman to cover the NFL as a beat, and I was basically terrified. The credentials, right there as I headed for the stadium, said, "No women or children in the press box," but the *Globe* had muscle—we'd published the Pentagon Papers, we'd won Pulitzers. When the great editor Tom Winship decided to have a woman on the NFL beat, he called Patriot owner Billy Sullivan and it was done. I remember being at one of the early games and the mythical Dan Jenkins was in the press box. I swallowed hard and said, "Gosh, Dan Jenkins, you're what we all want to be." He took a drag of his cigarette, looked at me, and said, "What, hung over?"

I hung on to him, too. Jenkins made me a character in his book *You Gotta Play Hurt*, where the wizened magazine writer (Dan) says to the young sportswriter leaving print for TV (me), "What, do you want to spend the rest of your life saying, 'Back to you, Jim Nantz'?" Which is, of course, exactly what I've done for the past twenty-five years. Maybe I'll call my book *From Jim Nantz to Jim Nantz*.

I was lucky to live in Boston to cover all the Celtic-Laker finals (some for the *Globe,* some for CBS). I covered the heartbreaking Red Sox run in 1986, and I was on the field in New Orleans when Adam Vinatieri's kick gave the Patriots their first title in 2001.

Boston writers are staggeringly original, and I don't mean Longfellow or Thoreau or Oliver Wendell Holmes. In 1977, the

talented, fiercely Catholic *Globe* sportswriter Michael Madden asked me to accompany him to Northern Ireland to take his last testament when he joined the Irish Republican Army. We were the only guests in the oft-bombed Europa Hotel in Belfast, and we walked the barbed-wire segregated neighborhoods on Shankill and the Falls Road. We came home two weeks later, with Mike deciding that living in Boston, for all its problems, was better than trying to fix the Troubles in Northern Ireland. Like any big city, Boston has its challenges, with education reform, job creation, and neighborhood safety, but to me Boston has always been the ultimate woman: great spirit, great body, great mind, great heart. It's a place that makes sense of the world through stories, not statistics — we know that words are our theater. Being born and bred in Boston, what I always carry are the words of Nora Ephron: "That which does not kill you . . . makes you funnier."

Next Stop: Back Bay

Hugh Delehanty

IT WAS SUPPOSED to be our most excellent adventure. My best friend, Glenn, and I — both eleven years old at the time — had talked our parents into letting us go into Boston on our own to see the movie *West Side Story*, which had just opened downtown. We lived in South Weymouth, a quiet, Norman Rockwell–esque village on the South Shore, then one of the safest towns in America, according to *Reader's Digest*. The actor Hal Holbrook, who once lived near my house, said that the primary reason he was able to re-create the character of Mark Twain so well was that he grew up in a world that was remarkably similar to Twain's Hannibal, Missouri.

Glenn was a quirky guy. It was no surprise that he later became a biology professor. He was always conducting wacky experiments. Once he carved his name into his arm with a razor blade to see what would happen. Then he almost blinded himself trying to examine the spots on the sun — with binoculars!

His most dramatic stunt, however, was firing his brand-new BB gun at the roof of the V.F.W. hall where a bunch of World War II vets were gathered. We cracked up watching dozens of potbellied ex-soldiers, dressed in uniform, running out the door and scurrying for their cars as if they were under attack by a division of Nazis.

We arrived at the movie theater early, so we headed for the red-light district nearby known as the Combat Zone to see if we could catch a glimpse of the go-go dancers. But while we were admiring the posters at one of the porn houses, three thugs from South Boston sidled up to us and asked where we were from. They seemed friendly enough, but as we moved down the street away from the crowds, they strong-armed us and asked for money. When I told them we didn't have any, the scariest of the three pressed his body against mine and said, "What's in your pockets, Weymouth?"

Luckily I had just purchased a pair of trick dice at a joke store down the street. When I pulled them out, our assailants were so transfixed that Glenn and I were able to slip away down a back alley.

As we ran away, Glenn suddenly flashed a switchblade out of his pocket and said, "I should have used this on them."

"What's that?" I asked, appalled.

"It's the knife my grandmother gave me before I left the house."

"Are you nuts? Those guys would've killed us."

This wasn't exactly the Boston I'd expected to find when our family moved to the area a few years earlier. The image my father painted for my brothers and me was that of a refined "city on a hill," the epitome of culture and higher learning that also coincidentally had some of the best sports teams in the country.

What appealed to Dad most about Boston, however, was its vibrant Irish culture. For a man who had the intense pride — and nagging inferiority complex — of many second-generation Irish Americans, Boston was a place he could call home. Unlike his native New Haven, Boston had a disproportionally large Irish-American population and a long tradition of charismatic politicians with names like Fitzgerald, Curley, and Kennedy. We had moved there from Hamden, a small suburb of New Haven, because Dad had been offered a good executive job in the post office. Nothing short of returning to the old sod in County Clare could have made him happier.

My mom had a good feeling about the Boston area as well, but for a different reason. Her father, who was of Scottish descent, had grown up in Thomaston, Maine, and had ancestors who had emigrated to Massachusetts from Cheshire, England, in the 1630s. Mom was intrigued with the idea of deepening her Yankee roots in the Land of the Bean and the Cod. In fact, she was so obsessed that during our first year in South Weymouth, we visited Plymouth Rock no fewer than twenty-five times. What fascinated her about the Puritans was not their charming fashion sense or their love affair with the turkey, but their glorification of moral rectitude. Mom, I'm convinced, was a Pilgrim at heart. That's why she became a second-grade teacher: to get students at a tender age and fill their heads with her Puritanical views of right and wrong before the dark forces of mass culture and raging hormones put them on the road to perdition.

As for me, I wasn't so sure. I loved Hamden and didn't want to leave. It was my little corner of paradise. Behind our house was a sprawling, mostly empty cemetery that my friends and I had transformed into our private playground. In one section we built a regulation baseball diamond complete with white-line base

paths and a makeshift outfield fence. In another section, marked by rolling hills and newly planted spruce trees, we played war games tricked out in camouflage uniforms and helmets.

The day our family left for Boston I was so upset I jumped out of the car, ran around the house screaming, and wrapped my arms around a tree in our front yard swearing never to move. Eventually my mother talked me back into the car. But I was bereft for days.

Massachusetts seemed like a foreign country to me. Everybody spoke with a funny accent and used the word "wicked" to describe everything from food to music to pretty girls. And the pizza tasted like glop compared to New Haven's divine Neapolitan-style *apizza*.

The main thing I couldn't understand was why everybody deified Ted Williams and the hapless Red Sox, who hadn't been in the World Series since 1946. To my eye, the Kid was a mean-spirited prima donna who was more interested in fine tuning his batting average than in winning games. He was a far cry from my hero, Jackie Robinson, who just two years earlier had led my team, the Brooklyn Dodgers, to its first World Series win.

It wasn't until I was in high school and got a chance to explore the city beyond the confines of Fenway Park and the Combat Zone that I began to understand why Oliver Wendell Holmes had dubbed Boston "the hub of the universe." My guide was my tenth-grade English teacher, Miss Toomey, who, for reasons that escaped me, had made it her life mission to turn me into a writer.

I had always dreamt of becoming a writer. When I was eight, I wrote what I called a novel about a star football player at my dad's alma mater, the University of Connecticut, who was mysteriously strangled with a stethoscope the night before the big game. That manuscript never made it into print, but a few years

later, when I was in the ninth grade, I published a story about my school football team's victory in the regional championships that gave me my first taste of the power of the printed word.

I'd originally written the story for the school paper, but when I handed it in, the faculty adviser, the terrifying Mrs. Driscoll, objected to my description of the school's poorly maintained field as "tattered" and told me she wasn't going to publish the story unless I changed it. In a rare act of defiance, I refused to let her tamper with my precious words and published the story myself using my mother's mimeograph machine. It was a huge hit. We sold hundreds of copies at five cents each, probably more because of my classmates' desire to see what Mrs. Driscoll had censored than the quality of my deathless prose.

Miss Toomey was more encouraging. She urged me to venture into poetry and fiction and raved about everything I wrote. On weekends she invited me to attend lectures and readings by famous authors. On one such trip, to Boston College, we heard the Irish writer Sean O'Faolain give a talk on the art of the short story. Afterward Miss Toomey took me backstage and had me show the great man some of my poems and stories.

I was mortified, but O'Faolain was extremely gracious and several weeks later sent me an encouraging note. He said he was moved by some of the visual imagery in the poems and added, "All I can say to you on the basis of this heterogeneous gathering of mss. is that you evidently have the itch good and strong, and here and there I lit on phrases that made me feel for those seconds that this man has somewhere a graphic gift." He advised me to avoid "luxuriating" in myself and look at the paintings of Goya, El Greco, and Rembrandt and say to myself, "This man is speaking to me through those visible signs, which I respond to, forgetting him. Can I as a writer do the same?"

My father was so excited when I showed him the letter that

he hid it in his bookshelf for safekeeping and soon forgot where he put it. Many years later I discovered the letter while leafing through his volume of Herodotus and was surprised to see how prescient O'Faolain had been. In the forty years since I'd met him, I'd devoted much of my time to trying to answer that very question.

Later that spring Miss Toomey enrolled me in a writing program for a select group of high school students at a small private school on Marlborough Street in the Back Bay. The teacher, Mr. R, was a Harvard grad and far more demanding than any other writing teacher I'd had. Like O'Faolain, he loved prose grounded in observed reality and abhorred grandiosity in any form. But it wasn't his wisdom that inspired me at first. It was the neighborhood.

I'd spent time in London and New York, but I'd never seen anything as elegant and graceful as the Back Bay. It took my breath away, walking through the flower-lined Public Garden, past the giant swan boats, and down Commonwealth Avenue, a broad boulevard modeled after the Champs-Élysées and dressed with row after row of Victorian-style brick mansions. At the corner of Commonwealth and Arlington, I peeked into the windows of the *Atlantic Monthly* offices and saw a group of editors in Ivy League tweed lounging in book-lined rooms, reading manuscripts and, I presumed, arguing about the fine points of punctuation. I could live that life, I thought.

The creation of the Back Bay was a key turning point in the cultural history of Boston. In the early nineteenth century the city was essentially a small island connected to the mainland by a long, narrow causeway surrounded by the Charles River on one side and the Boston Harbor on the other. In the 1820s a dam was

built on the Charles, but it didn't work very well, and by the late 1840s the tidal flats were regularly backed up with sewage. The town leaders worried that having a polluted eyesore on the edge of the wealthiest neighborhood, Beacon Hill, plus the growing influx of poor Irish immigrants into an already overcrowded city, would force the Protestant elite — the Boston Brahmins — to flee to the suburbs and take their capital, business expertise, and devotion to culture with them.

After the Civil War the city began filling in the tidal flats and creating a beautifully designed neighborhood that historian Lewis Mumford called "the outstanding achievement in American urban planning for the nineteenth century." The project not only doubled the inhabitable size of the city, it also produced a district that was prestigious and stylish enough to persuade a large contingent of Brahmins to stay in town. The Back Bay's wide tree-lined streets, orderly rectangular layout, and vast green spaces made the neighborhood feel less chaotic than the tangled mess of converted cow paths that made up the rest of the city. But what really appealed to the Brahmin set was that the Public Garden and Boston Common separated the neighborhood from the crowded, noisy districts where the teeming masses of Irish immigrants lived.

The Back Bay project allowed Boston, unlike many other American cities, to retain most of its wealthiest families. And those families had played a major role in giving birth to the nation, abolishing slavery, and turning the city into a paragon of intellectual and cultural refinement. Many of the institutions that Boston is best known for — the Museum of Fine Arts, Massachusetts Institute of Technology, Harvard Medical School — got their start in the Back Bay, financed largely by the wealthy families living nearby.

But the emergence of the Back Bay also helped preserve a rigid social hierarchy that was difficult for Irish Americans and other ethnic groups to penetrate. Toward the turn of the nineteenth century, the late-generation Brahmins, many of whom lacked the social consciousness of their elders, began to mimic some of the worst qualities of the British aristocracy. In the meantime, the new wave of Irish Americans, who were better educated and less diffident than their forebears, began to grow in prominence, in large part because of their political savvy and their drive to beat the Brahmins at their own game.

By the early 1960s, the neighborhood had changed considerably. The Depression had forced a number of families to sell off grand mansions, and many of the buildings had been divided into apartments for college students. Nevertheless, as a young man from a working-class suburb, I was dazzled by the neighborhood's upper-class veneer. This was a world that intrigued me, on one level, because it was so foreign and, on another, because it was so familiar. The clash of cultures between the Irish and the Yankees that had played itself out in these streets over the past century was easy for me to understand: it was the story of my own family.

That spring, the Back Bay was my learning laboratory. After class on Saturday mornings, I would wander around the neighborhood and the adjacent locales, soaking up as much culture as I could. I spent hours in the public library reading books I couldn't get in my hometown. I loved sitting in front of Monet's haystack paintings at the MFA, now in the Fens, or listening to chamber music in the courtyard of the Isabella Stewart Gardner Museum. Most of the time, though, I would just stroll around the Back Bay, marveling at the architecture and trying to imagine what was going on behind those stately walls.

At the end of the semester, I handed in my term project: a comic short story about my crazy family. Mr. R loved it and told me privately that it was one of the best stories he'd read all year. "You've got real potential," he said. "Don't waste it."

My head was spinning. I walked on air over to the Public Garden and sat beneath my favorite oak tree contemplating what lay ahead. It was one thing for Miss Toomey to praise my work, but quite another to hear it from Mr. R, the sophisticated Harvard man who didn't hand out compliments gratuitously.

That day, under the big oak, my future was sealed.

Over the next few years I got caught up in my life in Weymouth and only occasionally made it into the city. But when I was a sophomore at Brown, I had another life-changing episode in the Back Bay. That summer a friend from MIT offered to let me use his fraternity room on Beacon Street while I was working as a freight handler at Logan Airport. My parents weren't thrilled with the idea, but I did it anyway, even though it meant losing access to the family car. How could I turn down having a place in the city where I could be my own man?

Sadly, it didn't work out that way.

On my first day, I lost my key to the frat house and nobody answered the door when I arrived late at night after work. So I went around back, somehow found a ladder, and started climbing into a window. At which point I looked up and saw the barrel of a twelve-gauge shotgun staring me in the face.

I had to talk fast. The owner was an angry upperclassman who had woken up and pulled out his gun thinking that I might be the rapist who had been terrorizing the neighborhood for the past few weeks. When I gave him my friend's name, he lowered his shotgun and let me in. But after that flubbed entrance, he and

his frat mates treated me like a pariah. Which was fine with me, because their idea of fun was watching corny old sci-fi movies. Their favorite was *The Thing*.

That weekend, I had scheduled a date with my college girl-friend, Ginger, who lived in one of the city's tonier suburbs. But as I was preparing to leave, I got a puzzling phone message from her saying she wouldn't be able to make it. She didn't return my calls, and a few days later I received a strange letter from her telling me that she wanted to call it quits. The letter was so vague and convoluted I figured she must have written it under pressure from her mother, who didn't much like me.

Ginger's mom was an unabashed snob. She claimed to be a direct descendant of Sir Francis Drake and had dedicated an entire room in her house to pictures of the *Golden Hinde* and other mementos of her famous relative. (She didn't think it was funny when people — including me — pointed out that Drake was a slave trader and essentially a state-sponsored pirate.) To her, I was a threat on every level. Her worst fear was that if our love affair continued, Ginger might end up living in a garret with a penniless dreamer of dubious pedigree — namely, me. And apparently Ginger wasn't strong enough to stand up to her.

Frustrated by not being able to reach Ginger, I took a train to her house early one morning to see if I could talk to her in person. It was a desperate act. I'd worked a double shift the night before and hadn't gotten much sleep. To make matters worse, I'd foolishly decided to take along a giant pink piñata I'd bought for Ginger because I thought it might get a laugh.

It was barely dawn when I reached Ginger's house and plopped the piñata down on the front lawn. All the lights in the house were out, so I picked up a handful of pebbles and tossed them against what I thought was her window. Suddenly her mother

appeared at the front door, dressed in her bathrobe and slippers and with a cold glare in her eyes.

"What are you doing here?" she said.

"I want to talk to Ginger," I replied.

"What's this?" she asked, pointing at the piñata.

"It's a gift."

"That's nice, but she's not here right now. I'll let her know you came by."

I knew she was lying, but I couldn't see anyone else stirring in the house.

"How did you get here?" she asked.

"I took the train."

"Get in the car. I'll give you a ride back to the station."

"No, thanks. I think I'll just sit here and wait."

"No, you won't." Her voice turned hard. "Get in the car."

The ride back to the station lasted forever. When we finally reached the parking lot, Ginger's mom put her hand on my arm and told me a story about this guy she was madly in love with in high school whom she decided not to marry because it would have hurt her parents. She talked about how glad she was now that she had made that decision, because it was the sensible thing to do. I didn't buy it. The whole time she was telling me this story her eyes were rimmed with sadness.

"You'll thank me for this someday," she said as I opened the door to leave. "You've got your whole life in front of you."

On the train ride into town, all I could think about was how disastrous my latest adventure in the Back Bay had turned out. I was no longer the fresh-faced high school boy searching for inspiration. I was playing a different game now with much higher stakes. And the days when I could slide by posing as a starry-eyed romantic were quickly coming to an end.

The next day, I left the fraternity and returned home for the rest of the summer. During my final week on the job, my boss gave me a free flight to the San Francisco Bay Area, and I stayed in a funky hotel in Berkeley where everyone seemed to be stoned all day long. It was the summer after the Summer of Love, and I was smitten. A couple of years later, after I graduated from college, I strapped on a backpack and headed west. I'd grown weary of the East Coast, with its rigid stratified society and its outdated, puritanical style of life.

I was looking for something new to capture my imagination. Along the way, I realized much later, I discovered the life Ginger's mom was talking about.

Medora Goes to the Game

George Plimpton

LAST FALL, THINKING of it as a kind of Christmas present given in advance, I offered to take my nine-year-old daughter, Medora, to her first Harvard-Yale football game. Actually, it was a selfish idea — an excuse to see my alma mater play against the Yalies — and, as I expected, her enthusiasm was guarded. She has other ideas about Christmas. She has seen *The Black Stallion* six or seven times, and a horse, steaming in the winter air out on the lawn, is what she hopes to see through her window when she awakens on Christmas morning. It was easy to tell the Harvard-Yale game wasn't even on her "list." She looked at me gravely through the gray-green eyes she has inherited from her mother and asked, "What is it?"

"It's a football game," I explained, "so important that it's called The Game. There is no other The Game. A Yale coach named Ted Coy once told his players before The Game that they would never do anything quite as important in their lives as what they would

be doing that afternoon." I went on to say that Percy Haughton, the Harvard coach from 1908 to 1916, had tried to get his players pepped up before The Game by hauling a bulldog, the Yale symbol, into the locker room and actually strangling the animal.

"He did what? Killed a dog?" Medora's eyes blazed. I had made a bad error.

I explained that it was just a legend. "He never actually did that," I said. "He couldn't. A bulldog hasn't got a neck." I went on to say that what Haughton had done was ride around Cambridge dragging a papier-mâché bulldog from the rear bumper of his car. That was how the legend had started.

Medora wasn't placated in the least. "That's even grosser," she said, "pulling a dog around from the back of a car!"

"More gross," I corrected her, and tried hurriedly to explain that papier-mâché — a word she had apparently not heard in her young life — wasn't the name of a bulldog breed, as she suspected, but meant that the dog was fake.

I assumed that was the end of things. The Harvard-Yale game as a Christmas present was out. But the night before The Game, just after her supper, Medora appeared at my study door and announced, "I'm ready. I've packed."

I was delighted. I retrieved the two tickets I was planning to give away, and early the next morning we took the shuttle to Boston. The plane was crowded — many aboard, judging from the heavy coats and the predominance of blue and red in their attire, were on their way to The Game. Medora and I sat together. She was wearing a yellow jumpsuit, but the rest of her outfit, somewhat to my dismay, was blue — the Yale color. Her woolen hat was blue, and so were her parka, scarf, socks, shoulder bag, and sneakers. "My favorite color is blue," she said simply.

It worried me. I had ulterior motives (besides the chance to see The Game) in taking Medora to Cambridge. My vague hope

was that she would become impressed enough with Harvard to think about working hard at her studies so she might go there one day. I knew it wasn't important where she went as long as she approved of the choice herself. But I hoped it wasn't going to be Yale. After all, it would be one thing to sit in the stands and root for her as she performed for the Smith College field hockey team, or the Rutgers gymnastics squad, or whatever, but to think of her across the football field joyfully waving a blue pennant and yelling "Bow-wow-wow!" with the Yale team poised on the Harvard goal line, while I raise a feeble "Hold 'em!" across the way, is a possibility too intolerable to consider.

"I should tell you something," Medora was saying beside me in the plane. She pointed to a tall blue feather a man a few seats in front of us sported from his hatband. It had a white Y on it. "There's my favorite letter." When I asked her why, she said it was because the yacht club where she is learning to sail has a blue pennant with a Y in the center and she likes to see it snapping in the wind from the bow of the club launch.

"What's wrong with an H?" I asked.

"Well, it looks like a house with two chimneys that are too tall," she said as she produced a note pad from her shoulder bag and with her brown hair brushing the paper, as she bent to her work, fashioned an H. She finished it with some squiggles of smoke emerging from both chimneys.

"See?"

"Yes," I said.

Her interest in yachting is another vague worry. Medora spends her summers on the water. Her lips are pale from the salt. Her yellow slicker lies discarded on the lawn when she comes home exhausted; retrieved, it is flung over a shoulder as she heads for Gardiners Bay the next morning. I keep hoping she'll spend more time on the tennis court. She can hit a tennis ball

with authority, although she seems slightly hesitant about how the game is scored. Surely that will come. I see myself, like John McEnroe's father, peering out from under a white tennis hat, arms folded on the balustrade overlooking some exotic court, in Monte Carlo, say, and watching Medora move to the net under a high, kicking serve to Pam Shriver's backhand.

Medora was looking out the plane window. I interrupted her reverie. "When we get to Cambridge, would you mind if I bought you a Harvard hat?" I asked her. "We're going to be sitting among a lot of Harvards and there'll be confusion with all this blue you're wearing."

She nodded vaguely. She had some things she wanted to show me from her shoulder bag. She produced a four-page handwritten "newspaper." "Sherman Reddy and I are the editors," she told me. The front page dealt with the November election. CARTER IS DEFEATED the headline read in my daughter's recognizable penmanship. The subhead announced RAGEN WON THE ELECTION BY FAR. The news story was brief. It read: "Carter worked very hard but he was defeated. In 1981 Ragen will be Presedent. Let us hope he is good." Underneath this story was a poll on whether Ragen would be good. He got one yes and one no — the two editors apparently being not only the pollsters but also the sole respondents as well. I asked Medora, who was the only girl in her class to "vote" for Carter, what was wrong with President Reagan. "He laughs too much. He thinks everything is funny," she said. The rest of the paper was made up of "advertisements," most of them for restaurants. (Dining out tonight? Have a fish . . .) There was one recently added story: MEDORA TO SEE THE GAM.

"It has an *e* on the end of it," I said.

She brought out her pencil to make the correction.

"Perhaps you could do an extra on the Harvard-Yale game,"

I suggested as Medora returned the newspaper to the bag. She said she would discuss it with her coeditor.

She had brought along some good-luck tokens she showed me — a stuffed koala bear in a miniature straw basket suspended by a ribbon from her neck. The bear was nestled on crumpled-up pieces of Kleenex — "to make him comfortable," Medora said. She took him out to show him to me, revolving him solemnly between thumb and forefinger before returning him to the basket. "I hope he's the right one," she said. "I have another one, which looks exactly the same, who is bad luck."

"How do you tell them apart?" I asked.

"If I have really bad luck," she explained, "I know I've got the wrong one with me."

"Perhaps you could throw that one away," I suggested.

"It's better not to," she replied. "In case the other is really bad luck."

She then showed me an ivory whistle made of two intertwined fish. She said if the Yale players heard it they would, as she put it, "shrivel."

The day in Boston was brilliant and cold; the wind ruffled the surface of the Charles as we drove beside it in a taxi from the airport. I said that in the spring the crews came out on the river. "Eight men in a line, one rowing behind the other. The boats they row in are as thin as pencils," I said, trying to be graphic. "They're called shells." Medora tried to look suave at this explanation. What an enormous amount of odd pursuits there were in the world, I thought, and how difficult it was to make sense of them to a nine-year-old. We saw a number of sights that required my saying something about them: the scrum of a rugby game on the lawn of the Harvard Business School; the tailgaters along the banks of the river — "drinking cocktails out of the back of their

cars" was how I tried to describe it; the gay activist contingents chanting at the gates of Soldiers Field; the first raccoon coats she had ever seen.

We got out at Harvard Square. I had time before the game to show her part of the college. We wandered along the walks. I tried to think what would give her a sense of the history and the character of the university and yet would be interesting to someone infatuated with horses and sailboats. As we walked through the gates into Harvard Yard I said that I remembered that the Boylston Professor of Rhetoric was by tradition allowed to graze a cow in the Yard, though no holder of that position had been known to avail himself of the privilege. Professors rarely came with cows. Medora seemed especially interested. Was it possible to graze a horse in the Yard? she wished to know. "And what about birds?" she asked. "If I go to Harvard will I be able to bring Tiffany?" Tiffany is her parakeet. My heart jumped at her mention of the college. I said I was sure it could he arranged.

We started for Harvard Stadium. I bought her a wool Harvard cap and a large red BEAT YALE button. She exchanged the red hat for the blue one she had been wearing, but she dropped the button into her shoulder bag. I shrugged. Perhaps it was too big for her tastes. Outside the stadium I bought a Harvard banner and a game program.

We found our seats and Medora almost immediately came down with an acute case of the hiccups. "Am I going to hiccup for the entire game?" she asked me.

"I don't know," I replied. "What do you think?"

She said she wasn't sure.

As the teams came out onto the field I opened up the program to see who was who and discovered I had been gulled by a vendor into buying a *Harvard Lampoon* parody of the official program. The lead story was about a headless Yale player — Aemon

Bonderchuk: "the horrible freak who hopes to lead the Elis to victory"— and, sure enough, there were some photographs doctored so that it indeed looked as if Yale had a headless player. According to the story, Carmen Cozza, the Yale coach, had been asked about him: "Aemon? Sure. Nice boy. Good hands. Big heart. No head."

I showed a picture of Bonderchuk to Medora. "Look at this. Yale has somebody out there with no head."

"How awful," she said. "Was it a Harvard person who did that to him?"

After a while she said that she thought seeing the headless player in the program had startled away her hiccups. "I'm cured," she said. She gave a sigh of relief and looked out on the field.

"Does Yale have its bulldog over there?" she asked, squinting toward the opposite sideline. When I said I thought so, she asked what the Harvard mascot was.

"A Puritan."

"What's a Puritan?" Medora asked.

"He's a man with knee britches and a tall conical hat with a buckle on it. People like him founded Harvard."

As I brooded in the stands it occurred to me that there seemed to be so much more that Yale had to offer an impressionable young girl. Their songs were better. The bulldog, while hardly a comfy sort of animal, was infinitely more pleasant to have around than a Puritan, and he enabled the Yale songs to have catchy lines like "Bow-wow-wow." Why couldn't Cole Porter (Yale '13), who had written so many of those gems while an undergraduate, have gone to Harvard? Why had Leonard Bernstein (Harvard '39) waited until *West Side Story* before doing his best? The Yale band was playing one of Cole Porter's most memorable tunes, "March on Down the Field," and I realized with a start that I was singing along, my lips moving involuntarily.

It didn't turn out to be much of a day for Harvard. The wind, which remained brisk and into which yellow biplanes towing advertising messages above the stadium barely made headway, played havoc with the football — especially, it seemed to me, when Brian Buckley, the left-handed Harvard quarterback, tried to pass or when the Crimson's kicker, Steve Flach, went back to punt. On the whole, the brand of football was spotty, as symbolized by a play midway in the game when Flach, back to punt, took a snap that skittered along the ground like a dog running for him, leaping at the last second for his chest and bouncing off. By the time Flach had the ball under control, the Yale line was on him. He took a feeble swipe at the ball — the kind an elderly aunt might aim at a terrier nipping at her feet — and missed it.

The Yale middle guard, Kevin Czinger, picked up the ball and started for the goal line. There wasn't a Harvard man within yards. A number of Yale men raced up to join Czinger, and it was while this pack of players was running unencumbered by anything more serious than a scrap of windblown paper scuttling across the field that Czinger suddenly went down as if he had run into a trip wire, apparently having stumbled over the heels of one of his teammates. A gasp went up in the stadium — not really of dismay from Yale fans or of relief from Harvard rooters, but at the realization, I think, that because the game was being telecast throughout the East, this dreadful pratfall was being beamed into any number of places — bars in Hoboken, New Jersey, or Erie, Pennsylvania, perhaps — where people were quite likely scornful of Ivy League football to begin with and where now, peering up at the TV screen at the end of the bar, they saw a Yale player, racing for the Harvard goal line with a football under his arm, surrounded by his fellows, suddenly stumble and collapse as if poleaxed. And they would never know that after the

game it would be discovered that Czinger, far from having been tripped, had torn a back muscle.

The enormity of this, of course, was lost on Medora. I kept an eye on her. Every once in a while I caught her staring at the field in deep thought, lost in some internal consideration. Sometimes her lips moved slightly — a recitation of some sort — and when she caught me looking at her, she would start and smile quickly, her eyes sparkling. Once she said, "Gee, Dad, that's great!" though I hadn't said anything to elicit such a remark. She had her mind on something.

"What do you think of it?" I asked.

"I think my hiccups are coming back," she said, but she seemed to offer it as an afterthought rather than what was really on her mind.

I had spent much of the first half attempting to explain the meaning of "third down and ten." My father has always said that there are two things that women, however brilliant, fail with great charm to understand: one is the International Date Line, the other is third and ten. "Ask Lillian Hellman about third and ten," he once said abruptly at lunch. "See what you get." I never did that, but Medora certainly did nothing to suggest my father's theory was in error. "I like it better when they kick," she said. "Why can't they kick all the time? My friend at school told me that they have sixty footballs for each game. They keep them in sacks."

Could she have been thinking of baseballs? I said, "That seems like an awful lot of footballs."

"Oh, no," she said positively. "You wait and see."

In the middle of the second quarter Medora said that she really liked the blue Y's on the Yale helmets. She announced it with a faint sigh, as if she had been making comparisons and

had come to a decision. As I brooded over this disaffection, I was reminded that Alex Karras, the great Detroit Lions defensive tackle, had once told me that at the end of his illustrious career he had discovered his children were all Los Angeles Rams fans. They liked the way the horns curled up the side of the Rams' helmets. "To think," Alex said sorrowfully, "that I went out and slaved in the trenches all those Sundays to send my kids through school, getting my thumbs bent back so that I went like this in pain, 'AIEEE!' while all the time the kids were rooting for these guys across the line because they had nice-looking logos on their helmets, designed by some interior decorator in Pasadena."

The wind didn't let up. Before the half, Yale scored, and then again just after the third quarter began. Medora and I didn't see the second score. We spent the third quarter standing in line for a hot dog. The facilities at Harvard Stadium are notorious. The restrooms were described in the game-program parody as being "located under sections 6, 7 and 31 of the Loeb Drama Center on Brattle Street." It went on to call the stadium itself "the oldest standing concrete structure in the United States since the collapse of a similar arena 16 years ago. In its present condition, the Stadium is capable of supporting virtually 2,000 people."

When we got back to our seats, Medora discovered that she had lost her good-luck koala bear. Apparently it had tumbled out of its tiny wicker basket. She didn't seem especially put out by its loss. "It was probably the bad-luck bear anyway," she said. She reached in her bag and produced the backup charm — the intertwined ivory fish — and in the hubbub around us I heard the faint whistle that was supposed to make the Yale players shrivel.

Medora's mittens had disappeared, too. I felt her shivering. She curled into the sheepskin coat I was wearing. I took her bare hands and rubbed them. On one of her thumbs I noticed a face

she had drawn with a ballpoint pen; the back of her hand was decorated with a button with the word PUSH above it.

"What's this?"

She was embarrassed. "A push button," she said.

"What happens when you push it?"

She shrugged. "It starts engines and things," she said. She was still trembling.

I suggested, "Start up the heaters. Your mother will think I'm trying to kill you out here. Jiggle your feet. Then push the button for Harvard. They're not doing very well."

"Are they losing?" she asked.

"I'm afraid so."

"How much longer will it take them to lose?"

"About ten minutes," I said. "When you see the white handkerchiefs come out on the Yale side, then you'll know."

I tried to entertain her. We watched individual players to see what happened to them when the ball was snapped. I took another crack at third and ten. I told her about the pigeon that had caught the attention of the huge crowd one year — a pigeon that had settled down a yard or so from the goal line. A number of people in the stands noticed that in pecking here and there in the grass, the pigeon seemed to go right to the brink of the goal line and then back away, as if forced to do so by some psychic power. The stands took sides. Megaphones were raised. Cries began to go up, "Go, bird, go!" erupting from the far side and "Hold that pigeon!" from the Harvard supporters. At the opposite end of the stadium the football players toiled on in what must have seemed a bewildering maelstrom of sound — standing in the huddle as a crescendo of pleading would give way to shouts of triumph as the pigeon, unbeknownst to the players, had turned toward or away from the goal line. Medora wanted to know if the pigeon had crossed the goal line. I said I couldn't remember.

Medora began making a paper airplane from a page torn from the *Lampoon* parody. "I'm going to fly this down to the field with a message on it," she said. With her hands trembling from the cold she laboriously wrote a sentence across the inner folds of the airplane; after creasing it and preparing it for flight, she wrote OPEN, OPEN along its length to indicate it should be read by whoever picked it up.

"What did you say in it?" I asked.

She spread the airplane apart. The message read: YALE STINKS. RIGHT?

How odd, I thought, as she showed it to me, that she should add that demure "right?"

She refolded it and asked me to throw it for her. She wanted it to reach the Yale huddle. So I tried to do it for her, half standing and attempting to sail it into the wind. The airplane stalled and crashed into the hat brim of a man two rows down from us and fell off into his lap. He turned and could see from my expression, and the fact that my arm was still extended, that I was the one who had thrown the paper airplane. He looked, from the glimpse I had of him, like a professor or perhaps a Harvard overseer. He opened the airplane and read the message. He didn't look at me again. From the heavy set of his shoulders, I sensed that he was gloomily reflecting on an educational system that had produced a grown man capable of setting down such an infantile thought and in such execrable handwriting. I kept hoping he would turn around again and catch sight of Medora, who was giggling into the folds of my sheepskin coat.

From our side of the field the Harvard undergraduates began a melancholy chant of "We're number two! We're number two!" Across the way the handkerchiefs began to flutter in the Yale stands. Medora said she felt sorry for the Harvard team. I won-

dered vaguely if it was healthy to decide to go to a college because you felt sorry for its football team.

The game ended. The spectators in the Yale stands counted down the last seconds and the gun went off. I took Medora down to the field so we could hear the Harvard band and see what the field was like after it had been kicked up by the players' cleats, and I eased her up to a Harvard player standing with his parents so she could see how large he was. A faint odor of liniment and grass drifted off him. She peered at the eyeblack above his cheekbones as if she were inspecting a painting. He must have felt embarrassed under her scrutiny. He turned away. I heard him say to one of his group, "Thank God Priscilla didn't come. You say she's up at Dartmouth. What's she doing up there?"

Medora asked about his eyes. I told her that athletes often wore eyeblack to cut down the sun's glare. She said it made them look neat, like Indians. Did the Yale players wear the stuff too? Oh yes, I said. She announced that she thought she might wear it out on her Sunfish — the glare was just terrific off the water.

We slowly headed out of the stadium, Medora holding my hand. I commented to her that at times during the game she had seemed distracted. Was something on her mind? Had she had a good time?

"Oh, Dad, it was great," she said. "I liked the story about the pigeon. I wish you could remember if he went across the goal line."

We crossed the Anderson Bridge and walked up Boylston Street past the Houses. I pointed out the windows of the Eliot House room where I had lived. Someone had hung a hastily lettered sheet out the row of windows below. SO WHAT IF YOU WON, the message read. YOU STILL GO TO YALE.

"Six U.S. presidents went to Harvard," I found myself saying to

Medora as we strolled along. "William Howard Taft was the only one to come out of Yale, if you don't count Gerald Ford, who went to the law school there, and Taft was such an enormously fat man that they had to enlarge the doors of the White House to get his bathtub inside. Did I tell you that Harvard was founded one hundred and forty years before the Declaration of Independence?"

"Yes, Dad, you did."

I took her to some postgame parties. We went to the *Lampoon* building, where in the crowded Gothic hall I pointed to a suit of Japanese armor hanging on the wall and told her I had worn it in a curious baseball game against the *Harvard Crimson*, the undergraduate newspaper. The *Lampoon* was famous for its high jinks. A couple of years after I'd left, the editors had plotted to steal a battleship out of Boston Harbor. "They only had men on the board then," I told Medora. "Now they accept women. You could be the editor. You could plot to steal a battleship." I twirled the ice in my drink. It was my third. She stood, a diminutive form beside me, in the crush of the cocktail party. An undergraduate editor of the *Lampoon* turned up. I told him that I had admired the game-program parody; I had been reminded that we had done one like it when I was an undergraduate. In fact, I could remember editing an article entitled "Why Harvard Will Not Go to the Rose Bowl This Year," one of the reasons being, as I recalled, that California was "in some kind of time zone."

The undergraduate looked at me gravely over his plastic glass. "Fun-nee," he said without a smile.

It was dark when we left. We walked past Lowell House. I pointed up to the belfry. I told her the bells would be pealing if Harvard had won. They made a wonderful racket. In fact, the bells were something of a neighborhood nuisance because they were so loud; the person playing them sometimes got mixed up so that it sounded as if the bells were tumbling down a rock slide.

The Cambridge citizens complained. In fact, they threatened to shut down the bells. I told Medora that in revenge the great Lowell House legend was that all the people who lived there synchronized their watches and simultaneously flushed every toilet in the place.

"Why did they do that?" Medora asked.

"It apparently puts a terrific strain on the plumbing system," I said. "Floods things all over town. So it was a kind of weapon. It was to tell the Cambridge citizens and the college administration not to fool around with their bells."

"I would like to have heard them," Medora suddenly said.

I thought she was referring to the Lowell House plumbing, but it turned out to be the bells. "I wish Harvard had won," she said wistfully, "so that you could stand here and listen to them."

Impossible to tell about Medora. Didn't she want to listen to them too?

Not long after our trip, I wandered into her room when she wasn't there. Tiffany, her parakeet, was scrabbling around in its cage. Her room has always been an irresistible place to visit from time to time to see what is new in there—to check on the detritus of her complicated schoolgirl life. A "secret" note from a school chum pinned up on the cork bulletin board. What she has dropped into her fish tank lately. The newest of the mice figurines she has added to a fearsome array on a shelf.

On her desk was a draft of a newspaper that she was apparently putting together as a Christmas present. Green holly leaves were pasted at each corner. The headline read YALE BEATS HARVARD BY FAR, the subhead, SCORE IS 14–0 YALE ON FREEZING DAY. Involuntarily, I glanced back over my shoulder, to make certain I wouldn't be caught prying in her room, and then turned back to read: "Harvard fans had little to cheer about yesterday as Yale handkerchiefs fluttered in the air. There was lots of cheering

coming from the Yale stands. Harvard players slipped too much on the grass. At the end of the game the two gold posts were torn down by Yale fans. The Harvard fans went off to partys to drown their sorrows."

A pile of photographs from newspaper sports sections were waiting to be pasted in. I recognized Earl Campbell of the Houston Oilers in one of the pictures, vaulting into a dense pile of tacklers, the distinction of what team Campbell actually played on being of little significance to the young editor. I couldn't resist browsing through the paper. On the second page was a large advertisement for cats, illustrated with a dozen silhouette studies of cats with their tails hanging down, as though the cats were sitting on an imaginary shelf. Medora does a great many of these studies.

What caught my eye was a story on the same page under a large headline (with a line through the second word, the spelling of which had apparently stumped her): BLACK HORSE BUYED. The text, again with a number of words crossed out, read as follows: "The black horse arrived in a truck shortly after nightfall. It was dark outside. His name was [Abraham Lincoln Tom, Blueboy] Prince!" I suspected I knew then what those thoughtful silences I had detected on that chilly November afternoon were all about — not about whether she was going to hiccup or whether a pigeon had crossed a goal line or even whether she preferred Harvard, or Yale, or even Princeton. Names were under consideration, but not the names of colleges.

A small story caught my eye on the last page of the paper. The headline read HARVARD NOT DISCORAGED.

The story underneath, in its entirety, read: "Harvard is not discoraged."

The Everything Bagel

Leslie Epstein

I MOVED TO BOSTON thirty years ago from the Upper West Side of Manhattan and for many years I thought of New York every day, the way one thinks of a distant lover. Impossible, on Broadway, to walk a block without seeing something, or someone, interesting, invigorating, threatening; on one's toes, thus, one feels altogether more alive. By contrast, I've seen about six such things in my decades in Boston and Brookline, half of them involving dead animals. Until just the other day, it's been a snooze through existence. And yet, over time, one arranges a life for oneself and with luck falls in love with that too. Here, more or less randomly, more or less from the top of my head, is what I have been able to piece together and what, should I have to leave *this* city, I would undoubtedly miss with a great deal of my heart:

First things first: The everything bagels from Iggy's. My tennis matches at the BU Rec Center, though not when my Russian partner skims a drop shot a half inch over the net. *Bol'shoe spas-*

ibo! The double row of sycamores on Parkman Street. The drives to Mohegan Sun or Rockingham to play poker with Ernie and Bernie and Marty. The photograph of Uncle Julie hanging above the rattan chaise at the Casablanca in Cambridge. What? The Casablanca has just closed? Will Sari, its owner, miss me? Up until recently, all my representatives in Washington, particularly Ted Kennedy, who as senator had probably saved and enhanced more lives than all but two or three presidents. But Barney Frank and John Kerry too, both of whom have gone on to other things. Tommy Heinsohn. The brisket sandwich at Rubin's. The cabbage soup at Rubin's. The number 16 and the number 21 pizzas at Otto's. Anything at all at Oleana. The fact that the hundreds of thousands of students in Boston remain forever apple-cheeked as I turn increasingly gray. Eugene Goodheart. The other gentlemen in all three of my poker games whose lives I have considerably enriched. Ha Jin. Angell Memorial Hospital, for more than once putting Jasmine back on all four of her feet and then so humanely ending the one life that canines get. Would that we treated each other that way! Elizabeth Warren. Jim Carroll's columns in the *Boston Globe,* and Dan Wasserman's cartoons: to each my personal Pulitzer Prize. Walking down Newbury Street to see the Joseph Solman shows at the Mercury Gallery and the Joe Ablow shows at Pucker. What? The Mercury has moved to Rockport? And Joe Ablow is no longer with us? Oh yes he is, just go to the Pucker and see. Strolling down Beacon Street to Fenway — sometimes stopping at the wonderful Busy Bee — to take in a game with my son Paul from my other son's box. What? Certain things have changed? Very well, if I have to, I shall walk all the way to Wrigley. The music, Ravel, Debussy, et al., on 95.3, WHRB. Shem, aka Steven Bergman. John Silber, now gone, who one moment roared, "We're not turning BU into a love nest!" and the next made sure that a worthy student at Brookline High

got into the university after all. The drunken Gehry buildings at MIT. Room to Grow. The little plastic trucks and shovels that the town of Brookline deposits in the sandbox at Minot Park, for what my granddaughter, Annika, thinks is her exclusive use. The coffee candies, wrapped in gold and brown, at Trader Joe's. Ditto their individually wrapped pieces of cooked chicken breasts. One minute in the microwave, served with cold coleslaw. And their Hahn Cabernet or the — cheap! — Mission Point Pinot Noir. The fact that in an hour and a half in one direction one can be at Crystal Lake in Orleans and that in an hour and a half in another direction one can be at Barnacle Billy's in Maine. No-fat frozen yogurt at J.P. Licks. The dog biscuits at the counter of the Brookline Booksmith (Jasmine used to say). Little Brothers–Friends of the Elderly. My bike route: Beacon, past the Weston Golf Course, back on Commonwealth — nineteen huff-and-puff miles. How you can stand at the corner of Huntington and Gainsborough and hear more of those apple-cheeked youngsters practicing the oboe and singing their scales. Peter Gammons. Caroline, my assistant. The shy look of the men when they come into the Studio. Putting my feet up on the front-row mezzanine rail at the Coolidge Corner Theatre. Paul's bald head glistening as he runs down Beacon Street in the marathon. My own jogs five and a half times around the Brookline Reservoir (equaling five miles, half walking, half running, in exactly an hour) or down Memorial Drive: the river, the sails, the golden dome, and above all the Hancock Building changing shape, dieting, turning into a silver sliver, a wisp, vanished, gone!

Wounded, Boston's Heart
Remains Strong

Bud Collins

IT WAS NOT supposed to happen this way.

The Boston Marathon, one of the world's greatest sporting occasions, the granddaddy of footraces, dating to 1897 with an entry field of fifteen, has always been a joyful celebration of Patriots' Day. Who could imagine that Everyman's Sporting Jubilee would end in flames, death, and terror?

In an instant everything changed. A holiday became a horror of screams, bloodshed, and panic. A sunny, clear blue sky was immediately transformed into a smoky curtain over Boylston Street as bombs exploded amid a packed crowd of spectators. Sirens yowled. The festive atmosphere vanished; more than 260 wounded remained, many with missing limbs.

No, it wasn't supposed to happen this way. But it did. A never-to-be-forgotten explosion of warfare, a Boston street littered with bodies and frightening memories.

The attackers? Immigrant college students turned bombers. What went wrong? Two young men felt alienated from their adopted country, a society that had seemingly embraced and nourished them.

Why?

Boston is a pleasant place to go to college, loaded with students of all kinds. I was once one of them, pursuing a degree in journalism that led to the sports departments of the *Herald,* the *Globe,* and various TV stations around the world. I was fortunate to work under Tom Winship, the man who raised the *Boston Globe* to international prominence.

The marathon was frequently on my assignment list, usually a lot of fun as hundreds of struggling athletes of all varieties fought the twenty-six-mile course over hill and dale. I was the voice on WGBH for the first telecasts of the Boston Marathon in 1979 (entry field of 7,927) and the New York Marathon in 1980.

In those days, it was strictly and traditionally a men-only competition, until the historic breakthrough in 1967 by the camouflaged coed from Syracuse University, a bundled-up K. Switzer, number 261 on the entry form. Huddled by a revolutionary contingent of guys, the gritty Switzer, a Joan of Arc in running shoes, sneaked into the pack — soon to become a feminist heroine.

Of course she was caught. The marathon's administrators were stunned, sensing that their boys' party might be slipping away.

It was a terrific story and a break for feminists, as Kathrine dodged a would-be evictor: Mr. Marathon, Jock Semple, yelled furiously at her, "Get out of my race!" Jock fumed but was inevitably charmed by Switzer. Soon after, women were allowed to compete as equals.

That race was a sad blip in the marathon's history but served

to open it up to all comers. The Boston Marathon now attracts more than twenty thousand runners and over half a million spectators.

Kathrine Switzer later became a voice of the marathon as a TV commentator, the pioneer; we often worked together. In 1980, a runner we didn't recognize, finishing strongly, was the first to cross the finish line. I announced her the victor: Rosie Ruiz of New York. A bit off the money as it turned out. "Who's Rosie Ruiz?" runners kept asking. A genuine upset?

The faker was soon found out. Her best strategy had been to travel the trolley for most of the way, hopping off near the leaders. After a controversy and an investigation, she was disqualified, leaving the legitimate winner, a Canadian, Jacqueline Gareau, with the title.

Boston has changed and changed again in my years here.

But Patriots' Day, with the 11:05 a.m. Red Sox game and the marathon, has always been a one-day harbinger of spring, until 2013. That men raised in the area could so blithely commit such evil, bombing innocent people at the finish line of the marathon, is still incomprehensible to me.

I keep trying to understand.

When I first arrived in 1955, I saw history at every step: the Boston Common, the Old North Church of Paul Revere fame, Beacon Hill, Fenway Park, Symphony Hall, the dilapidated Boston Garden, and Harvard Yard, where so many students began their own journeys to fame and fortune.

There was a streak of racism in those days, which hurt the city. It was recognized but difficult to overcome. It didn't help that the public school system was lacking. The Red Sox and Bruins were about the only games in town when I arrived. The Celtics were

struggling, still years away from the dynasty they became with their record seventeen championships. The Patriots were not yet born; the team was established in 1959, and I covered the games.

The college sporting scene was more important than the professional teams. Harvard went back to the beginning of time; everything Harvard did was of importance. Harvard-Yale was simply The Game. Boston College, a stronger power but without Harvard's following, battled its main rival, Holy Cross.

Prep schools dotted the landscape and were written about religiously in the papers.

Julia Child started at WGBH at the same time I did, the early 1960s. She turned people on to good cooking, eliminating the need to go to Paris for fine food. I turned them on to tennis, a career in TV babbling that often took me to Paris and tennis courts around the world.

My first beat in Boston, however, was boxing. It is, in my opinion, the best sport to write about, because nobody can libel you. It was, in those days, full of Runyonesque characters.

Sam Silverman, a boxing promoter, was one such character. He got tired of going to BU's journalism school, where Professor Max Axelrod told him that one needs "to be actual and factual." Sam's guiding principle was "Don't spoil a good story with the facts."

Sam lied to me, frequently feeding me incorrect information. Nevertheless, he was amusing and sharp, and I liked him.

Silverman's house was once bombed by a disgruntled fight manager who disagreed with Sam about something. When the police arrived, they asked Sam who might want to bomb his house. He replied, "Don't be silly, it was a defective refrigerator that blew up."

Silverman's explosive was from a displeased colleague. I could

not have imagined that sixty years later, Boston would be the target of a terrorist plot — terrorists who attacked a worldwide sporting event and a city so crucial to America's origins and identity.

Another ongoing assignment of mine was covering the Red Sox. During the first World Series game that I covered, in 1963, between the Yankees and the Dodgers, in New York City, I was at a postgame dinner in the press room.

The Red Sox general manager, Mike Higgins, began circling the table where I was sitting with a group of managers. Suddenly my face was being pushed into my plate of beef stroganoff. I guess Mike Higgins did not care for my literary criticism of his management techniques.

In 1968, I was covering The Game and decided to sit for the first half on the Harvard bench and for the second half on the Yale bench. Harvard was being thumped in the first half and most of the second. In the final forty-two seconds, Harvard scored a thrilling, unfathomable sixteen points, prompting a headline in the *Harvard Crimson:* HARVARD WINS 29–29.

Boston is internationally known as a center of higher learning and medicine. In Greater Boston there are more than one hundred universities and colleges. Young people annually stream into the city from all over the world, including Chechnya, a country that remains obscure to many Americans.

Immigrant families also stream into Boston looking for a better life. How is it possible that the Tsarnaev family went astray? That, after all their years of living in the United States, the Tsarnaev brothers wanted to kill us? It does not make any sense.

In the course of its history, Boston has overcome numerous traumas: the Boston Tea Party, the Boston Massacre during the Revolution, the Battle of Bunker Hill, the Siege of Boston, the

blood of the Civil War and slavery, the great Boston fire of 1872, the Cocoanut Grove fire, the divisive upheaval of segregation and school busing in the 1970s.

The Boston Marathon bombing will never go away. In a city of enormous heart, it has become one of Boston's heartaches.

So You Want to Be in Pictures

Nell Scovell

A KID GROWING UP in Beantown who dreams of making it in Tinseltown has a lot of distance to cover. Geographically, Boston and Los Angeles are about as far apart as you can get and still remain in the continental United States. The cultural gap is even wider. Boston gave birth to John Adams the Founding Father. Hollywood gave birth to *John Adams* the miniseries. Boston has the Freedom Trail, which includes the graves of three signers of the Declaration of Independence. Hollywood has the Walk of Fame, which includes a star for the Three Stooges. Boston was built on the backs of stoics. Hollywood was built on the backs of starlets.

Recently, many Bostonians have managed to bridge the divide. Ben Affleck, Matt Damon, and Mark Wahlberg have become three of our biggest movie stars and two of our finest actors. Maura Tierney, Denis Leary, Conan O'Brien, John Kra-

sinski, and Mindy Kaling are just a handful of Boston-raised talent dominating in TV. But there weren't always role models.

Growing up in Boston in the sixties and seventies, you had to work hard to find a connection to show business. And when you did, it was tenuous — like when my grandmother called to tell me that Leonard Nimoy had just visited his parents, who lived in the same elderly Jewish housing in Brighton. Don't get me wrong: *Star Trek* was my favorite show, and hearing this was one of the most thrilling moments of my childhood. But as brushes with fame go, it was pretty tangential. (Full disclosure: my real crush was on Chekov, played by Walter Koenig. If Koenig had ever beamed down in the Cleveland Circle area, I would have died.)

I never thought about going into the entertainment industry. Boston has produced more than its fair share of statesmen, lawyers, and doctors, so when someone asked what I wanted to be when I grew up, I'd offer this safe and acceptable New England answer: "I like to argue, so my parents always tell me I should be a lawyer." You know who else likes to argue? People who work in television. But I didn't know that at the time.

Then, in 1972, Hollywood came to me. I was in seventh grade when I met my first movie star. It was not a chance encounter at the Chestnut Hill Mall but a planned segment for a short-lived WGBH educational show called *Earth Lab*. The producers had selected a girl (me) and a boy (long forgotten) to visit the set of *Fuzz*, a movie that was shooting at Boston Harbor and starred Burt Reynolds, Tom Skerritt, and one of the most beautiful women in the world.

Most people have never heard of *Fuzz*, and if they have, it's often for a disturbing reason. In the movie, the villain douses homeless people with gasoline and sets them on fire. Soon af-

ter the movie was shown, this disturbing act of violence was repeated in a horrific copycat crime that led to a Dorchester woman's death. And the list of uncomfortable parallels with real life has grown more recently. An Internet log line describes *Fuzz*'s plot: "Police in Boston search for a mad bomber trying to extort money from the city."

Still, the film held nothing but promise when I was whisked off to the set. It was way past my bedtime as we waited for a break in the schedule so we could meet one of the actors. Time ticked by and I stared into the harbor waters, watching the lights dance on the surface. There were no smartphones then, so we did what we could to amuse ourselves. Staring at the reflecting light was like checking your e-mail from the cosmos. Suddenly, one of *Earth Lab*'s producers grabbed me.

"It's time," the producer said, and hustled me from that dark spot toward the set.

I blinked my eyes to adjust to the production lights. And then, from behind those bright lights, she appeared — a vision with the big hair and big teeth of a true 1970s sex symbol. She flashed the most dazzling smile I have ever seen in my life.

"Hey, sweetie," Raquel Welch purred at me.

I was twelve years old, bespectacled, and gawky as all get-out, and though I can't recall how I responded, a flash of braces and a snort is a good bet. I don't remember much more except that initial greeting. *Earth Lab* shot some footage of us all chatting. We asked some questions and then Ms. Welch headed back to work, and I headed back to reality.

And the fact is, my reality had nothing to do with show business. We were practical people. Or so I thought. Years later, I learned that motion pictures had been instrumental in bringing my family over from the old country. My great-great-uncle Nathan H. Gordon had emigrated from Vilna, then part of Rus-

sia, in 1890 and opened penny arcades across New England. In 1906, he opened the first motion picture theater in Worcester, Massachusetts. Business boomed. (What else is there to do in Worcester?) Eventually, Uncle Nate became the largest operator in the area of vaudeville and movie theaters, including the Metropolitan in Boston (now the Wang Center).

Luckily, Uncle Nate was as generous as he was successful. He sent for his relatives, including his sister's son, Louis, who landed near Plymouth Rock around 1915. But instead of going to work for his uncle and giving me a shot at nepotism, my grandfather Louis decided to go into the shoe business. He worked hard, and once he was making a nice living, Louis married Rhoda Orentlicher and started a family. He could have lived anywhere, but he chose . . . Brockton.

And so, through no fault of his own, my father was born in Brockton. And my mother, through no fault of her own, was born in Fall River. Their paths crossed in Virginia, where my dad was stationed in the army and my mom was studying at William and Mary. In spite of their bad-ass birthplaces, they made homes in more refined towns like Brookline and Belmont. In 1963, they settled their growing family into a four-story brick Tudor in Waban, a village in the city of Newton and the third-to-last stop on the Green Line. Forget *Forty-five Minutes from Broadway;* this was twenty-four minutes to Fenway.

Now the Red Sox, Bruins, and Celtics, all achieved world domination (or *near* world domination — still painful for me to admit) during my childhood. One winning season melted into the next and I faithfully kept the TV tuned to the UHF dial. Those channels were my lifeline, not just for sports but on Saturday mornings when my three sisters and I would pile onto the couch to watch Shirley Temple movies on Channel 56.

We were mesmerized as Shirley sang, danced, and dim-

pled her way through every situation you could dream of. She charmed everyone in an orphanage (*Curly Top*), in the Swiss Alps (*Heidi*), on a plantation (*The Littlest Rebel*), and, for some reason, in a lighthouse (*Captain January*). Shirley made show business seem effortless and fun, and she always got to be in the center of the action. As the middle of five kids, I craved that sort of attention. I wanted to be like Shirley Temple — *but how?*

I decided to start with the basics and begged my mother to find a place that offered tap-dancing lessons. She said she would check. A week later, I asked again and she told me there were none. That made sense. Tap dancing was frivolous, and no one in Newton would want to devote their time to such a ridiculous endeavor.

Except they did. I discovered years later that the Women's Club, less than a mile from our home, offered tap. And I learned this from my mother, who, twenty years later, in a laughing confession, explained that it was the only time she had ever lied to me. And she did it to protect me. I was such a klutz — or, to use the parlance of my youth, "such a total fuckin' spaz"— that she thought it was better to spare the family both the cost and the embarrassment. I couldn't really be upset by her revelation. She had a point. Unlike my sister Alice, who took ballet, I was not graceful or even mildly coordinated. But you know what I was good at? Sitting and watching movies.

As I outgrew Shirley Temple, I discovered the afternoon movie musicals, the Marx Brothers, and late-night horror films. I still remember staying up late with my brother Ted to watch *The Omega Man* and freaking out when Lisa removed her scarf. The annual WGBH auction was also must-see TV. One year, my eldest sister, Julie, was answering phones when someone asked if she would model a handbag. We were watching at home when Julie sauntered out. We screamed with delight. Our sister was on

TV! We barely noticed that she had walked out with another girl who was much taller and they were told to stand back to back — which emphasized how much taller the other girl was. Mostly I remember Julie had the biggest smile. She was through the looking glass.

Another auction highlight occurred in 1970 when my parents bid on — and won — a cheap plastic phonograph (look it up, kids) that became instantly priceless when paired with a signed Mr. Rogers album cover. My sister Claire still has the cover, which reads, in fading blue pen, "For the Scovells, With gratitude, from Misterogers [*sic*]."

Mr. Rogers raises another important point: back in those days, Boston was a mecca of children's programming. Bozo the Clown and Captain Kangaroo both produced their programs in the area. I appeared on *Captain Kangaroo* when I was too young to remember, but Bozo eluded me. Bozo was big-time. And it truly blew my mind when I discovered that Bozo was Frank Avruch, the debonair host of *The Great Entertainment*. (Years later, I went to high school with Steve Avruch, Frank's son. I didn't know him well, but my sense was that there were both joys and sorrows associated with being the son of a clown.)

At this point, my understanding of entertainment was focused on performance. I had no concept of the behind-the-scenes aspects that someone growing up in Los Angeles or New York City might have. So no one was more excited when my elementary school English teacher Jeffrey Weisenfreund decided to put on a production of Gilbert and Sullivan's light opera *The Mikado*. It was madness to think fifth-graders could pull off that sort of sophistication. But it was just crazy enough that it actually worked.

I was a proud founding member of the Angier School Savoyards. I had hoped for a singing role but wound up in the chorus. The show was a success, and the next year, Mr. Weisenfreund

decided to put on *Iolanthe* with the fifth- and sixth-graders. I worked hard on my audition, hoping to grab a moment in the spotlight. I was a year older. A year more talented . . .

I was cast in the chorus again.

If only my mom had gotten me those tap-dancing lessons! I still yearned to be front and center like Shirley. So when a call went out to all area schools that they were looking for local kids to audition for a new children's program, I told my parents to sign me up.

It was 1972 and the show was called *Zoom*. And if you just sang "Zee-double-oh-em" in your head, you know what I'm talking about. For the less enlightened, *Zoom* was a variety show performed entirely by kids who ranged in age from nine to fourteen. For the audition, I'd been asked to prepare a song and a monologue. I chose a song that worked well in my (extremely limited) range and memorized a funny routine. They called us up to the big empty stage one by one. And suddenly I felt like I was exactly where I belonged. All those years of watching musicals and the Marx Brothers had prepared me for this moment.

I belted out my song. I was a total ham.

I got a goddamn callback.

And not just one callback, but several. I made it to the final cut, where the producers narrowed it down to twelve kids and told us they would choose seven. Not bad odds, except for one problem: the final audition consisted of the musical director teaching us a song-and-dance routine to test how quickly we could pick it up.

The chosen song was the jaunty "Rise and Shine," which begins, "The Lord said to Noah, 'There's gonna be a floody, floody.'" I could learn lyrics easily — thanks, Gilbert and Sullivan — but the tune was not really in my range. And the dance routine? I was OK when I was asked to plant my feet and pump my body up and down, but when we had to actually *move* . . .

And then they added clapping. It's right there, written into the song.

> *The animals, they came on, they came on by twosies,*
> *twosies.*
> *The animals, they came on, they came on by twosies,*
> *twosies.*
> *Elephants and* (clap once) *kangaroosies, roosies.*
> *Children of the Lord.*

That threw me. Nobody told me there'd be clapping. I mean, dancing *and* singing *and* clapping? It really was too much. I tried to hide behind others, to stand next to strong singers in hopes that their voices would drown out mine, to smile and power my way through with personality and enthusiasm. But at the same time, even I started to think that it might be better if they didn't select me.

Those who remember that premiere season of *Zoom* know there was a Nina. And there was a Nancy. But there was no Nell. Tommy, Joe, Jon, and, Kenny also made the cut. They all got to star in a breakthrough TV show. And what did I get?

I got to be on *Earth Lab* and tape a segment about moviemaking. That set visit was my consolation prize for getting cut from *Zoom* in the final round. So meeting Raquel Welch was less my introduction to show business and more my swan song. It was time to hang up my never-even-purchased tap shoes.

As for *Zoom*, the show was a massive hit, and I honestly watched it with joy and relief rather than bitterness. I do admit there was some small comfort years later when I heard that a certain female cast member had ended up with a nasty drug habit. Although completely unsubstantiated, I repeated that rumor often — and did it again just now. Meanwhile, I focused on

my studies, graduated from Newton South High School, and enrolled in a "small liberal arts college" just up the Charles.

At college, I jettisoned the notion of becoming a lawyer or a doctor and chose another Boston-approved profession: sportswriter. By my senior year, I was happily tapping away on a keyboard and covering schoolboy sports for the *Boston Globe*. Journalism seemed to suit me since it involved a lot of sitting. I moved to New York, where I was hired as the first staff writer at *Spy* magazine and later branched out to write for *Vanity Fair*, *Vogue*, and *Rolling Stone*. My Hollywood dream was long forgotten.

Then, in the late eighties, I bumped into a former editor on the street who made an observation that changed my life. She didn't intend it to. We were just catching up when she made this offhand comment: "Nell, I don't mean this as an insult, but I really think you could write for television."

Write for TV? Write for TV? Who wrote for TV? Well, people must. Except I had never thought about it. And yet once this editor mentioned it, I couldn't think about anything else. Within months, I had sold my first spec script. Within three years, I had moved from the Atlantic to the Pacific to write, produce, and direct TV.

That was over twenty-five years ago. And it's been nice living on the West Coast. I used to complain about the lack of seasons, and then one spring day when I was visiting D.C., everyone kept remarking on the gorgeousness of the weather — low seventies, slight breeze. And that's when it hit me: it's like that every day in Santa Monica. It's paradise. But it ain't Boston.

My roots remain in Boston. My dad lives in Cambridge and a sister lives in Wayland. My mother is buried in Waltham. My four grandparents — Frances and Rubin Cohn and Louis and Rhoda Scovell — are buried in Dedham. I'm biased, but I don't

think there's a better place to grow up. And while it didn't propel me into the entertainment world, I found my way.

And my Boston roots did help me once when I really needed it. In 1998, I was in Vancouver to direct my first film, a Showtime cable movie about a washed-up child actress who has to go to high school for the first time. (Definite shades of Shirley Temple in the plot.) Now, I'd been warned that there are three things that Canadian crews don't like: American directors, first-time directors, and female directors. I was a triple threat.

I prepared as best I could, but it was a rough first two days as I struggled to get the crew to follow my lead. They'd been hired by the director of photography and they kept looking to him for guidance. It was a frustrating situation that I had no idea how to fix. I couldn't stop being any of the three things they didn't like. The third day of shooting, it started to rain. We shot for as long as we could before seeking shelter, and by chance I ended up standing under a small tarp with Harvey, our A-camera operator. It was just the two of us, and so, forced to make small talk, I asked him where he was from.

"Parry Sound," he answered.

"Oh, Bobby Orr's hometown," I replied instinctively.

Harvey looked startled. He turned to me and, for the first time, looked me in the eye.

"How'd you know that?"

"I'm from Boston. I grew up watching the Bruins."

"I don't believe it," he said.

And although it was just an expression of surprise, I decided to make a true believer of him. I started rattling off from memory the team of my youth: Bobby Orr, Phil Esposito, Johnny Bucyk, Wayne Cashman, Ken Hodge, Gerry Cheevers, John McKenzie, Derek Sanderson. When I got to Dallas Smith, Harvey had heard enough. He broke into a smile. And I gave him a big smile back.

From that moment on, everything changed on the set. Harvey became my biggest supporter and made sure I got what I wanted before we left a scene. From that one exchange, he knew I wasn't some Hollywood dipshit (another word from my youth). I was a Boston girl and I knew my Bruins. And that, as Robert Frost would say, made all the difference.

America's Brain

Israel Horovitz

A<small>S A LITTLE</small> kid growing up in Wakefield, Massachusetts, Boston was where my parents took my sister and me for Chinese food and Red Sox games. Nothing else. At age eleven, however, Boston played a life-defining role for me, with two defining events.

Life Defining Event #1. I was younger than most kids in my grade by two years. Thus, when I was in sixth grade, at age eleven, most other boys were thirteen. Thus, I tended to follow more than lead.

On one particular day, I skipped school and followed a half-dozen older boys from my class to the train from Wakefield to Boston. The train conductor questioned us, and Dave, the oldest of the group, told him we were on a class outing and he was the student leader. Our goal, according to Dave, was the science museum. The conductor bought in.

In fact our goal was the Old Howard, a burlesque house in

Scollay Square, which had once been a legitimate theater featuring stars the likes of John Wilkes Booth. By the time of my visit, in 1950, burlesque stars the likes of Ann Corio, Sally Rand, Sophie Tucker, and Gypsy Rose Lee had bared (mostly) all on the Old Howard's stage.

The particular day of my particular visit brought a stripper named Valkyra (The Amazon Queen) to the spotlight. Not to be confused with the modern-day video-game star Valkyrie, Queen of the Amazon, Valkyra (The Amazon Queen) was, in my memory, a fiftyish, ginger-haired, pituitary-mammary gland freak, with a body I could only compare to the bodies of my sixth-grade classmates at the H. M. Warren School, or the body of my sister Shirley clad in circa 1950 gym bloomers. Valkyra (The Amazon Queen) was a definite eye-opener. But not life-defining.

A few days before my Valkyra (The Amazon Queen) sighting, I had been given reading glasses, prescribed by my parents' optician friend Paul Kline. Dr. Kline had written *Horovitz 33 Elm St Wakefield Mass.* on a sticker inside the eyeglass case. Since I had no intention of ever wearing eyeglasses, I neither took the eyeglasses from their case nor took the eyeglass case from my pocket. Nor did I realize that the eyeglass case had fallen from my pocket, presumably during the excitement of Valkyra's bumps and grinds.

Three days later, a letter arrived at my family's home from the manager of the Old Howard Theatre. "Dear Mr. Horovitz, Your eyeglasses have been found by our usher. If you would kindly . . ."

My mother screamed at my bewildered father. "A man your age!" My father not only swore that he'd never in his life been to the Old Howard, but also produced his one and only pair of eyeglasses, in their proper case.

And, within the same millisecond, my parents realized . . .

When I came home from school that day, my mother was still

teary-eyed. My father dragged me into his office, a leather belt in his hand, slamming the door behind us.

"Did you go to the Old Howard? Don't lie to me!"

"I did."

"Did you go alone?"

"No, I went with Richie and Buzzy and Dave and some other kids."

"And you lost your glasses?"

"I guess so."

And then my father said something life-defining: "Yell 'Ow!' when I smack the sofa." And he smacked the leather belt against the sofa three times and I yelled "Ow!" three times, until my mother screamed from the next room.

"Enough, Julie, enough!"

And my father yelled, "One for good luck!"

Smack!

"Ow!"

"You'll never do that again?"

Smack!

"Never!"

My father then opened the door and I ran past my mother, head down, sobbing, up the stairs and into my bedroom.

Legend has it that in 1953, the Boston Vice Squad secretly filmed a performance by Irma the Body and used the footage as evidence of gross indecency, resulting in the closing down of the Old Howard forever.

Life Defining Event #2. Somebody gave my father three tickets to a performance of Lorraine Hansberry's *A Raisin in the Sun,* in its pre-Broadway tryout in Boston.

My sister had to study for exams. I got to go.

Watching Hansberry's play, about a black family living on the

South Side of Chicago, I realized that plays could take their audiences to places of privilege. I thought, "How would I ever see inside the house of a black family on the South Side of Chicago if this play wasn't taking me there?" And it was in that moment that I realized there was something called a playwright.

At the end of the play, when the actors were taking their bows, I looked at the family onstage, looked at my own family, and thought, "I don't want to go home with my family, I want to go home with that family."

Within days of seeing *A Raisin in the Sun,* I began to write my own play, with a devilishly clever title, *The Comeback.* Eventually the play was put on at Emerson College in Boston, where the director Paul Benedict was teaching acting. It was a father-son play. I played the son, Peter MacLean played my father.

Nobody said it was a good play, but several friends said, "It's a play."

So, there it was. I had written a play. I was a playwright.

Nearly fifty years later, I'm still writing plays, with as much, if not more, excitement than back in my Boston days.

For me, Boston will always be a place of discovery, a place of great intelligence, a place of unquestioned freedom. Young people come to Boston by the hundreds of thousands each year, not just to study but to discover who they are . . . and who they will be.

Boston is where the spirit of America was born. It is America's intellect. America's brain.

In the Long Run

Shira Springer

I T WAS FOOLISH and foolhardy; every downed tree, every icy stretch of pavement, every ten-foot-tall snowbank said so. But I didn't listen. Less than twenty-four hours removed from a February blizzard, a travel-banning, two-foot snow dump, I ran toward the Charles River. Slip-sliding, slush-puddle-jumping along. I didn't care about news anchors urging extreme caution if venturing onto local roads. Runners do foolish and foolhardy quite well, maybe better in Boston, where winter weather provides ample opportunity. New England stoicism helps, too. On blustery, cold days when the mostly flat topography around the Charles turns both banks into wind tunnels, some runners wear T-shirts and shorts. (Not me. I don't have some frostbite fantasy.)

Mercifully, this was not one of those days. The strongest winds came and went with the storm, leaving behind occasional gusts that barely stirred the powdery top layer of snow piles. I worked my way up and down the piles, ducked beneath bent branches.

Sinking ankle-, knee-, sometimes waist-deep into the snow. Trudging more than running. I wanted an escape from the indoors, from endless updates about snow totals and power outages, from the banality that took away the postblizzard beauty.

Several strides past the Boston University boathouse, I tried to trace the path that dips down to the water's edge. Spotting cross-country-ski tracks and snowshoe prints, I used them as guides. On my right, the Charles appeared in perfect panorama beneath the Boston skyline. In warmer seasons, wedding parties and tourists pose on the path for photographs, capturing the river, the golden-domed statehouse on Beacon Hill, the famed Citgo sign by Fenway Park, the Prudential Building and John Hancock Tower in one frame. Now, surveying the storm-altered scene, I saw an aesthetic more abstract than postcard. Nearest the shore, the Charles had been transformed into a swirl of snow-dusted, yellow-gray ice. A ribbon of dark blue water peeked through and flowed in the middle, creating a natural Rothko. The blanketed landscape looked familiar and foreign all at once, the way old furniture does in a new home. I recognized landmarks, shapes, outlines, but not the geometry. The snow, the fuzzy white-gray all around, blurred where the riverbank ended and the river began. And everything seemed separated by more distance than I remembered.

For twenty years, I've run along the banks of the Charles and across its bridges. I've cycled down its bike path and kayaked against its gentle current. I've driven around the sharp Storrow Drive curves that follow the river's whims. But mostly I've run, logging somewhere close to forty thousand miles. The Charles is a reassuring constant, a relatively uncomplicated stretch of land and water amid a confused and confusing cityscape famous for one-way streets and rotaries. On the Charles, I'm always seeing the city anew, a participant-observer in the front row for free.

(Full disclosure: sometimes I'm a distracted runner, tripping and falling and getting a closer view of the river and riverbank than I want. I've done every embarrassing tumble possible — the full-out face-plant, the slow-motion topple, the skidding stop on my stomach. I'm always skinning knees and elbows.)

I know what the Charles looks like at sunrise when college rowers crowd the water; and under a full moon when tango dancers fill the Weeks Footbridge for monthly, summertime milongas, where pot smokers frequent and homeless men stash belongings; and when sea breezes spread salty air upriver and Red Line trains create deafening echoes beneath the Longfellow Bridge. The Charles reflects the city. Its tallest buildings mirrored in the water on all but the cloudiest and coldest days. Its passions visible in the Red Sox, Patriots, Celtics, and Bruins logos on the hats, jerseys, and jackets of people I pass; at Hatch Memorial Shell concerts and charity walks; in volunteer cleanup crews and on docked boats, sizable pleasure craft with names like *Summer Affair* and *Viva la Vida* and *Priority Too* and *No Rush III*.

Some of those same boats are cocooned in white, weatherproof covers during the winter, hibernating along the Cambridge side of the river in the shadow of the Museum of Science. After the blizzard, they appear neatly tucked in, teasing almost unimaginable changes in the seasons and scenery. And maybe this is what I like best about the Charles: the way it changes, sometimes reinvents itself, season by season, year by year, decade by decade. It has been made different by all the activity it hosts, the constant comings and goings. In a city saturated with history and historic institutions, it is the rare landmark without any pretensions, always welcoming.

My parents told me it wasn't a tough call, not even debatable. I found that hard to believe. Who lets a newly licensed teenager

drive a carpool forty minutes to school? Who lets her battle morning rush-hour traffic on backed-up bridges over the Connecticut River? The answer, as it turned out, was the burdensome commute over the river.

Growing up outside Hartford, Connecticut, the waterway divided east from west, blue-collar suburbs from wealthier towns. My family lived "east of the river," a designation that spoke as much to geography as it did to psychology. To be east of the river meant to be disconnected, disadvantaged by location, separated from the cool kids and the tonier neighborhoods, relegated to urban-planning afterthought. Proof: until the mid-1980s, no direct highway connection existed between my hometown and the three bridges into Hartford. The capital stood ten miles away, but always felt ten times more distant. And not just because childhood exaggerates the scale of everything. It was the river as barrier, as broad-shouldered bully. The Connecticut wore down my parents and the parents of my classmates, at least enough that a sixteen-year-old commuting with three teenage passengers seemed sensible.

Six days a week (there were Saturday classes), I drove my mother's old, Smurf-blue Volvo station wagon over the Bulkeley Bridge, across the Connecticut, to high school. Every day brought a different chaos, narrow highway ramps always squeezing vehicles to and from the bridges. Every lane-switch on the Bulkeley turned into a near miss. And not a miss at all when headed home one night, but an absurd hit-and-run accident in bumper-to-bumper traffic. When I pulled over, full of bravado and naïveté, and got out of my car, the guilty party made for the last exit before the bridge. I ran after the large sedan, futilely chasing the car for a hundred yards down the highway shoulder. I came to despise the river, the river crossing, the constant combative nature of the Connecticut. And I couldn't escape it. I

attended a private school nicknamed "the Island," a proud nod to a sprawling campus situated at the confluence of the Connecticut and Farmington Rivers. More river-built boundaries and barriers.

But there was one redeeming quality of growing up east of the Connecticut. In a state with sports loyalties and cultural leanings split between Boston and New York City, my hometown fell well inside the gravitational pull of Boston.

There were summer day trips to Fenway Park and the Freedom Trail and winter day trips to the Museum of Science. And the Charles River was the hub of the Hub. Turning onto Storrow Drive and glimpsing the water, I knew my family's final destination waited around the next bend or two or three. I spent enough time in Boston to make childhood memories, but not enough to know much beyond its surface, Revolutionary history and Red Sox curse. I didn't know back then that the Charles was dangerously polluted, that its banks attracted muggers and rapists, that its bridges drew people determined to commit suicide.

Visiting Boston as a kid, I mythologized the city and the Charles, filling in factual gaps with youthful fantasy. The Museum of Science floated on the Charles and the longest home-run balls left Fenway Park and landed in the water. I half-observed, half-imagined a city beside a river that was completely opposite of what I knew. Where the Connecticut was wide and formidable and endlessly frustrating, the Charles was intimate, accessible, easily crossed, and, in a revelation, at ease with its urban surroundings. Bridges conveniently spread over the water like broad stripes. Some were spaced no more than one-quarter mile apart. Some eminently practical, like the steel-girdered Harvard Bridge. Some architecturally elaborate, like the arched Longfellow Bridge, also affectionately called the Salt-and-Pepper Bridge because its four central ornamental towers look like giant salt

and pepper shakers. The whimsical nickname and imagery stuck with me, as did the shock of subway trains moving across the Longfellow with car traffic. In my young mind, I saw the river I wanted, and it was the Charles.

More than a century ago, influential Boston leaders and landscape architects saw the river they wanted, too, and made it reality. They started with construction of the Charles River Dam, from 1903 to 1910, then created and enhanced the Esplanade. The ambitious projects turned a vast tidal expanse of salt marshes and mudflats, an area strewn with sewage at low tide, from an industrial and commercial corridor into a public attraction. The new, manmade topography tamed the waterway and brought the Cambridge and Boston riverbanks closer. It showed imagination and foresight about the river and its environment; it framed the Charles as an extension of the city. In the decades that followed, the riverscape expanded along with its role in Boston's life. The Hatch Shell brought classical music and a Fourth of July extravaganza complete with the "1812 Overture" and cannon fire; Community Boating brought sailing to the masses; Storrow Drive brought cars; the Dr. Paul Dudley White Bike Path brought outdoor enthusiasts of all kinds in bigger and bigger numbers.

Running along the Esplanade, not far from the TD Garden and Fenway Park, I sometimes see the Charles as a public stadium unlike any other. It is a grand, historic staging area for spectacles big and small. It is where the city gamely puts itself on display, reveals itself in the routine and the rare, sometimes in the most literal sense, with nearly naked sunbathers populating docks and grassier riverbanks. Outside Harvard Square a monastery overlooks the water, and I suspect nowhere else would monks and sunbathers awkwardly meet but on the Charles. Spring, summer,

and fall days, I watch the water traffic as I run, the college sailors steering precariously close to each other during team drills, the coxswains shouting commands at rowers, the novice kayakers paddling in circles, the fishermen in Bass Tracker boats hoping for a big catch, the tall vessels passing through the Craigie Drawbridge while I wait for it to close and reset the roadway.

The biggest annual boat crowd comes every October for the Head of the Charles Regatta, a weekend filled with crew races by day and bacchanalian exploits at night. (In high school, stories of the event, day and night, only added to my Boston mythmaking.) The regatta is the Charles at its most preppy, spectators either channeling, reimagining, or appropriating some perceived Boston Brahmin ideal. I go for the vendors selling kettle corn and sweet potato fries and for the chance to see Olympians compete. Not far upriver, beside the Community Rowing boathouse, on a half-dirt soccer field, players take weekend games seriously. I see it in slide tackles and hear it in how loudly they shout in Spanish or Portuguese as I pass by. Old Boston and new Boston almost meeting.

Most memorably, the Charles is where the city celebrates. Reveling in the Red Sox curse-breaking 2004 World Series win, fans overflowed the banks, climbed on bridge supports, and cannonballed into the river as the team paraded by in tour Duck Boats. Dirty water be damned.

The last of my college all-nighters ended on the Weeks Footbridge at dawn. Hours before graduation, I gathered there with around thirty classmates, most of us coming from various parties on campus. Fortified by a potent mix of alcohol and caffeine, energized and terrified by what awaited in the real world, the Charles was a friendly, familiar place. We came to watch the sunrise over the river, to take one final, glorious snapshot of college

life. Then we stood around, lingering in some strange, overtired limbo. We leaned over the water, sticking heads, torsos, and arms through the footbridge's slotted sidewall and peering into the murky depths below. It wasn't long before mischievous minds went to work. A small group stripped down and launched off the bridge. Most of us watched as one, then another, then another dropped into the river, falling maybe twenty feet. We cheered as they resurfaced and swam ashore.

Stepping off the footbridge, someone wondered whether our soaking-wet classmates should get tetanus shots. We'd heard about how industrial waste and untreated sewage once polluted the Charles and how the effects remained. It pierced the river mythology I'd created when younger, as did cross-country and track teammates who cautioned not to run along the river alone at night. Living on the Charles in college, I started to view it differently, with less innocence and more nuance. The river marked the passage of time, and the passage of time marked the river. The waterway evolved and adapted, settling into new rhythms each season. I ran along its banks almost daily, searching for its quirks and hidden charms. The Charles remained the river I wanted. But making real memories on the river, I learned nostalgia can be a more powerful draw than mythology.

The nostalgia comes on fall afternoons when local college cross-country teams take over the river. In a blur of school colors and ponytails, a dozen runners speed past at an impressive clip, staying close together and chatting about classes and popular culture and guys. At intersections, they briefly consider where they will turn around, the best bridge back to campus for mileage goals. On the move again, there is a subtle competition within the group, someone always, ever so slightly pushing the pace. I know, because I was one of those runners twenty years ago. Now, it's strange crossing paths with college cross-country

teams, running into my past. It's even stranger returning to the Charles with former teammates. We cover familiar routes, still sporting ponytails and striving for an impressive clip. But pace is dictated by how fast a Baby Jogger can be pushed over curbs and down uneven parts of the bike path. Inside the stroller, one former teammate's fourth child, an eight-month-old girl, sleeps. We take turns steering the stroller and talk about parenthood, politics, and travel. The conversation flows easily, despite a slight breathlessness as the pace quickens. The harder we push forward, the more the Charles takes us back.

I remember pushing forward after the blizzard, talking myself through the deepest snowdrifts. I crossed the Harvard Bridge and scanned the riverbanks for other runners as foolish and foolhardy as I was. I didn't see anyone, though by now the white-gray all around played tricks with my mind and my eyes. Sifting through river memories, I tried to recall a moment that would transport me, take me to a warmer, more hospitable day. Then I spotted movement coming from under the bridge. As I got closer, I recognized the herky-jerky motions of runners struggling for balance in the snow. Three runners followed each other, one after another after another, in a postblizzard version of a conga line. Soon I joined in the awkward run-dance. We didn't speak, focusing instead on each slippery step. I was in my own world, but felt the presence of the other runners keeping me upright and pulling me along. I sensed us connected by the Charles.

Messing With the Wrong City

Dennis Lehane

The Day After

When I was nine years old, at the height of the busing crisis in
1974, I drove with my parents and brother through South Boston
on our way to Dorchester, where we lived. On West Broadway
we got stuck in bumper-to-bumper traffic and crawled for a mile
through one of the more frightening mass gatherings I've ever
witnessed. Effigies of Judge W. Arthur Garrity and Senator Ed-
ward Kennedy and Mayor Kevin White were hung from street
lamps and set afire. The flames were reflected in the windows
of my father's Chevy, and I looked through them at the faces of
a mob so incensed it was medieval. Reason was not popular on
West Broadway that night. Nor was compassion or a desire to
debate our differences with nuance or a respect for complexity.
In the place of civil discourse, rage ruled.

I bring this up now, in the wake of a terrorist attack on the city
where I was born and from which I draw my creative fuel, for

two reasons: (1) Because that night was my *ur*-experience, if you will, with rage. I'd seen anger, of course, and I'd seen violence, too, but rage — beyond reason, beyond intellect, beyond conciliation — was a different beast. (2) When I speak of my love for this city, it will be understood that the love does not come filtered through a soft-focus lens. I'm fully aware of the sins that litter the Hub's rearview.

But I do love this city. I love its atrocious accent, its inferiority complex in terms of New York, its nut-job drivers, the insane logic of its street system. I get a perverse pleasure every time I take the T in the winter and the air conditioning is on in the subway car, or when I take it in the summer and the heat is blasting. Bostonians don't love easy things, they love hard things — blizzards, the bleachers in Fenway Park, a good brawl over a contested parking space. Two friends texted me the identical message yesterday: "They messed with the wrong city." This wasn't a macho sentiment. It wasn't "Bring it on" or a similarly insipid bit of posturing. The point wasn't how we were going to mass in the coffee shops of the South End to figure out how to retaliate. Law enforcement will take care of that, thank you. No, what a Bostonian means when he or she says "They messed with the wrong city" is "You don't think this changes anything, do you?"

Trust me, we won't be giving up any civil liberties to keep ourselves safe because of the marathon bombs. We won't cancel next year's race. We won't drive to New Hampshire and stockpile weapons. When the authorities find the weak and terminally maladjusted culprit or culprits, we'll roll our eyes at whatever backward ideology they embrace and move on with our lives.

A half hour after the attacks, I crossed the marathon route two miles west of the explosions to drop off my tax return at the post office. By this time I knew what had happened; the whole city did. Beacon Street was splattered with enough crushed Ga-

torade cups to give it the appearance of a poppy field. A lot of hugging was going on. People stared at their phones even though cell service was down. I passed a homeless woman on a bench. She asked, "Them demons been caught yet?" I said I didn't know. She said, "They will, they will." A few blocks later, I came upon a young woman in runner's clothing sitting on a lawn, weeping. I asked her if she was all right. She nodded. I asked if I could get her anything or do anything for her, and she shook her head.

I went home and tried to explain to my four-year-old daughter that the reason Mommy and Daddy were upset was because bad people had done some bad things. I'm not used to feeling so limited when it comes to expressing myself, but trying to explain an act of mass murder to a four-year-old rendered me as close to speechless as I can remember being. My daughter asked if the bad men were like the bad woman who hit her on the head with a suitcase last time we were on a plane and then didn't apologize. I assured her the bad men were worse, and my daughter asked if they would hit her on the head when she was on the street. I promised her they wouldn't, but really, what do I know? The bad men — strangers — wait to hit us on the head. Or remove our limbs. Or shake our conviction that the world should be a place where people live free of fear.

When the civilian bystanders to the attack ran toward the first blast to give aid to the victims, without a second thought for their own safety, the primary desire of the terrorists — to paralyze a populace with fear — was already thwarted.

The little man or men who did this will, I have faith, be arrested, jailed, and forgotten. Whatever hate movement they belong to will ultimately go the way of the anarchist assassination movements of the early twentieth century or the Symbionese Liberation Army of the 1970s. Those killed and maimed, starting with eight-year-old Martin Richard of my neighborhood,

Dorchester, and his injured sister and mother, will be remembered. The community will eulogize the dead and provide care and solace for the injured. And, no, we'll never forget. But what we'll cling tightest to is what the city was built on — resilience, respect, and an adoration for civility and intellect.

Boston took a punch on Monday — two of them, actually — that left it staggering for a bit. Flesh proved vulnerable, as flesh is wont to do, but the spirit merely trembled before recasting itself into something stronger than any bomb or rage.

Boston à la Carte

Susan Sheehan

MY MOTHER HAD decided that I would go to Wellesley
before my junior year of high school in New York City
had begun. It was one of the selective "Seven Sisters" schools; my
mother fancied elite places. Wellesley's advantage over Radcliffe,
she informed me, was that Radcliffe was "citified" and we lived in
a superior city. Wellesley, in contrast, "looks like a country club,"
my mother said approvingly when she, my stepfather, and I were
in New England and stopped by to inspect the campus one day
in 1953.

My parents drove me, my Smith-Corona portable, and my
trunk to Wellesley in the fall of 1954, took me into the town of
Wellesley (always referred to as "the Vil") to buy a bedspread,
curtains, a butterfly chair, and a scatter rug at Filene's, and left.
The twenty-four freshmen in my dorm made friends quickly
and went out on blind dates arranged by the sophomores in the
dorm, who were kind to us in many ways. We had a limited num-

ber of times we could stay out until 11:30 p.m. (once a week) and a still more limited number of times we could be abroad until 1 a.m. (a total of fifteen, first semester), so we kept count.

The catalogue offered a pleasing array of courses and set out a half-dozen "distribution requirements," which conjured up a Chinese menu of that era. Freshman English was the only first-year requirement. I opted for French Literature, Astronomy, Sociology and Anthropology, and History of Art 100. I would have classes six days a week: Saturday-morning classes were impossible for freshmen to avoid.

I was usually glad if an assignment took me out into what I began to consider the real world: everything beyond Wellesley's gates. It was fun to go into the Vil for a Sociology assignment to observe "Motorists' Behavior at a Stop Sign Located at a Cross-Traffic Intersection." Notebook in hand, I stood at the corner of the college bookstore and watched 75 motorists: 41 came to a full stop, 17 to a near stop, 11 slowed down slightly, and 6 continued at high speed. Then, per instructions, I selected "a well-defined norm operative in the community" and worked out "a procedure for observing four or five categories ranging from perfect conformance to disregard of the norm." I chose the number of dorm mates who were early, on time, slightly late, or very late to dinner. Not surprisingly, Wellesley students were in better conformance to the norm than the motorists. On my own I proffered another example. I counted the amount of drinking done at a suite at a Harvard house one Saturday evening. Three people abstained from any alcoholic beverage, 12 had one or two drinks, 47 had three or four drinks, and 8 had five or more drinks. My professor had the humor to scrawl in red at the bottom of the Dunster experiment: "How did you manage to get this data?"

I rejoiced when Thanksgiving came and I could go home to be with family and old friends, sleep in soft sheets (we rented

rough towels, a pillowcase, and one sheet per week from the college linen service, with the top sheet becoming the bottom sheet on weekly change-of-linen day), and eat good food. My mother never cooked, but a succession of housekeepers had been taught to prepare my grandmother's wonderful dishes from the Austro-Hungarian empire: Wiener schnitzel, veal goulash, and paprika chicken. Mystery meat was the centerpiece of most Wellesley dinners. Lunches featuring carrot and raisin salad were a cultural shock to me. Liver and Friday's fish were worse. I had sold clothes at a department store the summer before starting Wellesley, and waited on tables at Sun Valley during the three summers between college years, and from my earnings had enough money to pay for textbooks, and for welcome dinners with classmates on Fridays at Howard Johnson's in the Vil.

The Vil is still described on Wellesley's website as "tidy, safe, and sweet." The Vil was sweet on Friday evenings, but I was a city mouse, not a town or country mouse, and longed to be in Boston or Cambridge during my free time. Like all Wellesley students of our era, we were not permitted to have cars on campus until the last few weeks of senior year. Like many classmates, I lacked a Harvard beau with wheels. And like most of my friends, I didn't have the money to travel into Boston by cab: I was a prisoner of public transportation. Once, during freshman year, I had to go to the Busch-Reisinger Museum of Germanic Culture in Cambridge to research an Art History 100 paper, an excursion of over two hours each way, which included a bus to Newtonville, a walk to Watertown, and a trolley to Harvard Square. Radcliffe students went easily to the Brattle Theatre, Hasty Pudding productions, Harvard football games, museums, tryouts of Broadway plays, and surely had far more opportunities to imbibe at Dunster. I lamented Wellesley's farawayness, yet I never did apply to transfer to Radcliffe. In my generation, the primary reason to switch to

another college was to be where a fiancé was studying. A considerable number of classmates left Wellesley after a year or two and married before graduation. I remained there and graduated single. On graduation day I resolved to never again board a train in New York and disembark at Route 128, the somnolent stop nearest college. My rail destination in the future would be Boston's monumental and bustling South Station. That is perhaps the only resolution I have made in life that I have kept. In June 1958 I returned to Manhattan, soon took a job as a fact checker on a magazine, and became a writer for *The New Yorker* the following year.

I started out writing Talk of the Town stories and "casuals," as short, light pieces were called, before turning to long, serious pieces of nonfiction that became books. Staff writers were paid by the piece, so to supplement my capricious paychecks, I accepted assignments from other magazines with alacrity. In 1962, in order to write "The Tourist's New York" for *Holiday* magazine, I left my modest apartment on East Forty-eighth Street on a Wednesday and taxied to the Hotel Manhattan, at Forty-fourth Street and Eighth Avenue. I would diligently practice tourism in my own backyard. I spent a good part of Thursday on a Circle Line boat, sailing counterclockwise around Manhattan, charmed by the sights but not by the guide's gallimaufry of statistics, sales pitches, and wisecracks. On Friday's all-day bus tour of Manhattan I was subjected to a verbal drubbing from two prattling guides. Saturday evening, I endured a Gray Line tour of New York with fifty-three other night-lifers. The less written about the Latin Quarter, Sammy's Bowery Follies, and a deservedly obscure night spot in Brooklyn, the better. I was glad to return home on Sunday, having earned enough to pay the $105 monthly rent on my apartment for a year. I was cured of comprehensive sightseeing excursions. I would in the future travel to Boston/

Cambridge (I prefer to think of the two as one place) and other cities and see them à la carte.

I have had a couple of dozen reasons to go to Boston over the past half century. On a visit there in the 1970s to sign a book contract with Houghton Mifflin (my publisher back then), I spent an afternoon at Trinity Church, Henry Hobson Richardson's splendid Romanesque building with its John La Farge stained-glass windows, ventured out to Fenway Park to see my first Red Sox home game, and was treated by my editor to dinner at Locke-Ober, one of the city's oldest and costliest restaurants. From escargots to baked Alaska, by way of lobster and endive salad, Locke-Ober surpassed my expectations.

On a book publicity tour, also in the seventies, which had me scurrying from TV and radio studios to newspaper offices, I saw the Boston Celtics play, attended a performance of the Boston Symphony Orchestra, and had coffee at the Hayes-Bickford Cafeteria. By then I was married to a Harvard alumnus who spoke often of the hours he'd wasted with friends from the *Advocate*, the college's literary magazine, at "the Bick." Like Locke-Ober, the Hayes-Bickford has closed. As E. B. White eloquently put it in a foreword to his jewel box of a book, *Here Is New York*, when describing a hotel he had frequented a year earlier, "The Lafayette Hotel, mentioned in passing, has passed despite the mention."

After I chose to write the biography of Alfred A. Knopf, the publisher, I flew to Boston from our home in Washington, in April 1975, and crisscrossed Cambridge and Boston for four days, interviewing fourteen of AAK's authors, former employees, publisher friends, and historian friends, among them William L. Langer (with whom my husband had studied Ottoman history);

Frank Freidel; Henry Laughlin; Julia Child and her husband, Paul (in their kitchen); Louis Kronenberger; Walter Muir Whitehill and his wife, Jane (at the Boston Athenaeum); Wendy Beck (Samuel Eliot Morison's daughter); Dorothy Abbe (in the William Addison Dwiggins rooms at the Boston Public Library; David Donald and his wife, Hilda; and John Updike, then between marriages and living in a rented apartment on Beacon Street. I didn't record the weather in my diary, but Updike surely nailed it in his inscription to me of his first novel, *The Poorhouse Fair:* "in memory of a poorhousy kind of day."

I tend to remember weather only if it is unexpectedly dreadful, as it was on April 6, 1982. I had been in New York City from April 4 to 6, to appear on the *Today* show and several radio shows for a new book, when it started to snow prettily. Houghton Mifflin canceled the rest of the day's schedule and insisted I take the next train to Boston, where publicity events deemed more important had been booked for April 7. The train departed New York at 5:40 in the afternoon, but was delayed by frozen track switches along its northward way. At 1 a.m. it reached South Station, where there were no taxis. Snow-bootless, I half walked, half hitchhiked to the Parker House, where the previous night's guests, stranded there by the late-winter storm, had kept their rooms. I crashed on a sofa in the lobby at 3 a.m. The Boston part of this tour is a blur, with some of the day shows canceled by the deep snow and ice but the late-night shows airing on schedule. After peddling the book sleepily on one program called *Five Live All Night,* I returned to the Parker House at 3 a.m. and flew home to Washington, which had escaped the blizzard, a few hours later.

In December 1987, I contrived a brief trip to Boston with Brigitte Weeks, editor of the *Washington Post*'s Book World section. Brigitte and I were serving on the 1988 Pulitzer Prize general-

nonfiction jury with Edward O. Wilson, then Harvard's Baird Professor of Science and its curator in entomology. Professor Wilson was overwhelmed by academic duties and consented to having the jury convene in the Museum of Comparative Zoology. There, in addition to composing citations for the three books the Pulitzer rules permitted us to nominate, in alphabetical order, he graciously obliged us with a private lecture on the 368,419 formicid friends in his office (the number and the words are those of Ed Wilson, the country's premier insect man). I rarely venture to Boston without walking to the Museum of Fine Arts and the Isabella Stewart Gardner Museum, and did so on that occasion too. It was the last time I would see the latter museum before the 1990 theft of thirteen masterworks from the collection. The museum's empty frames give the Gardner a melancholy air.

I was frequently in Boston in the 1990s. An assignment to write about Kenneth Noland, the color field painter, took me to an off-limits area of the Fogg Museum (where two Nolands were in storage) and to I. M. Pei's Jerome Wiesner Building at MIT, where Noland, in collaboration with two other artists, had boldly addressed the use of color in architecture by painting on the building's metal skin. In the first decade of the new century, when I revisited the Wiesner, Noland's mural, *Here-There*, had been restored to its original bright hues. On my first Noland visit I took in a Boston Bruins game. I'd grown up following the New York Yankees, Rangers, and Knicks, and felt I'd completed a Boston trifecta.

When I attended my thirty-fifth Wellesley reunion, in June 1993, I stayed with a classmate in Boston, preferring the reverse commute. My classmate had dedicated a significant part of the previous five years to volunteering at the Vilna Shul, Boston's last immigrant synagogue, which was in the process of being

transformed into a museum and cultural center, and showed me through it with understandable pride. We also meandered through the Cambridge antique shops on Monsignor O'Brien Highway.

Whatever happens in your past, you often get second chances, and sometimes even twentieth chances. As a consequence of my travel-lazy college years, I had to play catch-up in getting to know the Boston of centuries past, which has proved to be a fortunate way of making the city's acquaintance. Boston underwent a building boom in the 1960s and 1970s, so I was able to see the skyline in real time.

Henry N. Cobb of I. M. Pei & Partners designed my favorite skyscraper in Boston, the John Hancock Tower. At sixty stories, it is the city's tallest building and the one I most admire. At first I was attracted to it because it was mysterious, and I am partial to mysteries. For years, its windowpanes kept breaking and falling to the ground, and, after being repaired, repeated the breaking and crashing cycle. At last, engineers solved the window mystery dilemma and others (the building swayed in the wind, giving occupants of its upper stories motion sickness), and the beautiful blue-windowed, minimalist, parallelogram-shaped Hancock Building was completed in 1976, eight years after construction had begun. I am now especially drawn to the Hancock because it has defied opponents who feared it would detract from its near neighbor, Trinity Church, a National Historic Landmark. Instead, the brown and red granite and sandstone church, finished ninety-nine years earlier, has never appeared more magnificent than when reflected in the Hancock's icy blue panes.

Before recently flying to Kenya for a week, I didn't read a guidebook. Instead, I reread Isak Dinesen's *Out of Africa* and Beryl

Markham's *West with the Night*. From early childhood, my most vivid visions of places not my own have come from fictional writing. On one of my visits to Cambridge to talk to the Nieman fellows, I booked a room at the Ritz-Carlton Hotel, an extravagance inspired by E. B. White's third and final children's book, *The Trumpet of the Swan*. Louis, White's mute and erudite trumpeter swan, had spent the night at this luxurious hostelry before he started playing the trumpet alongside the swan boats on the pond in Boston's Public Garden.

Landing at Logan isn't as exotic an experience as, say, landing in Nairobi — no on-the-spot visa to procure, no dollars to convert to shillings, no Swahili phrasebook to memorize — but starting at the baggage claim and continuing to the taxi line, I know from the prevalence of "Pahk your cah in Hahvad Yahd"–accented English that I am not in Kansas. A quick bowl of clam chowder and a side of beans at one of Logan's airport eateries confirms my presence in Boston.

I experienced fewer difficulties than Louis had when I presented myself at the front desk of the Ritz: I lack plumage, so no clerk could tell me at the outset that the hotel did not accommodate birds. Like Louis, I had luggage — the clerk seemed to consider that another significant requisite for accepting swan-guests — although my suitcase on wheels was less remarkable than Louis's trumpet, moneybag, slate, chalk pencil, and the shiny medal he had been awarded for saving the life of Applegate Skinner, an obnoxious child who disliked birds but had tipped over a canoe he had been forbidden to take out and was on the verge of drowning. Nor did the clerk express misgivings that I would mess up the room, although surely many previous author-guests had been guilty of the spillage that results from overimbibing. My personal habits were not questioned either, as Louis's

were when he came to the Ritz with the Boatman who would be his employer, starting the following morning.

"I can't allow a large bird to occupy one of our beds — it might put us out of business," Louis and the Boatman had been told. "Other guests might complain."

"I sleep in the bathtub," Louis wrote on his slate. "Will not disturb bed."

I registered quickly and rode the elevator to the seventh floor; I had requested a room on the floor to which a bellboy had escorted Louis. I asked for room service, attempting to duplicate Louis's order of twelve watercress sandwiches, eleven with mayonnaise, one without. After sampling the first sandwich, Louis concluded he didn't fancy mayo — or sandwich bread either — and really wanted just the watercress. Room service regretted to inform me that no watercress sandwiches were available. I was grateful — I am not fond of watercress — and ordered a cheese omelet. I can't play the trumpet, as Louis had done before being advised that guests at the Ritz were not allowed to play brass instruments in the bedrooms, so I turned on the television set for diversion. I took a plain bath rather than a swan shower-bath, and didn't fall asleep in a full tub of cold water. I lay down on a nice firm mattress. With my head on two plump but fluffy down pillows, the feathers supplied by I-didn't-care-to-know what species of waterfowl, I took my copy of *The Trumpet of the Swan* from the night table. Our first daughter was born in 1967, our second in 1969; the book had been published in 1970. I had often read it aloud to the girls when they were young, and read it that evening with silent pleasure. Before switching off the light, I turned to the flyleaf to enjoy again the elegance with which E. B. White, who wrote the most lambent prose of all the writers I have known, had inscribed the book: "To Maria Gregory Sheehan and

Catherine Fair Sheehan" with "greetings from the old cob, E. B. White."

The next morning, I rode on one of the swan boats, imagining Louis gliding alongside the painted paddleboat and playing "Row, Row, Row Your Boat."

. . . Life is but a dream.

The Athens of America

James Atlas

THAT IT HAPPENED in Boston was unsettling — more so than if it had happened somewhere else in America. New York and Washington, D.C., made sense as targets for the hijackers: the centers of financial and political power. But Boston was "the Athens of America," as it was known during an earlier phase of its history — "a city of great statesmen, wealthy patrons, inspiring artists, and profound thinkers," according to the historian Thomas O'Connor. Its claim to being a bastion of civilization was visible in its monuments and institutions: the Boston Athenaeum, the Isabella Stewart Gardner Museum, the Massachusetts statehouse. Its history was visible to anyone who walked the streets. Bunker Hill, the Freedom Trail, the Old North Church: it was here that the American Revolution had been fought.

It also boasted the largest concentration of colleges and universities in America. The most famous of these, Harvard, situated on the other side of the Charles River, had produced gen-

erations of leaders in business and politics over its nearly four hundred years in existence. But it was the "leaders" in literature that I cared about. I had arrived as a freshman at Harvard in 1967 with the ambition to become a writer but unaware of how many of my literary heroes had gone there: T. S. Eliot, James Agee, E. E. Cummings, Wallace Stevens, Norman Mailer. Some were there at that very moment, as I had learned from the course catalogue that arrived at my home in Evanston, Illinois, that summer. Robert Lowell, widely regarded as one of the greatest poets of the twentieth century, was teaching an advanced poetry course; so was Elizabeth Bishop, who had served as U.S. poet laureate, and Robert Fitzgerald, the translator of *The Odyssey*.

Lowell's world was Boston, where he had grown up among the Brahmins of Back Bay; his family had a townhouse on "hardly passionate Marlborough Street," as he wrote in *Life Studies*. In "For the Union Dead," he described a statue to the Civil War dead on the Boston Common:

> *Parking lots luxuriate like civic*
> *sand piles in the heart of Boston.*
> *A girdle of orange, Puritan-pumpkin-colored girders*
> *braces the tingling Statehouse, shaking*
>
> *over the excavations, as it faces Colonel Shaw*
> *and his bell-cheeked Negro infantry*
> *on St. Gaudens' shaking Civil War relief,*
> *propped by a plank splint against the garage's*
> * earthquake.*

There were also poems about Cambridge, where Lowell had once lived in an apartment on Ellery Street. His roommate was

Delmore Schwartz, who wrote a poem titled "Cambridge, Spring 1937":

> *At last the air fragrant, the bird's bubbling whistle*
> *Succinct in the unknown unsettled trees:*
> *O little Charles, beside the Georgian colleges*
> *And milltown New England; at last the wind soft,*
> *The sky unmoving, and the dead look*
> *Of factory windows separate, at last,*
> *From windows gray and wet . . .*

It was this world that I would come to know as my own over the next decade, from 1967 to 1977, where I spent my undergraduate years, got married, and wrote my first book.

Were there more bookstores in Harvard Square than anywhere else in America? Maybe Telegraph Avenue in Berkeley had as many; maybe Book Row, the street of used-book shops on Fourth Avenue in New York. But they were long gone by now . . .

One day not long after my arrival in Cambridge, I stood outside a tiny bookshop on Plympton Street looking through the plate-glass window. There was a sign overhead:

GROLIER POETRY BOOK SHOP, INC.
EST. 1927

In the window display were books of poetry, old and new, and announcements of local readings. I pushed open the door and entered the shop, a single room lined with book-crammed floor-to-ceiling shelves. On a table in the center of the room were more books, piles of them; on the walls above the shelves were framed photographs of every major American poet of the cen-

tury, from Robert Frost to Conrad Aiken, Archibald MacLeish to Ezra Pound. Seated in the corner was an elfin white-haired man whom I took to be the proprietor. I went over and introduced myself — "I'm a poet" — and he gave me his name: Gordon Cairnie. (Did he have an Irish accent? I can't remember.)

I would get to know him well during my college years. Whenever a poet came to town, the Grolier was the first stop. In the late afternoon, the Cambridge poets — there were many, though not, as Yeats said of the Rhymers' Club that met at the Cheshire Cheese in London, "too many." Impossible: Cambridge was a poetry-besotted community. You could go to the Woodberry Poetry Room in Lamont Library, put on earphones, and listen to Eliot recite *The Waste Land* in his funeral voice; you could visit the back room of a restaurant with brick walls on Mass. Ave. that I forget the name of and listen to local poets recite their often terrible verse, or get up and recite your own; you could drop in at 21 South Street, the white clapboard home of the *Advocate*, the college's literary magazine, and listen to undergraduates recite their work; or you could buy a ticket to a reading by a major poet at Emerson Hall. (I heard Robert Bly give a thrilling recital of his anti–Vietnam War poems there.) And it wasn't just a Harvard culture; the poets who gathered at Charlie's Kitchen, off Harvard Square, after readings were Boston poets, Somerville poets, Cambridge poets. I was twenty, and had arrived at the center of the world — a world of civility and grace and literary fellowship. (Also — why be naïve — one that displayed resentment, competitiveness, crude ambition, and other unpalatable human qualities. But how could it be otherwise? "Culture," the nineteenth-century critic Matthew Arnold famously declared, "is the best that has been thought and said." And the worst.)

Then there was Schoenhof's, on Mount Auburn Street, which specialized in recondite foreign titles — the books on display in

the window tended toward members of the Frankfurt School, the Structuralists, and Continental philosophers like E. M. Cioran and Roland Barthes. Mr. Schoenhof, the shy, slight, bespectacled proprietor, had exacting standards. If you asked for a book that he disapproved of — which happened, in my experience, more often than not — you would know because he didn't have a copy on hand, and would have to order it, which he did with an ostentatious show of reluctance, muttering to himself as he filled out the invoice. I spent hours in Schoenhof's, reading and not buying the books. I don't know how he made a living; others also browsed for protracted lengths of time, only to leave the store empty-handed. But he seemed not to care. Unlike every other bookstore owner I've ever known, Mr. Schoenhof was a fanatical reader: he would sit behind the counter, head bent over some thick volume, and react with irritation if someone approached him with the apparent intention of purchasing a book. It was all he could do to ring up the sale.

There were others, too, that I could name, such as the Starr Bookshop, at the base of the strange, pseudo-medieval castle known as the *Lampoon* Building, which had two wooden bins out front where you might come across, as I once did, a complete set of Byron's journals (I still have it). Like Schoenhof's, the Starr was almost belligerently naïve about its function as a business; the prices penciled on the inside cover were so low that they made you feel guilty about buying the book.

I didn't just frequent bookstores; I wasn't as high-minded as all that. There was the legendary Club 47 behind the Coop, where Joan Baez, Tom Rush, and Taj Mahal performed; the Algiers coffee house (still there) and Peasant Stock, where you sat at long wooden refectory tables; the Plough and Stars, not far from Harvard Square, which served Guinness in pint glasses; the brick, barnlike Brattle Theatre, where you could watch *Casablanca* at

midnight in the company of an audience that knew the entire movie by heart and recited the dialogue aloud.

And if I tired of Cambridge, I could jump in my bright red VW Beetle and drive across the Mass. Avenue Bridge to Boston — the glittery rectangular tower of the Prudential Building ("the Pru") rising in the night sky, the old-fashioned lights on the bridge aglow, the headlights of the traffic on Mem. Drive streaming — and go to Durgin-Park, at Faneuil Hall, with its red-checked tablecloths and flamboyantly rude waitresses; or to the Union Oyster House, where the wives of John Hancock and Samuel Adams had dined while their husbands were off at war; or to Anthony's Pier 4, on the harbor, for lobster fresh off the boat.

And if I tired of Boston . . . But I never did.

Bothering Bill Russell

Leigh Montville

THE PUBLIC RELATIONS man for the Boston Bruins in the spring of 1969 was Herb Ralby. There was a *Guys and Dolls* aspect to him. He was fifty-four years old, single, a flashy dresser in that Nathan Detroit way, all plaids and bright colors. He didn't talk like Nathan Detroit, but he was familiar with the horse people at Suffolk Downs, with the greyhound people at Wonderland in Revere, with the boxing people like Sam Silverman and Rip Valenti, who operated in the shadows around the Boston Garden. An old-time sport, that was what Herb Ralby was.

As a public relations director, he specialized in using the word "no." PR men in professional sports, probably in most endeavors, are divided into two groups: the ones who believe their job is to sell the product to the general public and the ones who believe their job is to protect their product from the general public. Ralby was definitely in the second group.

"Herb, do you think I could have five minutes with Bobby Orr?" a reporter might ask.

"No," Ralby would reply.

"But —"

"Impossible."

Trying to find out when and where the Bruins practice would be held on a given day was like trying to find out the pope's underwear size at the Vatican. ("Give me a call later.") Asking for a Bruins press guide was like asking for the minutes of a top-secret Pentagon briefing. ("Didn't I give you one of these last month?") The inquiring reporter was a pest buzzing around the proceedings.

The irony was that Ralby, the man with the perpetual no, had a second job: he also was a sportswriter for the *Boston Globe*. In the local pest business, he was both exterminator and exterminatee. Take away a couple of years in the U.S. Coast Guard, in the Pacific during World War II, and he had worked at the *Globe* since he graduated from Boston Latin School in 1931. He had been both a sportswriter and local sports PR man for a long time.

If the paper, or even the Bruins, had ethical reservations about conflict of interest, no one apparently said a word. The one adjustment was that Ralby did not cover the Bruins; he covered the Celtics. The teams played on different nights in the same building, so there was no obvious conflict. The fact that, oh, a good story about the Bruins might be scheduled to appear in Tuesday's paper and a better Celtics story might be squashed by the PR man/beat reporter never seemed to interest any of the interested parties. Ralby was the equivalent of the Democratic town chairman covering the Republican political campaign for the largest newspaper in town.

The one good thing about this situation for another reporter on that newspaper, aside from a close-up lesson in how big-time,

objective journalism should not work, was that the Celtics did play a lot of games on the road on the same nights the Bruins played at the Garden. Since Herb Ralby had to appear as his Nathan Detroit self to say no to a succession of people at the Garden, the other reporter had to travel sometimes to cover the Celtics in other arenas. The other reporter in this case was me.

I was twenty-five years old, new on the scene from New Haven, Connecticut. I had covered a number of Celtics games during the 1968–69 season, and as the playoffs arrived, the good news also arrived. The Bruins and Bobby Orr had reached the Stanley Cup playoffs, the second time in two years. This meant that starting on April 2, 1969, with a game at the Garden against the Toronto Maple Leafs to open a best-of-seven quarterfinals, Herb Ralby would be a very busy man. This also meant that someone else would have to cover the Celtics in the playoffs.

Thank you, Boston Bruins.

The hardest part about covering the Celtics was dealing with Bill Russell. He was the coach now as well as the all-star center, finishing his third season in both roles. As coach, he was someone who had to be seen every day, checked, just to make sure no one was hurt, that no changes were being made in the lineup, that all was right with the team. This was the hard part. On some days Bill Russell did not like to be seen, did not like to be checked.

"Bill . . . ," the reporter might say.

"Not now," the player-coach might reply.

"When?"

Silence.

Not a lot of people covered the Celtics on a full-time basis in 1969. After an off-day practice, there might be two or three writers in the locker room looking for words from the coach and the players. Sometimes there might be only one writer on the job.

Interviews were intimate, conversations more than grand presentations. They were more dialogue than Q and A.

The Celtics players mostly were gracious in this forced relationship. The tsunami of easy money had not arrived, and though they made more than the average sports reporter, they didn't make a thousand, two thousand, ten thousand times more.

John Havlicek was terrific. He would talk about anything, deep, reflective stuff. He studied the reporters the same way they studied him. He gave grades in his head when he read their stories in the paper the next day, checking to see how accurately he had been quoted. If he found mistakes, rather than confronting the reporter, he took pains to explain himself better the next time the reporter came to his locker.

"There's one guy, no matter how many times I explain, he always gets it wrong," Havlicek lamented once. "I spell things out for him. He still gets them wrong."

Tom Sanders was a very good interview, deep voice, funny. Don Nelson was good. Sam Jones. Bailey Howell. Emmett Bryant, maybe the coolest man on the planet. Larry Siegfried. ("I know every move Oscar Robertson is going to make before he makes it," Siegfried said one night in frustration in a bar, getting down into a defensive stance. "I just . . . can't . . . get . . . there . . . before he makes it.") The relationships with all of these people were back-fence easy, no different from neighbors talking to one another, people who might be different in a bunch of ways but found themselves living on the same street.

Not so with Bill Russell. He lived on a bunch of different streets.

In later life, in shorthand history, in retrospect, he has become a revered figure, William Felton Russell, basketball great, basketball statesman, known for his cackle at things funny, for his

thoughtful observations about all of life, not simply his sport, for his place in the one-foot-after-another march forward for civil rights. A statue of him is going to be added soon to the Boston landscape, along with statues of mayors and senators, of people like Paul Revere and George Washington and, OK, Red Auerbach. He is cast as sort of a Gandhi in short pants and Chuck Taylor sneakers.

In 1969, he was not Gandhi. True, there were moments when he could be introspective, charming. There was no doubt about his intelligence. He could flip subjects upside down and look at them in different, interesting ways. He simply didn't want to flip sometimes. He didn't want to talk. He didn't want to be bothered.

"Bill?"

Silence.

Especially by a twenty-five-year-old reporter.

The Celtics were not expected to do very much in these playoffs. The exclamation point at the end of the Russell era supposedly had been delivered at the end of the 1968 season, when the aging center and his aging teammates rallied from a 3-1 deficit against the Philadelphia 76ers to survive the Eastern finals and then whipped the Los Angeles Lakers for the NBA title in six games. That comeback was late-career magic, giving Russell and company not only their tenth NBA title in twelve seasons, but revenge for a championship they had lost in 1967.

The 1968–69 season was a different story. Russell was now thirty-five years old and shooting guard Sam Jones was almost thirty-six, and the defending champions had finished fourth in the six-team Eastern Division with a 48-34 record. Seventeen of those losses were by three points or less, a sign that the home

runs of the past now landed on the warning track. Age had taken control. These were the close games the old Russell Celtics had always won.

NBA greed was the only reason the team was in the playoffs. Fourth place in a six-team division was good enough in the gate-conscious league. The Celtics were embarrassed at their situation. They finished nine games out of first place.

"It's bad overall for the fourth-place team in a six-team league to make the playoffs," Sam Jones said. "But the league needs money and here we are. We're going to do the best that we can."

As the playoffs began, the Celtics against the 76ers in the first round, I had a suggestion for my boss at the *Globe*, Ernie Roberts. I think it came from a secret desire to put myself in harm's way. The other papers in town, the *Boston Record American* and the *Boston Herald Traveler*, had ghostwriters doing columns for Havlicek and for Celtics general manager Red Auerbach. I suggested we should do that, too.

"Who would we have?" Roberts asked.

"What about Bill Russell?" I said.

He mulled the idea as if it was the strangest suggestion that ever came across his desk. I don't think any black athlete had ever been featured in a ghostwritten article in Boston.

"Would he do it?" Roberts asked.

"I'll ask," I said.

The price was very short money. I want to say $200 per column. I laid out the possibility for Russell after a practice. He agreed almost immediately. He liked the money. Or maybe he liked the idea. He liked something. I volunteered to be his ghost, but he said he'd write his own stuff, thank you very much. He would call a *Globe* number and speak into a Dictaphone recorder and some office boy would type his words and put them into the paper.

The *Globe* had the headline RUSSELL TO COVER FOR GLOBE on the first day of the Philadelphia series. The text was priceless.

"From a height of 6 feet 9 inches," the story read. "From the unequalled experience of 13 playing years and 10 world championships in professional basketball. From the emotional perspective of the most involved Celtic in tonight's Philadelphia playoff. And with the candor of a man who tells it as it is, who knows no subterfuge . . . That's the viewpoint Globe readers will enjoy when Boston's Bill Russell reports the opener and all the rest of the Celtics' playoff battles exclusively in the Morning and Evening Globe . . ."

My job, as the Celtics rolled through the Sixers in five games, then through the Knicks in six in the Eastern finals, was to write informative, hopefully different stories for both the morning and evening editions, and, of course, to make sure Russell made that phone call at the end of all games. I worried more about the phone calls than the stories or the games.

"Bill . . . ," I would say, a foot shorter than the big man as he dressed.

"I'll call."

End of dialogue.

His stories were punchy, informative, pretty good. He called after every game, win or lose.

The finals, of course, were against the Lakers of Jerry West, Elgin Baylor, and Wilt Chamberlain. This became a classic series, coast to coast. The Lakers went ahead, two games to none, in the first two games in L.A. The underdog Celtics won the next two in Boston, the second by an 89-88 score, on a jumper by Sam Jones at the end. The fifth game, back in L.A., went to the Lakers, and the sixth, in Boston, to the Celts. This set up that legendary final seventh game at the Fabulous Forum, where Lakers owner Jack Kent Cook had filled the rafters with balloons and instructed the

organist to play "Happy Days Are Here Again" when the final buzzer sounded and the Lakers were world champions.

The plans went awry when Wilt was injured, then was kept on the bench at the end of the game as Don Nelson made a circus shot that hit the back rim, went high into the air, then back through the basket, and the Celtics pulled off the 108-106 win. This still is one of the biggest upsets in NBA history.

The end was surreal, the Celtics whooping and tumbling off the court, running and shouting to one another through a fog of silence and resentment. The Lakers fans looked as if they'd all lost their wallets. Wilt was on the bench? What was that? The Celtics had won again? What was that? The eight bags of balloons remained unopened at the top of the Forum. Five cases of champagne remained unopened in the Lakers locker room. A victory cake remained unsliced in the Forum press room.

In the corridor outside the visitors' dressing room, waiting for the door to open, chaos around me, I tried to slow down my head and make a game plan. Whom did I want to see? What did I want to ask? Before I could decide very much, I had an extra assignment.

"Wait until everyone is gone," Will McDonough, also covering the game for the *Globe*, told me. "Grab Russell when he's alone. Ask him if he's going to retire. A guy told me it's going to happen."

"A guy?" I said.

"A guy."

That was Will. He had the ultimate newsman's sources. There always was a guy. There never was a name attached to the guy. Will always had a different look at all situations. While everyone else was dizzy at the newest grand moment, still digesting what had just happened, he had already moved along to the next one.

"Why don't you ask Russell yourself?" I asked.

"Russell hates me," McDonough said. "You've got to do it."

The door opened. I rolled in with the crush, television cameras whacking people in the head, push, shove, push, push, push. The game plan was gone. I asked questions wherever I landed. I kept my eye on Russell.

Havlicek told me there had never been champagne in a Celtics locker room for any of the eleven championships. He wasn't sure why. Probably superstition. Sam Jones told me he had worn Bailey Howell's shorts for the last half of the season. There had been a mixup one day, and the jumpers fell that day for both parties. The shorts were lucky. In the Lakers locker room, I listened to Wilt and to Butch van Breda Kolff talk like a divorced couple, recriminations delivered in cold, dispassionate words. Changes were sure to happen. Jerry West, who scored forty-two points in the game despite a sore hamstring, talked about sadness.

"Every year it gets more difficult to sit here and talk about it," he said. "It gets more difficult after hearing those guys yelling and celebrating in that other room . . . I guess it's just not my fate to be with a champion."

Russell never left my mind. Get him alone. Get him alone. He was in a crowd for the longest time. Then he was in the shower for the longest time. Then there was another crowd when he started to dress. I waited. The crowd did become smaller as Russell put on each piece of clothing, but the process was slow. Would he ever be alone? As he finished dressing, a moment from leaving the arena, Russell talked with one last friend. The friend was Jim Brown, the former Cleveland Browns running back, maybe the greatest football player who ever lived.

Jesus Christ.

If I wanted to talk to Russell, I had to move into the middle of this conversation. Or never move at all.

"Bill," I said, interrupting the greatest basketball player of all time as he talked with the greatest football player of all time.

A look came my way.

Actually two looks.

These were not pleasant looks.

Jim Brown was wearing a dashiki and one of those little African hats he favored at the time. Russell . . . I can't remember, but I'm sure it was one of his cool outfits, maybe with the full Batman cape. He was huge and Jim Brown was huge and in the spring of 1969, that time of racial upheaval and revolution and all of that stuff, one year from the Martin Luther King riots, here were the two most militant African-American figures in professional sports, not to mention the two greatest players of all time in their respective sports, and I had interrupted them and they both stared down at me and I felt very white and red-headed and short and insignificant.

Jesus Christ.

"Are you going to retire?" I blurted.

The question was a housefly floating in the air.

Slap!

"Retire?" Jim Brown replied in a loud voice before Russell could speak. *The man just won a world championship!* Why would he retire?"

I nodded, of course, in quick agreement. Why would he retire? Ridiculous. I wanted to say that I hadn't thought up this question, that Will McDonough had thought it up because some guy, whoever the guy was, had said something. You know?

"I have another year on my contract," Russell said. "I signed that contract."

I nodded again. Of course. Silly of me.

We stood there, the three of us, a locker room tableau. Two proud, great, iconic black men, not only Hall of Famers, but

higher than that. Legends. Two legends! And one twenty-five-year-old sportswriter.

"One more thing, Bill," I said.

"I'll call when I get back to the hotel," the greatest basketball player of all time said.

And he did.

And a couple of months later, of course, he retired. He sold the story to *Sports Illustrated*.

From Somewhere

Tova Mirvis

THIS CITY WASN'T supposed to be mine. As a child, faced
with the prospect of my family moving from Memphis to
Boston, I tore up my Red Sox baseball cards in protest. Is Carl
Yastrzemski a good player? I asked my brother, and upon dis-
covering who he was, took extra pleasure in ripping that card in
half. At a restaurant, I ordered the Boston cream pie — "hold the
Boston." "I AM NOT MOVING TO BOSTON," I wrote on page after
page in my diary.

Boston was a world away from the city where I was deeply
rooted, where my family had lived for five generations, in a
thicket of more relatives than I could identify and a close (some-
times overly close) community where I was identifiable not just
by my name but by who my grandparents or great-grandparents
were. "I can't imagine living anywhere else," my grandmother
once said to me in her Southern drawl, as she sat in the living
room of the house she had lived in for more than forty years — for

her Memphis wasn't a place she happened to live, but something visceral, entrenched, necessary to who she was.

To be from a place: for a Southerner, this was the crucial thing. Not where your house was, not where you happened to live, but some core element of who you were. To be from a place: this implied an almost metaphysical connection to this one spot of earth, which was indelible, regardless of where you lived the longest. To be from Memphis — this didn't mean to have lived there for years but to have had a parent or a grandparent who was born there. My father, it has long been said in my family, is not from Memphis, even though he has lived there for forty years. Ultimately he turned down the job offer in Boston, and others, too, which would have taken us to Chicago or Indianapolis, electing to stay in a city where this appellation — *not from here* — is correct. Despite the number of years my father has lived there, he feels not part of this place, not at home in a city that feels like a town, that feels small and closed, and decidedly not his own.

Once I got over that early horror at the prospect of moving away from Memphis, I too longed for cosmopolitan, intellectual, arty urban spaces. "There's nothing to do here," my friends and I complained, imagining that other cities offered endless options for bored, restless teenagers. I left to go to college in New York City and knew that I probably wouldn't live in Memphis again. But unlike my father, I still believed that nowhere else would define who I was in the world. To be from somewhere — it didn't mean that you loved the place, or even liked it; to be from somewhere meant that the city was entrenched in your identity — like family we are born into, not friends we choose on our own.

I was right that I wouldn't again live there, and right, too, that Memphis — even just the word — would always evoke what it means to be rooted, to feel connected and necessary and whole.

"How often have I lain beneath rain on a strange roof, thinking of home," said William Faulkner, who captured more than anyone the Southern sense of place. More than twenty years since I have lived in Memphis, and the hottest, stickiest of days, in any city, when the air feels thick enough to swim through, makes me feel as if I am there. Any mention of the Mississippi and my mind turns to that muddy river with its sense of both history and myth that wends its way past the small, almost miniature downtown skyline. The sound of a Southern accent instantly carries me home: "Where are you from?" I feel compelled to ask strangers when I hear that slow lilt, wanting to tell them that even though they hear no trace of it in my voice, I too am from somewhere nearby.

But New York — the Upper West Side of Manhattan more specifically — this was the city of my choosing. I went to college there, then graduate school, but was certainly not from here, never rooted, always transient. I finished school and stayed, still feeling as though I were on some kind of long-term student schedule, on an emotional visa that let me stay as long as I liked without ever becoming a resident. I carried a Tennessee driver's license for ten years after I stopped living there and only gave it up when it was pickpocketed from my bag on the streets of the city. In Manhattan, it didn't matter. I didn't need a license. I had no need for a car; you needed to rent a car only when you intended to leave the city, which I could go months without doing. On this island of strangers, I was happy to be stranded. The tight-knit community in which I grew up was nowhere around me; I loved living among the fellow-unrooted, where to buy curtains was too big a commitment because we didn't know for how long we would be living in that apartment. And there was no need anyway for curtains; we saw our neighbors, they saw us,

all of us participating in a shared intimate anonymity that only urban living can create.

I was newly married, then a young mother with a baby I walked to sleep on the streets of the city. That baby became a little boy who studied bus maps at the age of four. For entertainment, I took him on the crosstown bus where he happily told strangers how to get from any one location to another. He played T-ball in the living room of our apartment; a home run was hitting the wood of the china cabinet. Once, when visiting my parents in Memphis, he looked at the grass and asked if he was allowed to walk on it. We had another child, whom I strapped to myself as I pushed his brother in the stroller to school through rain, through snow. I was not going to move; not ever. One by one our friends with kids peeled away to the suburbs. I was still not going to move. Our apartment grew smaller. The city was too expensive. And there were other problems: a husband's job that required him to be in his office at all hours, a growing feeling of something not right and the strain of trying not to know that. We had to move, but where? We ruled out large swaths of the New York area. Any place felt random: a town in New Jersey — why there?

Boston started to creep into the conversation. This was the city my husband was from, the city he loved, the city where his family lived. He was tired of being a Red Sox lover among Yankees fans, tired of feeling emotionally oriented a four-hour drive to the north. He loved the Boston architecture, loved the intangible qualities that make a city itself. More than anything, he wanted to feel at home. After thirteen years in New York City, I too was ready to again feel a sense of permanence. I agreed. If not Manhattan, I thought, then anywhere else.

We strapped the kids into the back of a Volvo station wagon,

our first car, and drove to the blue-shuttered, white Cape we'd
bought in Newton. We would have a yard. Our sons would play
in Little League, and not in the living room. Most of all, we
would create the sense that we, together, were from somewhere.
I watched how at home my husband felt here, and I hoped for vi-
carious belonging, a Bostonian by marriage. "What brought you
to Boston?" people asked, and I would say we moved because my
husband is from here, because he loves Boston, and I, a writer
with a transportable career and no other place I wanted to live,
could go anywhere.

All these good intentions, yet it caught me off-guard how for-
eign Boston was, how decidedly not-from-here I felt. I spent my
first few months going back and forth to New York. "How of-
ten do you go into the city?" someone here asked me, and I said
about once a month — until I realized she meant Boston, not
New York, which for me was still and always *the* city. Still feel-
ing like that kid who'd asked the waitress to hold the Boston, I
secretly rooted for New York sports teams, purposefully read the
Times, not the *Globe.* Having grown up in a city where a few flur-
ries was enough to shut down the place, I chafed at the endless
snow, marveled that you were expected to drive in all that. I took
little advantage of Boston the city, spending my days sealed in-
side my car on suburban streets, shuttling kids to schools, miss-
ing the way that in the city I had walked everywhere, meeting
friends and neighbors along the way. Now if I passed anyone I
knew, it was at forty miles an hour, with little hope of recogni-
tion, let alone connection.

More than anything, driving was how I knew I was not from
here. Bostonians were a different breed of driver than the def-
erent Memphians I knew, where the only time you honked was
when you were passing a friend and wanted to say hello. Here,
there is no mercy for the tentative driver. What am I doing here,

I asked myself again and again. I had foolishly decided not to buy a GPS, so I studied the maps, trying to take hold of the city in my mind, to grasp its turns before I set out in the car.

Months passed, and years. I made some friends, found things to like about living here. But still, I knew that this would never be where I was *from*. One day, I thought, we would move, not back to Manhattan or Memphis but to some other place where I would feel less of this sense of dislocation. Before we moved here, we had agreed that if I didn't like it after three years or four, we would leave, though that promise was quickly lost amid the realities of jobs and mortgages and children. I begrudgingly learned to shovel snow and drive over snowbanks at the foot of the driveway. I feigned good feelings toward the sports teams, though I quietly hoped for playoff losses so the kids would go to bed on time. The highways were still the stuff of my night-mares — I was terrified of making a wrong turn and somehow ending up on some bridge that would take me to some unknown highway, with no exits and no way back.

After almost nine years of living here, we got divorced — this in its own way is to be from nowhere, cut off from your own past, every day unrecognizable, as you search out the most basic of landmarks. Gone is the idea that you know where you are going, that you know who your friends are, that you know who you are. To get divorced is to feel entirely lost on streets that you could once navigate with your eyes closed. The past feels cut off, across a divide, barely visible behind you.

"Why did you move here?" I am asked now from time to time, and I stumble over the answer. Why exactly did I, I ask myself. What if we hadn't moved here, I sometimes wonder; how would this, all of this, be different? "Because my ex-husband is from here" makes for a drawn-out story, and a less than compelling reason, as though I'm some kind of stranded shipwreckee. In this

city of history, my own personal history feels fractured. "Are you going to stay in Boston?" a few people asked soon after the divorce—people who clearly know little about custody law. Now there is no choice about Boston; like it or not, this is where I will be living for many years to come.

But even if I could realistically entertain the idea of moving away from Boston, I've found, to my surprise, that I no longer want to leave. Absent any other connection, absent the feeling that the city belongs to someone else, not me, I've come to see Boston in a new way. I have, however ironically and belatedly, started to feel at home. It's not the at-home kind of feeling that my children have here, they who are emblazoned with Boston logos, who root for Bruins, Sox, and Celtics with the undivided passion of fans who know from where they come. (My children, it occurs to me sometimes, will never be Memphians—their connection to that city is only as a vacation venue where they visit their grandparents.) Nor is my belated notion of home anything like that deep-seated sense that my grandmother expressed, that where you live is where you must live.

Instead, it's the happenstance at-home feeling of a transplant—which is perhaps the most fitting way to feel in this college town and immigrant hub, a city of people who are from elsewhere, who live with a backward glance toward other homes where they no longer live. How many of these people came for one reason—for school, a job, a fellowship—and have stayed long after that reason has disappeared? How many of these people here have found that Boston is a city in which you can always find another reason to be here, in which you can always start again?

To be from somewhere else is to know that things change, that connections are broken, that people move on and away. It is to shed the idea that what is now will always be so, that life can only

be lived one way in one place. We all leave home sooner or later, all leave the idea of home as well. Living here still has an accidental feel, yet life itself has an accidental feel. It feels less important to be from somewhere; more important just to be somewhere.

In the past year or two, I've lost my fear of Boston driving, finally quieted that voice in my head that seeks an easier, alternate route, that whispers I can't go there. The city and its surroundings have opened up. There are endless places to go and I feel newly determined to explore them, as though I were arriving wide-eyed in the city for the first time. I came to accept the inevitability of getting lost (which I am able to do even with my phone offering its sage advice). There is an odd pleasure in not knowing exactly where I am. Even after living here for ten years, few places feel cast with immense familiarity. It is easy to continually see this city anew.

A wrong turn, trying to get to the Boston Common to take my daughter on the swan boats, and somehow we are across the Charles from where we intended to be, and yet the consolation prize is to pass the domes of MIT and gaze at the white sails of boats against a bright blue sky, shimmering silver buildings in the distance. Keep driving, in varied direction, through the streets of downtown where history beats so loudly, past the Boston Public Library, in this city of writers and artists, past Trinity Church, which looks like it belongs more in some fabled fairy tale of castles and witch houses than in the middle of a modern busy city. On an early-summer day, drive past the Esplanade, where it seems the entire city is walking, because why would you be anywhere else — anywhere except for one of the kayaks or sailboats passing by, which remind you that you, too, could be spending your day doing this. Keep driving, and everywhere there is an abundance of students and colleges, fooling you into thinking that you are still this young, unencumbered age. Drive farther

out until you reach Walden Pond; walking around it, you discover a small swimming spot where you can slip into the water and it seems you are the only one there. Drive south on I-95 and the sand-duned beaches of the Cape await. Behind a small gallery off 6A, take a mazelike walk through a salt marsh, across a shaky wooden bridge and amid stalks of grass taller than I am, over ground dotted with colored glass stones and metal sculptures that hang from trees as though, in this magical space, it's entirely possible they grew there naturally. Drive west on the Pike and the city skyline gives way to the rise of mountains, a reminder that the abundance of tall buildings and the crowds of people are only one part of this larger place in which we live. Closer to home, Crystal Lake, where swimmers reportedly cross in the dark of night even though it's prohibited, and the Chestnut Hill Reservoir, around 6 p.m. on a summer evening, where everyone, it seems, is fleet-footed and you believe momentarily that you too can run swiftly, endlessly.

For me, Boston is a city in which there is no grid, in which there is no clear pathway but an abundance of windy streets that change names and become one way, and lanes disappear as you drive down them. It is a city that reminds me we don't end up where we thought we would; we don't live only where we belong. We don't always follow the paths that are laid out for us; we don't arrive where we once were intended to go.

Boston Marriage

Pagan Kennedy

LIZ IS EXPLAINING the situation to some guy in customer service.

"My roommate and I need to network our computers together," she's saying, seated at the other desk in the office that we share.

The word "roommate" jumps out at me. It's an inadequate word, but it's all we have. What else do you call two friends who are shacked up together in a decaying Victorian, run several businesses and one nonprofit group out of its rooms, host political meetings under oil portraits of Puritan and Jewish ancestors, cook kale and tofu meals for all who stop by, go to parties as a couple, and spend holidays with each other's families? If we were lesbians — as people sometimes assume us to be — we would fit more neatly into a box. But we're straight.

In the year and a half we've lived together, I have struggled with the namelessness of our situation. The word "roommate"

conjures up a college dorm, scuff marks on the floors from hundreds of anonymous occupants, locks on all the doors, the refrigerator balkanized into zones where you can or cannot put your food, death metal blasting from the speakers down the hall. It means transience and twenty years old. It does not mean love or family.

Words offer shelter. They help love stay. I wish for a word that two friends could live inside, like a shingled house with faded Persian rugs. Sometimes, in an attempt to make our relationship sound more valid, I tell people Liz and I are in a "Boston marriage." The usual response is "You're in a what?"

It's an antique phrase, dating back to the 1800s. In Victorian times, women who wanted to maintain their independence and freedom opted out of marriage and often paired up to live together, acting as each other's "wives" and "helpmeets." Henry James's 1886 novel about such a liaison, *The Bostonians,* may have been the inspiration for the term, or perhaps it was the most glamorous female couples who made their homes in Boston, including Sarah Orne Jewett, a novelist, and her "wife" Annie Adams Fields, also a writer.

Were they gay? Was "Boston marriage" simply code for lesbian love? The historian Lillian Faderman says this is impossible to determine, because nineteenth-century women who kept diaries drew curtains over their bedroom windows. They did not bother to mention whether their ecstatic friendship spilled over into — as Faderman so romantically puts it — "genital sex." And ladies, especially well-to-do ones who poured tea with their pinkies raised, were presumed to have no sex drive at all. Women could share a bed, nuzzle in public, and make eyes at each other, and these cooings were considered to be as innocent as schoolgirl crushes.

So, at least in theory, the Boston marriage indicated a platonic,

albeit nerdy relationship. With ink-stained fingers, the Victorian roommate-friends would smear jam on thick slices of bread and then lounge across from each other in bohemian-shabby leather armchairs to discuss a novel-in-progress or a political speech they'd just drafted. Their brains beat as passionately as their hearts. The arrangement often became less a marriage than a commune of two, complete with a political agenda and lesson plan.

"We will work at [learning German] together — we will study everything," proposes Olive, a character in *The Bostonians,* to her ladylove. Olive imagines them enjoying "still winter evenings under the lamp, with falling snow outside, and tea on a little table, and successful renderings . . . of Goethe, almost the only foreign author she cared about; for she hated the writing of the French, in spite of the importance they have given to women." James poked fun at Olive's bookworm passion. But he lavished praise on his own sister Alice's intense and committed friendship with another woman, which he considered to be pure, a perfect devotion.

Most likely, the Boston marriage was many things to many women: business partnership, artistic collaboration, lesbian romance. And sometimes it was a friendship nurtured with all the care that we usually squander on our mates — a friendship as it could be if we made it the center of our lives.

"I am on my way through the green lane to meet you, and my heart goes scampering so, that I have much ado to bring it back again, and learn it to be patient, till that dear Susie comes," Emily Dickinson wrote to her friend — and maybe lover — Sue Gilbert. Today I see tragedy in these words, for Sue ended up married to Emily's brother, and the women never had a chance to build a life around their love. I find myself wishing I could teleport them to our own time, so that Emily D. and her Susie might find an

apartment in San Francisco together, fly a rainbow flag out front, shop at Good Vibrations, and delight each other with dildos in shocking shades of pink. And yet, it's not that simple. When I read the passionate letters between nineteenth-century women, I become keenly aware of what I'm missing, of how much richer Victorian friendships must have been. While our sex lives have ballooned in the last hundred years, our friendships have grown stunted. Why don't I shower my favorite girls with kisses and mash notes, hold hands with them as we skip down the street, or share a sleeping bag? We don't touch anymore. We don't dare admit how our hearts scamper.

Several years ago, I fell in love with a man because of all he carried — he would show up for the night with five plastic bags rattling on his arm, and then proceed to unpack, strewing possessions everywhere. The next day, I'd find his orange juice in the refrigerator, his sweater tucked into my bureau, a software program installed on my computer. Night after night, he installed himself in my apartment.

At first, every one of these discoveries charmed me — his way of saying, "I need to be with you." But one morning I surveyed my bedroom — guy's underwear on the floor, books about artificial intelligence stacked on the night table, a jar of protein powder on the shelf — and realized that I had a live-in boyfriend. And that he and I had completely different ideas about what we wanted from a living space. He thought of an apartment as a desktop where we could scatter papers, coffee mugs, and computer parts. What I regarded as a mess, he saw as a filing system that should under no circumstances be disturbed. Meanwhile, I drove him crazy by hosting political meetings in our living room, inviting ten people over for dinner at the last minute. We loved each other, but that didn't mean we should share an apartment.

And then, when our Felix-Oscar dynamic seemed insurmount-

able, I picked up a magazine called *Maxine* and stumbled across an article that gripped me. Written by twenty-seven-year-old Zoe Zolbrod, it celebrated the passion that flashes up between women, even when they are both straight. "I would meet women who I would need to know with an urgency so crushing it gave the crush its name. And in knowing them I would feel a rush of power and possibility, of total self, that seemed much more real to me than heterolove," Zolbrod wrote. When she met her friend V, "it was like finding the person you think you'll marry." The two moved in together. They took care of each other, became family, called each other "my love" and "my roommate" interchangeably.

I remember reading that article and thinking, "Yes." I adored my boyfriend, but he and I had never meshed in the way that Zolbrod described. We tried to make a home together, but we didn't agree on what a home should be.

Years later, when our love fizzled into friendship and he moved out, I made a vow to myself: I would not drift into a domestic situation again. Instead, I would find someone who shared my passion for turning a house into a community center — with expansive meals, weekend guests, clean counters, flowers, art projects, activist gatherings, a backyard garden, and a pile of old bikes on the porch, available to anyone needing to borrow some wheels.

My friend Liz seemed like the right person. And so I proposed to her. Did she want to be a cocreator of the performance art piece that we would call "home"? She did.

Recently, at a party, I met a thirty-something academic who has settled alone in a small town outside Boston. "I can step right out my door and cross-country ski," she told me. "But I'm lonely a lot." Around us, people sweated and threw their arms wildly in time to an old Prince song. The academic wedged her hands into her jeans pockets, and her eyes skated past my face and scanned the room.

If you're lonely, get a roommate, I suggested. Move into a group house. "No," she said, sighing. "I'm too old for that. I'm set in my ways." What if you marry? I asked. She laughed. "That's different."

She might be speaking for thousands, millions of women all over this country. According to the U.S. Census Bureau, one out of four households in 1995 had only one member, a figure expected to rise as the population ages. I see the future of single women, and frankly, it depresses the hell out of me. We're isolating ourselves in condos and studio apartments. And why? Sometimes because we need to bask in solitude — and that's fine. But other times, it's because we're afraid to get too comfortable with our friends. What if you bought a house with your best friend, opened a joint bank account with her, raised a child? Where would your bedmate fit into the scheme? This is where the platonic marriage — for all its loveliness — may force you to make some difficult choices and rethink your ideas about commitment.

Liz's love, a theoretical physicist, meanders down our street clapping. Standing beside a triple-decker house, he cocks his head, listening to the sharp sounds reverberating off a vinyl-sided wall. He's designing an exercise for the students in the Physics of Music class that he's assistant-teaching. When he's done, he'll come back inside to find Liz and me draped across the sofa, discussing urban sprawl. We'll all make dinner together, and if I feel like it, I might join them for a night out, or I might head off with the guy that I'm seeing.

I date scientists too, men who understand what it is to experiment, to question and wonder. Liz's love or mine might sit in our kitchen scrawling equations into a notebook, or disappear for days to orbit with subatomic particles or speak with machines. These men are wise enough to see that the Boston marriage

works to their advantage. Liz and I keep each other company. Our Boston marriage has made it easier for us to enjoy the men in our lives.

But how do we commit to each other, knowing that someday one of us may marry? One of us might fall in love with something other than a man — a solar cabin in Mexico, a job in Tangier, a documentary film project in Florida, a year of silence in the Berkshire woods. Any number of things could pull us apart. We have made no promises to each other, signed no agreements to commit. For some reason, that seems OK most of the time.

For this piece, I talked to many women who'd formed platonic marriages or who'd thought about it seriously. All of them discussed the complicated issue of commitment, or lack thereof, between friends.

Janet calls her arrangement with Greta intentional. "In the same vein as creating an 'intentional community,' we have an 'intentional' living arrangement," she says. The two high school friends, both straight women in their early thirties, moved to Boston together five years ago, knowing that they would share an apartment, and a life. They eat dinner together and check in with the how-was-your-day conversation most people expect from a mate.

"Greta is the person I say to contact when I fill out emergency cards," Janet tells me. "She is the first person I would turn to if I needed help."

And yet the two have left their future open, and the promises they have made to each other are full of what-ifs. If Greta doesn't marry by the time she's thirty-five, they might raise a child together. It's the what-ifs that drive many women away from closeness with each other.

One married woman, I'll call her Lisa, says she's deeply dis-

appointed with the way women treat their friendships as disposable, dumping friends when an erotic partner comes along. "Even though my friends and I used to talk about buying a house together, we all knew at some level that it wasn't going to work. Ultimately, we would betray each other, find a man, marry him. I got married because I knew everybody else was going to. If I knew I could trust a friendship with a woman—that there was a way of making a friendship into a bona fide, future-oriented relationship—I would rather have that than be married."

As for me, I've come to think of commitment as something beyond a marriage contract, a joint bank account, or even a shared child. I know that eventually Liz and I may drift to other houses, other cities. Yet I can picture us reuniting at age eighty, to settle down in an old-age home together. Maybe we will have husbands, maybe not, but we'll still be conspirators. We'll probably harangue the youngsters who spoon spinach onto our plates about the importance of forming a union; we'll attend protests with signs duct-taped to our walkers; maybe we'll write an opera and perform it using some newfangled technology that lets us float in the air. Liz and I are committed. We share a vision of the kind of people we want to be and the world we want to inhabit.

"We formed a family core with the possibility of exhilaration," wrote Zoe Zolbrod in her article. "Yet Hallmark never even named a goddamn holiday after us, can you believe it?" We're not sure what to call ourselves. We have no holidays. We don't know what our future holds. We have only love and the story we are making up together.

Liz sashays into the kitchen, a shopping bag crinkling under her arm. "I bought you these," she says, "because you've been wearing those mismatched gloves with holes in them."

I slide on the mittens, and my hands turn into fuzzy paws, pink and red with a touch of gold. "I love them," I say, and hug her, patting her back with my fuzz. She laughs and shifts her eyes away, a bit embarrassed by her own generosity. "I couldn't have my roommate going around in shabby gloves," she says.

She uses the word "roommate." But I know what she means.

Reading Around Boston

Scott Stossel

I N THE FALL of 1991, not long out of college and living in a closet-sized room above a dentist's office in the Back Bay, I spent many of my nonworking hours wandering around in bookstores. Which was odd because that fall, as it happened, I was also spending all of my *working* hours in a bookstore — I had a job at WordsWorth Books, in Harvard Square. Loitering in bookstores in my leisure time was like carrying coals to Newcastle, or taking a busman's holiday, or perhaps just an indication of how limited my imagination was. Couldn't I think of anything better to do? But, feeling anxious and adrift, I'd browse the stacks of various bookstores and libraries, indulging the fantasy that I might someday write books that would share space on the shelves I perused, lending me a permanence and solidity I felt I otherwise lacked. (What I didn't understand then was that most books have all the permanence of mayflies, going from pub-

lication to the remainder shelf in less time than they take to get written.)

To my parents' dismay, I'd decided not to go to law school. I had no visible prospects beyond the six dollars an hour I was earning operating the bookstore cash register, which, my parents made clear, represented a poor return on the money they'd invested in my college tuition. I couldn't disagree. Sometimes, when certain former college classmates would come into the store, I'd scurry behind a shelf in the mystery section to hide. These classmates were by then working as junior consultants or investment bankers, or were earning their PhDs, or had climbed onto the professional-school conveyor belt and were on their way to being minted as doctors or lawyers or architects — on track, some of them, to eventually becoming cabinet secretaries, ambassadors, CEOs, or other species of Master of the Universe. Whereas I was working as a retail clerk, peering out at them from behind rows of Robert B. Parker's Spenser novels, on track to do nothing much at all. (Parker himself, who lived a few blocks away from WordsWorth and whose stories were set all around Boston, was a regular visitor to the store.)

I'm buying time to write, I told my parents, and myself. But in fact I did very little writing that year (I published just two articles, in obscure publications, and made feckless attempts at writing fiction), while doing an enormous amount of reading and — truth be told — a fair amount of television watching with my roommate Ben Mezrich, whose writerly productivity put mine to shame. (That year Ben wrote, completed, and failed to publish about seven novels; scores of rejection letters adorned the walls of his bedroom. He was then four or five years from becoming a published author of thriller novels — and about twelve years away from becoming a Boston demi-celebrity, a best-sell-

ing author of nonfiction(ish) books that get pilloried by jealous journalists while selling hundreds of thousands of copies and getting optioned to Hollywood for millions.)

Books, for better and probably mostly for worse, were my religion — my consolation and my diversion, my hope of transcending my dreary day-to-day life. Temples of my religion were thick on the ground then in Greater Boston. Today, Charlottesville, Virginia — home of the University of Virginia, where one of America's first book collections, Thomas Jefferson's, resides — claims to have the highest concentration of bookstores per capita in America. I haven't made a scientific study of this, but I've toured the bookstores of Charlottesville and, as numerous as they are, they don't hold a candle to the bookstores of Boston and its environs in the early 1990s.

Consider Harvard Square alone. Not twenty yards from WordsWorth, where I worked, across the cobblestone sidewalks of Brattle Street, was another discount bookstore, a branch of Paperback Booksmith, where I often went on my lunch breaks. One block southwest, on Mount Auburn Street, some seventy-five yards away, was yet a third discount bookstore, Barillari Books, which was understaffed and did a poor job of sorting its books, stacking them in messy and seemingly random piles. (Barillari didn't last long; a Kinko's has long occupied the space it once inhabited.) One block in the other direction was the alleyway entrance to the Harvard Coop, a combination of department store and official college bookstore. (Undergraduates could get their textbooks on one floor, shoes and a suit on another, and posters and the latest U2 album and a hotpot for their ramen noodles on a third. If you had a Coop membership, you got a small percentage of your cash back at the end of the year, making the Coop effectively the fourth discount bookstore within a two-block radius. Today the Coop is still a bookstore, but it's now operated

by Barnes & Noble.) One block the other direction down Brattle Street was Reading International, which was soon to close, but which was notable for being open twenty-four hours a day, and was therefore popular among insomniacs, graduate students, and the homeless — three groups among which, come to think of it, there was probably a fair amount of overlap. (WordsWorth had its own homeless person, Ed, a schizophrenic man who lived under the front stairs. Ed was a Harvard Square fixture for years. He would wander the streets in his pea-green jacket and his long, matted beard, muttering to himself and picking up still-smoldering cigarette butts off the sidewalk whenever he could find them. A few times each day he'd come into the store — you could smell him coming two aisles away — muttering gibberish. Most of the time he made no sense, but every once in a while he would say something completely lucid, which was always completely surprising. Other times, something mysterious would provoke him and he'd make a series of barking noises that sounded like a cross between a rooster and a dog. As far as I know, he never hurt anyone. We'd sometimes offer him sandwiches, which he'd sometimes take and sometimes decline, always without remark. On very cold nights the owners would let him sleep in the store.)

If you walked out WordsWorth's front door and curved around to the left up Mount Auburn Street, the first doorway you'd hit was the entrance to a basement mini-mall that included the Million Year Picnic, a first-rate comic-book store that smelled of soap and spices because of the unusual collection of shops that surrounded it. One block farther on in the same direction, on the corner of Mount Auburn and JFK Streets, in a building known as the Garage, was another comic-book store, the slightly edgier — because it also sold records and punk-rock paraphernalia — Newbury Comics, which smelled of the pizza wafting over from Café Aventura.

From there, if you walked down JFK Street toward the Charles River, you'd hit, in succession, Seven Stars Books, which sold new age and occult books, as well as incense and crystals; Revolution Books, which sold socialist treatises, union-organizing pamphlets, Marxist propaganda, *The Anarchist's Cookbook*, and T-shirts with pictures of Mao or Castro or Lenin on them; and, for a brief time, a store, whose name has been lost to history (or at least lost to my memory), specializing in used academic books, that tried, vainly, to compete with the Coop for student business. If you walked the other direction down JFK, away from the Charles and toward the center of the square, you would find, just a couple of storefronts down, and up a flight of stairs from the Wursthaus restaurant, the cozy and untidy Pandemonium Books, which sold science fiction and fantasy novels.

At the center of Harvard Square, just outside the front door to the Coop, were not one but two first-rate newsstands, Nini's Corner and Out of Town News, where one could find not only the more esoteric porn magazines (much more essential in the days before the Internet) but also foreign newspapers and obscure, small-circulation literary magazines.

The newsstands are still there, but most of those other stores are long gone. What a cornucopia of bookstores in such a small area, with so many specialties and subspecialties! In Nathan Pusey's first address to Harvard undergraduates after becoming university president in 1953, he told them that an essential part of their education would be browsing in the bookstores of Harvard Square. I recently came across a 1963 guide published in the MIT student newspaper that lists nineteen bookstores within a mile. In a few years the number of stores within that small radius grew to at least twenty-three.

If you wanted feminist literature, you'd go to New Words Books, a mile or so away, near Inman Square. If you wanted re-

ligious books, you'd go to Divinitas Books, down Mass. Ave. toward Central Square — or to the Harvard Divinity Square Bookstore, on Francis Street. (If you wanted feminist *and* religious books, you'd go to House of Sarah, on Hampshire Street.) If you wanted crime fiction, you'd visit Kate's Mystery Books, just north of Porter Square. If you wanted foreign-language books, you'd go back to Mount Auburn Street, to a place across from Elsie's sandwich shop: Schoenhof's, by almost all accounts the best foreign-language bookstore in the country. (Established in 1856, Schoenhof's still exists, claiming to be the fourth-oldest bookstore in America.) If you wanted poetry, you'd pop into Grolier Books, just off Massachusetts Avenue on Plympton Street. (Helen Vendler, a renowned professor and literary critic, would — alone among the professors of Harvard, most of whom would by default order their textbooks through the Coop — instruct her students to buy their anthologies at Grolier's.) If you wanted gay or lesbian books, you'd cross the river to visit Glad Day Books, on Boylston Street. If you wanted children's books, you'd visit Savanna Books in Central Square or (starting a few years later) the peculiarly named Curious George Goes to WordsWorth, right in the center of Harvard Square where a Howard Johnson's used to be. If you wanted books on psychology or philosophy, you'd go to Mandrake Books, nestled between Mount Auburn and Brattle at 8 Story Street. (Run for fifty years by the eccentric Irwin Rosen, who had bought the store in 1951 from two Harvard faculty wives, Mandrake was defiantly anti-technology. Rosen never bought a computer or, as I recall, even a cash register; he just used a calculator and kept the money in a desk drawer. He seemed to have read every single book the store carried, and he would critique your purchases, telling you bluntly if he thought a book you were buying was stupid.) If you wanted maps or travelogues, you'd go to the Globe Corner Bookstore, just up the alley from the Coop.

If you wanted Asian books, you'd go to, well, Asian Books, on Arrow Street, which also had a good collection of Islamic texts. And if you wanted to browse only those books published by Harvard University Press, you'd go to the press's display shop, tucked behind Au Bon Pain in Holyoke Center.

And if you wanted used books? Simply march up Mount Auburn Street toward Central Square and you'd hit a bunch of them. Within two blocks you'd find Pangloss Books, which specialized in used scholarly books (the *Christian Science Monitor* once reported that "Pangloss is to bookstores what oatmeal is to breakfast cereal: no-nonsense and good for you"); the Starr Bookshop, which for several decades occupied the back side of the *Harvard Lampoon* building and which had large philosophy, Judaica, and art book collections, as well as a "new" books section, which in fact consisted of illicitly procured advance review galleys that were technically not legal to sell; and McIntyre & Moore, which was in the early nineties a youngster among its more venerable peers, having opened for business only in 1983. Like its more aged brethren, though, McIntyre & Moore failed to survive the Internet: the store migrated around for a few years, from Cambridge to Somerville and back to Cambridge again, moving to smaller and smaller spaces before finally expiring in 2010. (On its second stint in Cambridge, it occupied the space formerly claimed by another used-book store, the Bookcellar Café, just north of Porter Square, a place that was always more cellar than café.)

Among the few establishments that remain from that golden era of bookstores is Harvard Bookstore, which was unusual in that it carried both used books (in the basement) and new books (upstairs), and which, of all the bookstores in the Boston area, always had the most interesting collection of new books on display. This is all still true today. It is also the case today, as it was twenty

years ago, that no bookstore is more redolent of hamburger. From next door, the smell of delicious Mr. Bartley's burgers wafts over every day but Sunday. For a while, starting in 1980, the Kramer family, which had operated Harvard Books since 1932, also operated the Harvard Bookstore Café, on Newbury Street in Boston, the first bookstore café in the region. I remember that my parents first took my sister and me there for lunch not long after it opened, when we were in elementary school. What a wondrous concept: a restaurant that sold books! Later, when I lived in the Back Bay while working at WordsWorth, I would steer dates to their conclusion via the Harvard Bookstore Café, where I'd try to seduce women with cookies and coffee. (And by "dates" I think maybe I mean "date": I didn't have many of them that year.) It closed in 1994.

I worked from 3 p.m. to midnight at WordsWorth, and in the morning I would walk down Newbury Street and visit Avenue Victor Hugo, my favorite used-book store, which smelled of mustiness and bagels because of the bagel shop next door. (Victor Hugo closed in 2002; the bagel shop is now a Dunkin' Donuts.) Then I'd cross the street to Trident Books, which smelled of patchouli and pancakes. (Trident survives today.) And I'd drop in on a basement bookstore on Newbury Street, whose name I can't remember but which specialized in selling mysteries. Sometimes I'd walk all the way to Downtown Crossing and spend time in the upstairs Barnes & Noble, or in the Borders store on the corner of Washington and School Streets. When my first book was published, in 2004, the first place I saw it on a bookstore shelf was at that Border's. Seeing the book piled on a display table, next to other real books, I thought, Hey, I'm a published author now. (I glanced around: no one cared.) The store closed in 2011; now the whole Borders chain is dead.

During the time I worked at WordsWorth, the competitor

its owners feared most was Waterstone's, the British bookstore chain that opened its flagship American store in the Back Bay in 1991, in a grand, Romanesque stone edifice on the corner of Exeter and Newbury Streets, a site that had previously been home to a Conran's furniture store and, before that, the Exeter Street Theater, which showed movies for seventy years. Before 1914, appropriately enough, the building had housed a church. With its plush red carpeting and its three floors of books, Waterstone's was — traitorously, given WordsWorth's fears about it — my favorite bookstore in the city. Some said that angry spirits had haunted the building ever since the church had been converted into a theater. Those spirits took their revenge on the bookstore in 1995 when a fire at the T.G.I. Friday's restaurant next door caused Waterstone's sprinkler system to go off, destroying nearly its entire inventory. The store eventually reopened, but before long it closed for good. Today the building is home to a Montessori school. When Waterstone's closed, a *Boston Globe* writer declared that "the Athens of America feels a bit more like Elmira."

When I worked at WordsWorth I took for granted how saturated Boston was by books and bookstores. (I haven't even mentioned the Boston University Barnes & Noble in Kenmore Square, or the computer-book stores in Kendall Square, or the used-book stores on Commonwealth Avenue, or Brookline Booksmith, or the New England Mobile Book Fair in Newton, or the various chain bookstores — Lauriat's, Waldenbooks — populating the malls inside Route 128.) Bookstores aside, the town had (and still has) wonderful libraries. For starters, of course, there is the Boston Public Library, with its glorious barrel-vaulted ceiling in the Bates Hall reading room. (Writing in the *Globe*, Sam Allis described Bates Hall as "vast and hushed and illuminated with a profusion

of green lampshades like fireflies" and as one of those "secular spots that are sacred.") There are also all the university libraries. (Harvard's library system alone consists of some ninety libraries with more than sixty million books, including the Houghton Library with its ancient manuscripts and the Widener Library with its sad tribute to Harry Elkins Widener, the book collector who drowned on the *Titanic*.) Finally, and most uniquely, there is the gorgeous, stately Boston Athenaeum, at 10½ Beacon Street — such a delightfully Harry Potteresque address — overlooking the Granary Burying Ground and featuring, among other things, the largest collection of Civil War books in the world.

When I left WordsWorth, it was to take an internship, and then a junior editorial job, at the *Atlantic Monthly*. I didn't yet have a full understanding of the magazine's deep literary roots in the city. But I was so book-addled that I oriented myself to the magazine via a book about books — Nicholson Baker's memoir *U & I*, about his obsession with John Updike, in which Baker stalks Updike at *Atlantic* parties and in which he describes reading Updike's review of an Edmund Wilson book while standing in the Back Bay branch of Paperback Booksmith, which was just a few doors down from the entrance to the building where the *Atlantic*'s offices were then located, at 745 Boylston Street (in front of which, twenty-two years later, one of the two pressure-cooker bombs would detonate at the Boston Marathon finish line). On one of my earliest lunch breaks while working at the *Atlantic*, in the summer of 1992, I stood dreamily in Paperback Booksmith thinking to myself: This is the bookstore where Nicholson Baker stood reading John Updike while waiting for a meeting with the editor of the *Atlantic* — and now I'm standing in the same bookstore and I work at the *Atlantic*. I believe I was thinking that by some magical transitive property or associative power I would

attain some of the literariness that Nicholson Baker had, even as he himself was seeking more of it by pursuing his bizarre Updike obsession.

Two decades later, I am again employed at the *Atlantic,* where I have now worked on and off for the better part of seventeen years — only now the magazine is based Washington, D.C., where I moved in 2005. When the *Atlantic* was in Boston and people, usually New Yorkers, would ask me why it made sense for a national magazine that presumed to speak about important political and cultural affairs to be based in Boston — a relative backwater compared to Manhattan or Washington or Los Angeles or even Chicago or Dallas or Philadelphia — I would answer that there was an advantage to Boston's being outside both the klieg lights of Manhattan and the Beltway echo chamber of D.C., a benefit to our being rooted in the tweedy, academic soil of Boston. This answer was partly defensive posturing — but it was also, I believe, kind of true. Both New Yorkers and Washingtonians often believe, with considerable self-regard but also some accuracy, that they live at the center of the universe. Bostonians, notwithstanding our claim to be living in "the Hub," cannot with a straight face any longer make that claim. But Boston's literary roots — and in fact our nonliterary roots — go deeper than any other American city's. Yes, San Francisco has City Lights, and Iowa City has Prairie Lights, and New York is New York. But Boston has the Transcendentalists (Thoreau and Emerson and the Alcotts) and Nathaniel Hawthorne and his friend Herman Melville and the founding of the *Atlantic Monthly* over dinner at the Parker House in 1857, which, I would parochially argue, helped give birth to and enshrine American literary culture. Or, if it didn't, then maybe John Harvard did, whose bequest of four hundred books to a fledgling "schoale or Colledge" in the Massa-

chusetts Bay Colony in 1636 enriched the soil for the city's literary flowering.

Those deep literary roots would later give rise to the cornucopia of bookstores that dotted the landscape twenty years ago. Most of the stores are gone now, but their efflorescence speaks to something inherently literary about the culture of Boston.

By the way, WordsWorth's owners were wrong: Waterstone's did not drive them out of business. Amazon did.

In the age of the Kindle and the iPad and Google Books, the love of physical books starts to seem increasingly like an indulgent fetish — and a prissy, shameful one at that. All that space taken up by shelves of books! Those rows of spines could be compressed into bits and bytes and stored on an inch-long memory stick, or lodged in the cloud. Those libraries and bookstores we once revered as temples of knowledge now seem like monuments to excess, repositories of dead trees. All that wasted real estate. Better to replace those shelves with computer terminals.

Humbug. I miss those bookstores. It's been more than seven years since I last lived in Boston, but my internal GPS still orients itself from there. I am forever mistakenly saying that I will be going "down" to New York from Washington — obviously a geographic impossibility. My body may be in Washington, but my defiantly bookish soul remains in Boston.

"Souvenir of the Ancient World"

Robert Pinsky

O UT OF TOWN, watching the horror on a screen, in a familiar place on a familiar occasion, I had my personal emotions: a daughter who works at Mass. General, a daughter-in-law who was in Copley Square a couple of hours before the explosions.

Along with grief, sympathy, and that personal dread, I thought of a poem by the Brazilian poet Carlos Drummond de Andrade (1902–1987). Writing about a long-ago war, in another place, de Andrade understands what might be called the loss of the normal. Boston will endure, the marathon will endure, we will celebrate as well as remember, but to some distinct degree, yet to be known, the security of the normal will be, for many of us, diminished. Or if not exactly diminished, it will include a note of being — in de Andrade's terms — ancient:

Souvenir of the Ancient World

Clara strolled in the garden with the children.
The sky was green over the grass,
the water was golden under the bridges,
other elements were blue and rose and orange,
a policeman smiled, bicycles passed,
a girl stepped onto the lawn to catch a bird,
the whole world — Germany, China —
 all was quiet around Clara.

The children looked at the sky: it was not forbidden.
Mouth, nose, eyes were open. There was no danger.
What Clara feared were the flu, the heat, the insects.
Clara feared missing the eleven o'clock trolley,
waiting for letters slow to arrive,
not always being able to wear a new dress. But
 she strolled in the garden, in the morning!
They had gardens, they had mornings in those days!
— Carlos Drummond de Andrade (trans. Mark Strand)

Boston Sports: Something for Everyone to Love — and Complain About

Bill Littlefield

Is BOSTON A great sports town?

Defenders of Fenway Park can make the case that there's no more historic place to watch a major league ball game, though there are lots of more comfortable places. Nearly all of them. It matters to the defenders of Fenway that Ted Williams hit there, and they're fine with the fact that Babe Ruth and Joe DiMaggio and Mickey Mantle hit there, too, because there had to be another team on the premises or it would have been batting practice. Actually, it often was batting practice for the Yankees of Babe Ruth, Joe DiMaggio, and Mickey Mantle.

The old Boston Garden had some of the same sort of charm as Fenway. It also had rats. It matters to defenders of the old Boston Garden that Bill Russell played there, although Bill Russell has come to matter a lot more to people in Boston some decades after his retirement than he did when he was pulling on a Celtics jersey every night and taking the floor with Sam Jones,

K. C. Jones, and various other worthies, who didn't fill the building even when they reached the point where their championship rings outnumbered the fingers on which they could comfortably wear them.

The new Garden, where the Bruins and Celtics have been playing since the old Garden was torn down, would not be out of place in Indianapolis or San Antonio or Columbus. This is not meant as a compliment. The building feels as if it is part of the same movement that put a Starbucks on every corner. Like Starbucks, the new Garden is comfortable and overpriced, and it feels as if it was designed and built by the same people who designed and built the other places where NHL hockey and NBA basketball are played.

The NFL team associated with Boston plays in a town called Foxboro. Or Foxborough. The Patriots' home, Gillette Stadium, sits in the middle of a shopping mall full of restaurants and high-end shops. There is also a cinema complex, which is what movie theaters used to be called, for the days when the Patriots are winning by so much that at halftime everybody decides to go to a movie. Or a lot of movies, if they like.

There is also a big hotel, in case the traffic jam after the game goes on for so long that thousands of people decide to get a room.

So it could be argued that Green Bay is a better football town than Boston, which has no pro football team, and a better football town than Foxboro, too. Or Foxborough. It could be argued that Pittsburgh, and the aforementioned Indianapolis — where the stadium is downtown — and New York are also better football towns, because although the New York Giants play in New Jersey, at least they don't play in Foxboro. My brother-in-law is among those who would make the argument for Pittsburgh. He drives across the state of Pennsylvania to go to games there. He sits in freezing wind. He does not leave early to beat the traffic.

He talks about the last time he did this, and the next time he will do it, with enormous enthusiasm. The presence of people like him is the mark of a great football town.

Part of the reason some people don't consider Boston a great soccer town is that the soccer team associated most closely with the city also plays in Foxboro. The team plays in the same stadium that is filled for football games. When there's a professional soccer game there, the building's employees put enormous blue tarps over the acres of seats that haven't sold, in part because nobody has tried to sell them. This does not make the place look like a soccer stadium. It makes it look like a football stadium foolishly trying to conceal with enormous blue tarps the fact that it's a silly place to play soccer. Probably a great soccer town must be home to a team owned by somebody who cares enough about it to build it a proper workplace of its own, which Patriots owner Robert Kraft, for all his bonhomie and good works, has not done. Perhaps there was no room left when he'd finished with the shopping mall and the cinema complex and the hotel.

Boston is also home to the Boston Marathon, of course, which begins in Hopkinton. Though it finishes in Boston, you can comfortably watch it in Framingham, Newton, Brookline, and several other communities. When my daughters were small, we regularly watched the runners go by from the front yard of a house in Natick, where a friend of mine used to live. My daughters handed out water, oranges, and Kleenex to the runners as they went by. Or to some of the runners. The slower ones. The Kenyans and Ethiopians did not slow down to accept water or oranges or Kleenex. They were focused on winning the race. They probably had their own, prearranged water and fluid stops, and apparently they had trained their noses not to run.

Some of the runners who did need to blow their noses were so grateful to see my daughters standing at the side of the road

with Kleenex that they said "Thank you" even though they were running the Boston Marathon.

My daughters often said, "You're welcome."

"Good for them," I would think, and that brings me to the recollection of various other personal connections that make for the designation of a place as a good sports city, or maybe even a great one, one story at a time, because concerning all the preceding cranky business, I've just been fiddling and diddling, as the late, great Johnny Most used to say of whichever Celtic had the ball when Most didn't know where the ball would go next.

Anyway, personal connections. At Fenway Park during part of the tenure of manager John McNamara, coaches Johnny Pesky and Joe Morgan, both baseball lifers, could often be found at the end of the first-base dugout several hours before games. Apparently they had no pressing responsibilities. They passed the time playing a game in which one of them would toss out some of the characteristics of a ballplayer from their collective past, and the other would have to try to identify the player.

"OK, big right-hander, threw about three-quarters over the top, started with Cleveland, and bounced around a lot until somebody taught him to throw a sinker. Then he was pretty good."

"Joe Smith."

"Joe Smith was left-handed —"

"Not the Joe Smith I'm thinking of."

"— and he never played for Cleveland, which this guy did, or maybe it was Cincinnati."

"You can't — Cincinnati? How do you change it to Cincinnati now?"

The guessing and the derision that followed featured the language of the clubhouse, and the esteem in which Pesky and Morgan held each other was evident, as was the affection these two

baseball men had for each other, which taught me something about the world in which they lived that I'd not have experienced if I hadn't been in the dugout several hours before game time. The dugout was in Fenway Park, which is in Boston, and Boston was the place where that privilege was mine.

So there was that, and there was also the aftermath of the fifth game of the 1986 World Series, which also occurred in Boston. By winning that game, the Red Sox put themselves in a position to win their first championship since 1918, if they could beat the Mets in game six, which they didn't, or in game seven, which they also didn't, though by that time it didn't really surprise any of us. It did make us all feel more like a community than ever before, albeit a community of the doomed. This was not such a bad thing, because a community based on something sad is better than no community at all, and it was harmless. And it was also kind of fun in a perverse sort of way, so that some of us have actually been a little nostalgic about that time and place since the Red Sox won the World Series in 2004.

Football, hockey, and basketball fans more passionate than I am about the teams that play in Boston (or in Foxboro, or in Foxborough) could compile lists of their own experiences as evidence of the traditions both great and grim that accrete like barnacles in any place that claims it's a great sports town.

Then there are the soccer fans, of which I am surely one, and proudly so. As I've suggested, Boston is not a great soccer town when compared with, say, Barcelona, Rome, Munich, or London. (If it's an exaggeration to say that every block in London has a professional soccer team of its own, it's not much of an exaggeration.) But Boston has been home to a team in each of the three incarnations of women's pro soccer, and each of those teams has been called the Breakers. They have wandered like nomads from Nickerson Field on Commonwealth Avenue to the cavern-

ous and ridiculously inappropriate Soldiers Field across the river from Harvard Square to Dilboy Field in Somerville, which, like Foxboro, is not really Boston at all, and which, according to the songwriter Jonathan Richmond, has a sub shop on every corner — essential if you're trying to make it on a female pro soccer player's salary. The first two incarnations of the Breakers featured Kristine Lilly, who has represented her country a preposterous 352 times. This is a record that will not be broken until weird science has created a bionic soccer player impervious to age, injury, or the impulse to do something other than play soccer, such as start a family.

In their second incarnation, the Breakers were coached by Pia Sundhage. At press conferences, she sometimes sang. Energetically. Lots of people employed in the games industry have said they loved their work so much that they'd do it for free. Almost all of them are full of beans and bananas. I never heard Pia Sundhage say she'd have coached soccer for free, but if she said it, I'd believe her. While she was in Boston, she went a great distance toward making it a great sports town all by herself, at least for the fortunate people who took notice of her and her team.

Sundhage went on to coach the U.S. women's team that won the Olympic gold medal in 2008, and then the Swedish national team. My favorite Pia Sundhage story emerged when the U.S. national team star Megan Rapinoe announced that she, Megan, was gay. The question arose whether that would matter to her coach, and Rapinoe shrugged and said she didn't think so, since Sundhage had come out years earlier.

On the men's side, Boston soccer gave us the irrepressible Alexi Lalas in the first year of MLS's New England Revolution (aka the Foxboro Revolution). The league subsequently shipped him from town to town, figuring his flamboyance would scare up interest wherever it went, but I will always consider Lalas a

member of the Revolution, since he told me once while we were standing beside a noisy bus in New York City that it hadn't been his idea to leave the Revs, and I believed him. He said Boston was a great sports town.

And it is.

The tunnel between the visitors' dugout and clubhouse in Fenway Park stinks and leaks, and the water would swirl around the ankles of opposing players trying to reach the field if the groundskeepers didn't plunk down a temporary boardwalk each time the sky over Back Bay grew dark. What the hell? For all the renovations, additions, and upscale advertising signs, Fenway's an old ball yard. But it's our old ball yard, and most Bostonians who've seen a couple of games there feel pretty good about it, especially if they don't know that Ted Williams sometimes used to shoot pigeons off the girders over the grandstand.

They feel good about the marathon, too, even if they've only watched it on TV and never handed out tissues to the plodders, because for years the quirky race has been a part of the identity of the place where they've chosen to live. Other cities have marathons; Boston has Heartbreak Hill and its lesser siblings, and among the hills it has Johnny Kelly, preserved in a piece of statuary that has him running as the young man who won the race and as the old man who seemed as if he'd never stop running. What a brave and vainglorious idea for a statue. Maybe there ought to be one like that for Bill Rodgers, and one for Joan Benoit Samuelson, too.

Other cities have NHL teams, but none of them have Bobby Orr at his peak, then and now and forever. In lots of Boston bars and lesser places, he still soars across the crease, arms raised, young forever, after beating the Blues of St. Louis forty-three years ago so the Stanley Cup could come home.

The great risk here is that I've left out your favorite character

or characteristic of the Boston sports world. Check that. It's not a risk; it's a certainty. So, John Havlicek, Larry Bird, Bud Collins, Dom DiMaggio, Cy Young, Wade Boggs, Derek Sanderson, John Hannah, and Tom Brady. Am I still missing somebody? Of course I am. So complain to the sports-radio call-in show of your choice. We're Boston. We've got them in numbers, too.

The Landscape of Home

Carlo Rotella

I F YOU LIVE in the Boston area and you're not from around
here, you receive frequent reminders of your nonbelonging.
You can grow into this place only so far, and then you hit the
limit. I'm fine with that. Being an interesting place to live as an
outsider is part of what makes Boston not like other places. I'm
already from somewhere else — Chicago, a bigger and rougher
city, but also more welcoming to people from elsewhere — and
it feels to me as if the brisk stiff-arm of Boston localism sets me
up at just the right distance: close enough to appreciate the city's
idiosyncrasies, yet far enough to sustain a little healthy observa-
tional detachment.

But if you live anywhere long enough, even as an outsider,
the way of life there and the lay of the land itself will sink into
you. In matters of place and selfhood, as in so many other things,
who you are creeps up on you. Years and then decades go by in
which you vaguely assume that there's a you who you're going to

be when you grow up, and then you realize that you have been grown up for a while and this is you, pretty much for keeps.

I grew up as a person of the grid, the rectilinear layout imposed on the cities and countryside of the Midwest. I navigated by familiar right angles even when far afield from my home turf, and my experience of city life was arranged on the grid of Chicago like morning glories growing on a trellis. At the corner of 72nd and Oglesby a dog in a yard lay in wait to hurl itself against the chain-link fence and scare the daylights out of me on my way to the public library; at 43rd and Vincennes was the Checkerboard Lounge, where I learned to love my hometown music; I made at least two serious mistakes at 59th and Stony Island, and only undeserved dumb luck saved me each time. Leaving the grid, whether to ramble in the rundown reaches of Jackson Park or in the medieval cities of Europe, felt like an adventure — exciting but disorienting.

But I am a person of the grid no longer. Life in New England and especially in Boston, where straight lines are in short supply, has reversed my polarities. My new normal is the dense tangle of short, curving streets converging raggedly on a "square" with no 90-degree angles, a layout often likened to cow paths but perhaps more reminiscent of rabbit warrens. The trains of my branch of the Green Line, the D, weave through greenery that yields irregular strobe-glimpses of wooden back porches and brick façades, bent snatches of streetscape, scenes out of Miyazaki's dreamlike anime fantasies.

What feels strange to me now is to find myself on a long straightaway, like the tedium of Route 9 as it carries you away from the city toward Route 128. Even the orderly angles of the Back Bay feel a little too regular. The me I've become, the me Boston has shaped, wants to scrunch up any such foursquare arrangement, to make it satisfying by throwing in some hooked

lines and messy nodes that reward the eye even as they tangle the flow of movement.

Not far from my house in Brookline, just on the other side of Route 9, stands the Frederick Law Olmsted National Historic Site, the former house and office of America's greatest landscape architect. The parks of my childhood and young adulthood — Jackson Park in Chicago, Prospect Park and Central Park in New York — all bear his signature. Olmsted, who in my estimation rivals J. S. Bach when it comes to leaving the world a permanently better place than he found it, did more than anyone else to create the green breaks in the grid in which I had my adventures beyond the rectilinear, back when I was a person of the grid. And it was Olmsted, no friend of straight lines, who codified the principles that inform my adopted home ground: the beauty of a landscape is rooted not only in the sense of purpose that shaped it but also in the quality of surprise it offers even to a visitor who knows it well.

Purpose and surprise describes the seductive rise and fall of the garden and yard around Olmsted's house, a miniature landscape that feels far larger and calls out for repeated visits in different light and weather. The same goes for Boston's curiously shaped lots, dead ends, and obtuse angles, and for the ideal landscape without straight lines that's imprinted so deeply on me that it's now part of who I am.

As I've settled into life here, I've found myself wanting to take a hand in maintaining this landscape, especially the parts of it closest to home. Recently, for instance, I served as a citizen member of a design review committee planning the renovation of the park at the end of my street. Like having my kids in the nearby public school, doing my bit to help the Parks and Recreation

Commission fix up our well-used, well-loved park has given me a fresh appreciation of public life at the face-to-face level of the neighborhood.

Renovating the park, tucked away on a compact site between the D Line tracks and the backs of low-rise apartment buildings lining Beacon Street, struck me as a pretty straightforward proposition. It's not broken; it's just a little too broken-in. So, I figured, we should just plan to do the obvious things — put new equipment in the playground, regrade the field to solve flooding problems, resurface the basketball and tennis courts, maybe put in a loop path — and be sure not to do anything stupid, like cutting down trees or messing up the lovely grass slope that attracts sunbathers and sledders. We'd be done in no time, right?

Not so fast. The public meetings to discuss the design offered a primer in the dynamics that give a community its inner life. Parents with older kids didn't want the same things as parents with little kids. No matter how sensitive the dog people and skateboarders were to the positions of non–dog people or non-skaters, they couldn't quite accept that the special facilities they wanted would make the park less pleasant for everyone else. Abutters prioritized peace and quiet, especially after dark, which tended to pit them against skaters, basketball players, proponents of erecting a covered pavilion, and teenagers in general.

And during our deliberations I was repeatedly reminded just how important parks are to the very young and to the old. This natural alliance of the park's heaviest daily users wielded a combination of practical and moral authority that was usually potent enough to carry the day against all comers. Nobody wants to be seen as steamrolling preschoolers and grandparents.

I was also reminded that I'm kind of intolerant in my views about the purpose and form of public meetings. I see them as ex-

ercises in horse-trading pluralism in which participants choose their objectives and then drive toward them, bargaining whenever those interests come into conflict with others'. So I grew impatient when some people treated the committee's open meetings as occasions to philosophize, speculate, indulge fantasies of personal heroism, wax nostalgic, decry the downfall of all that was once good, identify nefarious conspiracies, or make off-topic suggestions about how to improve the world.

But I came to see that my impatience was misplaced. There was value in all that apparent digression. Longtime residents reminiscing about long-ago concerts or long-ago-removed play equipment showed me how the park figures in local routines and traditions that give shape to lives. While I was inclined in principle to dismiss overprotective parents' and fearful abutters' gripes, I learned to listen to thoughtful speakers who could locate the point where their own worries touched legitimate questions of public concern. I could even discern a useful purpose in rambling stand-up monologues about what's wrong with people today or what some terrible kids did to the neighbors' entryway. It was all part of the process of a community explaining to itself not only why it cared about its park but what it cared about, period.

We got to the finish line eventually, agreeing on a reasonable plan, comprehensive but not too fancy, that addressed the needs of most of the park's many different kinds of users. Our shared objective was a satisfying landscape, an essential amenity and quality-of-life issue, especially in a nose-to-screen age that encourages us to retreat from public space and the public life it makes possible. While our elected representatives in Washington seem to be going out of their way to make it harder to identify with the abstraction of national identity, it still feels easy and

natural to belong to a neighborhood, a school district, a city — this city. The park belongs to the community, but it's just as true that a community takes shape on the frame of the park.

Living in Boston, arriving at middle age as my kids grew into and then out of the park- and playground-intensive years that push a family into heavy use of public space, has made me intensely aware of how important good feng shui can be to one's quality of life. Much of this city just feels right to me: proportional, human-scaled, pleasingly irregular, densely layered with my own and others' lived experience. That's never more apparent than when I return home from traveling in China. I feel as if I'm coming back to a country estate or to a college campus between terms, a green and peaceful retreat where change happens in measured, carefully considered ways. It's probably not the first image that comes to mind when you think of Boston, but a little time in China could well alter your view.

Each time I've been in China, the impression of dynamic forward movement has been stronger. Cities are growing so fast and by such heroic leaps and bounds that even longtime residents can get disoriented. A government employee whose work takes him all over Anhui province told me, "If you work in the office for a couple of months, when you go out in the cities everything's different. I went to pick up my wife at the train station in my own hometown, and I couldn't find it."

Even second- and third-tier provincial cities like Huangshi and Lu'an — the Worcesters and Springfields of China — boast brand-new airports that put dowdy, dingy Logan to shame; massively transformative highway projects that make the Big Dig look like overpriced cosmetic surgery; bullet-train service that makes Amtrak's Acela look like a musket ball fired underwater;

and forests of new high-rises, going up thirty and fifty at a time, that make even the most hotly debated development in Boston seem modest by comparison.

The toll taken by that growth is equally apparent. All those construction projects add clouds of grit to the pollution pouring out of all the new cars on all those new roads and out of the coal-burning plants that provide power to the growing cities. The air's bad, the water's worse, and cityscapes are harsh studies in shades of gray.

When I get back from China I no longer take for granted the lush greenery along the D Line, or that I can walk with my kids down our street past trees, yards, and lawns to a park with a playground in it. Other newly appreciated daily pleasures: you can take a deep breath and not cough; you can drink tap water; you can swim without undue worry in various bodies of water around the region. If the Charles River, which most locals still regard as toxic, flowed through Wuhan or Chengdu, it would draw swimmers in daily packs — not just kids (in the rare moments when they weren't in school or studying) but also hardy senior citizens who would perform slow tai chi movements and slap their limbs to promote circulation before plunging in.

Some of the dramatic contrasts between Boston and Chinese cities can be chalked up to differences in wealth and function. Boston is a relatively rich postindustrial metropolis, a service and research center with its factory era mostly in its past; the cities of China are industrial centers, still relatively poor even as they fill the world's orders for manufactured goods while absorbing a folk migration of world-historical scale from rural hinterlands.

But some of the differences also have to do with civic culture, another aspect of life here for which I gain fresh appreciation each time I return from China. Michael Rawson, a historian at

Brooklyn College and the author of *Eden on the Charles: The Making of Boston*, put it this way: "It's always hard to say that there's a particular culture in one city that's had continuity over centuries, but it's more possible to say it of Boston. It's a place where the search for environmental permanence was born, at least for America, versus just tearing things down. Boston led the charge in developing an appreciation of historical land and historical buildings."

Eden on the Charles traces the rise in the nineteenth century of a set of related impulses: to control the destruction of land and buildings in the course of business as usual, to create a viable relationship between the city and nature, to determine whether amenities such as clean water are a privilege or a right. It's not a story of tree-hugging idealism. Rather, it's one of nature-themed political and cultural contests between Brahmins and immigrants, Boston proper and surrounding communities, private profit-makers and defenders of the public interest.

The result, Rawson told me, is that in nineteenth-century Boston there developed a lasting new civic priority: "to manage inevitable and wanton change and to balance it with what's already here." It became an important value that passed from elite culture into general circulation, marking a major change in American urbanism. "Up until then," said Rawson, "all of America had expected permanent change and not much else."

Rawson helped me understand why Boston seems old and well preserved in comparison to Chinese cities that are much older, some of them well over a thousand years older, but feel as if they were built with slipshod haste within living memory. If Boston sometimes feels poky when compared to them, it also feels more humane. That's not just because American society in general is more affluent. Boston's quality of comparatively slow, thoughtful continuity with its own past also has roots in a dis-

tinctive civic culture. That culture can be contentious and frustrating, its inbuilt obstructionist impulse drives developers crazy, and it doesn't always produce the right result (the example of Government Center leaps to mind), but I've come to appreciate it more and more as a crucial element of a livable city.

And I have come to appreciate, on both aesthetic and anthropological grounds, the sometimes bizarre ways in which the people of this city actually move through their landscape. One of the distinctive local traits that first struck me when I moved here sixteen years ago was the curious variety of gaits on display. Back then I lived in Huron Village in Cambridge, and I got used to seeing certain characters. There were, for example, the Lean and Hungry Tiny Steps People, a gaunt couple who had apparently made a study of running and concluded that six-inch strides were the key to efficient exercise. There was Witness Protection Man, who carried a big stick and wore shades and a parka, no matter what the weather, and appeared to stiffen into some kind of lockkneed imminent-threat mode whenever an oncoming stranger drew near. And there was the Rabbit Man of Cambridge, who walked at a terrific pace in the bike lane with an air of barely suppressed desperation, his upper body drastically levered forward from the hips. The Rabbit Man ate carrots and lettuce leaves while on the move, and a sort of hush seemed to travel with him. I'd feel the encroaching stillness and turn to spot him cresting a rise on the avenue, approaching like a prophesied event.

There was further peculiarity on two wheels, and on three — recumbent tricyclists, often with forked beard fluttering in the wind, who pedaled and hand-signaled with an air of ergonomic superiority. And on four, of course: drivers shouted empty threats or perhaps cries of distress as they swerved and lurched, tried to time the green light with a bold rush along the right-hand

curb, and counter-honked plaintively to register outrage at having been honked at by other, equally inept drivers. The drivers crashed into each other a lot, and it was hard to tell whether they were trying to avoid bikers and pedestrians or trying to run them down. The daily spectacle was quietly astonishing. To run along Huron Avenue and around Fresh Pond was to catch a glimpse of what a massive nerve-gas attack might look like in its early stages.

After a few years I moved across the river, where I encountered a new form: the Green Line Mock Panic. This is the dreamy, ground-skimming faux-sprint that a would-be T rider will employ to cross a busy street to get to a train already at the stop. It's not really a sprint at all, since to throw yourself headlong into traffic is even foolhardier in Boston than it would be elsewhere in America. The Green Line Mock Panic, rather, is a kind of mime show in which you accelerate negligibly from walking speed while performing a slow-motion parody of running all-out. You thereby put approaching drivers on the defensive and exert moral leverage on the train's operator. Given your ostensible willingness to risk all, what kind of savage would close the doors and leave you behind?

I got used to all this variation on the theme of getting from here to there, and I came to regard it as an expression of certain local cultural tendencies: the Yankee tradition of tinkering to improve on conventional ways of doing things; independence from standard definitions of looking silly that prevail everywhere else but here; and, of course, sheer cussedness.

I didn't think it had anything to do with me. I wasn't from here. I got around the normal way, just as I spoke standard American English without quaint regional flourishes. But a couple of years ago, after a run with a friend, the friend said, "You ever notice that you run with your elbows out, like you were protecting your

food in prison?" No, I hadn't, but it confirmed something my wife had told me not long before: "You know how you talk about the way people run in Cambridge? Well, you kind of run funny, too."

It's entirely possible that living here has done something to the way I run. Or maybe I always had within me the latent possibility of developing an odd gait, which drew me, subconsciously, to Boston, where I'd fit in when the oddness blossomed. Well, it has apparently blossomed, and perhaps it even allows me some partial access to a sense of belonging. You live around here and you run funny? Hey, so don't I.

Thinking Locally, Acting Globally

Neil Swidey

HERE'S SOMETHING I love about Boston: it can sometimes feel comically small.

In 2004, I sat down for dinner at a trendy Newbury Street bistro with Nomar Garciaparra. The fan-favorite Red Sox shortstop, who for years had been compared to Ted Williams as the face of the franchise, was now in the final year of his contract. His relationship with the club had turned poisonous, and his equation with the media was even worse. Garciaparra had gone so far as to make a masking-tape perimeter around his locker and declare it a reporter-free zone.

A lot of drama had preceded my sit-down with the prickly ballplayer, including the interruption of my interview with his parents at Nomar's house in Arizona when he had unexpectedly called home and was alarmed to learn of their cooperation with me. But a startling thing happened during this meal at Sonsie. Tight-lipped, tightly wound Nomar, whose rare interviews

tended not to exceed twelve minutes in duration, started talking, and kept talking, as my tape recorder rolled. The conversation was going so well that I was afraid to do anything that might disrupt the rhythm. After the waitress had repeatedly refilled our water glasses, I had a powerful urge to use the men's room. But like a child on an endless car ride along a desolate stretch of highway, I forced myself to hold it. When finally I relented and excused myself, I glanced down at my watch. We'd been talking for four hours.

The resulting article generated hundreds of letters and lots of impassioned commentary. But my favorite was an exchange on something called the Sons of Sam Horn, a Red Sox message board dominated by stat-head fanatics and unknown to most other fans. In my story, I had mentioned the unusual length of the interview, and that led one commenter to accuse me of being a fabulist. "No way did Nomar speak for four hours," he complained. "This guy's lying."

Before I could decide whether to rise to my own defense, another user chimed in. "Believe it. It's true," this commenter wrote. "I was their waitress, and it sucks to have a table not turn for four hours." (And here I thought I had tipped really well.)

Only in parochial Boston could the waitress serving you your medium-rare duck at an expensive restaurant also be trolling an obscure sabermetrics fan site in her off hours.

Yet here's something else I love about Boston: it can sometimes feel fully global.

That's true whether it's the former African leaders taking up residence at Boston University, the members of oil-flush Middle Eastern families checking into the city's hospitals for concierge health care, or the diplomats using Harvard and Tufts as negotiation/refueling stops between Geneva and Turtle Bay. And then there are all those restless minds at MIT whose ambition recog-

nizes no terrestrial boundaries and who toil away in their labs to shape tomorrow's world.

Or consider another of my most memorable meals. A few weeks after the September 11 attacks, I found myself sitting with Osama bin Laden's youngest brother, Abdullah, in his Cambridge apartment. It was the first interview any member of the mastermind's family had given since the twin towers came down. Abdullah had come to Boston from Saudi Arabia to study law at Harvard, and had liked it so much that he'd never left. Now he was leading me and a colleague on a short walk from his apartment to a dimly lit restaurant. The United States was still several days away from launching its war in Afghanistan, and several months away from helping to install Hamid Karzai as that country's new leader. So it wasn't until later that I grasped the significance of Abdullah's choice of restaurant, the Helmand. Here I was interviewing bin Laden's youngest brother at a restaurant owned by Karzai's older brother.

The real beauty of Boston is that it manages to be big and small at the same time. Few of the most popular stops on the standard Boston tourist itinerary convey that distinguishing civic characteristic. Not the Freedom Trail, not Faneuil Hall, not even Fenway Park. (OK, maybe Fenway does a little.) To appreciate this fully, make a pilgrimage to a small bridge tucked inside a building on Massachusetts Avenue.

The Mapparium is my favorite of the city's tourist attractions, even if relatively few tourists ever find their way there. It stands three stories high but is just thirty feet long. Like Boston itself, the place is small yet ambitious, intimate yet international, and in some ways absurdly rooted in its past.

The one-of-a-kind structure is a walk-in globe, made of glass and built to scale. Step onto the bridge and you can walk from

India to Ecuador. The 608 panes of stained glass that make up the globe feature bright colors and the names of dozens of countries and colonies that no longer exist, from Siam and Anglo-Egyptian Sudan to the Soviet Union. Although the world map painted inside the sphere was entirely accurate when the Mapparium opened in 1935, it's been frozen in time. The only panel that has been changed in more than seventy-five years sits just below the glass bridge, a few shades of ocean blue darker than the rest. It replaced one a worker accidentally shattered when he dropped his wrench.

The Mapparium's unusual acoustics add to its appeal. Shortly before my most recent visit, a young guy standing on one end of the bridge leveraged the globe's unusual whisper-gallery acoustics to propose marriage to his girlfriend standing on the opposite end.

The Christian Science Church built the Mapparium when both the church and its international newspaper, the *Christian Science Monitor*, were in their ascendency. Both have since suffered considerable decline, but like Boston itself, they work hard to prop up their standing by proudly displaying artifacts from a more influential time.

It's remarkable that the Christian Science religion could be born in Boston and that Boston could become the home of its world headquarters. The message engraved in the handsome marble of the domed Mother Church, a blend of Byzantine and Italian Renaissance architecture, memorializes founder Mary Baker Eddy's determination to reinstate primitive Christianity and spiritual healing. Despite the "science" in its name, it is a religion built on hostility to medical intervention. Yet just a couple of miles in either direction stand the world's finest hospitals and research labs, our temples to modern medicine, where the high priests push the limits of intervention a bit more every day.

The audio recording that plays in the Mapparium intones, "Our ideas shape and reshape the world we live in." In many ways, Boston is built on a powerful idea whose roots can be traced back to its rigid Puritan founding. Although it has been reshaped to embrace the coexistence that was painfully absent in those early days, the central message endures: if you believe in something, go all in.

In recent years, egged on by a generous tax credit, Hollywood filmmakers have turned Boston into a popular backdrop for their big-screen productions. Most of us Bostonians still haven't decided how to feel about this. We like the attention from the visiting A-listers, and the newspaper gossip columnists in town certainly enjoy the respite from having to pretend that our usual supply of weathermen and restaurant owners are real celebrities. But the many years of seeing the Boston accent butchered on-screen by characters packaged in a handful of cardboard variations — from the slippery Kennedyesque pol to the effete Harvard intellectual to the drunk yahoo in a Bruins jersey — have left us all with a little bit of posttraumatic cinematic stress.

A notable exception to this filmography of shame is *Good Will Hunting*. Sure, the breakout hit from Matt Damon and Ben Affleck includes a few of those stock characters in minor roles. But since the movie was made by our own guys, the accents are spot-on, and the performances are packed with both heart and authenticity. What's more, the film's central theme exposes the false choice embedded in the many oversimplified takes on this deceptively complex city. You don't have to choose between being smart and worldly and being loyal and local. Like Boston, you can be both.

Jamaica Pond: My Walden

Jessica Shattuck

Day 1

Everyone agrees that a writer should go for a walk when she is stuck or in need of inspiration. For me, a walk is not a walk unless it involves the path around Jamaica Pond. With three small children and limitless mundane details and logistics threatening to take over my brain, this fifty-three-foot-deep glacial kettle pond in the center of southwest Boston is my Walden. It is the most quietly inspiring and most democratic place I know.

This morning there are two white swans swimming in front of the pond's dying island — a tiny patch of land with two weeping willows elegantly slipping into the water. One of the swans sticks its head down under the pond's ruffled surface and the other follows. They stay that way for an improbably long time and come up almost in unison. Is this a result of coincidence? Longtime partnership? Some secret underwater swan language?

Jamaica Pond is a mecca for joggers of all stripes: middle-

aged Guatemalan women, marathoners in training, fit young couples pushing jogging strollers, an aggressively barefoot sixty-something runner with long, gray-nailed toes.

This morning, the barefoot runner is wearing a star-spangled unitard. He is followed by two large black men, possibly at the beginning of a lose-fifty-pounds pact, bare-chested with their shirts tucked into their waistbands. Sweat flies in cartoon splats onto the paved path. From behind, another regular: a Prufrock figure with tortoiseshell glasses and gray hair neatly parted and slicked against his scalp. He runs in a polo shirt, zippered cardigan, pleated khaki shorts, and bright modern sneakers I would guess a sales clerk picked out. He jogs with his elbows bent, hands dangling like underwear on a laundry line: embarrassing, revealing even, what is he to do with them?

Running is not the primary activity here at Jamaica Pond, though. The majority of the people on the path are good old-fashioned walkers. With dogs, with friends, with children. By my estimation, this is one of the last places people come to walk, alone, and not talk on their cell phones. If I were a photographer I would make a photo essay of this dying phenomenon and call it "Just Walking, Not Talking." Possibly no one would be interested. The faces of these not-talking walkers have something in common: they look sad, stricken even. I am always imagining awful traumas they have been through. But maybe this is just the modern human's resting expression.

There are also plenty of benches here at Jamaica Pond, and plenty of sitters, both regular and transient.

My favorite of these is the man I like to think of as the Human Pancake. Giant, white-haired, he wears only a pair of athletic shorts and sandals, and soaks up the sun without getting sweaty. He is roasted to a rich, slightly freckled brown. When he stands there must be pale rings where the folds of flesh were.

Day 2

The swans are gone. But along the trashy banks of the Perkins Street side of the pond, in a particularly mucky green-algae-filled cul-de-sac, there is an actual fish jumping at the surface. One, two, three times, and then it disappears, maybe taken down by some bigger fish? How big do the fish get here?

At this time of year there are babies everywhere at Jamaica Pond, and not just human. Baby turtles on a branch sticking out of the water, shiny and dark as polished stones. Ducklings, at least three families of these, and goslings too. The goslings are going through an awkward stage and have a feral quality, rushing and flapping their nubby, flightless wings, stretching their thin necks. Their parents seem overly subdued, hunched at the water's edge, ignoring their children. Judging by the numbers (who ever heard of a goose laying only two eggs?), they have probably all witnessed some sort of family tragedy. Which offers an explanation of sorts.

The nice weather has brought out the human babies in droves. With mothers and fathers and nannies and grannies. Especially Asian grannies pushing chubby-cheeked charges, who gaze out from their strollers like bored royalty.

The nannies and mothers from the islands are the strictest.

"Get away from those bushes!"

"Why?"

"Because I say so, that's why."

A simple equation I should learn to employ.

"Because I say so, that's why." My kids would probably go to bed on time and take good naps and eat their broccoli and never fight with each other if I could just be that succinct.

The Human Pancake is browning up nicely. This morning he

is visiting with a friend, a man of about his age (sixty? seventy?) in a baseball cap and track pants, holding a hefty Chihuahua. "You don't say *woof, woof, woof,* do you?" the friend is saying to his dog, holding it upright, the way you'd hold a baby. The dog looks smug and self-satisfied, chin tucked foolishly in a way that makes you understand why dogs, especially Chihuahuas, are the fodder for so many Hollywood kids' movies.

Two middle-aged women walk briskly along, talking about emotional transference. "It was a projection," one of them is saying. "I always do that . . ."

It gives me what I think is a brilliant idea to share with a friend who is a psychoanalyst: why don't you start a new school of therapy called "walk therapy" in which you go for walks while you talk with your clients? Wouldn't that be well suited to this age of multitasking? When I deliver her this little nugget of gold she tells me, very kindly, that it is *such* a good idea that it already exists. "It's very popular in L.A." That is what I call a Jamaica Pond Inspiration Buzz-Kill.

Day 3

Every spring the pond is stocked with pickerel, bass, and perch, so recreational fishermen flock to it.

The pond's best spot for fishing is a grassy, squarish promontory with a reedy poplar at the tip, trailing its lowest branches into the water. From here you can see across to the boathouse and down to a beach where dogs splash around, often, improbably (dangerously even), on those extendable leashes that seem likely to snag on something and drown them. On the lee side of this little promontory is a glassy black patch of fish-friendly water. For the past few mornings this has been occupied by an older Asian man sitting on an upturned bucket, wearing a glossy

duck-billed cap. He sits like a statue, hands on his knees, looking into the middle distance, fishing rod propped beside him.

Around the bend, in a rockier spot at the bottom of a steeper bank, there is a fisherman in waders who takes the opposite approach to fishing. He is all wiry movements, baiting his hook, swinging it out, reeling it back quickly. Like Brad Pitt in *A River Runs Through It*, except he's here at Jamaica Pond. And he has a little gray braid sticking out from under his cap like a curly piglet's tail.

Jamaica Pond is many things to many people. Sometimes, but rarely, there is a condom, or a broken vial trampled at the side of the path.

A little down from the Tudor-style boathouse and pavilion, where the pond is closest to the busy traffic of the Jamaicaway, there is a regular foursome of fishermen. Two are black, two are Puerto Rican. All seem to be good friends. They have an 1980s-style boom box tuned to talk radio and a small arsenal of propped fishing rods. "Here's my thing . . . ," one of them lays it out as I pass today. His buddies give up a chorus of ascent. Even with the traffic, Jamaica Pond is a good place to be heard.

When I first came to Jamaica Pond, I often saw a monk in full brown Friar Tuck robes walking around it. The nearby monastery has, in the past year, I understand, been racked by scandal, and I haven't seen him since then. But monks are not the only seekers here.

Day 4

Saturday morning is the morning of fathers and babies, fathers and toddlers. Big kids are noticeably absent here. They're off playing soccer, or going to tai chi class, School of Rock lessons, or hockey practice — a year-round possibility here in Boston — any

of the myriad Saturday-morning activities available to a modern, urban over-five-year-old.

The fathers of toddlers are all carrying balls and organizing challenges. The fathers of newborns are all focus, wearing vigilant, perplexed expressions and pushing their swaddled cargo in strollers capable of surviving the Apocalypse or climbing Kilimanjaro. Or they hold their babies tentatively in carriers, arms hovering mistrustfully, diaper bags banging around their hips.

Once I saw a man carrying his baby bare-handed. No carrier, no stroller. Just the path around the pond and a baby gazing out of his arms wide-eyed. It seemed dangerous. No gear! Nowhere to put the baby! Just walking! He looked defiant. Like someone making a statement, an anti-baby-industry protest even, a kind of Take Back the Night for infants.

The Courageous sailing school is open today. One chubby little sailboat puffs across the pond like a marshmallow floating in a cup.

On the path there are more joggers, more strollers, more chatterers than usual. There are even, it seems, more animals today. A whole family of black cormorants or egrets has convened on the dying island, a super-speedy turtle races down a drainage duct into the water, frightened by the foot traffic. The geese seem to be convening a flash mob.

And the swans are back, but out of synch. He lifts his head, swims; she submerges hers. She lifts up, looks around; he plunges his long neck underwater. There is an air of agitation to their movements; a pair of malcontents.

A sparrow shoots out of a submerged pipe, right out of its rusty craw, shaking off water, sputtering up into a tree. Is this possible? Can sparrows swim? Why not, I guess. Like the trees that ring the pond, submerged knee-deep in water, we all evolve.

Day 5

Sunday.

The swans are in synch again. They look happy but exhausted, floating, heads tucked back into their feathers. Now they're on the far side of the island, away from the egrets. And there is a new family of ducklings — tiny, the smallest I've ever seen. They pop effortlessly off the rocks into the water, like fuzzy gray tufts of cotton blown by the breeze. And their mother leads them nervously, quacking, lecturing — I've never heard a duck make so much low-pitched noise.

Sunday is the day of couples jogging together. Young and old, black and white, fit and not, the usual Jamaica Pond mix. There is a sleepy feeling all around. A laxness. A young family rides bikes on the path — strictly verboten here, but the little park service truck is nowhere in sight.

This is also the day of dogs and their owners. The new question is not What kind of dog is that? but Where did he come from? The modern urban canine companion in Boston, or at least here at Jamaica Pond, is a "rescue" found on Petfinder, a kind of Match.com that links humans (mostly from the North) to dogs (mostly from the South). Apparently, Southerners don't believe in spaying and neutering. Or Northerners think Southern dogs are cuter than their own local pound's pit-bull-mix offerings.

Four women are walking around the pond in bright-colored T-shirts and sensible shoes, carrying compact, over-the-shoulder purses. Generally, Jamaica Pond is not a big attraction for tourists — too far from the T, too removed from the gory Revolutionary War drama that people come to Boston looking for.

Jamaica Pond is largely unlandscaped. Unlike most other public parks, there are no beds of stiff little flowers, no carefully

mulched and trimmed plantings. There are a few extensive rose-bushes, brambly and wild, and some bold thickets of poison ivy. The trees along the edge are partially submerged in water at least half of the time, but they don't seem to suffer from this. The road is always close enough to be heard, in some sections close enough to throw a stone at, but somehow it is never obtrusive. The steady hum of traffic is part of what gives this pond life. Cut past the muscles and sinews of the city's streets, the bones and calcifications of its history, and here is a vital urban organ. Its liver, if not its heart — its lungs maybe. When you walk around it, you can feel the city breathing.

Hub Fans Bid Kid Adieu

John Updike

FENWAY PARK, IN Boston, is a lyric little bandbox of a ball-park. Everything is painted green and seems in curiously sharp focus, like the inside of an old-fashioned peeping-type Easter egg. It was built in 1912 and rebuilt in 1934, and offers, as do most Boston artifacts, a compromise between Man's Euclidian determinations and Nature's beguiling irregularities. Its right field is one of the deepest in the American League, while its left field is the shortest; the high left-field wall, 315 feet from home plate along the foul line, virtually thrusts its surface at right-handed hitters. On the afternoon of Wednesday, September 28, 1960, as I took a seat behind third base, a uniformed groundkeeper was treading the top of this wall, picking batting-practice home runs out of the screen, like a mushroom gatherer seen in Wordsworthian perspective on the verge of a cliff. The day was overcast, chill, and uninspirational. The Boston team was the worst in twenty-seven seasons. A jangling medley of

incompetent youth and aging competence, the Red Sox were finishing in seventh place only because the Kansas City Athletics had locked them out of the cellar. They were scheduled to play the Baltimore Orioles, a much nimbler blend of May and December, who had been dumped from pennant contention a week before by the insatiable Yankees. I, and 10,453 others, had shown up primarily because this was the Red Sox's last home game of the season, and therefore the last time in all eternity that their regular left fielder, known to the headlines as TED, KID, SPLINTER, THUMPER, TW, and most cloyingly, MISTER WONDERFUL, would play in Boston. "WHAT WILL WE DO WITHOUT TED? HUB FANS ASK" ran the headline on a newspaper being read by a bulb-nosed cigar smoker a few rows away. Williams' retirement had been announced, doubted (he had been threatening retirement for years), confirmed by Tom Yawkey, the Red Sox owner, and at last widely accepted as the sad but probable truth. He was forty-two and had redeemed his abysmal season of 1959 with a — considering his advanced age — fine one. He had been giving away his gloves and bats and had grudgingly consented to a sentimental ceremony today. This was not necessarily his last game; the Red Sox were scheduled to travel to New York and wind up the season with three games there.

I arrived early. The Orioles were hitting fungos on the field. The day before, they had spitefully smothered the Red Sox, 17–4, and neither their faces nor their drab gray visiting-team uniforms seemed very gracious. I wondered who had invited them to the party. Between our heads and the lowering clouds a frenzied organ was thundering through, with an appositeness perhaps accidental, "You *maaaade* me love you, I didn't wanna do it, I didn't wanna do it . . ."

The affair between Boston and Ted Williams was no mere summer romance; it was a marriage composed of spats, mutual

disappointments, and, toward the end, a mellowing hoard of shared memories. It fell into three stages, which may be termed Youth, Maturity, and Age; or Thesis, Antithesis, and Synthesis; or Jason, Achilles, and Nestor.

First, there was the now legendary epoch when the young bridegroom came out of the West and announced, "All I want out of life is when I walk down the street folks will say, 'There goes the greatest hitter who ever lived.'" The dowagers of local journalism attempted to give elementary deportment lessons to this child who spake as a god, and to their horror were themselves rebuked. Thus began the long exchange of backbiting, bat-flipping, booing, and spitting that has distinguished Williams' public relations. The spitting incidents of 1957 and 1958 and the similar dockside courtesies that Williams has now and then extended to the grandstand should be judged against this background: the left-field stands at Fenway for twenty years have held a large number of customers who have bought their way in primarily for the privilege of showering abuse on Williams. Greatness necessarily attracts debunkers, but in Williams' case the hostility has been systematic and unappeasable. His basic offense against the fans has been to wish they weren't there. Seeking a perfectionist's vacuum, he has quixotically desired to sever the game from the ground of paid spectatorship and publicity that supports it. Hence his refusal to tip his cap to the crowd or turn the other cheek to newsmen. It has been a costly theory — it has probably cost him, among other evidences of good will, two Most Valuable Player awards, which are voted by reporters — but he has held to it. While his critics, oral and literary, remained beyond the reach of his discipline, the opposing pitchers were accessible, and he spanked them to the tune of .406 in 1941. He slumped to .356 in 1942 and went off to war.

In 1946, Williams returned from three years as a Marine pilot

to the second of his baseball avatars, that of Achilles, the hero of incomparable prowess and beauty who nevertheless was to be found sulking in his tent while the Trojans (mostly Yankees) fought through to the ships. Yawkey, a timber and mining maharajah, had surrounded his central jewel with many gems of slightly lesser water, such as Bobby Doerr, Dom DiMaggio, Rudy York, Birdie Tebbetts, and Johnny Pesky. Throughout the late forties, the Red Sox were the best paper team in baseball, yet they had little three-dimensional to show for it, and if this was a tragedy, Williams was Hamlet. A succinct review of the indictment — and a fair sample of appreciative sports-page prose — appeared the very day of Williams' valedictory, in a column by Huck Finnegan in the *Boston American* (no sentimentalist, Huck):

> Williams' career, in contrast [to Babe Ruth's], has been a series of failures except for his averages. He flopped in the only World Series he ever played in (1946) when he batted only .200. He flopped in the playoff game with Cleveland in 1948. He flopped in the final game of the 1949 season with the pennant hinging on the outcome (Yanks 5, Sox 3). He flopped in 1950 when he returned to the lineup after a two-month absence and ruined the morale of a club that seemed pennant-bound under Steve O'Neill. It has always been Williams' records first, the team second, and the Sox non-winning record is proof enough of that.

There are answers to all of this, of course. The fatal weakness of the great Sox slugging teams was not-quite-good-enough pitching rather than Williams' failure to hit a home run every time he came to bat. Again, Williams' depressing effect on his teammates has never been proved. Despite ample coaching to the contrary, most insisted that they liked him. He has been generous with advice to any player who asked for it. In an increasingly combat-

ive baseball atmosphere, he continued to duck beanballs docilely. With umpires he was gracious to a fault. This courtesy itself annoyed his critics, whom there was no pleasing. And against the ten crucial games (the seven World Series games with the St. Louis Cardinals, the 1948 playoff game with the Cleveland Indians, and the two-game series with the Yankees at the end of the 1949 season, when one victory would have given the Red Sox the pennant) that make up the Achilles' heel of Williams' record, a mass of statistics can be set showing that day in and day out he was no slouch in the clutch. The correspondence columns of the Boston papers now and then suffer a sharp flurry of arithmetic on this score; indeed, for Williams to have distributed all his hits so they did nobody else any good would constitute a feat of placement unparalleled in the annals of selfishness.

Whatever residue of truth remains of the Finnegan charge those of us who love Williams must transmute as best we can, in our own personal crucibles. My personal memories of Williams began when I was a boy in Pennsylvania, with two last-place teams in Philadelphia to keep me company. For me, "W'ms, lf" was a figment of the box scores who always seemed to be going 3-for-5. He radiated, from afar, the hard blue glow of high purpose. I remember listening over the radio to the All-Star Game of 1946, in which Williams hit two singles and two home runs, the second one off a Rip Sewell "blooper" pitch; it was like hitting a balloon out of the park. I remember watching one of his home runs from the bleachers of Shibe Park; it went over the first baseman's head and rose methodically along a straight line and was still rising when it cleared the fence. The trajectory seemed qualitatively different from anything anyone else might hit. For me, Williams is the classic ballplayer of the game on a hot August weekday, before a small crowd, when the only thing at stake is the tissue-

thin difference between a thing done well and a thing done ill. Baseball is a game of the long season, of relentless and gradual averaging-out. Irrelevance — since the reference point of most individual contests is remote and statistical — always threatens its interest, which can be maintained not by the occasional heroics that sportswriters feed upon but by the players who always care; who care, that is to say, about themselves and their art. Insofar as the clutch hitter is not a sportswriter's myth, he is a vulgarity, like a writer who writes only for money. It may be that, compared to such manager's dreams as the manifestly classy Joe DiMaggio and the always helpful Stan Musial, Williams was an icy star. But of all team sports, baseball, with its graceful intermittences of action, its immense and tranquil field sparsely settled with poised men in white, its dispassionate mathematics, seems to me best suited to accommodate, and be ornamented by, a loner. It is an essentially lonely game. No other player visible to my generation concentrated within himself so much of the sport's poignance, so assiduously refined his natural skills, so constantly brought to the plate that intensity of competence that crowds the throat with joy.

By the time I was in college, near Boston, the lesser stars Yawkey had assembled around Williams had faded, and his rigorous pride of craftsmanship had become itself a kind of heroism. This brittle and temperamental player developed an unexpected quality of persistence. He was always coming back — back from Korea, back from a broken collarbone, a shattered elbow, a bruised heel, back from drastic bouts of flu and ptomaine poisoning. Hardly a season went by without some enfeebling mishap, yet he always came back, and always looked like himself. The delicate mechanism of timing and power seemed sealed, shockproof, in some case deep within his frame. In addition to injuries, there was a heavily publicized divorce, and the usual storms

with the press, and the Williams Shift — the maneuver, custom-built by Lou Boudreau of the Cleveland Indians, whereby three infielders were concentrated on the right side of the infield. Williams could easily have learned to punch singles through the vacancy on his left and fattened his average hugely. This was what Ty Cobb, the Einstein of average, told him to do. But the game had changed since Cobb; Williams believed that his value to the club and to the league was as a slugger, so he went on pulling the ball, trying to blast it through three men, and paid the price of perhaps fifteen points of lifetime average. Like Ruth before him, he bought the occasional home run at the cost of many directed singles — a calculated sacrifice certainly not, in the case of a hitter as average-minded as Williams, entirely selfish.

After a prime so harassed and hobbled, Williams was granted by the relenting fates a golden twilight. He became at the end of his career perhaps the best old hitter of the century. The dividing line falls between the 1956 and 1957 seasons. In September of the first year, he and Mickey Mantle were contending for the batting championship. Both were hitting around .350, and there was no one else near them. The season ended with a three-game series between the Yankees and the Sox, and, living in New York then, I went up to the Stadium. Williams was slightly shy of the four hundred at-bats needed to qualify; the fear was expressed that the Yankee pitchers would walk him to protect Mantle. Instead, they pitched to him. It was wise. He looked terrible at the plate, tired and discouraged and unconvincing. He never looked very good to me in the Stadium. The final outcome in 1956 was Mantle .353, Williams .345.

The next year, I moved from New York to New England, and it made all the difference. For in September of 1957, in the same situation, the story was reversed. Mantle finally hit .365; it was

the best season of his career. But Williams, though sick and old, had run away from him. A bout of flu had laid him low in September. He emerged from his cave in the Hotel Somerset haggard but irresistible; he hit four successive pinch-hit home runs. "I feel terrible," he confessed, "but every time I take a swing at the ball it goes out of the park." He ended the season with thirty-eight home runs and an average of .388, the highest in either league since his own .406, and, coming from a decrepit man of thirty-nine, an even more supernal figure. With eight or so of the "leg hits" that a younger man would have beaten out, it would have been .400. And the next year, Williams, who in 1949 and 1953 had lost batting championships by decimal whiskers to George Kell and Mickey Vernon, sneaked in behind his teammate Pete Runnels and filched his sixth title, a bargain at .328.

In 1959, it seemed all over. The dinosaur thrashed around in the .200 swamp for the first half of the season, and was even benched ("rested," Manager Mike Higgins tactfully said). Old foes like the late Bill Cunningham began to offer batting tips. Cunningham thought Williams was jiggling his elbows; in truth, Williams' neck was so stiff he could hardly turn his head to look at the pitcher. When he swung, it looked like a Calder mobile with one thread cut; it reminded you that since 1954 Williams' shoulders had been wired together. A solicitous pall settled over the sports pages. In the two decades since Williams had come to Boston, his status had imperceptibly shifted from that of a naughty prodigy to that of a municipal monument. As his shadow in the record books lengthened, the Red Sox teams around him declined, and the entire American League seemed to be losing life and color to the National. The inconsistency of the new superstars — Mantle, Colavito, and Kaline — served to make Williams appear all the more singular. And off the field, his private philanthropy — in particular, his zealous chairmanship of

the Jimmy Fund, a charity for children with cancer — gave him a civic presence matched only by that of Richard Cardinal Cushing. In religion, Williams appears to be a humanist, and a selective one at that, but he and the abrasive-voiced Cardinal, when their good works intersect and they appear in the public eye together, make a handsome pair of seraphim.

Humiliated by his '59 season, Williams determined, once more, to come back. I, as a specimen Williams partisan, was both glad and fearful. All baseball fans believe in miracles; the question is, how many do you believe in? He looked like a ghost in spring training. Manager Jurges warned us ahead of time that if Williams didn't come through he would be benched, just like everybody else. As it turned out, it was Jurges who was benched. Williams entered the 1960 season needing eight home runs to have a lifetime total of 500; after one time at bat in Washington, he needed seven. For a stretch, he was hitting a home run every second game that he played. He passed Lou Gehrig's lifetime total, and finished with 521, thirteen behind Jimmie Foxx, who alone stands between Williams and Babe Ruth's unapproachable 714. The summer was a statistician's picnic. His 2,000th walk came and went, his 1,800th run batted in, his 16th All-Star Game. At one point, he hit a home run off a pitcher, Don Lee, off whose father, Thornton Lee, he had hit a home run a generation before. The only comparable season for a forty-two-year-old man was Ty Cobb's in 1928. Cobb batted .323 and hit one homer. Williams batted .316 but hit twenty-nine homers.

In sum, though generally conceded to be the greatest hitter of his era, he did not establish himself as "the greatest hitter who ever lived." Cobb, for average, and Ruth, for power, remain supreme. Cobb, Rogers Hornsby, Joe Jackson, and Lefty O'Doul, among players since 1900, have higher lifetime averages than

Williams' .344. Unlike Foxx, Gehrig, Hack Wilson, Hank Green-
berg, and Ralph Kiner, Williams never came close to matching
Babe Ruth's season home-run total of sixty. In the list of major
league batting records, not one is held by Williams. He is sec-
ond in walks drawn, third in home runs, fifth in lifetime average,
sixth in runs batted in, eighth in runs scored and in total bases,
fourteenth in doubles, and thirtieth in hits. But if we allow him
merely average seasons for the four-plus seasons he lost to two
wars, and add another season for the months he lost to injuries,
we get a man who in all the power totals would be second, and
not a very distant second, to Ruth. And if we further allow that
these years would have been not merely average but prime years,
if we allow for all the months Williams was playing in subpar
condition, if we permit his early and later years in baseball to be
some sort of index of what the middle years could have been, if
we give him a right-field fence that is not, like Fenway's, one of
the most distant in the league, and if — the least excusable if —
we imagine him condescending to outsmart the Williams Shift,
we can defensibly assemble, like a colossus induced from the
sizable fragments that do remain, a statistical figure not incom-
mensurate with his grandiose ambition. From the statistics that
are on the books, a good case can be made that in the *combina-
tion* of power and average Williams is first; nobody else ranks so
high in both categories. Finally, there is the witness of the eyes;
men whose memories go back to Shoeless Joe Jackson — another
unlucky natural — rank him and Williams together as the best-
looking hitters they have seen. It was for our last look that ten
thousand of us had come.

Two girls, one of them with pert buckteeth and eyes as black as
vest buttons, the other with white skin and flesh-colored hair,

like an underdeveloped photograph of a redhead, came and sat on my right. On my other side was one of those frowning chest-less young-old men who can frequently be seen, often wearing sailor hats, attending ball games alone. He did not once open his program but instead tapped it, rolled up, on his knee as he gave the game his disconsolate attention. A young lady, with freckles and a depressed, dainty nose that by an optical illusion seemed to thrust her lips forward for a kiss, sauntered down into the box seat right behind the roof of the Oriole dugout. She wore a blue coat with a Northeastern University emblem sewed to it. The girls beside me took it into their heads that this was Williams' daughter. She looked too old to me, and why would she be sitting behind the visitors' dugout? On the other hand, from the way she sat there, staring at the sky and French-inhaling, she clearly was *some*body. Other fans came and eclipsed her from view. The crowd looked less like a weekday ballpark crowd than like the folks you might find in Yellowstone National Park, or emerging from automobiles at the top of scenic Mount Mansfield. There were a lot of competitively well-dressed couples of tourist age, and not a few babes in arms. A row of five seats in front of me was abruptly filled with a woman and four children, the youngest of them two years old, if that. Someday, presumably, he could tell his grandchildren that he saw Williams play. Along with these tots and second-honeymooners, there were Harvard freshmen, giving off that peculiar nervous glow created when a sufficient quantity of insouciance is saturated with enough insecurity; thick-necked army officers with brass on their shoulders and steel in their stares; pepperings of priests; perfumed bouquets of Roxbury Fabian fans; shiny salesmen from Albany and Fall River; and those gray, hoarse men — taxi drivers, slaughterers, and bartenders — who will continue to click through the turn-

stiles long after everyone else has deserted to television and tramporamas. Behind me, two young male voices blossomed, cracking a joke about God's five proofs that Thomas Aquinas exists — typical Boston College levity.

The batting cage was trundled away. The Orioles fluttered to the sidelines. Diagonally across the field, by the Red Sox dugout, a cluster of men in overcoats were festering like maggots. I could see a splinter of white uniform, and Williams' head, held at a self-deprecating and evasive tilt. Williams' conversational stance is that of a six-foot-three-inch man under a six-foot ceiling. He moved away to the patter of flashbulbs and began playing catch with a young Negro outfielder named Willie Tasby. His arm, never very powerful, had grown lax with the years, and his throwing motion was a kind of muscular drawl. To catch the ball, he flicked his glove hand onto his left shoulder (he batted left but threw right, as every schoolboy ought to know) and let the ball plop into it comically. This catch session with Tasby was the only time all afternoon I saw him grin.

A tight little flock of human sparrows who, from the lambent and pampered pink of their faces, could only have been Boston politicians moved toward the plate. The loudspeakers mammothly coughed as someone huffed on the microphone. The ceremonies began. Curt Gowdy, the Red Sox radio and television announcer, who sounds like everybody's brother-in-law, delivered a brief sermon, taking the two words "pride" and "champion" as his text. It began. "Twenty-one years ago, a skinny kid from San Diego, California . . ." and ended, "I don't think we'll ever see another like him." Robert Tibolt, chairman of the board of the Greater Boston Chamber of Commerce, presented Williams with a big Paul Revere silver bowl. Harry Carlson, a member of the sports committee of the Boston Chamber, gave him a plaque,

whose inscription he did not read in its entirety, out of deference to Williams' distaste for this sort of fuss. Mayor Collins, seated in a wheelchair, presented the Jimmy Fund with a thousand-dollar check.

Then the occasion himself stooped to the microphone, and his voice sounded, after the others, very Californian; it seemed to be coming, excellently amplified, from a great distance, adolescently young and as smooth as a butternut. His thanks for the gifts had not died from our ears before he glided, as if helplessly, into "In spite of all the terrible things that have been said about me by the knights of the keyboard up there . . ." He glanced up at the press rows suspended behind home plate. The crowd tittered, appalled. A frightful vision flashed upon me, of the press gallery pelting Williams with erasers, of Williams clambering up the foul screen to slug journalists, of a riot, of Mayor Collins being crushed. ". . . And they *were* terrible things," Williams insisted, with level melancholy, into the mike. "I'd like to forget them, but I can't." He paused, swallowed his memories, and went on, "I want to say that my years in Boston have been the greatest thing in my life." The crowd, like an immense sail going limp in a change of wind, sighed with relief. Taking all the parts himself, Williams then acted out a vivacious little morality drama in which an imaginary tempter came to him at the beginning of his career and said, "Ted, you can play anywhere you like." Leaping nimbly into the role of his younger self (who in biographical actuality had yearned to be a Yankee), Williams gallantly chose Boston over all the other cities, and told us that Tom Yawkey was the greatest owner in baseball and we were the greatest fans. We applauded ourselves lustily. The umpire came out and dusted the plate. The voice of doom announced over the loudspeakers that after Williams' retirement his uniform number, 9, would be permanently retired — the first time the Red Sox had so hon-

ored a player. We cheered. The national anthem was played. We cheered. The game began.

Williams was third in the batting order, so he came up in the bottom of the first inning, and Steve Barber, a young pitcher born two months before Williams began playing in the major leagues, offered him four pitches, at all of which he disdained to swing, since none of them were within the strike zone. This demonstrated simultaneously that Williams' eyes were razor-sharp and that Barber's control wasn't. Shortly, the bases were full, with Williams on second. "Oh, I hope he gets held up at third! That would be wonderful," the girl beside me moaned, and, sure enough, the man at bat walked and Williams was delivered into our foreground. He struck the pose of Donatello's David, the third-base bag being Goliath's head. Fiddling with his cap, swapping small talk with the Oriole third baseman (who seemed delighted to have him drop in), swinging his arms with a sort of prancing nervousness, he looked fine — flexible, hard, and not unbecomingly substantial through the middle. The long neck, the small head, the knickers whose cuffs were worn down near his ankles — all these clichés of sports cartoon iconography were rendered in the flesh.

With each pitch, Williams danced down the baseline, waving his arms and stirring dust, ponderous but menacing, like an attacking goose. It occurred to about a dozen humorists at once to shout, "Steal home! Go, go!" Williams' speed afoot was never legendary. Lou Clinton, a young Sox outfielder, hit a fairly deep fly to center field. Williams tagged up and ran home. As he slid across the plate, the ball, thrown with unusual heft by Jackie Brandt, the Oriole center fielder, hit him on the back.

"Boy, he was really loafing, wasn't he?" one of the collegiate voices behind me said.

"It's cold," the other voice explained. "He doesn't play well when it's cold. He likes heat. He's a hedonist."

The run that Williams scored was the second and last of the inning. Gus Triandos, of the Orioles, quickly evened the score by plunking a home run over the handy left-field wall. Williams, who had had this wall at his back for twenty years, played the ball flawlessly. He didn't budge. He just stood still, in the center of the little patch of grass that his patient footsteps had worn brown, and, limp with lack of interest, watched the ball pass overhead. It was not a very interesting game. Mike Higgins, the Red Sox manager, with nothing to lose, had restricted his major league players to the left-field line — along with Williams, Frank Malzone, a first-rate third baseman, played the game — and had peopled the rest of the terrain with unpredictable youngsters fresh, or not so fresh, off the farms. Other than Williams' recurrent appearances at the plate, the *maladresse* of the Sox infield was the sole focus of suspense; the second baseman turned every grounder into a juggling act, the shortstop did a breathtaking impersonation of an open window. With this sort of assistance, the Orioles wheedled their way into a 4–2 lead. They had early replaced Barber with another young pitcher, Jack Fisher. Fortunately (as it turned out), Fisher is no cutie; he is willing to burn the ball through the strike zone, and inning after inning the tactic punctured Higgins' string of test balloons.

Whenever Williams appeared at the plate — pounding the dirt from his cleats, gouging a pit in the batter's box with his left foot, wringing resin out of the bat handle with his vehement grip, switching the stick at the pitcher with an electric ferocity — it was like having a familiar Leonardo appear in a shuffle of *Saturday Evening Post* covers. This man, you realized — and here, perhaps, was the difference, greater than the difference in gifts — really

desired to hit the ball. In the third inning, he hoisted a high fly to deep center. In the fifth, we thought he had it; he smacked the ball hard and high into the heart of his power zone, but the deep right field in Fenway and the heavy air and a casual east wind defeated him. The ball died. Al Pilarcik leaned his back against the big "380" painted on the right-field wall and caught it. On another day, in another park, it would have been gone. (After the game, Williams said, "I didn't think I could hit one any harder than that. The conditions weren't good.")

The afternoon grew so glowering that in the sixth inning the arc lights were turned on — always a wan sight in the daytime, like the burning headlights of a funeral procession. Aided by the gloom, Fisher was slicing through the Sox rookies, and Williams did not come to bat in the seventh. He was second up in the eighth. This was almost certainly his last time to come to the plate in Fenway Park, and instead of merely cheering, as we had at his three previous appearances, we stood, all of us, and applauded. I had never before heard pure applause in a ballpark. No calling, no whistling, just an ocean of handclaps, minute after minute, burst after burst, crowding and running together in continuous succession like the pushes of surf at the edge of the sand. It was a somber and considered tumult. There was not a boo in it. It seemed to renew itself out of a shifting set of memories as the Kid, the Marine, the veteran of feuds and failures and injuries, the friend of children, and the enduring old pro evolved down the bright tunnel of twenty-two summers toward this moment. At last, the umpire signaled for Fisher to pitch; with the other players, he had been frozen in position. Only Williams had moved during the ovation, switching his bat impatiently, ignoring everything except his cherished task. Fisher wound up, and the applause sank into a hush.

Understand that we were a crowd of rational people. We knew that a home run cannot be produced at will; the right pitch must be perfectly met and luck must ride with the ball. Three innings before, we had seen a brave effort fail. The air was soggy, the season was exhausted. Nevertheless, there will always lurk, around the corner in a pocket of our knowledge of the odds, an indefensible hope, and this was one of the times, which you now and then find in sports, when a density of expectation hangs in the air and plucks an event out of the future.

Fisher, after his unsettling wait, was low with the first pitch. He put the second one over, and Williams swung mightily and missed. The crowd grunted, seeing that classic swing, so long and smooth and quick, exposed. Fisher threw the third time, Williams swung again, and there it was. The ball climbed on a diagonal line into the vast volume of air over center field. From my angle, behind third base, the ball seemed less an object in flight than the tip of a towering, motionless construct, like the Eiffel Tower or the Tappan Zee Bridge. It was in the books while it was still in the sky. Brandt ran back to the deepest corner of the outfield grass, the ball descended beyond his reach and struck in the crotch where the bullpen met the wall, bounced chunkily, and vanished.

Like a feather caught in a vortex, Williams ran around the square of bases at the center of our beseeching screaming. He ran as he always ran out home runs — hurriedly, unsmiling, head down, as if our praise were a storm of rain to get out of. He didn't tip his cap. Though we thumped, wept, and chanted "We want Ted" for minutes after he hid in the dugout, he did not come back. Our noise for some seconds passed beyond excitement into a kind of immense open anguish, a wailing, a cry to be saved. But immortality is nontransferable. The papers said that the other players, and even the umpires on the field, begged him to come

out and acknowledge us in some way, but he refused. Gods do not answer letters.

Every true story has an anticlimax. The men on the field refused to disappear, as would have seemed decent, in the smoke of Williams' miracle. Fisher continued to pitch, and escaped further harm. At the end of the inning, Higgins sent Williams out to his left-field position, then instantly replaced him with Carroll Hardy, so we had a long last look at Williams as he ran out there and then back, his uniform jogging, his eyes steadfast on the ground. It was nice, and we were grateful, but it left a funny taste.

One of the scholastics behind me said, "Let's go. We've seen everything. I don't want to spoil it." This seemed a sound aesthetic decision. Williams' last word had been so exquisitely chosen, such a perfect fusion of expectation, intention, and execution, that already it felt a little unreal in my head, and I wanted to get out before the castle collapsed. But the game, though played by clumsy midgets under the feeble glow of the arc lights, began to tug at my attention, and I loitered in the runway until it was over. Williams' homer had, quite incidentally, made the score 4–3. In the bottom of the ninth inning, with one out, Marlan Coughtry, the second-base juggler, singled. Vic Wertz, pinch-hitting, doubled off the left-field wall, Coughtry advancing to third. Pumpsie Green walked, to load the bases. Willie Tasby hit a double-play ball to the third baseman, but in making the pivot throw Billy Klaus, an ex–Red Sox infielder, reverted to form and threw the ball past the first baseman and into the Red Sox dugout. The Sox won, 5–4. On the car radio as I drove home I heard that Williams, his own man to the end, had decided not to accompany the team to New York. He had met the little death that awaits athletes. He had quit.

The Classroom of the Real

Pico Iyer

IN THE SPRING, toward the third week in April, the green appeared, and it was welcome after five hard months of snow and grit. There was no equivalent in England — only flowers — and none really in California, where there were splashes of extravagant color across the dry hills, and days of blue only a little deeper than the rest. But in Boston, spring felt earned, because of everything that had come after and would follow soon, and so the days had a shape to them, and the seasons had a meaning, of restoration and balance. I'd grown up between my parents' home in the endless summer of Santa Barbara and the low gray skies of school in England, and so it seemed only right, in search of a postgraduate education, to land up in a tough, resilient, red-brick city that was not quite cloistered and not quite wide open.

The many myths of Boston, accumulated over decades like the slush upon the sidewalk, came in on me the minute I arrived: the surfaces of the place seemed weathered, broken, tight, but

the minds were as sharp and pungent as their famous "Pahk your cah in Hahvad Yahd." My first week there, Allen Ginsberg came to my newly favorite beatnik coffee house, Passim, to shout out Bashō haiku in homemade translation: "Old pond / Frog jumps in / Kerplop!" The leaves began to turn and, on my initial trips around Concord and Walden, I saw how an individual soul's cry for independence might be set against a young nation's struggle for the same. The first week that our obligatory seminar The History of Criticism met, the whole city more or less stopped for a one-game playoff between the Sox and the hated Yanks, after an inevitable, almost impossible Boston collapse over the agonizing last few weeks. In the seventh inning, the scrappy, ninth-hitting Yankee shortstop, Bucky Dent, smasher of just forty home runs in five thousand professional plate appearances, hit the ball out of the park, and the Sox were gone, again.

That sense of tragedy, spiked with a stubborn passion — a rowdy sense of community and partisanship at once — all came together in what quickly proved to be the best sporting town I'd ever meet. The Celtics fans were so committed to the struggle that they'd make space even for a solitary Lakers supporter as we crowded into the Garden for the latest phase in the eternal Workingman-versus-Showtime matchup. At Fenway, both home team and visitor often seemed to attain double figures, so that games became four-hour slugfests in which each fighter ended up exhausted and bloody against the ropes. Sometimes, on Saturday afternoons, I traveled to beat-up areas in Dorchester to engage in table-tennis tournaments; much of what I learned in Boston came through long walks after midnight back from the Harvard Law School dorms, where I'd gone to watch the latest Magic Johnson–Larry Bird confrontation, broadcast from the Coast till one a.m.

Boston's pleasures were particular and grounded and had

none of the sleekness or international swagger of California or New York. For me they consisted of Chinese food at Fresh Pond and the hunks of meat on sale at Savenor's market. Charles Laquidara on WBCN and the poky bars of Somerville and Central Square. Elsie's sandwiches and little suburban cinemas and drivers who would train you for winning a grand prix in Varanasi or Marrakesh; the perfect place to watch Springsteen shout out, with hoarse and ragged warmth, his hymns of imprisonment and escape. I devoured the *Boston Phoenix* and the *Real Paper* every week, and the name of the latter caught something of what the town was imparting to all of us.

I spent only four years in Boston in all, but they were years of transformation. I made friends whose raptures and doubts would be with me for life — their names were Emerson and Thoreau, Dickinson and Melville — and I saw how a city could nurture some of the hopefulness of California, but in a frame that had everything to do with getting real: Boston was the home of revolutionary heroism — and hard luck ever since. It opened my eyes to Indian miniatures and the work of Cartier-Bresson, but only after I'd negotiated an unglamorous ride on the T to Commonwealth Avenue. After four years of weekly trips to the Three Aces pizza joint, I was accorded the ultimate effusive greeting — a single raised eyebrow from the taciturn Greek owner, Stan.

In the end, Boston gave me the two most important things any city can give you: a sense of possibility and a sense of limits. It was exactly this that it had conferred on so many visitors from far away, not least my grandfather, who'd ended up studying economics here just after World War I, and my one uncle on my mother's side, who'd come to Boston to learn science just as the next war broke out (and so been unable to go home). The place was harsh and uncensored and thick with grimy tradition,

and that gave it a humanity, even a solidity, that other places I'd haunted often lacked.

The lessons of Boston I learned came from those sturdy New Englanders called Henry and Waldo, who told us that we have more power inside us than we know, and that true learning is found only on the streets. The American Scholar is one who turns his back on the classroom and absorbs things on the pulse and in the clamor of right now. There was nothing airy-fairy or abstract about Boston, as there could be about parts of California and Oxford; it was home to the Combat Zone and Filene's Basement and a wind-chill factor you could feel in your bones.

I learned about the weather in Boston, and what costs it exacts and the rough sense of camaraderie it fosters. I learned that nothing is new under the sun and that that is how we remain unbroken. I learned about challenge and contention and how they make loss as temporary as victory, whether you're a city or a person, and enable you to withstand more in the future. And every April I felt a fresh and luminous radiance as the new green showed itself, in the midst of realest life.

This Is the Way I Point My View

Sally Taylor

WHITE SPIRES POINT at a porcelain-blue sky. Keys jangle. Red Converse sneakers prattle me up Newbury Street, across warming beige sidewalks that flash like paparazzi as I stroll. I'm not far from where the marathon bombing took place. It's been almost two months since that unthinkable atrocity, and while calm has been restored for the most part, there seems to be a "hic" without its relieving "cup" stuck in the hearts of most of us around here.

It's early still. The sun rolls down the street like it is going someplace luxurious and adventurous. Birds paint *tweeps* on a backdrop of silence while people in flip-flops keep time like indecisive metronomes. Suspensionless taxis chortle over potholes. Locals, butts clenched, stiff as chalk, walk like proper backslashes past me as I make myself comfortable outside a sunny coffee shop and sample a mocha from the local vendor.

A woman at the table next to me takes her sandals off to read

the paper. She jostles it considerately in a whisper and with a cinched brow, shoos a sparrow who's had the audacity to land on her table. Looking at her, I recall my mother warning me not to make silly faces, that my face might get stuck that way, and I realize she might have been right. This woman's face is stuck in a scowl so deeply etched no Botox could erase it, and I feel compassion for her and all the metaphorical sparrows she's shooed away in her lifetime.

Green copper drools down brick façades. Awnings look like batting eyelashes in the warm breeze. They beckon Come In as they flirt knowingly above their Closed sign. There's a cough going around. I have the ends of it. So does the woman in camouflage pants to my left. The frizz around her head lights up like a halo backlit as she is against the sun. She's tucked her chin deeply into her neck to allow her eyes to scale her glasses, which clearly inhibit her ability to read her iPhone. Our coughs converse accusingly without us. I wonder what they're saying in their rude, barking tones. The scent of bakers manipulating butter and yeast and sugar caresses the morning air. It comes in waves, moving me like a song and then it's gone.

Acknowledgments

This is the time and place to acknowledge.

I am not from Boston. I acknowledge that that might engender, the question: how could someone from somewhere else (a New Yorker, no less) do justice to editing a book about Boston? That would be akin to a man from Medford becoming mayor of New York.

Ever since taking three trips to Ireland, when I was a kid, I have been in love with virtually everything to do with it — the place, the people, the sensibility, the green, all of it. I started harboring a dream of becoming the first Jewish quarterback at Notre Dame. And the seeds were planted to become whatever the equivalent of a Francophile would be for all things Irish, Celtic ... And very early, it struck me that Massachusetts was America's Ireland. Or better yet, as Madeleine Blais puts it in her piece, that Boston is "Dublin West."

I took my first trip to Boston, a school class trip, when I was fifteen. It was a short trip, but something stuck, and it was like an open-faced grilled cheese sandwich, pushed together and pulled

apart, and though I left no mark on Boston, part of it was from then on inextricably part of me.

That was 1979. The same year that Larry Bird came to Boston. Starting then, and to this day, some of my oldest and closest friends call me Bird — nothing to do with my having a big beak, and everything to do with my all-time favorite player. That was also the year that Mike Milbury and friends famously climbed the glass at Madison Square Garden. I was there that night. Wearing a Terry O'Reilly jersey.

Born and bred in Manhattan, I went to college in New England, and felt something change, a good kind of undertow pulling, a sense that while my virtual DNA is in New York, along with family, friends, forever Proustian experiences, and so much else, I was more of a New Englander at heart, at core.

Never was that more deeply felt, more intensified, more crystallized than on April 15, 2013. Growing up, I'd never heard of Patriots' Day, embarrassingly provincial as I was. Starting in freshman year at Brown, though, I saw it on the local calendar, and once it arrived, and I experienced it, even at a slight remove in Providence (Boston's little cousin?), I remember well the mischievous pleasure and freedom of not just not going to class, but of watching the Red Sox play not just a weekday day game, but a morning game. And then the marathon. The glory, festivity, celebration of it all.

Ever since the bombings, I've felt a kind of inner Bostonian unleashed. And now, as never before, I feel connected with all things Boston-related, with the zealotry of a convert. From Hondo to Rondo, Kennedy to Kerry, Dunkin' Donuts to *Make Way for Ducklings*, jimmies to the Jimmy Fund.

Boston has given so much to so many. On the most intimate level, it has given me the Solomons — Richard and Ann, John

and Jimmy, all of whom were born in Boston — who are family to me.

Three days after the bombings, when the initial shock began to abate a little, I asked myself, What can I do? How can I possibly help? One thing I wanted to try to do was put together this book and give anything that might come from it to what would become the One Fund, to benefit the victims and their families. I wanted it to be an homage to Boston, a loving tribute to all things Boston, a book for Boston and Bostonians and beyond, a book about what makes Boston the special, endearing, and enduring place that it is. What makes Boston Boston.

All of those wants would have been for naught had it not been for the Boston-based Houghton Mifflin Harcourt and the writers whose work appears in this book.

When I sent Bruce Nichols, the publisher at Houghton, the germ of the idea for this book, he responded immediately, viscerally, perfectly, and galvanized support — complete and unconditional — from everyone at the house, Gary Gentel, president of trade publishing, on down, instilling a spirit the likes of which I have never seen from any publisher for any book.

In a digital culture, book publishing continues to move, for the most part, at a glacial pace. All the more astonishing, then, that Houghton was able to do everything it did to make the vision for the book a reality and to publish it six months to the day after Patriots' Day.

I'm indebted to Tim Mudie, who was a fantastic in-house editor for this book and did everything masterfully. Michelle Bonanno is simply the best publicist with whom I have worked, and I feel very lucky to have her championing this book. All the considerable credit for the book's cover design goes to Mark Robinson. Also at Houghton, my sincere gratitude to Brian Arundel, Laura Brady, Laurie Brown, Ken Carpenter, Larry Cooper, David

Eber, Lori Glazer, Carla Gray, Andrea Schulz, and Michaela Sullivan.

The book was, by definition, a labor of love for everyone, and for nobody more than the writers presented here. They worked magnificently, passionately, selflessly, inspirationally. When the pieces began to come in, on deadline, one on top of the other, it felt like witnessing gold coins cascading out of a slot machine on that rarest of occasions when one hits the jackpot.

If only I could adequately express my awe, admiration, and appreciation for what these writers did. But it's otherwise ineffable. Together, their work embodies the title of E. B. White's "Boston Is Like No Other Place in the World, Only More So." It testifies to their devotion to Boston that so many did what they did in such a short time. They gave much and received nothing in return. Ages ago, I first learned the word "altruism" in a book written by the great Robert Coles, a Bostonian himself. The contributors here are altruism personified.

My gratitude to those who helped facilitate and make some of the contributions to the book possible, including the George Plimpton estate, the John Updike estate, Ethan Bassoff, Deborah Garrison, Bette Graber, Will Lippincott, Maria Massie, Derek Parsons, Ann Rittenberg, Lauren Rogoff, Mark Strand, and Richard Wilbur.

Special thanks to Elizabeth Kurtz, who is like my own personal GPS.

My admiration and appreciation to Phillip Lopate and David Ulin for their bar-setting books *Writing New York* and *Literary Los Angeles*, respectively.

Thanks for your assistance, in many forms, to Jaime Clarke and Mary Cotton, Renee Coale, Kyle Damon, Robin Desser, Darcy Frey, George Gibson, Ellyn Kusmin, Beth Laski, Dan-

iel Menaker, Anton Mueller, Heidi Pitlor, Johnny Temple, Alec Wilkinson, and Ande Zellman.

Thank you to the Collegiate School for that class trip in ninth grade and beyond. Eternal gratitude to Mary Kelly, who took me on those seminal trips to Ireland, to her family there, and thanks to my mother for letting me take those trips. Thank you to my family and all my friends for your support.

To Boston's first responders, you can never be thanked and praised enough. I salute you.

When it comes to Boston, even if I am not a native son, it has always felt very personal, and never more than this moment. I hope and plan to move to Boston, at long last, next year, and, to paraphrase James Taylor, in my mind, I'm already gone.

John F. Kennedy is never far from my thoughts, and in the past few months three things he said have strongly resonated:

Ask not what your country can do for you; ask what you can do for your country.

A rising tide lifts all boats.

Ich bin ein Berliner.

In the aftermath of the bombings, the brave struggles to heal, and the determination to move ever onward, and with reverence for President Kennedy, his strong words allow me to paraphrase Kennedy:

Ask not what your Boston can do for you; ask what you can do for your Boston.

A rising Boston lifts all Americans.

We are all Bostonians.

This is for you, Boston.

With love,
Bird

Contributors' Biographies

André Aciman was born in Alexandria, Egypt, and is an American memoirist, essayist, novelist, and scholar of seventeenth-century literature. His work has appeared in *The New Yorker*, the *New York Review of Books*, the *New York Times*, the *New Republic*, *Condé Nast Traveler*, the *Paris Review*, and *Granta*, as well as in many volumes of *The Best American Essays*. Aciman received his PhD in comparative literature from Harvard University and is chair and distinguished professor of comparative literature at the Graduate Center of the City University of New York. Aciman is the author of the Whiting Award–winning memoir *Out of Egypt* and of three novels, *Harvard Square*, *Eight White Nights*, and *Call Me by Your Name*, for which he won the Lambda Literary Award for men's fiction. He is also the author of two essay collections, *False Papers* and *Alibis*.

Jabari Asim is an associate professor of creative writing at Emerson College and the executive editor of the NAACP's *Crisis* magazine. His books include *The N Word: Who Can Say It, Who Shouldn't, and Why*; *A Taste of Honey: Stories*; and *Fifty Cents and a Dream: Young Booker T. Washington*. He has received two NAACP Image Award nominations and a Guggenheim fellowship. He lives outside Boston with his wife and children.

James Atlas is the author of *Delmore Schwartz: The Life of an American Poet,* which was nominated for a National Book Award, and of *Bellow: A Biography.* He was the editor of the series Penguin Lives and two other series of brief biographies, Eminent Lives and Great Discoveries. He worked for many years at the *New York Times,* first at the *Book Review* and then at the *Magazine.* He has been a staff writer for *The New Yorker,* the *Atlantic,* and *Vanity Fair.* He is currently writing a book called *The Shadow in the Garden: A Biographer's Tale,* about his adventures in the trade.

Mike Barnicle was a *Boston Globe* columnist for twenty-five years, writing three times a week about Boston and beyond. Today he is a regular on the MSNBC *Morning Joe* program, seen each weekday morning from 6 to 9 a.m.

Madeleine Blais is a Pulitzer Prize–winning journalist and the author of a collection of her work, *The Heart Is an Instrument;* a memoir, *Uphill Walkers;* and the story of a girls' championship basketball team, *In These Girls, Hope Is a Muscle,* a finalist in nonfiction for the National Book Critics Circle Award and chosen by ESPN as one of the top one hundred sports books of the twentieth century. Blais teaches in the journalism department at the University of Massachusetts and has served as a visiting professor in Goucher College's MFA program in creative nonfiction, as well as a writer-in-residence at Florida International University in Miami.

Few people are as synonymous with tennis as the legendary journalist and expert historian **Bud Collins**. For more than fifty years, Collins has artfully delivered the greatest stories of the sport to fans around the world through eloquent and insightful newspaper coverage and dynamic, engaging television broadcasts. He has written for the *Boston Globe* for half a century, covering all sports, as an op-ed columnist, and as a war correspondent in Vietnam. His TV credentials include all the major U.S. networks as well as networks around the world. He is currently with the Tennis Channel. In 1994, in recognition of his im-

mense contributions to tennis, he was inducted into the International Tennis Hall of Fame. In 2002 Collins was elected to the National Sportswriters and Sportscasters Hall of Fame. In 1999 he received the AP Red Smith Award, the highest honor in sportswriting. He is also an award-winning tennis player.

George Howe Colt is the author of *November of the Soul: The Enigma of Suicide* and *The Big House: A Century in the Life of an American Summer Home,* which was a finalist for the 2003 National Book Award in nonfiction. His most recent book, *Brothers,* was the winner of the 2013 Massachusetts Book Award in nonfiction. He lives with his family in western Massachusetts.

Kevin Cullen is an author and a columnist for the *Boston Globe.* He was part of the *Globe*'s investigative team that won the Pulitzer Prize for public service in 2003 for exposing the cover-up of sexual abuse of minors by Catholic priests. As a columnist, he is the only two-time winner of the Batten Medal from the American Society of Newspaper Editors. In the aftermath of the Boston Marathon bombings, his columns about the bravery of first responders, the courage of victims, and the defiance of his city led CBS's Norah O'Donnell, among others, to dub him "the voice of Boston" in the wake of the attack. He is the coauthor, with Shelley Murphy, of the *New York Times* bestseller *Whitey Bulger: America's Most Wanted Gangster and the Manhunt That Brought Him to Justice.*

Hugh Delehanty is a best-selling author and an award-winning editor for several national magazines. His most recent book, *Eleven Rings: The Soul of Success,* written with former NBA coach Phil Jackson, debuted at number one on the *New York Times* bestseller list. *Sacred Hoops,* another bestseller he wrote with Jackson, is widely regarded as a modern sports classic.

Leslie Epstein is the son and nephew of, respectively, Philip and Julius Epstein, the writers of *Casablanca* and fifty other great films from

Hollywood's great age. He is the father of Theo Epstein. Hence he is the only sandwich in the history of the world with the meat on the outside. On the inside, he has written eleven books of fiction and directed the creative writing program at Boston University for more than thirty years.

Israel Horovitz's plays have been translated and performed in as many as thirty languages. His seventy-plus plays include *Line* (now in its thirty-ninth year of continuous performance, off-Broadway, at the 13th Street Repertory Company), *The Indian Wants the Bronx*, *Rats*, *The Wakefield Plays*, *The Widow's Blind Date*, *Today I Am a Fountain Pen*, *Park Your Car in Harvard Yard*, *North Shore Fish*, *Sins of the Mother*, and his newest drama, *Gloucester Blue*. His screenplays include *Author! Author!*, *The Strawberry Statement* (Prix du Jury, Cannes Film Festival), *Sunshine* (European Academy Award, Best Screenplay), and the Emmy-nominated *James Dean*. His awards include the Obie (twice), the Prix Plaisir du Théâtre, the Prix Italia (for radio plays), the Writers' Guild of Canada's Best Screenwriter Award, the Drama Desk Award, an Award in Literature of the American Academy of Arts and Letters, and many others. Horovitz is the founding artistic director of the Gloucester Stage Company and is the acting artistic director of the New York Playwrights' Lab. Horovitz is married to Gillian Adams-Horovitz and is the father of five children.

Pico Iyer is the author of two novels and eight works of nonfiction, including *Video Night in Kathmandu*, *The Lady and the Monk*, *The Global Soul*, and most recently *The Man Within My Head*. Born in England to Indian parents, and raised between England and California, he found himself a typical Bostonian for four life-changing years in his early twenties.

Pagan Kennedy, the innovation columnist for the *New York Times Magazine*, has authored ten books and written for dozens of magazines and newspapers. A 2010 fellow at MIT's Knight Science Jour-

nalism Program, she has also been awarded an NEA fellowship for her fiction, as well as two Massachusetts Cultural Council grants and several other literary prizes. Her essay in this book originally appeared in *Ms.* magazine in 2001; Pagan and Liz still consider each other "Boston spouses," even though they now live apart.

Dennis Lehane grew up in the Dorchester section of Boston's inner city. Since his first novel, *A Drink Before the War,* won the Shamus Award, he's published nine more novels, which have been translated into more than thirty languages and become international bestsellers: *Darkness, Take My Hand; Sacred; Gone Baby Gone; Prayers for Rain; Mystic River; Shutter Island; The Given Day; Moonlight Mile;* and *Live by Night,* which won the Edgar Award for Best Novel in 2013. He also published *Coronado,* a collection of five stories and a play, and *Mystic River, Gone Baby Gone,* and *Shutter Island* have been made into award-winning films. Lehane adapted his short story "Animal Rescue," which appeared in *Playboy* as well as in *Boston Noir,* as a feature for the Chernin Company and Fox Searchlight. Lehane has an MFA from Florida International University and is the writer-in-residence at Eckerd College, in St. Petersburg, Florida, where he runs the Writers in Paradise writers' conference. Before becoming a full-time writer, Lehane worked as a counselor with mentally handicapped and abused children, waited tables, parked cars, drove limos, worked in bookstores, and loaded tractor-trailers. He and his wife and children live outside Boston.

Bill Littlefield hosts NPR's weekly sports program *Only a Game,* from WBUR in Boston. He is the author of two novels, *Prospect* and *The Circus in the Woods,* and four other books, and he is writer-in-residence at Curry College in Milton, Massachusetts.

Charles McGrath, a contributing writer to the *New York Times,* is the former editor of the *Times Book Review* and former deputy editor of *The New Yorker.* He divides his time between New Jersey and Massachusetts.

David Michaelis, author of the national bestsellers *N. C. Wyeth* and *Schulz and Peanuts*, is writing a new life of Eleanor Roosevelt.

Tova Mirvis is the author of *The Ladies Auxiliary*, a national bestseller, and *The Outside World*. Her third novel, *Visible City*, will be published in 2014. Mirvis's essays have appeared in the *New York Times Book Review, Commentary, Good Housekeeping*, and *Poets and Writers*, and her fiction has been broadcast on National Public Radio. She has been a visiting scholar at the Brandeis University Women's Studies Research Center and was the recipient of a Massachusetts Cultural Council fiction fellowship. She lives in Newton, Massachusetts, with her three children.

Leigh Montville is the author of eight books, mostly biographies. A sports columnist at the *Boston Globe* for twenty-one years, a senior writer at *Sports Illustrated* for nine, Montville has also delivered commentaries for the CNN/SI television network and written for a range of other publications. He has interviewed most of the famous and infamous sports-page names of the past fifty years and covered more than twenty Super Bowls, at least a dozen World Series, numerous big prizefights, eight Olympic Games, the Tour de France, NASCAR, the Kentucky Derby, the Indy 500, and the First Gulf War. Montville is also the recipient of the Cable Ace Award for television commentary, a National Headliners Award for local feature columns, the Casey Award for Best Baseball Book of 2004, and a National Association of Black Journalists award for Best Magazine Article. In 2009 he was named to the National Sportscasters and Sportswriters Hall of Fame.

Susan Orlean has been a staff writer for *The New Yorker* since 1992 and is the author of eight books, including *The Orchid Thief, The Bullfighter Checks Her Makeup, Saturday Night*, and most recently *Rin Tin Tin: The Life and the Legend*, which won the Ohioana Book Award and the Theatre Library Association's Richard Wall Memorial

Award. *Red Sox and Bluefish*, a compilation of her columns for the *Boston Globe*, in which she attempted to deconstruct the character of New England, was published in 1987. Orlean graduated from the University of Michigan. She lived in Boston in 1982 to 1986, working at the *Boston Phoenix* and the *Boston Globe*. She returned to the city in 2003 as a Nieman fellow at Harvard University. These days, she lives in Los Angeles and in upstate New York with one dog, two cats, eight chickens, three turkeys, and her husband and son.

Robert Pinsky's recent works include his *Selected Poems* and *Poem-Jazz*, a CD with Grammy-winning pianist Laurence Hobgood. As a United States Poet Laureate, he founded the Favorite Poem Project (www.favoritepoem.org), in which thousands of Americans — of varying backgrounds, all ages, and from every state — shared their favorite poems. Pinsky celebrates his own favorite poems in his newest anthology *Singing School: Learning to Write (and Read) Poetry by Studying with the Masters* (Norton, August 2013). Pinsky teaches in the Creative Writing Program at Boston University.

George Plimpton (1927–2003) was editor of the *Paris Review* for fifty years. He was also the author and editor of numerous books and was known as a pioneer of "participatory journalism," in which he wrote about his experiences as an amateur participant in professional sports. Among his works are *The Curious Case of Sidd Finch*, *Paper Lion*, and *Truman Capote*.

Katherine A. Powers lives across the river from Boston, in Cambridge. She wrote literary columns for the *Boston Globe* for twenty years and now writes "A Reading Life" for the *Barnes and Noble Review*. She is the editor of *Suitable Accommodations: An Autobiographical Story of Family Life: The Letters of J. F. Powers, 1942–1963*.

Carlo Rotella is director of the American Studies program at Boston College. His books include *Playing in Time: Essays, Profiles, and*

Other True Stories; Cut Time: An Education at the Fights; Good with Their Hands: Boxers, Bluesmen, and Other Characters from the Rust Belt; and *October Cities: The Redevelopment of Urban Literature.* He has been a Guggenheim fellow and received the Whiting Writers' Award, the L. L. Winship/PEN New England Award, the *American Scholar*'s prize for Best Essay and Best Work by a Younger Writer, and U.S. Speaker and Specialist grants from the State Department to lecture in China and Bosnia. He writes for the *New York Times Magazine,* he writes an op-ed column for the *Boston Globe,* he has been a regular commentator on WGBH, and his work has also appeared in *The New Yorker, Critical Inquiry, American Quarterly,* the *American Scholar,* the *Believer,* and *The Best American Essays.*

Nell Scovell is a journalist and TV writer who has worked on a broad range of shows, including *The Simpsons, Coach, Murphy Brown, Monk,* and *NCIS.* She created *Sabrina, the Teenage Witch* for ABC, which ran for seven seasons. Her print work has appeared in *Vanity Fair, Rolling Stone,* and the *New York Times Magazine.* In 2013 Scovell cowrote the best-selling *Lean In* with Sheryl Sandberg. Her Massachusetts roots run deep: Her mother was born in Fall River. Her father was born in Brockton. Her grandparents lived in Brookline and Brighton. She was delivered at Boston Lying-In Hospital, raised in Newton, educated at Harvard, and her first professional writing job was covering high school sports for the *Boston Globe.*

Jessica Shattuck is the author of the *New York Times* Notable Book *The Hazards of Good Breeding* and *Perfect Life.* Her short fiction has appeared in *Open City, Glamour,* and *The New Yorker,* among other publications.

Susan Sheehan is the author of eight books, including the Pulitzer Prize–winning *Is There No Place on Earth for Me?* She has been a staff writer for *The New Yorker* for over forty-five years and a contributing writer for *Architectural Digest* for fifteen years.

David M. Shribman, executive editor of the *Pittsburgh Post-Gazette*, grew up on Boston's North Shore. He was educated at Dartmouth College and won a Pulitzer Prize while he was the Washington bureau chief of the *Boston Globe*.

Shira Springer, an avid marathoner, has been a sportswriter at the *Boston Globe* since 1997. She regularly contributes to the Sunday *Globe Magazine* and Travel section. She is working on a book about the special relationship between a U.S. senator from Connecticut and a Jewish family trapped in Nazi Germany. She lives less than a mile away from the Charles.

Scott Stossel, the editor of the *Atlantic*, is the author of *Sarge: The Life and Times of Sargent Shriver* and *My Age of Anxiety: Fear, Hope, Dread, and the Search for Peace of Mind*, to be published in December 2013.

Neil Swidey, a staff writer for the *Boston Globe Magazine*, is the author of two nonfiction books set in Boston. *Trapped Under the Sea: One Engineering Marvel, Five Men, and a Disaster Ten Miles into the Darkness* will be published in 2014. *The Assist: Hoops, Hope, and the Game of Their Lives*, published in 2008, was named one of the best books of the year by the *Washington Post*. As an outgrowth of that book, Swidey founded the nonprofit Alray Scholars Program, which gives Boston students a second chance at college through scholarships and mentoring. Swidey was also a coauthor of *Last Lion: The Fall and Rise of Ted Kennedy*, and his work has been featured in *The Best American Science Writing*, *The Best American Crime Writing*, and *The Best American Political Writing*. He lives outside Boston with his wife and three daughters.

E. M. Swift was hired as *Sports Illustrated*'s hockey writer in 1978 and over the next thirty-two years wrote more than five hundred articles for that magazine. He has written four books and covered fifteen

Olympic Games, including the 1980 Miracle on Ice in Lake Placid. He lives in Carlisle, Massachusetts.

Sally Taylor is an artist and musician. In 1998, reluctant to sign with a major record label, she formed her own, producing and recording three albums (*Tomboy Bride*, *Apt #6S*, and *Shotgun*). She and a five-piece band toured 180 days of the year. Taylor thrived on the production elements of running a label and the creative elements of writing, recording, and performing. When she retired from the road, at age thirty, she moved to Boston and began teaching music. She is currently taking time off from the Berklee College of Music to work exclusively on ConSenses, a multidisciplinary global art initiative aimed at exploring the nature of the human experience and the origins of perception. In this effort she is dedicated to enlarging the scope of artistic collaboration, the recognition of art as a journey, and the exploration of human perception.

John Updike was born in Shillington, Pennsylvania, in 1932. He graduated from Harvard College in 1954 and spent a year in Oxford, England, at the Ruskin School of Drawing and Fine Art. From 1955 to 1957 he was a member of the staff of *The New Yorker*. His novels have won the Pulitzer Prize, the National Book Award, the National Book Critics Circle Award, the Rosenthal Foundation Award, and the William Dean Howells Medal. In 2007 he received the gold medal for fiction from the American Academy of Arts and Letters. Updike died in January 2009.

Lesley Visser is the most highly acclaimed female sportscaster of all time. She is the first and only woman enshrined in the Pro Football Hall of Fame. She was the first woman sportscaster to carry the Olympic torch, the only woman to handle a Super Bowl trophy presentation, and is the first and only recipient of Billie Jean King's Billie Award for Outstanding Journalist. Visser was voted the number one female sportscaster of all time by the American Sportscasters Association. As a reporter for CBS for more than twenty-five years, she has

covered everything from the NFL to the Olympics, the NBA finals, the NCAA final four, the World Series, the Super Bowl, and other major sports events. Visser also worked at ESPN and ABC, where she became the first woman assigned to *Monday Night Football* while also covering the Triple Crown and the World Series. A graduate of Boston College, Visser won a prestigious Carnegie Foundation grant in 1974 that entitled her to write for the *Boston Globe*, where she became the first woman to cover the NFL as a beat reporter. Visser is married to businessman Bob Kanuth, a former basketball captain at Harvard. They live in Bay Harbor Islands, Florida.

Joan Wickersham's most recent book, *The News from Spain: Seven Variations on a Love Story*, was named one of 2012's best fiction picks by National Public Radio, *Kirkus Reviews*, and the *San Francisco Chronicle*. Her memoir *The Suicide Index: Putting My Father's Death in Order* was a 2008 National Book Award finalist. Her short fiction has appeared in *The Best American Short Stories*, *The Best American Nonrequired Reading*, and many other publications. Joan writes a regular op-ed column for *the Boston Globe*, and her pieces often run in the *International Herald Tribune*. Her work has also appeared in the *Los Angeles Times* and on National Public Radio. She has been awarded fellowships by the National Endowment for the Arts, the Corporation of Yaddo, and the MacDowell Colony. She lives in Cambridge, Massachusetts, with her husband and two sons.

CREDITS

"Pride or Prejudice" by André Aciman. Copyright © 2013 by André Aciman.

"Transplants" by Jabari Asim. Copyright © 2013 by Jabari Asim.

"The Athens of America" by James Atlas. Copyright © 2013 by James Atlas.

"Walking an American Avenue" by Mike Barnicle. Copyright © 2013 by Mike Barnicle.

"Things in Threes" by Madeleine Blais. Copyright © 2013 by Madeleine Blais.

"Wounded, Boston's Heart Remains Strong" by Bud Collins. Copyright © 2013 by Bud Collins.

"Getting Over Boston" by George Howe Colt. Copyright © 2013 by George Howe Colt.

"Running Toward the Bombs" by Kevin Cullen. Copyright © 2013 by Kevin Cullen.

"Next Stop: Back Bay" by Hugh Delehanty. Copyright © 2013 by Hugh Delehanty.

"The Everything Bagel" by Leslie Epstein. First published in a different form as "Reflections, Leslie Epstein's Favorite Things" in *Where GuestBook: Boston.* Copyright © 2007 by Leslie Epstein.

"America's Brain" by Israel Horovitz. Copyright © 2013 by Israel Horovitz.

"The Classroom of the Real" by Pico Iyer. Copyright © 2013 by Pico Iyer.

"Boston Marriage" by Pagan Kennedy. First published as "So . . . Are You Two Together?" in *Ms.*, June/July 2001. Copyright © 2001 by Pagan Kennedy.

"Messing With the Wrong City" by Dennis Lehane. First published in the *New York Times*, April 16, 2013. Copyright © 2013 by Dennis Lehane.

"Boston Sports: Something for Everyone to Love — and Complain About" by Bill Littlefield. Copyright © 2013 by Bill Littlefield.

"A Boy's Boston" by Charles McGrath. Copyright © 2013 by Charles McGrath.

"Our Chowder" by David Michaelis. Copyright © 2013 by David Michaelis.

"From Somewhere" by Tova Mirvis. Copyright © 2013 by Tova Mirvis.

"Bothering Bill Russell" by Leigh Montville. Copyright © 2013 by Leigh Montville.

"Accents, or The Missing R" by Susan Orlean. First published in the *Boston Globe*, June 22, 1986. Copyright © 1986 by Susan Orlean.

"Souvenir of the Ancient World" by Robert Pinsky. First published as "Boston: Forever Changed" in the *Boston Globe Magazine*, April 21, 2013. Copyright © 2013 by Robert Pinsky.